*Art and Popular Religion
in Evangelical America, 1915–1940*

Art and Popular Religion in Evangelical America, 1915–1940

Robert L. Gambone

THE UNIVERSITY OF TENNESSEE PRESS / KNOXVILLE

Library of Congress Cataloging in Publication Data

Gambone, Robert L., 1949–
 Art and popular religion in evangelical America, 1915–1940 /
 by Robert L. Gambone.—1st ed.
 p. cm.
 Bibliography: p.
 Includes index.
 ISBN 0–87049–588–7 (cloth : alk. paper)
 1. Painting, American. 2. Painting, Modern—20th century
 —United States. 3. Art and religion—United States.
 4. Regionalism in art. 5. United States—Religious life and customs.
 I. Title.
 ND1431.6.G36 1989
 755'.0973—DC19 88–17444 CIP

Contents

Illustrations

Acknowledgments

This book is the result of over three years of intensive research and study, and during that time I received the generous assistance of several individuals and institutions. I particularly wish to acknowledge with deep gratitude the receipt of a Samuel Kress Foundation Fellowship in 1983–84 and the award of a University of Minnesota Dissertation Fellowship granted me in 1984–85.

I would like to thank the staff of the Interlibrary Loan Division, Wilson Library, University of Minnesota, for their kind patience and willingness to extend themselves beyond the call of duty in meeting my requests for loan material. I also wish to acknowledge the aid provided by the staff of the Archives of American Art, Smithsonian Institution, Washington, D.C., and the Midwest branch of the same archive for allowing me to review microfilmed material and unfilmed papers in their collection, and to thank the individuals who granted me written permission to view restricted materials from this same archive. A special debt of gratitude is due the trustees of the Thomas Hart Benton and Rita P. Benton Trusts in Kansas City and to the United Missouri Bank for permitting me to view materials in their possession. I also wish to thank the staff of the National Archives, Washington, D.C., and the staff of the film branch of the Library of Congress.

During the course of my research, several museums and art institutions generously responded to my requests for information on paintings and artists discussed in this study. While I cannot name all of them here, I am grateful for their assistance.

Special thanks is due Karal Ann Marling, who provided invaluable assistance throughout the course of my research. I also wish to acknowledge the generous help of Marion J. Nelson and Roland Delattre for reading the manuscript and making useful suggestions. Cynthia Maude-Gembler and all the folks

at the University of Tennessee Press deserve a huge round of applause for their efforts at making this project a reality.

A debt of gratitude is due Arthur and Nancy Gambone and Jim Peterson. I dedicate this book to them. Their unflagging support, constant encouragement, and interest in my work has made this experience an enjoyable one.

Preface

The twenty-five-year period from 1915 to 1940 marked the end of American religious harmony. The peaceful coexistence that had governed relations between "modernists" (those who accepted Darwinian theories and literary form-criticism of the Bible) and "orthodox" Protestants (those who rejected such developments as incompatible with the historic Christian message) reached the breaking point. Faced with a crisis in faith of monumental proportions, American Protestantism responded in the accustomed way—with mass revivalism and emotional displays of faith.[1] But, whereas the great revivals of the past involved emotional responses to external threats facing the "old-time religion," the internal difficulties besetting Protestant America in the period following the First World War intensified the terms of the debate. Discussion of religious issues spilled over into the public arena by means of the press, movies, radio, and in the mass following cultivated by a new breed of revivalist leadership.

This same twenty-five-year span witnessed evidence of the growing interest on the part of American artists in depicting and recording aspects of the American Scene. Paintings and drawings that presented unmistakably American subject matter in a clearly recognizable and representational style, divorced from what Regionalist Thomas Hart Benton called the "cockeyed isms" of European artistic theory, became for many American artists the means by which they revolted from the deleterious influence of modern European painting.[2] This development gave birth to American Scene—or Regionalist—art in the decades following World War I.

To the extent that American artists of the 1920s and 1930s shared a commitment to present viable American subject matter in terms meaningful to a broad cross section of the American people, we would also expect them to depict those scenes and events of vital interest to the popular culture of their day.

During the years 1915–40, such subject matter existed in abundance in the rise of American religious fundamentalism, the rebirth of mass revivalism, and the ensuing public debates over the role of Biblical prophecy, evolution, and religiously inspired moral reforms such as Prohibition. And, in fact, many artists active in this era *did* depict popular religious goings on in America.

But their canvases, drawings, and lithographs are worthy of serious study not simply because they portray quaint religious customs safely lumped under the catch-all phrase of the "American Scene." Rather, they continue to be important precisely because they exist as unique cultural artifacts from a critical period in American religious history. These paintings, drawings, and lithographs reveal both the private and the social attitudes that American artists held toward that religious culture for which they acted as visual interpreters, attitudes which in several respects they shared with other Americans in the 1910s, 1920s and 1930s. Understood in this way, these works become valuable documents. They are capable of revealing anew the intensity of emotion, conflicted feelings, and downright confusion Americans — not just artists — experienced as they came to grips with the untidy state of religion in an America rapidly changing from a rural to urban, agrarian to industrial, and prosperous to depression society.

In short, this book offers a cultural understanding through art of the religious turmoil affecting Americans during a particular era. In writing this book I have attempted to go beyond the narrow confines of traditional art historical methodology (analysis of form and content) in order to get at the deeper cultural meaning of these works apart from any aesthetic distinction between "high" and "low" art, or "good" and "bad" art. Given the fact that these works exist and that their quality varies greatly, one is confronted with the question of their meaning — that is, what do these paintings and drawings tell us about American culture between the wars and the artists who depicted that culture?

Because of this central concern, the structural organization of the entire book came to be determined by what the artifacts themselves present. Originally, I planned a careful, theoretical organization subdivided into neatly arranged chapters based upon what I perceived the central issues to be: evolution and Adam and Eve, grace and sin, redemption, etc. I soon abandoned this framework as being inadequate when measured against the actual material evidence of the paintings before me. What emerged was a much more flexible arrangement of chapters under whose popular-sounding headings the artists' works are organized, not as a sociologist or religious historian might organize them, but according to the broad themes the artists themselves depicted because they were of personal interest and revelatory of popular religious culture.

This arrangement allowed for some rather startling discoveries, for I soon realized that personalities as much as theoretical or theological issues seemed

to have captured the attention and imagination of both artists and the American public. Much as today we are familiar with the names of a Billy Graham, a Pat Robertson, or an Oral Roberts, without necessarily understanding the nuances of their theology, so too, for an earlier generation, the antics of Billy Sunday, Aimee Semple McPherson, or Father Divine attracted widespread curiosity, hostility, and interest, while their particular religious beliefs may or may not have been widely understood and accepted. Likewise, I found that a surprising number of paintings dealt with popular hymns or spirituals. This discovery raises the question of whether there is a close relationship between art and popular culture, indicated, for example, by the recurrence of numerous paintings bearing the title "Swing Low Sweet Chariot." Whenever visually oriented artifacts of popular culture — movies, plays, revival handbills, photographs, postcards, cartoons, and songs — provided the models for a particular painting or drawing I have included them in my discussion. The inclusion of this material affords a measure of proof that American artists meant their canvases to appeal to a broad spectrum of the American people who could be expected to easily recognize visual motifs drawn from popular culture and transferred to the less familiar context of a painting or drawing.

For similar reasons, I have excluded so-called high art commissions — those painted as part of a church decorative program under the guidelines provided by a congregation or individual acting as patron. Such works have an obvious "propagandistic" or doctrinal content, and their religious message admits of little debate as to intended meaning when measured against the concerns of the wider public community.

The central plan of this book, then, is not to make a strict art historical study of form and content, nor is it simply to perform sociological or analytical research such as might be expected from the writings of a theologian or historian. Rather, it is intended as a social history about culture, which uses art works as its primary documentary evidence to learn about that culture — in this case, to learn something about the way popular religion in America influenced how artists chose to paint America and what they felt about what they painted. Religion — popular religion — provided fertile material from which artists selected dramatic and colorful episodes or personalities, and painted or drew these people and events in an effort not solely to ridicule but also to understand and react to these powerful religious forces. They did so fully realizing, and perhaps expecting, that public confession of their feelings, as displayed on their canvases or drawings, also would resonate with the experience of the American people as a whole who, after all, constituted the intended audience for these works. It is because of this belief in the *public* nature of art that the religious background of a Benton, or a Bellows, or a Curry, growing up in rural Missouri,

Ohio, or Kansas, has been given so much attention in my book. Their experiences, while personal, were not unique. Rather, to that generation born "in the corner of the century," as Benton phrased it, the shift away from an essentially nineteenth-century religious world view toward one more in conformity with twentieth-century values and lifestyle was an experience common to most Americans. How Benton or Bellows or Curry reacted to their time and circumstances, then, and, more to the point, how they chose to paint what they felt about American religion is worthy of serious study because of what it reveals about the culture as a whole. It is this premise that underlies the entire book and provides its unifying theme.

Because this is a book about art and artists, I have chosen to begin and end my discussion with a look at three leading painters of the period — Benton, Curry, and Wood — who, as the chief exponents of what became known as "Regionalism," helped determine the stylistic parameters for other artists interested in depicting religious concerns. Continued adherence to the literalism of the Regionalist style also is partly responsible for the rapid decline of public interest in religious theme paintings. For as rapidly as the religious crisis pitting fundamentalists against modernists erupted into open theological warfare across America, just as rapidly did the furor die down, only to be replaced by the more basic issue of national survival in the 1940s. By that date many of America's most colorful revivalists had either passed from the national scene or else had lost much of their influence over the American people. For revivalism in the late 1930s, the handwriting appeared on the wall to anyone who cared to look at it. Modernists became firmly entrenched in all major Protestant denominations, including such previously evangelical strongholds as the Methodists and Northern Baptists. Evolution could be freely espoused without fear of legal action. Most denominations ceased to think of revivals as effective, practical — or even desirable — ways of attracting converts to the faith.

Likewise, American painters who had captured the popular imagination in the 1910s, 1920s and 1930s, and who found in such religious events an important source of subject matter, turned away from such subjects under the growing pressure of the international situation evident to all by 1941. Faced with a changed political and religious climate, American artists either abandoned religious themes altogether or modified their use of such imagery to reflect the new global situation.

In the 1940s Regionalism passed out of favor. New times gave birth to new artistic styles such as Surrealism and Abstract Expressionism. Religious imagery would appear occasionally in such works, but the private vocabulary of Surrealist and Abstract Expressionist painters would no longer reflect the role the "old-time religion" played within American life and culture. This significant shift,

and its occurrence with the changed political and religious climate in America, forms a logical end point for this study.

To the reader: Tracking down all the paintings, drawings, and lithographs of the 1920s–1940s discussed in the text has, in a few instances, proved to be exceedingly difficult. Despite myrids of inquiries to museums, university collections, publishers, and even surviving artists, a handful of works simply could not be located. Some works are known to have been destroyed. Others have vanished into the hands of elusive collectors who have proven impossible to contact. Some were originally intended to be reproduced as illustrations for journal or book articles and survive only in this secondary form. In all these cases public queries in the *New York Times Book Review* have not produced any further information on the location of this handful of works. Because of these circumstances a few works reproduced in this text have been photographed directly from journals or periodicals when these provided the only source for the illustrated materials under discussion. Although such illustrations may not appear to be of the highest aesthetic quality, their historical and scholarly value made their inclusion in the text imperative.

Chapter One

Religion, Revivalism, and the American Scene

The term Regionalism was, so to speak, wished upon us [Benton, Curry, Wood]. . . . However, our interests were wider than the term suggests. Those interests had their roots in that general and country-wide revival of Americanism which followed the defeat of Woodrow Wilson's universal idealism at the end of the First World War and which developed through the subsequent periods of boom and depression until the new internationalism of the Second World War pushed it aside. . . . We symbolized esthetically what the majority of Americans had in mind — America herself.[1]

With these words, Thomas Hart Benton, sole surviving member of and spokesman for the Benton-Curry-Wood Regionalist triumvirate, offered a retrospective rationale for the long duration and popular acclaim accorded Regionalist painting in the decades preceding World War II. Though quick to admit that Regionalism did not constitute a unified school, Benton stressed that all Regionalists shared the conviction that aesthetic values expressed in painting should emerge from "penetrating to the meaning and forms of life as lived . . . American life as known and felt by ordinary Americans."[2] Certainly for Benton this included familiarity with the folk patterns of American life.

The artist recalled such patterns in his autobiography, *An Artist in America* (1937). Casting himself in the role of a flesh-and-blood embodiment of the restless American spirit, Benton relentlessly traversed the highways and byways of America, seeking out places where "old manners persisted and old prejudices were sustained."[3] The inquisitive Missourian attended revival meetings, southern "Holy Roller" gatherings, and such diverse religious rites as Negro hymn sings, Ozark baptisms, and Salvation Army street testimonials. Assembling a large portfolio of sketches from these journeys, Benton carefully extracted the drawings of the religious goings on he had witnessed and used these sketches

as the bases for scenes included in his *American Historical Epic*, the *America Today* panels for the New School for Social Research, the *Arts of the South* mural for the Whitney Museum, and in the panels for the *Social History of the State of Indiana* and *Social History of the State of Missouri.*

While Benton rambled along rural byways, fascinated by the fundamentalist faiths he encountered en route, other soon-to-be-labeled Regionalist painters also set about recording the religious practices familiar to them since childhood. Kansan John Steuart Curry began his career with a series of lithographs, watercolors, and paintings which transposed the Bible into familiar midwestern terms. In 1929 he painted *Gospel Train* ("Holy Rollers") and *Prayer for Grace.* Iowan Grant Wood offered in *American Gothic* his vision of an agrarian America where the religious values of the past still held sway. Though widely diverse in style and approach, Benton's, Curry's, and Wood's canvases demonstrate that American Scene artists found in religious subject matter themes that captured the popular imagination in the 1920s and 1930s. Their work conveys a personal experience of American religion and serves as a provocative commentary upon its role in American society.

In the carefully crafted self-mythology underlying his autobiography, Benton created for the reader an elaborately tough image of himself as a clear-eyed and unsentimental realist. He claimed to be not at all religious. In fact, Benton would have his reader believe that he not only professed irreligion but also chose to remain amoral when it came to making value judgments on the behavior of others.[4] However, by carefully picking away at the circumstances surrounding Benton's life, as revealed in his letters and the artifacts with which he surrounded himself at home, as well as through his canvases and murals, it becomes possible to deflate forever this illusion cultivated for public consumption that he was devoid of religious feeling or connection.

Benton's mother hailed from the staunchly Baptist hill country of southern Appalachia. Like her sisters, this woman displayed many of the religious characteristics which the artist would later rediscover and sketch on field trips during the years 1924 to 1929. Benton's grandfather likewise manifested a fanatical religious obsession for "talking with God."[5] These childhood reminiscences remained important enough for Benton seriously to consider writing a book about them. In a manuscript candidly titled *The Intimate Story — Boyhood*, Benton revealed that his forebears delighted in appearing "offbeat" in reference to the accepted modes of Christianity.[6] As cultists and radical sectarians, they envisioned themselves as superior to and separated from other people.

Benton further recalled how his mother and aunts would gather at the family homestead in Neosho, Missouri, for weekly Bible readings following Sunday supper. The artist's father, an adherent of the Methodist church, often

"sounded off" at these gatherings, reciting entire passages of Scripture from memory.[7] In *An Artist in America*, Benton later claimed this Sunday exercise was the only form of religious instruction his Baptist mother and Methodist father agreed to provide him. However, the artist avoided mentioning the influence of his aunts. That omission raises the interesting possibility that the unpublished typescript may, in fact, be a later attempt at telling the complete truth about the circumstances influencing his early life.

During his high school years, Benton secretly read Robert Ingersoll's book, *Why I Am an Agnostic*. This experience convinced the young artist "that we were more likely to be descended from some monkeylike animal than from Adam and Eve."[8] Yet he later confided that "I would never become . . . a militant atheist; the poetry of religion was too appealing for that, but I would never again have any of those fears of hell which the fanaticism of my mother's sisters had earlier instilled in me. . . ."[9] Benton's brief sojourn as a newspaper cartoonist in Joplin, Missouri, only confirmed his curiosity about the fervors of "soliciting preachers" in a southwestern boomtown.[10] Later in his career he chose to memorialize the central role these purveyors of the gospel exercised in Joplin in 1906 by prominently placing a Gideon Bible and a revival poster upon a parlor table in the foreground of his 1972 mural, *Turn of the Century Joplin*.

Benton would have the reader of *An Artist in America* believe that he lived a carefree, libertine existence as an art student in Chicago, one punctuated by frequent visits to the Congress Café, chop suey joints, and expeditions into the "sporting districts" of the South Side. But Benton could also demonstrate a curiosity about important religious figures. In a letter to his mother, written from the Windy City in March 1907, the artist raved about a church service he attended conducted by Rev. Frank Wakeley Gunsaulus,[11] the most famous preacher in Chicago:

> In all my life I have never seen or heard anything so inspiring, so grand and magnificent as in that hour and a half this morning in the vast theatre. It is impossible to conceive, until you have seen it, the largeness of the house. . . . A house capable of seating over 6,000 people. . . . Such is the church of the greatest preacher in Chicago.[12]

Benton continued to attend services at Dr. Gunsaulus's Central Church, "the stranger's sabbath home."[13] Moreover, the religiously curious artist occasionally attended other services, only to return in disappointment to the fold of "Chicago's greatest preacher."[14] Along with his regular church attendance, Benton added the habit of reading from the Psalms following his evening meal.[15]

The artist spent one year in Chicago before heading for Paris — the mecca for all aspiring artists. Benton's brief sojourn in the City of Light only served

to increase his alienation from the techniques of modern art. Returning to America and the life of a struggling artist in New York City, the youthful painter wrestled with the problems of form and composition. During World War I, Benton worked as a stoker and amateur pugilist at the Norfolk, Virginia, navy yard; an experience that rekindled his desire to paint American subject matter—particularly its dynamic history. He worked out these ideas in his first great mural cycle, *American Historical Epic,* from 1919 to 1926. The panels *Discovery* (1919–24) and *Prayer* (1919–24) (Figs. 1.1, 1.2) from the first chapter of this epic, and *Jesuit Missioners* (1924–26) (Fig. 1.3) from the second chapter, provide concrete evidence that Benton considered overt religious activity engaged in by early Americans as worthy of artistic attention.

In *Discovery* (Fig. 1.1), a group of Spanish conquistadores embarks in a small skull from their galleon. Rowing ashore, they prepare to claim the newly found land for the crown, but a tribe of Indians peers at them from behind the protective screen of a forest bluff. Along with the Spanish has come a Franciscan friar, recognizable by his brown robe and the wooden cross he cradles in his arms. His figure occupies the center of the composition as it stands out in sharp relief against the vivid blue of the ocean backdrop. The ambiguity of the spatial relationships in the canvas clearly indicates that Benson had not yet fully resolved the compositional problems inherent in organizing a large group of figures in space. The background figures of the friar and the Spanish soldiers oscillate between the ocean in the background and the foreground where Indians witness the invasion.

This spatial ambiguity exists to a lesser degree in *Prayer* (Fig. 1.2). Here Benton portrayed a group of pilgrimlike figures, recognizable only in the high-crowned hat worn by the man in the central background and by the blunderbuss rifle he carries. As these pilgrims kneel in prayer, their bodies twist and bend into contorted forms. The artist has signaled the contemplative nature of their activity through a careful repetition across the surface of the canvas of the popular Albrecht Dürer praying hands motif. In the remaining canvas from this series, *Jesuit Missioners* (Fig. 1.3), the artist has resolved many of the compositional problems that plagued him in the earlier works. *Jesuit Missioners* depicts the French Catholic priests who fanned throughout the Ohio Valley preaching the gospel to the Huron, Iroquois, and other tribes along the Great Lakes and Ohio River.

Art historians usually claim that Benton's interest in painting American subject matter developed in the Navy, where he read J.A. Spencer's four-volume *History of the United States.* Spencer's engravings of John Vanderlyn's *Landing of Columbus* and Charles Lucey's *The First Landing of the Pilgrims, 1620* display many of the same elements the artist attempted to incorporate into his

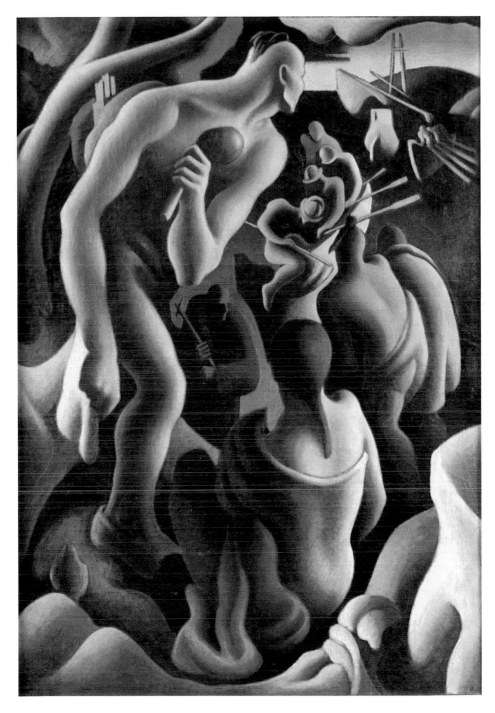

Fig. 1.1. Thomas Hart Benton, *Discovery* (1919–24). Oil on canvas,
60 x 48 inches. The Nelson-Atkins Museum of Art, Kansas City, Missouri.
Bequest of Thomas Hart Benton.

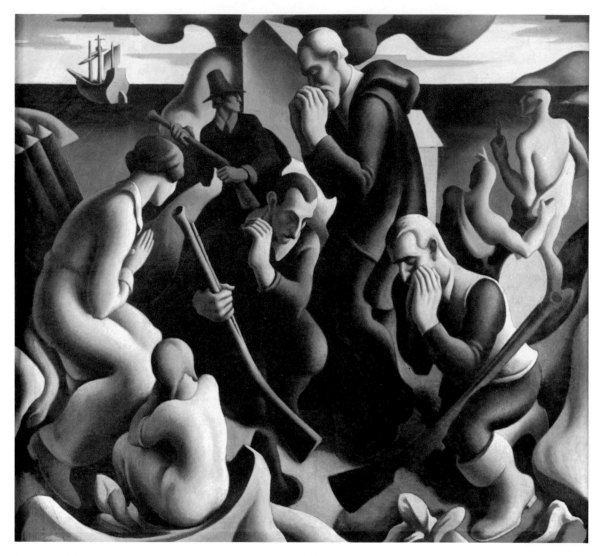

Fig. 1.2. Thomas Hart Benton, *Prayer* (1919–24). Oil on canvas, 60½ x 72 inches.
The Nelson-Atkins Museum of Art, Kansas City, Missouri. Bequest of Thomas Hart Benton.

painted versions of these scenes. While in Paris, Benton also read about the in-
terrelationship between art and society as set forth in Hippolyte Taine's *Phi-
losophie de l'Art.* This experience, plus the required architectural drawings he
executed while serving as a Navy draftsman, acted as catalysts in the artist's de-
cision to paint American life. This explanation, however, does not adequately
clarify why Benton selected the particular episodes he did nor why religious im-
ages should figure so prominently in at least three of the mural panels from
American Historical Epic.

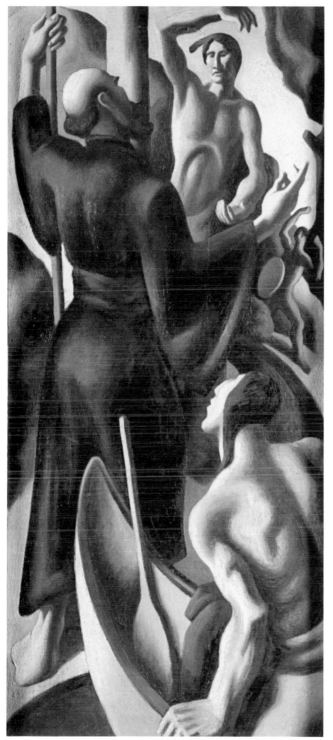

Fig. 1.3. Thomas Hart Benton,
Jesuit Missionaries (1924–26).
Oil on canvas, 72 x 36 inches.
The Nelson-Atkins Museum of Art,
Kansas City, Missouri.
Bequest of Thomas Hart Benton.

On a number of occasions, the artist stated that he intended to paint a social history, one where the emphasis fell on the ordinary doings of American folk as opposed to the movers and shakers of society.[16] This artistic expression of Frederick Jackson Turner's famous "frontier thesis" certainly caused Benton to reflect anew on the relationship between the forces operative on the American frontier, the American folk who inhabited that region, and the development of American religion. Turner felt that the frontier acted as a "safety valve," siphoning off potentially discontented masses from the eastern seaboard at the same time as it molded the shape of American democracy and the pragmatic, emotional character of its people. The parallel growth of democracy and American revivalist religion caused them to act as mutual influences:

> As they wrestled their clearing from the woods and from the savages who surrounded them, as they expanded that clearing and saw the beginnings of commonwealths . . . they became enthusiastically optimistic and confident of the continued expansion of this democracy. . . . Whether Scotch-Irish Presbyterian, Baptist, or Methodist, these people saturated their religion and their politics with feeling. Both the stump and the pulpit were centers of energy, electric cells capable of starting widespreading fires.[17]

The frontier may have closed by 1890, but its survival after this period in American fundamentalism and revivalism—then on the rise in America—provided a living, tangible link to a bygone era. The importance of this for Benton became obvious when he returned from New York to Missouri to his father's death bed in 1924. The memories and visions conjured up in that final meeting between Tom Benton, his father Maecenas Benton, and his father's old political cronies profoundly affected the artist: "I began to meet people I'd known, and in the interim moments I went with brother down in the Ozarks to see if that life I knew in my youth still existed. I guess that got me started walking around the rural parts of the South and West, sketching the people and joining in their revival meetings.[18] Recalling those political stumping tours made as a lad with his father, at which attendance at camp meetings provided grass-roots contact with "the folk," Benton began to awaken to the fact that, whether for good or ill, those "folk" practiced religion, or at least engaged in religious observances. In any authentically painted epic that purported to represent a social history of ordinary Americans, religion would have to occupy an important place.

By 1920, when Benton set up a studio in New York City, the religious influence of his family and the artist's scrupulous attendance at church services had become a thing of the past. Nowhere in Benton's correspondence with his mother after this date do the earlier ubiquitous references to church services appear. However, when Benton married Rita Piacenza on February 19, 1922, the

couple celebrated a Catholic Nuptial Mass at Francis Xavier Church in New York.[19] And although Benton never was a practicing Catholic—or Protestant either—the influence of Rita's faith permeated the Benton home.[20]

When Benton painted *Discovery* (Fig. 1.1.) and *Prayer* (Fig. 1.2), he had not yet resolved satisfactorily the interrelationships among the American frontier, frontier religion, and the religion he knew as a boy. Searching for a new mechanics of painted form and structure in *Discovery* and *Prayer*, Benton only suggests the specific incidents underlying each scene. In resorting to clearly recognizable popular images (such as the Dürer-like praying hands in *Prayer*), the artist not only signals his willingness to draw upon popular religious images but also reveals an awareness of the power of such images to communicate to a broad spectrum of individuals.

In light of this fact, Benton's summers in Martha's Vineyard in the 1920s remain important because the quaint "Yankee" inhabitants he met there gave him an opportunity to explore religious themes that later bore fruit in the New School, Whitney, Indiana, and Missouri murals. *The Lord is my Shepherd* (1926) (see Plate 1) is the outstanding religious painting from Benton's 1920s Martha's Vineyard sojourn. The title refers to the opening verse of the Twenty-third Psalm, a phrase Benton repeated visually in the picture in the form of a nineteenth-century embroidered sampler hanging on the wall behind the figures. A motif familiar in many pious Victorian homes, this sampler memorializes a psalm of utter trust and dependence upon the Lord and establishes a chain of relationships linking the word of God contained in the Scriptures, the actual figures of George and Sabrina West dining in their Martha's Vineyard farmhouse, and the past of Thomas Hart Benton.

Benton's family had encouraged devotional Bible reading. If, as a boy, the artist failed to remember the place where the previous week's lesson had ended, he received a stern rebuke from his father. While at art school in Chicago, he made a point of writing home that the Psalms constituted his favorite part of the Bible. Moreover, long after returning to Kansas City, Benton kept a copy of Guy Emerson's *The Psalms* in his personal library. This suggests that the artist chose to paint Martha's Vineyard residents George and Sabrina West not simply to demonstrate their preprandial piety but to show qualities in their life which he associated with his own familial recollections and which he believed the Wests shared with other Americans.

It wasn't until 1926 that Benton completed this painting, although he began to sketch the couple in the summer of 1922. This initial sketch simply shows George West at the table, with no indication of the sampler that frames his head in the final painting. Stricken by the twin handicaps of deafness and muteness, the Wests lived in a world of total silence.[21] They maintained an indepen-

dent existence by farming and fishing, and they also raised a family and held a respected place in the tiny Vineyard community of Chilmark.

Self-reliance, independence, and perseverance—these qualities are those Benton believed had existed in the people of the American frontier and which, by 1926, he attempted to capture in the *American Historical Epic*, billed as a people's history. The Wests represented a type, the old Yankee stock whose frugal lives and strong, independent wills helped to populate a continent. Their silent lives forged a living link with the world of Benton's Missouri boyhood, the world of his father. This link extended symbolically to their very names. Benton certainly recognized this chain of connections. Writing on the *American Historical Epic* for *Creative Art* in 1928, the artist noted "what happened in Oklahoma in my lifetime, happened in Missouri in my father's and in Kentucky and Tennessee in my grandfather's; and living words from people, not books, have linked them in feeling and established their essential sameness."[22] By pushing this analogy back a few generations further the chain would be complete: Oklahoma, Missouri, Kentucky, Tennessee, New England.

The fact that Benton's father died in 1924, when the artist had yet to complete *The Lord is my Shepherd*, explains the inclusion of the religious sampler. The summer of his father's death, Benton began in earnest his treks through the Ozark and Cumberland mountains, making several sketches of the religious doings of ordinary folk. During these trips, the artist attempted to get in touch with his past. If religion formed an important part of this past world, then it took but a simple, logical step to look for that religious past in the lives of the rustic (i.e., frontierlike) island folk of Martha's Vineyard. The island had served as a Methodist camp-meeting ground in the nineteenth century, and in the 1920s an active Methodist congregation still populated the island.[23] What better way for the artist to express this than to include a Psalm verse from his favorite part of the Bible in his new painting? In the finished work, however, the sampler not only appears, but its position carefully intersects with George West's head, making it impossible to ignore. Like a balloon caption from a newspaper comic strip, the words of the sampler seem to reveal the silent, inner thoughts of this old Yankee farmer mutely partaking of a meal.

Sketches executed during the five-year period of 1924–29 and exhibited at the Delphic Studios in New York from mid October to mid November 1929 constitute another important source for gauging the interest that American religion held for the artist. Benton organized the exhibition, which included one hundred nine drawings and watercolors, grouped around four distinct regional subdivisions: King Cotton (sketches done in Georgia, Mississippi, Alabama, and Louisiana); Lumber Camp (sketches from West Virginia, Tennessee, and Kentucky);

Holy Roller Camp Meeting (sketches done in the Cumberland Mountains); and Coal Mines (sketches from West Virginia).[24] The Holy Roller Camp Meeting segment comprised the sketches numbered 91 through 103, and the Thomas Hart Benton and Rita P. Benton Trusts in Kansas City, Missouri contain several pen-and-wash sketches which in all probability formed part of the Holy Roller Camp Meeting series (Figs. 1.4 and 1.5). The overall compositional placement of the preachers in these drawings bears a remarkable similarity to the poses and gestures of revivalists Benton later depicted in his New School, Whitney, and Indiana murals. Benton repeats in his mural figures the same curving, elongated bodies and arched, upraised hands of the ministers first found in these sketches, as well as the huddled, kneeling figures surrounding the preacher's rostrum. Such parallels suggest that already, by the mid 1920s, Benton attached enough importance to revivalism to garner sufficient material for later use in his public mural programs.

In another drawing (Fig. 1.6) Benton depicted worshippers in a Greenville, South Carolina, "Holiness" church. The hard-nosed Missourian stayed long enough to sketch the woman preacher who presided at this service and Red, a fleabitten, lewd-talking, banjo-strumming hymn singer. These figure studies served as models for characters portrayed in *Lord Heal the Child* (see Plate 2), painted in 1934. In *An Artist in America* Benton discussed how the woman preacher moved back and forth across the platform, waving her hands as she pleaded with the Lord to heal a little girl. The banjo players and fiddlers burst into an appropriate hymn as the congregation clapped and stomped their feet. In depicting this event, the artist tilted up the background space and carefully cropped the edges of the painting so that the action spills over into the viewer's space. Finding ourselves suddenly within the confines of a Holiness gathering, our eyes are led by the receding diagonals of the pews to focus upon the girl and the woman preacher who occupy center stage. As the brightest spots in the canvas, the preacher's blue dress and blond hair further attract and hold our attention, set off as they are by the glow of a kerosene lamp functioning as an artificial halo.

These early sketches and their relationship to Benton's public mural programs raise a number of questions concerning the significance that he attached to religious subject matter. In 1931, why did the artist include in the *City Activities* panel (see Plate 3) for the New School a soapbox preacher and a Salvation Army lassie? And, in 1932, why did he choose to highlight "Holy Rollers," "Negro Spirituals," and the "Sabbath Call" in *Arts of the South* (see Plate 4) for the Whitney Museum? And how are these panels related, if at all, to the *Cultural Progress* scenes (Fig. 1.7) of the Indiana mural and to the Missouri murals?

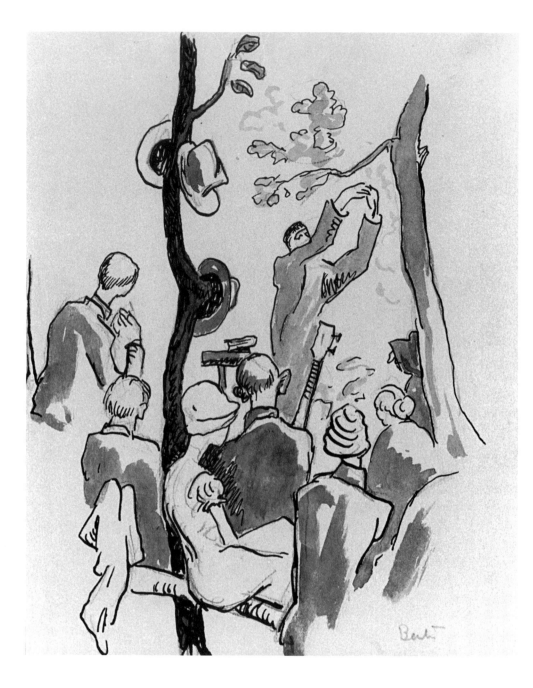

Fig. 1.4. Thomas Hart Benton, *Revival Meeting Sketch* (1924–29). Watercolor, ink wash, pencil, 9 x 7 inches. United Missouri Bank of Kansas City, N.A., and Lyman Field, Co-Trustees of Thomas H. and Rita P. Benton Testamentary Trusts.

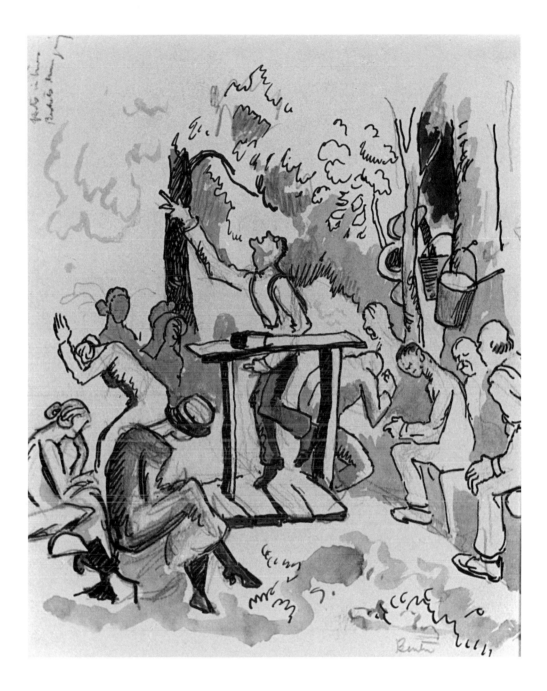

Fig. 1.5. Thomas Hart Benton, *Revival Meeting Sketch.* (1924–29). Watercolor, ink wash, pencil, 9 x 7 inches. United Missouri Bank of Kansas City, N.A., and Lyman Field, Co-Trustees of Thomas H. and Rita P. Benton Testamentary Trusts.

When discussing these works the artist openly stated that "only knowledge which is deeply and profoundly a part of one can be communicated through the logical conventions of a form."[25]

Paralleling the years in which Benton painted his first three murals, and coincident with his quest to recapture his past, several newly published sociological and religious studies examined the role religion had played on the frontier. Noteworthy in their novel approach, these writings established connections between contemporary revivalism and the effects of the frontier on shaping American religious behavior. In July 1921, Peter G. Mode, writing in the *Journal of Religion*, underlined the important relationship between revivalism and frontier life, claiming that "revivalism constituted the outstanding feature of American Protestantism."[26] Mode noted that "for almost two hundred years it is revivalism more than any other phenomenon that has supplied the landmarks in our religious history. . . . It would not be difficult and by no means unsatisfactory to write the history of American Protestantism from a standpoint of its periodic awakenings."[27] He further elaborated upon these ideas in *The Frontier Spirit in American Christianity* (1923). Taking pains to note the firm hold revivalism continued to exercise upon the American mind long after the passing of the frontier, the author contended that revivalism represented a tenacious carry-over from that particular phase of social development.

In addition to these important studies, a series of articles appeared in historical journals reexamining the role revivalism played on the frontier. The *Mississippi Valley Historical Review* featured at least three such articles: Martha L. Edwards, "Religious Forces in the United States, 1815–1830"; Francis L. Moats, "The Rise of Methodism in the Middle West"; and V. Alton Moody, "Early Religious Efforts in the Lower Mississippi." Common to all three is the emphasis on the growth of democracy and a parallel growth in the democratic spirit engendered in revivalist-oriented religion.

Such implicit connections found explicit elaboration in Arthur B. Strickland's *The Great American Revival: A Case Study in Historical Evangelism with Implications for Today* (1934). Strickland claimed that the United States had depended on religious revivals in becoming a powerful nation, inasmuch as the first settlers arrived under the influence of both the Puritan Revival in England and the Pietist Revival on the Continent. Out of this seed sprung the forces of national life, or as Strickland would phrase it, "America's conception as a great republic was in a revival atmosphere. The forms and forces of its national life took their rise in the religion of her people."[28] For all his skepticism, Benton could find a common ground with such ideas, especially with the notion that revivalist and Holy Roller types constituted a group of democracy-loving, frontier-oriented pragmatists. Such a view fit in well with Benton's stated goal of painting

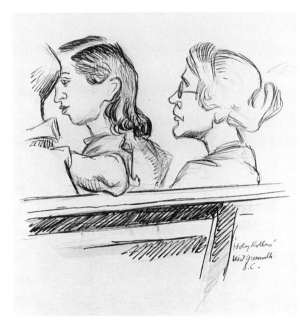

Fig. 1.6. Thomas Hart Benton, *Holy Rollers, West Greenville, S.C.* (1924–29). Pencil, ink (dimensions unknown). United Missouri Bank of Kansas City, N.A., and Lyman Field, Co-Trustees of Thomas H. and Rita P. Benton Testamentary Trusts.

social histories holding significance for ordinary Americans and provided ample justification for including revivalists and street preachers in his mural cycles. In fact, Benton revealed his favorable disposition toward the primitive world view held by "Holy Rollers" in a typewritten manuscript entitled *What I Think*:

> I sympathize even with man's habit of projecting his sublimated self into that void. Reasonable or not there is a sort of poetic justification for his so doing. . . . Why if we must fill the void of the unknown with a fiction should it not be filled with a Being who possesses all those magnified attributes of man to which men as individuals so continuously and so hopelessly aspire?
> I gave my vote to the God of the Holy Rollers, the hard-sell Baptists, the shouting Backwoods Methodists, and the black fundamentalists of the South. I like the idea of an old whiskered man who sits eternally in infinite space, whose power is all embracing, who does what he likes and who sometimes unbends and comes down to talk matters over with his weak, erring, and suffering children.[29]

When Benton depicted a soapbox preacher in a city revival, or when he portrayed a Salvation Army band competing for attention with the roar of a streetcar (in his New School mural), or when he claimed that the sounds of a revivalist urging his flock to "get next to God" and the plaintive notes of a Negro spiritual deserved the recognition accorded all true arts (as in the Whitney Mural), he expressed nothing less than his conviction that something basic to American

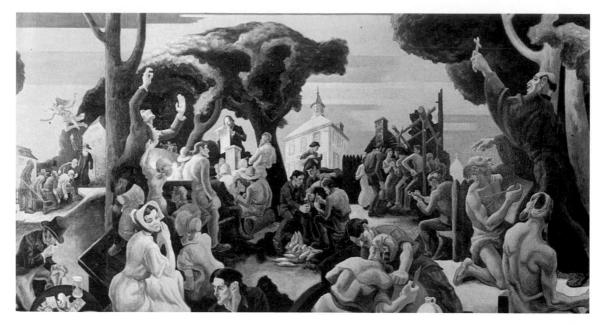

Fig. 1.7. Thomas Hart Benton, *Cultural Progress* (1933). Egg tempera on canvas mounted on panel, 12 x 20 feet. Indiana University Auditorium.

civilization could be found there. The frontier which had given America its unique character, nurturing self-reliance and grass-roots democracy, continued to flourish and survive in the frontierlike religious atmosphere nurtured in revivalist religion.

The social histories Benton painted for the states of Indiana and Missouri make explicit the connecting threads between this frontier past and the American revivalist-oriented present. In a panel for the Indiana mural, significantly labeled *Cultural Progress* (Fig. 1.7), Benton depicted Jesuit Missioners, Methodist revivalists, and the communal, pietistic sect known as Rappites. The figure of the saintly Père Allouez at the extreme right of *Cultural Progress* depicts the famous Jesuit missioner to the natives of the St. Joseph Valley as he "preaches the cross" to the natives. The figure of Père Allouez glorifies the early years of settlement and, like a larger-than-life hero out of Benton's childhood fantasies, represents "an extraordinary record of extraordinary men who endured unparalleled hardships, suffering and sacrifice."[30]

At the opposite end of the panel, Benton portrayed a Methodist revival occurring one hundred fifty years later. Here religion again acts as a civilizing influence, providing social as well as spiritual nourishment to lonely, isolated families settled upon the frontier. Offering a democratic religion to a democratic people, Methodism took the lead in gaining converts, far outstripping the conservative Presbyterians and doctrinaire Baptists in bringing the gospel to rural

outposts. Just beyond this scene Benton portrays a colony of Rappites. Originally a band of pietistic Württemberg peasants who journeyed up the Wabash in the spring of 1815, they established a celibate communal sect under the leadership of George Rapp at New Harmony, Indiana. Expert farmers and craftsmen, this fiercely independent and self-reliant sect flourished under Rapp's patriarchal leadership, guided, as he claimed, by messages from the angel Gabriel. In his mural, Benton memorializes this belief by depicting George Rapp as pointing to the celestial messenger. The Rappites constructed handsome stone dwellings, and their communistic social structure allowed them to earn a reputation as efficient farmers. But when economic success brought about the demise of the tightly organized communal structure, Rapp sold out to Scottish educator and reformer Robert Owen. Owen imported into this early Hoosier community an imposing array of zoologists, chemists, teachers, artists, and reformers. Religion thus served as the entré into Indiana for modern education and technology, linking the world of the nineteenth century with the technological present.

Benton again depicts this curious coexistence of religion and modern technology in his Missouri Capitol mural, on the south wall of the House Lounge (Fig. 1.8). A panorama reveals 1936 St. Louis: a secretary types a letter, coopers hammer shut kegs of beer in a modern brewery, shoe manufacturers ply their trade at leather stamping machines, and coal is unloaded at the Union Railroad Depot. Tucked high above this bustling city, a large billboard displays a bearded, messianic figure in flowing robes who holds a staff in one hand and stretches out his other arm in warning. The figure's actions underline the words on the sign: "Veiled Prophet will appear—St. Louis." Benton juxtaposed this modern survival of prophetic religion with its nineteenth-century Missouri counterpart on the north wall of the House Lounge (Fig. 1.9). Here a fundamentalist Ozark creek baptism takes place, and in the vignette at the bottom vigilantes tar and feather a Mormon and torch his homestead before expelling him from the state.

Benton also knew enough about American religious habits to realize that the Bible constituted the supreme authority for many American Protestants. In 1937 the artist recalled that his own boyhood questions concerning the Biblical whore of Babylon, who "glorified herself and lived deliciously," met with stern rebuffs whenever he sought clarification on the subject.[31] Filled with this libidinous recollection, no doubt, Benton painted *Susannah and the Elders* the following year (see Plate 5). A midwestern version of a Biblical tale recorded in the Book of Daniel, chapter 13, the incident depicted refers to the legend of Joakim and his beautiful wife, Susannah, who lived in Babylon. Elders and judges of the people often visited Joakim to seek his advice. During one visit, two unscrupulous elders saw Susannah in her garden, and lusted for her. Trapping her alone at her bath, they attempted rape, intending to blackmail her if she

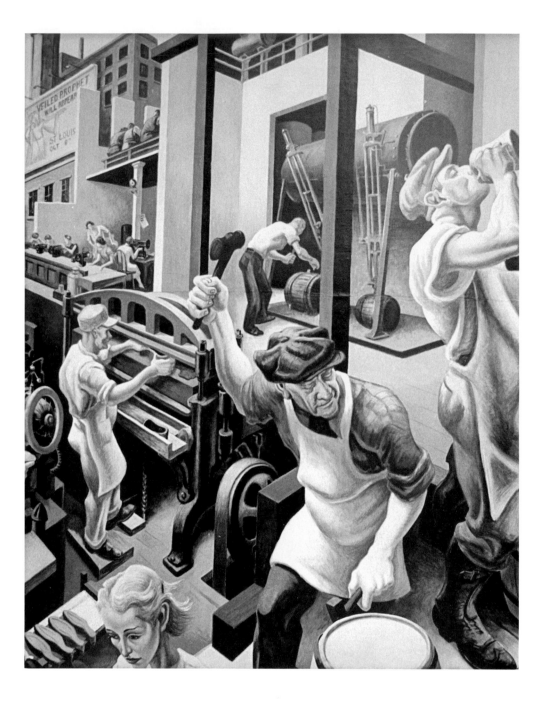

Fig. 1.8. Thomas Hart Benton, *St. Louis* (1936). Oil and egg tempera on linen mounted on panel, 14 feet 2 inches x 12 feet. Courtesy Missouri State Museum. Photo: John Viessman.

Art and Popular Religion in Evangelical America, 1915–1940

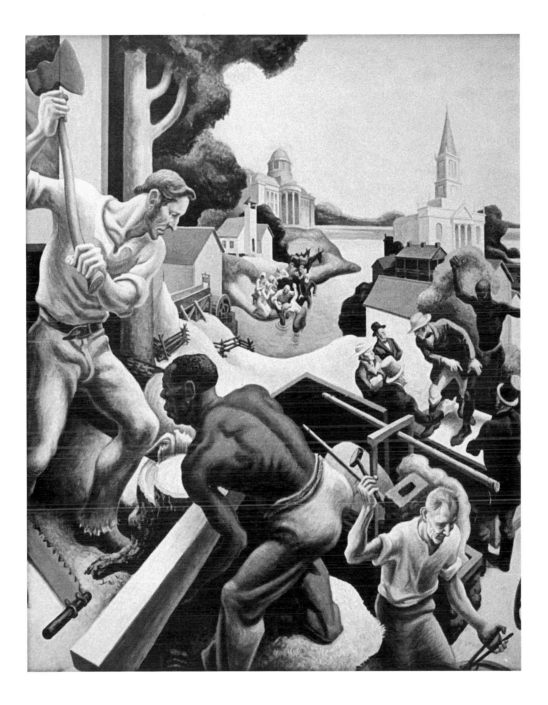

Fig. 1.9. Thomas Hart Benton, *Early Settlers* (1936). Oil and egg tempera on linen mounted on panel, 14 feet 2 inches x 12 feet. Courtesy Missouri State Museum. Photo: John Viessman.

refused their advances. When Susannah spurned them and called out for aid, the elders claimed to have caught her with another man, the penalty for which was death by stoning. As Susannah was being led away, the young prophet Daniel demanded that the two accusers be questioned separately. Asked to state under what type of tree they had seen Susannah, the men gave conflicting testimony; the corrupt elders thereupon received the death sentence, and Susannah's life was spared.

Benton's depiction of this scene became a cause célèbre when he exhibited his canvas at the St. Louis Museum of Fine Arts. Instead of using a traditional formula in which naked bodies appear surrounded by a vaguely Biblical backdrop to make them acceptable, the artist presented Susannah as a modern midwestern type whose carrot-colored, marcelled hair, red nails, and flashy diamond ring help transfer the Biblical tale into the up-to-date present. The young Susannah has blithely discarded her clothes as she dips her toe into a country creek. A branch from an oak tree, to which she clings, as well as the Ozark mountain church, Missouri mule, and Model-T on the distant horizon proclaim that this Babylon belle, like Dorothy Gale and her Kansas farmhouse, has been plucked from her customary setting and dropped into a strange new land — Middle America. The two Hebrew elders appear as country deacons, the hindmost of whom suspiciously resembles the middle-aged Benton. Pressed forward against the picture plane, the naked Susannah displays all her charms to the viewer. Stripped of any acceptable Biblical guise, her nakedness appears as the equivalent of a raw saloon nude. The viewer becomes party to the secret voyeurism of the ogling church elders in the background, only more so, because we can see what they can only imagine. A crusading female evangelist passing through St. Louis happened to visit the museum to view Benton's Biblical picture. What she saw shocked her. She promptly pronounced the picture "lewd, immoral, obscene, lascivious, degrading, an insult to womankind and the lowest expression of filth."[32]

The decision to paint this Biblical nude in a contemporary American setting may have appealed to Benton as a result of the controversy then swirling around the use and interpretation of Scripture in America. Prior to the fundamentalist/modernist split, a host of "dispensationalists" actively carried on independent gatherings and assemblies that stressed Biblical literalism and the role of prophesy. Dispensationalist thought reached America through the writings of John Nelson Darby, British leader of a sect known as the Plymouth Brethren. Darby's writings focused attention on prophecy and determination of the time when the one-thousand-year reign of Christ (the Millennium) would commence. Through a peculiar reading of Scripture, Darby determined that his-

tory could be divided into a series of successive "dispensations," or eras of grace between God and His people. These included a period of Innocence (before Adam's fall), Conscience (Adam to Noah), Human Government (Noah to Abraham), Promise (Abraham to the Ten Commandments), Law (under the Ten Commandments), Grace (from Christ to the Second Coming), and finally Kingdom (Millennium).[33] Under this system, popularized through publication of the *Scofield Reference Bible* (1909), great stress was placed upon discerning the signs of the times for the approaching millennium. By 1930, well over two million copies of the *Scofield Reference Bible* had been sold, and dispensationalists actively propagated their ideas at summer Bible conferences in such locales as Winona, Indiana, the Moody Bible Institute of Chicago, and through the Bible Institute of Los Angeles.

Such a particular use of Scripture met with harsh criticism from mainline Protestant theologians. By the late 1920s, the debate between these warring factions centered around the use of the Bible in public schools and the efficacy of forcing children to attend Sunday schools (which Benton never did). *Forum* magazine provided a particularly active platform for this debate. Across its pages a battle of words was waged in which proponents of daily Bible reading asked, "without God, is it education?" Opponents countered by asking, "which God? And why schools?"[34] Perhaps Frederick K. Stramm best expressed this dilemma for 1930s Protestants in his article "The Best Seller Nobody Reads." Noting that adherents of widely divergent doctrinal viewpoints found texts in the Scriptures upholding their own positions, Stramm openly questioned the value of a Bible in which every partisan beheld "the reflected oddities of his own particular face."[35]

Given Benton's attitude that fundamentalism reflected survivals of a frontier culture in twentieth-century America, this debate over the role of Scripture must certainly have interested him. Taking the words of Frederick K. Stramm to heart, Benton resurrected memories of childhood Bible readings and recollections of revivalist preachers. He also recalled the days spent in Joplin as a young man. The House of Lords saloon in that town displayed a painting of a nude woman over the main bar. Staring at that painting for quite a while, Benton attracted the attention of the saloon regulars, who let loose with a barrage of quips and obscenities at the expense of the red-faced young man. Embarrassed by their jokes, Benton defended himself by stating that he was an artist studying the painting's technique. When the scoffers heard this fib, they took Benton to the newspaper office, then badly in need of an illustrator, and within half an hour he produced a suitable sketch, earning a spot as cartoonist on the *Joplin American.* Such memories, combined with Benton's interest in and awareness

of the use of the Bible and Biblical prophecy in contemporary American culture, formed the backdrop against which he created *Susannah and the Elders*.

Benton was not alone in depicting Biblical events in a contemporary American setting. Fellow Regionalist John Steuart Curry also consulted the Scriptures in selecting themes providing suitable material for lithographs, watercolors, and paintings. Between 1928 and 1935 Curry used Middle America as the setting in his portrayals of the Bible: *Flight into Egypt* (1928), *The Prodigal Son* (1929), and the legend of Noah and the flood, titled *Mississippi Noah* in both the lithograph (1932–35) and the painted version (1935).

Curry grew up in the staunchly religious home of his Scotch Covenanter parents on a farm near Dunavant, Kansas. Looking back, Curry described his youth as one of ceaseless toil against the elements and of strict religious propriety. "I was raised on hard work and the Shorter Catechism," he stated, adding that his artistic style "was formed on the King James version of the Bible."[36] The Scotch Covenanters stemmed from a group of Presbyterians whose bloody struggles for religious liberty in seventeenth-century Scotland led many of them to immigrate to the New World. Rigidly Calvinistic in belief, they held fast to the original Solemn League and Covenant that enjoined members to assent to the doctrines of predestination, election, and divine retribution for sin. From his childhood study of the Shorter Catechism, Curry imbibed such teachings as:

Q. How is the Sabbath to be sanctified?
A. The Sabbath is to be sanctified by a holy resting all that day, even from such a wordly employment and recreations as are lawful on other days; and spending the whole time in the public and private exercises of God's worship, except so much as to be taken up on the works of necessity and mercy.[37]

Curry's family faithfully followed this latter prescription, attending church at least twice every Sunday.[38] The entire Curry clan appears to have actively participated in church affairs, serving as deacons, in the Sabbath school, and as missioners on the church "Gospel Team."[39] Curry's second wife recalled of her husband that "the fear of God was always in his heart. 'If you don't stand firm and you don't do the right thing you're going to be damned.' That was always there."[40] In the Curry home the Bible served as the standard against which the painter's mother measured all behavior. Once when the young Curry ran out of drawing materials, he crept upstairs to his parents' bedroom, opened a jar of Vaseline, and casually used it to draw upon the newly installed wallpaper until the sound of his mother's footsteps moved him to slide under the bed. His mother, in "the most typical religious Kansan attitude," simply moved the rock-

ing chair next to the bed and sat rocking and reading the Bible until the shame-faced Curry came out from his hiding place.[41]

Despite their conservative stance in religious matters, Curry's parents were atypical in that they had traveled to Europe for their honeymoon. Curry's mother brought back many colored reproductions of Giovanni Bellini and Peter Paul Rubens paintings and a complete volume of Gustave Doré's illustrations. Doré was the nineteenth-century French lithographer and illustrator of the famous "Doré Bible."

From earliest childhood, Curry manifested an interest in drawing. By his third year of high school, the young Kansan decided to study art and enrolled for a two-year course at the Art Institute of Chicago. In Chicago, Curry at first maintained his ties to the religious world view of his Kansas boyhood. Resolutely holding to the rigid requirements of Covenanter morality, he abstained from smoking and drinking and actively participated in Presbyterian church services.[42]

Despite this pious routine, Curry began to experience doubts about Covenanter doctrines. And like Benton before him, his letters home reveal his earnest strivings and attempts to grapple with Covenanter theology. In a letter to his mother dated February 3, 1917, the artist mentioned his attendance at the "4th Presbyterian Church and Sunday School," at which the new "minister from Manhattan" not only permitted the use of a pipe organ and "wonderful music" but also distributed communion "for everyone."[43] Curry also cryptically added, "I have just finished reading Scott's 'Old Morality' . . . Covenanters are treated by the author . . . not quite as I have supposed them to be." In the Windy City, Curry first learned about fundamentalist disputes between pre-Millennialists (those who held to the imminent return of Christ ushering in a thousand-year period of grace) and the post-Millennialists (those who believed that Christ's return would transpire only after the thousand-year period of grace). The Moody Bible Institute of Chicago was a hotbed for these debates.

Already by June 1916, Curry had established friendships and contacts with Moody Institute students, and nearly a year later he seriously considered joining the army in a company of Moodyites.[44] By December 1917, Curry even went so far as to insert in a letter to his parents, an interpretation of scriptural prophecy with obvious dispensationalist and pre-Millennial overtones.[45]

Curry's confusion over the doctrines preached at the Moody Bible Institute is worthy of greater attention because it provides clues on how he viewed his later lithographs and paintings of Biblical themes. The Institute had been founded in 1886 to train professional evangelists, but its program still reflected Moody's belief in an inerrant Scripture and pre-Millennial second coming of Christ. By

1916, the Moody Bible Institute had grown into the premiere midwestern center from which pre-Millennial thought flowed to other Bible colleges in Minneapolis and St. Paul, St. Louis, Los Angeles, and Philadelphia.[46]

Students, encouraged to find in the Scriptures the "signs of the times," for the coming Day of the Lord, readily engaged in prophetic conferences. The largest conference, involving over two thousand delegates from every state in the Union plus Canada, occurred February, 1914 at the Moody Bible Institute — less than a year and a half before Curry arrived in Chicago. Curry was informed about Covenanter interest in Biblical prophecy from his mother's letters relating how Rev. Coulter, pastor of the Winchester, Kansas, Covenanter Church, had prophesied the First World War.[47] Furthermore, by 1910, even non-Covenanter Presbyterians had assented to the Five Points set forth in *The Fundamentals*, one of which included belief in the inerrancy of Scripture.[48]

When Curry turned his attention to depicting Biblical subject matter, as in *Prodigal Son, Flight into Egypt*, and *Mississippi Noah*, he did not simply view these subjects as representations of Biblical narrative in contemporary guise, but rather referred back to his personal experiences growing up as a Scotch Covenanter in Kansas and as an earnest young adult grappling with challenges to his faith in the volatile religious atmosphere of Chicago. A clue that these experiences did, indeed, provide Curry with the inspiration for religious lithographs and paintings exists in his very first attempt at depicting religious subject matter.

In 1927 Curry drew *The Three Wise Men* (Fig. 1.10) under the guidance of Charles Locke at the Art Students League in New York. This lithograph resembles Doré's *The Wise Men Guided by the Star*, familiar to the artist from his mother's treasured volume of Doré's engravings — but with noticeable differences. While both artists present the scene so that the action progresses from right to left and align the principal figures so their backs are turned toward the viewer, Curry pictures his Magi as riding on horses rather than camels, and floating above the earth rather than riding upon it. Borrowing imagery more appropriately ascribed to Dürer's *Four Horsemen of the Apocalypse* than to the birth of Christ, Curry's work suggests that Christ's birth, far from ushering in an era of peace and good will, heralds the final end of the ages. Like a pre-Millennialist apocalyptical vision, in which the four horsemen from Revelations float above the earth unleashing pestilence, war, famine, and death, Curry's Magi, cloaked in shroudlike garments, gallop above the globe — riding toward an uncertain destination.

Curry's other Biblical lithographs and paintings demonstrate this preoccupation with pre-Millennialism in a more subtle way. *Flight into Egypt* (Fig. 1.11), *Prodigal Son* (Fig. 1.12), *Sanctuary* (Fig. 1.13), *and Mississippi Noah* (Fig. 1.14) conflate titles bearing religious significance with scenes of midwestern rural

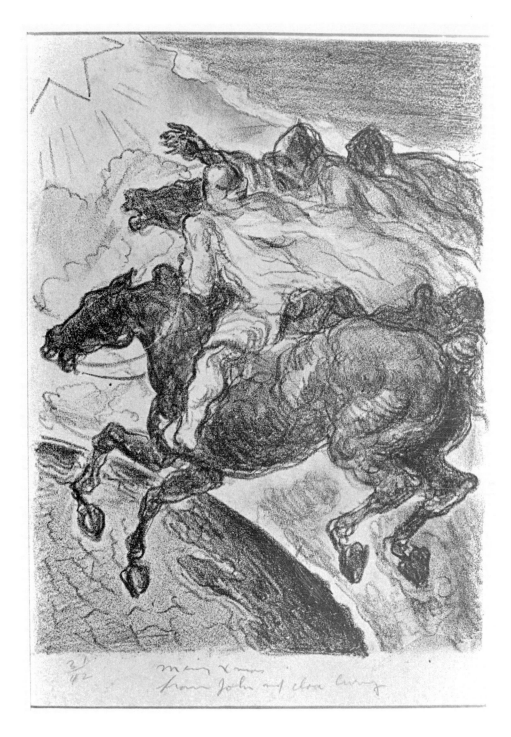

Fig. 1.10. John Steuart Curry, *The Three Wise Men* (1927).
Lithograph 8⅜ x 6¼ inches. Courtesy of the Syracuse University Art Collections.

life. Thus, the artist invites a comparison between entities that would ordinarily appear incongruous. The comparison further suggests that, although Curry eventually abandoned the Covenanter faith, he continued to remain intrigued by a religious world view that held the Bible as literally true and employed Scripture to confirm the present-day fulfillment of ancient prophesies.

Curry depicted the flight of Joseph and Mary into Egypt (Matt. 2:13–18) in the guise of a pioneer woman and her newborn babe accompanied by her farmer husband (Fig. 1.11). In this way the artist invites a comparison between the courage and nobility of these pioneers and that of the Holy Family in first-century Palestine. The fact that Curry repeats traditional iconography common to "Flight into Egypt" pictures (such as the use of a donkey and the fact that Joseph is walking while Mary and the babe ride) reinforces the web of interrelationships between the Biblical past and the American present. In Kansas, during the 1920s, migrating farm workers, driven northward from the drought-ridden fields of Arkansas and Oklahoma, emerged as a serious problem in yet another state where the depressed agricultural economy made farm employment bleak.[49] Given this scenario and the tendency for Kansas farm folk to attribute adverse agricultural conditions to the acts of a vengeful God, the artist could easily associate such events and equate them with as portentous an occurrence as the flight of the Holy Family into the exile of Egypt.

When Curry depicted the parable of the *Prodigal Son* (Luke 15:11–32) as a watercolor scene of a midwestern farmer shoveling corn husks from the back of a truck to a herd of hungry swine (Fig. 1.12), he invited comparison between the plight of this farmer and Jesus' story of the spoiled rich boy. Having squandered his inheritance, this once-wealthy heir was forced to tend a herd of swine until he repented and returned home to seek forgiveness. For Curry, this scene not only telescoped Biblical time with the American present but also compared the story told by Jesus with events personal to his own boyhood. Curry endured the regimen of farm life only until he could begin his art studies. Writing home to his father from Chicago in 1916, he quipped, "Mighty glad to get your letter about the farm. But I believe I would rather draw a picture of myself shoveling manure than do it."[50] And like the penniless prodigal, Curry's letters home frequently requested money or complained about his poverty, yet he declined an offer from his father, who wanted to set him up with land and livestock.[51]

Furthermore, Curry became terribly homesick in 1929, the year he painted *Prodigal Son.* Like the prodigal son of the parable, Curry did return home, spending six weeks in Kansas during the summer of 1929 sketching and painting along the Kaw Valley. The artist confirmed that he viewed himself as a latter-day prodigal returning to the fold when, in a speech before the Madison Art Associa-

Fig. 1.11. John Steuart Curry, *Ne'er-Do-Well* (*Flight Into Egypt*) (1929). Oil on canvas, 20 x 26 inches. Collection of the Whitney Museum of American Art. Acq. # 31.160.

tion on January 19, 1937, he noted, "While in my youth I fled from the arms of agriculture to the more seductive charms of art; now I return."[52]

The elemental conflicts between humanity and nature and nature's God which Curry depicted in *Sanctuary* (Fig. 1.13) took on renewed immediacy for the artist at the time of his 1929 visit to Kansas. That spring the Kaw River overflowed its banks, causing disastrous flooding. Evidently the pathos and drama witnessed by Curry at the time of the 1929 Kaw Floods affected him deeply. That summer he made several sketches, using material from these drawings to produce a watercolor with the religious-sounding title *Sanctuary*.

Under a leaden sky a menagerie of barnyard critters congregates upon a high patch of ground, hoping to secure refuge from the rising river that com-

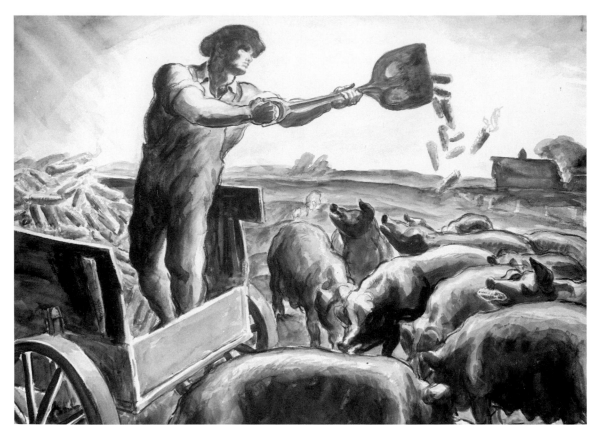

Fig. 1.12. John Steuart Curry, *Prodigal Son* (1929). Watercolor (dimensions unknown). Photograph: Peter A. Juley and Son Collection. National Museum of American Art, Smithsonian Institution.

pletely surrounds them. At the left a lowing cow makes a desperate plea for aid. By applying such a title to his canvas, Curry equates the plight of these animals to that of a medieval fugitive imploring God's protection within the narrow confines of a church sanctuary. Originally the term signified that part of a church in which the Eucharist, reserved in a golden tabernacle, was kept. For this reason, medieval Christians believed the sanctuary to be God's very dwelling place, an area of the church where no temporal power could exercise any jurisdiction nor violate (under pain of excommunication) the "sanctuary" of an individual who sought refuge there. Because of this belief, the name of the sanctuary proper gradually came to apply to the act of granting refuge, or "sanctuary." In his painting Curry suggests that the oasis of land on which the animals huddle will not be breached by the raging waters that threaten on all sides.

By including such a diverse group of animals, Curry also suggested a connection between them and the *Peaceable Kingdom*, a motif familiar from Ameri-

Art and Popular Religion in Evangelical America, 1915–1940

can folk art. Illustrating the messianic promise found in Isaiah 11:6–9, which describes a future, idyllic age of the world in which hostile animals will lie down together and dwell in peace, the subject had proven a favorite with nineteenth-century Quakers. Men like Elias Hicks and William Hallowel illustrated this text, often including specifically American landscapes and river views to imply that, in the new nation, this ancient prophecy at last bore hope of fulfillment. The emphasis on prophecy and its association with diverse animals and swelling waters would certainly have appealed to Curry in his search to find a suitable visual vocabulary capable of equating the floods of the Kaw to a religious Kansan view that held acts of nature to be acts of God. Curry's use of the title "Sanctuary" bears an affinity to the *Peaceable Kingdom* in that both suggest ultimate security despite what appears to be a potentially hostile situation.

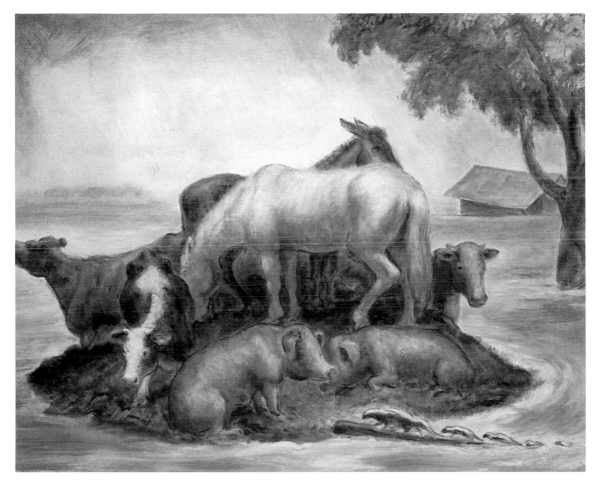

Fig. 1.13. John Steuart Curry, *Sanctuary* (1935). Oil on canvas mounted on masonite panel, 24⅛ x 30 7/16 inches. Courtesy of the Pennsylvania Academy of the Fine Arts. Collection Fund Purchase.

Curry's reliance upon a well-known Currier and Ives chromolithograph titled *High Water in the Mississippi* provides additional evidence with which to gauge the artist's familiarity with American popular arts as sources for painting.[53] *Mississippi Noah* (Fig. 1.14) of 1935 closely parallels the theme of the Currier and Ives lithograph; both depict a black family stranded on a cabin roof in the midst of a Mississippi flood. Here, too, Curry appropriates a religious title from Biblical history, the story of Noah and the Deluge (Gen. 6:5–8:14), and transposes it to a local, midwestern setting. Although the immediate source for Curry's painting lies in the same catastrophic floods that caused the Kaw River to overflow in 1929, the particular equation he makes between this event and the legend of Noah and the flood is in all likelihood borrowed from Marc Connelly's play *The Green Pastures.*

Depicting events of Genesis in terms that a black southern pastor might use to explain such stories to his Sunday school class, Connelly's play recreated on stage the fable of Noah and the ark. Noah appears as a folksy old man whose knee develops a painful crick before the coming rain and who argues with God over the merits of taking along a couple of jugs of corn liquor. Negro spirituals like "Ol Ark's a'Moverin'" and "Noah was a Witness" accompany the dialogue and swell to fill the theater. On the stage a life-sized shanty ark bobs and tosses in the water. Curry could easily have employed this source, combining it with the black family and the flood theme suggested by Currier and Ives, to produce *Mississippi Noah.* That he, in fact, borrowed the pyramidal compositional format of his canvas from Géricault's *Raft of the Medusa*, which he studied at the Louvre, indicates that the artist resorted to other sources to help him develop his ideas for this painting.[54] In his finished canvas Curry underlined the religious theme implied in the title through the gesture of prayer and supplication made by the desperate father.

As Curry began to develop Biblical themes veiled in a midwestern setting, he also focused his attention directly upon the Middle Border, painting *Gospel Train* (see Plate 6) and *Prayer for Grace* (Fig. 1.15) in 1929.[55] While Curry acted out the role of the prodigal son by returning to his Kansas homeland that summer, he managed to take a slight detour to St. Joseph, Missouri, where he attended a storefront service of ecstatic "Holy Rollers."[56] Attracted by a crudely painted sign emblazoned with the words "Gospel Train," the artist sat enthralled as he watched a group of young children, stout women, and older men wheel and spin about the room with arms raised and palms extended outward, uttering strange sounds and trancelike moans. Too respectful—or frightened—to draw during the service, Curry dashed out as soon as things quieted down and covered two full pages of his sketchbook with pencil and watercolor figures,

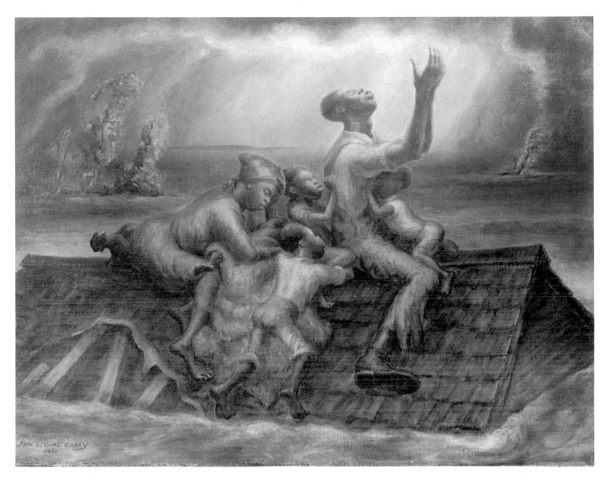

Fig. 1.14. John Steuart Curry, *Mississippi Noah* (1935). Tempera on canvas, 36 x 47½ inches. The Saint Louis Art Museum.

faces, and, above all, hands. These sketches formed the basis for *Gospel Train*, popularly called "Holy Rollers." Curry followed this same procedure at a service he attended back in Kansas, where sketches he made at a local prayer meeting revival formed the basis of *Prayer for Grace*.

 Gospel Train and *Prayer for Grace* are not simple genre paintings differing only in their actions and ceremonies from those of the more religiously conservative Scotch Covenanters. It is true that Curry did choose not to paint Covenanter ceremonies outright, an omission that caused his mother to complain gently to her son.[57] But for whatever reason the artist refrained from painting Covenanter ceremonies proper, Covenanter doctrine as expressed in the Shorter Catechism he memorized as a young boy contains several questions whose an-

swers reveal a striking similarity to the theology underlying the pentecostalism portrayed in Curry's paintings.

> Q. What is justification?
> A. Justification is an act of God's free grace, wherein he pardoneth all our sins, and accepteth us as righteous in his sight.
> Q. What is adoption?
> A. Adoption is an act of God's free grace, whereby we are received into the number, and have a right to all the privileges, of the sons of God.
> Q. What is sanctification?
> A. Sanctification is the work of God's free grace, whereby we are renewed after the image of God, and are enabled more and more to die unto sin and live unto righteousness.[58]

This tripartite doctrine—justification, adoption, and sanctification—became the focal point around which Holiness groups rallied. And a crucial center where that rally took place was Topeka, Kansas.

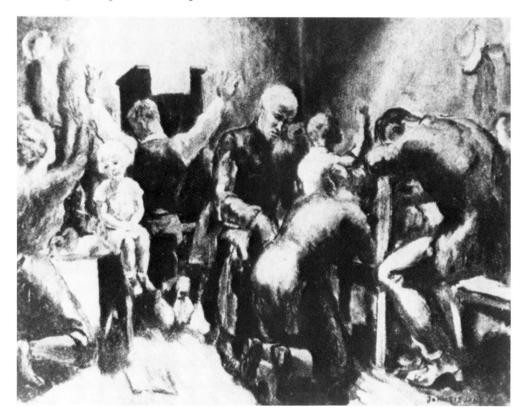

Fig. 1.15. John Steuart Curry, *Prayer for Grace* (1929). Oil on canvas. Present location unknown. From: Laurence E. Schmeckebier. *John Steuart Curry's Pageant of America.* New York: The American Artists' Group, 1943. Pp. 53 and 103.

Disturbed over the declining role of revivalism within Methodism as well as what they felt to be a corresponding lack of emphasis upon the Wesleyan doctrines of blessing and sanctification (traditionally experienced as personal assurance of salvation and growth in grace in the newly converted sinner), a group of Methodists founded the National Holiness Association as early as 1866.[59] Conceived as an effective way to register their concern that Wesleyan doctrines receive their rightful emphasis, the continued influences of such Holiness associations gradually spawned new groups. These groups placed increasing importance upon an additional "crisis of sanctification," to be experienced after conversion and the previously expected blessing of assurance.[60] Proponents of this latter experience (sometimes referred to as a "second blessing") claimed that once received, all remaining traces of sinfulness disappeared, enabling the believer to live a completely sanctified or "holy" life here and now. Alarmed at such extremist claims, bishops of the Southern Methodist church denounced this "holiness" teaching. In response, adherents to belief in a second blessing withdrew to form independent "Holiness Churches."

As a result of the continued emphasis placed upon Christian perfection by churches, a new force — "Pentecostal" or "Holy Rollers" — emerged, which stressed the centrality of the Holy Spirit in bringing about the necessary second blessing of perfection. As the Holy Spirit descended upon the original disciples at Pentecost, empowering them with the ability to speak in foreign tongues, so, too, Pentecostals laid claim to an analogous experience to be expected of anyone truly baptized in God's spirit. This doctrine attained widespread support under the guidance of Holiness preacher and Kansas Bible-school teacher Charles F. Parham, who encouraged students at his Bethel Bible "College" in Topeka to pray, fast, and study the Scriptures intensely in order to expect the "Baptism of the Holy Ghost." On New Year's Day 1901, one of the students awoke to find herself uttering "Chinese." Quickly, others followed suit, including Parham himself. Parham eventually moved from Topeka to take charge of a Holy Roller Assembly near the Tri-State district along the Kansas-Missouri-Oklahoma border. This area quickly developed into a leading center of Holiness activity.

The theological similarities between Covenanter doctrines and the Holiness idea of a second blessing and sanctification, however different in practice, indicate that Curry recognized in Holiness gatherings ceremonies that displayed all the peculiarities of Covenanter theology while providing colorful and dramatic scenes for paintings, which the staid Covenanter worship lacked. Although the artist eventually ceased to consider himself a Covenanter (he later joined the Christian Science Church), he frequently attended revivals throughout the 1930s along with his daughter, who later said she grew up believing that such settings were perfectly natural and did not realize that most children hadn't been to a

revival meeting.[61] The fact that, in 1929, Curry made a special trip to St. Joseph, Missouri, and there witnessed the events pictured in *Gospel Train* provides a further indication that Curry's interest in revivals was more than just that of a curious outsider.

It is interesting to note that little girls occupy significant roles in both *Gospel Train* and *Prayer for Grace*. In *Gospel Train* (Plate 6) whose title derives from a popular hymn indicated by the cartoon train on the rear wall of the church, a group of believers circles about in charismatic ecstasy. Two brilliant floodlights shine down on the congregation like some illumination from on high. In the center of this group, two little girls become the focus of attention. Clothed in vivid yellow and pastel green dresses and sporting, respectively, carrot-red and honey-blonde hair, they are the brightest spots in the canvas. Joining in the dancing and hand-waving with apparent abandon, they seem to echo the words of Curry's daughter, who found such surroundings "perfectly natural." In *Prayer for Grace* (Fig. 1.15), the artist also included a little blond girl sitting on the edge of a bench, calmly looking at her mother kneeling in near-hysterical abandon. The child acts as a brightly lit counterpoint to the sobbing, kneeling woman and to the group at the right side of the canvas who receive the ministrations of a solicitous preacher.

In contrast to Benton and Curry, Regionalist Grant Wood spent his entire career in the Midwest, painting all his major works in Iowa. Unlike his fellow Regionalists, Wood did not resort to painting overtly religious subject matter. Rather, he chose to channel his creative energies into mythologizing the Iowa of his 1890s boyhood, and, in so doing, celebrating the virtues of rural America. Yet Wood's paean of praise for a bygone agrarian age, revealed in such works as *American Gothic*, demonstrates the importance of religious symbols to the creation of these midwestern mythologies.

Because their religious convictions led them to oppose slavery, Wood's father's Quaker family left Virginia in 1859, eventually settling in Iowa. The artist himself cultivated the story that during his childhood his father forbade the reading of Grimm's *Fairy Tales* because "Quakers read only true things."[62] In fact, the artist's father, Francis Maryville Wood, attended the local Strawberry Hill Presbyterian Church in Anamosa and rose to the position of superintendent of the Sunday school.[63] At the school, he met a teacher, Hattie Weaver, and they later married.

Conflicting accounts exist as to the degree of piety practiced in the Wood household. Darrell Garwood, who worked closely with friends of the artist and published Wood's biography shortly after the artist's death, stated that Wood's father "didn't go in for Bible reading much and didn't have any family prayers."[64]

Wood contradicted such statements in *Return from Bohemia.* This unpublished, ghost-written autobiography is embellished with descriptions of nostalgic events such as Christmas evenings spent at home reading the Bible and church socials organized by his Aunt Sarah. This roseate, retrospective account of life on the farm, should be accepted with caution, however. On other occasions, the artist mentioned such experiences as attending Sunday School, noting that his intense shyness made it painfully difficult for him to recite the required lessons, an admission that indicates he had some religious training as a child.[65]

Wood also offers a candid look at his childhood religious fears. Daydreaming about joint-snakes during a "Hellfire and Brimstone" sermon one Sunday morning, the young Wood was jolted back to attention by the heavy hand of his father and made to feel doomed to hell for failing to listen to the sermon.[66] The sensitive Wood never forgot such moments. This unpleasant experience formed but one of his many unfortunate associations with the Presbyterian church. At fifteen, Wood received the contract to paint the chapel at the Central Park Presbyterian Church in Cedar Rapids, a task that cost him more in supplies and paint than the paltry twenty-five-dollar fee he received.[67] On another occasion, when the Ladies Aid Society of the church decided to sell a cookbook and agreed to pay Wood one dollar for a cover design, a church elder refused to pay him.[68] Little wonder that later in his life the artist "didn't seem interested" in Rev. William S. Evan's invitation to join Central Park Presbyterian Church.[69]

The only commitment of a quasi-religious nature that the artist ever undertook occurred on his thirtieth birthday in 1921, when he joined the Cedar Rapids Mount Herman Masonic Lodge Number 263. In that same year, he received a commission from fellow Mason George L. Schoonover, of Anamosa, to paint *First Three Degrees of Free Masonry* (Fig. 1.16). Borrowing the form of a medieval altar triptych with its large main panel and two smaller supporting panels, *First Three Degrees of Free Masonry* reveals Wood's eclectic use of styles and sources. The leafy background, with its cloud-filled sky and marble balustrade, looks like a Masonic version of a dreamy Maxfield Parrish setting and provides early evidence of Wood's willingness to employ popular sources of imagery in his art.[70] The nude comrades-in-arms in the center panel, displaying Masonic symbols as well as their curiously asexual bodies, seem like figures from a Lorado Taft relief group, heroically naked yet discreetly "covered up" in the appropriate places. The seated, brooding figure in the right panel is a direct copy of Rodin's *The Thinker.* Pondering the weed-covered, decaying temple lying about him, this figure begins the narrative, representing the newly entered apprentice pondering how to restore true religion.[71] In the left panel, amid scaffolding, ladders, and mortar, the reconstructed temple rises in the background. Here the formerly idle thinker actively chips away at his stone base, symbolic of his progress at

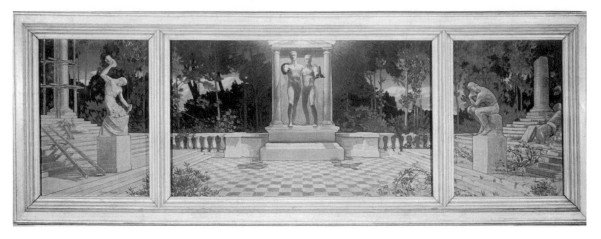

Fig. 1.16. Grant Wood, *First Three Degrees of Free Masonry* (1921). Oil on canvas, center panel 25 x 41 inches, side panels 25 x 18 inches. Iowa Masonic Library, Grand Lodge of Iowa, A.F. & A.M.

carving out and forging his new character. The Doric-column-framed figures in the central panel display Masonic symbols indicative of the rules and guidelines governing this rational faith.

How seriously Wood accepted his Masonic obligations remains questionable. No evidence exists that he ever wore a Masonic apron or any other regalia, and he did not receive funeral obsequies from the Mount Herman Lodge. In 1939 the artist made a wry comment about the antics of similar secret societies in a lithograph titled *Shrine Quartet* (Fig. 1.17). Against a mural backdrop depicting the pyramids of Egypt and two camel-riding Bedouins, four Shriners sporting fezzes bearing the crescent and star logo join in song. Cut off below the waist and placed forward in the picture plane, they look like an amateur vocal group performing before their fellow members at a convention or meeting. Wood highlighted their stagelike appearance by casting the figures in the harsh glare of a spot-light, a device that accentuates as it distorts their features and causes the quartet to seem grotesque and ghoulish. The viewer, who takes the role of a front-row spectator at this entertainment, becomes aware of the bizarre nature of this group by virtue of his or her proximity to the scene. The tableau-like effect of these singing figures may well have been inspired by the painted backdrops and elaborate canvas scenes hung in midwestern theaters during ritual entertainments for Shriner members.

Wood probably received additional inspiration for this lithograph from a 1939 *Life* magazine photo essay on the Shriners. Featuring a two-page spread with nearly a dozen photographs, *Life* headlined the fact that "30,000 Fezzed Shriners Take Over Baltimore for Giddy Seven-Day Convention."[72] Noting the

tolerance of Baltimorians in allowing fezzed Shriners to "dump feathers and water on them from hotel windows, tie up traffic [and] accost ladies in the street with oriental dances," the article featured graphic photographs of grass-skirted Shriners performing a hula, carrying a rubber chicken that laid real eggs, and playing "Maryland, My Maryland" to the reedy sound of an Oriental musette.[73] The highlight of the convention featured an actual camel patrol that traveled to Baltimore all the way from Zor Temple in Madison, Wisconsin. The spectacle of conservative midwesterners making themselves look ridiculous by riding camels through the streets of Baltimore appealed to Wood's sense of humor. In *Shrine Quartet*, the artist underscored the exceedingly odd nature of this fraternal brotherhood by juxtaposing the starched white shirts, triangle handkerchiefs, and dark business suits of the singers against their incongruous fezzes and a backdrop featuring pyramids and mounted camels.

Around 1928, following a period in which he found employment principally as an interior decorator and craftsman, Wood began to abandon his eclectic style in favor of painting a series of realistic portraits of local folk. Among this group of paintings, *American Gothic* (see Plate 7) remains Wood's Region-

Fig. 1.17. Grant Wood, *Shrine Quartet* (1939). Lithograph, 7¼ x 12 inches. The Fine Arts Museums of San Francisco, Achenbach Foundation for the Graphic Arts. Gift of George Hopper Fitch.

alist masterpiece and the work that catapulted the artist to national attention after it captured the Bronze Medal at the Art Institute of Chicago in 1930. Depicting a small town Iowan—not a farmer but perhaps a local feed store operator or post office clerk—and his daughter, Wood's painting relied on the use of familiar, stereotyped elements to convey an atmosphere of quaint domesticity and underline the old-fashioned virtues of this pair.[74] The Carpenter Gothic house of the title, an actual home Wood saw on a lecture trip to Eldon, Iowa, dated from the 1880s. The lancet Gothic window in the gable forms the central motif in the work, and Wood let it be known that he modeled the oval faces of his figures to represent "Gothic people" who might live in such a dwelling.[75] Farfetched as this explanation might seem, Wood's statement was probably meant quite literally.

During the artist's several trips to France (summer of 1920, 1923–24, and summer of 1926), he painted numerous works depicting cathedral portals and architectural motifs. With his love of handicraft and design born from his studies under Batchelder and from reading Gustav Stickley's *The Craftsman*, Wood found the sculptured facades and varied patterns of light and shade mirrored in Gothic cathedrals fascinating. Inspired by the curious survival of a wooden Gothic motif on a southern Iowa farmhouse, the artist compared it to what he knew in France. The stony looks of the two figures in *American Gothic*, the male staring straight ahead while the female averts her gaze, presents a combination often seen in figures on Gothic portals. The fact that the figures found on these portals usually depicted the Virgin, Christ, or the saints reinforces the notion that Wood meant to associate his Iowa pair with the religious attitudes of midwestern folks.

Several commentators have viewed the fine, meticulous detail and glaze techniques in *American Gothic* as related to Wood's interest in Flemish painting, particularly that of Hans Memling, whose works Wood studied while in Germany supervising the execution of his stained-glass window for the Veterans Memorial building in Cedar Rapids.[76] A close inspection of *American Gothic*, however, shows that, unlike a Memling panel, where the use of translucent oil glazes eliminates all trace of brushwork, Wood not only revealed his brushwork (especially evident in the man's bib overalls) but also did not follow Flemish glazing technique. Wood never used egg tempura as an underpainting, and he applied general wash glazes of a single tint across large areas of the canvas rather than using local layers of translucent color glazes to build up each detail.[77] These differences suggest that, although Wood found inspiration in Flemish painting, his free adaptation of technique probably resulted from looking at examples closer to home.

In reporting the reaction of Iowans to *American Gothic*, *Art Digest* noted

that Wood could have chosen a more appropriate title for his picture and suggested "Puritan Happiness" as entirely apt.[78] When Wood revealed his intentions in painting *American Gothic,* he also remarked on the "colonial print apron" worn by the woman in the painting.[79] Such comments indicate that the artist, who had an interest in early American design, looked to the native tradition of colonial portraiture as expressed, for example, in the well-known *Self-Portrait of Thomas Smith* (c. 1690). In this canvas, the clear, precise features of the unsmiling face, the direct stare of the eyes, the meticulous love of detail, and the overall moral and didactic message indicated by the pious poem and the human skull held by Smith provide a fine example of Puritan portraiture that served a religious function. By preserving a visual record of one's economic and social status, such portraits provided direct proof of heavenly election by God.

If one of the problems Wood meant to explore in *American Gothic* centered around an examination of American religious traits as these existed in his native Iowa, his specific attitude toward such traits remained elusive to many. Generally, Iowans responding to the painting tended to focus on the outward characteristics of the pair, noting the outmoded clothes, farm equipment, and lack of sexual appeal in the woman's face.[80] In so doing, they recognized a key feature of the painting: Wood deliberately used out-of-date elements—a collarless shirt, a rickrack-trimmed apron, a three-tined pitchfork, and a cameo brooch—to lend the pair an old-fashioned cast. Nan Wood Graham, the artist's sister and the model for the woman in *American Gothic,* confirmed the truth of this fact in her statement to *Magazine Digest:*

> I had as much difficulty finding the rickrack as Grant had in persuading the dentist [Dr. McKeeby, model for the man] to pose. I was told such trimming was out of date, that stores hadn't carried it in stock for years. So I had to rip the rickrack off one of mother's old dresses. Later when *American Gothic* became popular the stores were full of rickrack and the late O.O. McIntyre, famous newspaper columnist, blamed the revival on Grant's painting.[81]

By deliberately archaizing his figures, Wood implied that the values of the past—religious values among them—maintained a hold on the lives of this pair, and he hinted at this religious influence, as in Puritan portraiture, by a judicious selection of meticulous details, such as the halo-like tree form behind the woman, the church spire poking up amidst the trees, and the Gothic window of the farm house. Nan Wood Graham also revealed her brother's intent in this regard in a letter she wrote to the *Des Moines Sunday Register* in December 1930. Previously, the *Register* had published a photograph of *American Gothic* under the mistaken title "An Iowa Farmer and his Wife." Soon the paper began receiving irate letters and phone calls complaining about this slander against Iowa farmers.

In defense of herself as much as her maligned brother, Graham wrote to set the record straight and clarify once and for all the real scenario behind the painting:

> I am not supposed to be the gentleman's wife but his daughter. Papa keeps a feed store — or runs the village post office, or perhaps he preaches in a little church. . . . Anyhow, he is a very religious person. I am supposed to be one of those terribly nice and proper girls who get their chief joy in life out of going to Christian Endeavor and frowning horribly at the young couples in back seats if they giggle and whisper.[82]

Darrell Garwood also confirmed that Wood dressed Dr. McKeeby in a black jacket to represent a farmer "who might be a preacher on Sundays."[83] Picking up on this suggestion, the *Boston Herald* speculated that the artist "as a youth . . . suffered tortures from these people, who could not understand the joy of art within him and tried to crush his soul with their sheet-iron brand of salvation.[84] Such harsh characterizations of the natures of the pair in *American Gothic* cannot be justified by pictorial evidence alone. However, that Wood did view the farmer and daughter as religious types finds indirect confirmation in the fact that he intended to follow up *American Gothic* with two paintings of a circuit-riding minister on horseback and a Bible Belt revival meeting.[85] Wood abandoned these ideas because of all the criticism *American Gothic* received. Disturbed that critics could rant on about the supposed tortures his soul underwent at the hands of the folk he painted when in fact he was only hinting at their religious piety, Wood backed off from attempting an out-and-out portrayal of a Curry-style revival meeting.

Born near the turn of the century, Thomas Hart Benton, John Steuart Curry, and Grant Wood shared a midwestern heritage in which religion played a significant role. All three attended art school in Chicago and studied in Paris, and, although claiming to have rejected the faith of their childhood, all three eventually returned to the Midwest and paid considerable attention to American religious themes. Unable to divorce themselves from religious influences, they, in fact, employed religious imagery in their work to underscore the uniquely American and regional aspects of the national character they so intensely portrayed. Benton, Curry, and Wood's commitment to paint American evangelism is evidence that, although they adopted the viewpoint of outside observers, the vivid recollections of their own, once-religious pasts continued to influence how they chose to paint "the old-time religion."

Chapter Two

Baseball, Booze, Bass Drums, and Ballyhoo

In 1927, when the publishers at Harcourt, Brace and Company agreed to print Sinclair Lewis's novel *Elmer Gantry*, they no doubt realized that, behind all the ballyhoo of the Roaring Twenties, revivalism continued to play an important role in modern American society. The Reverend William Ashley Sunday, known to his friends as "Billy," emerged from World War I as a national figure whose folksy ways and gutsy gymnastics dazzled thousands. The Salvation Army, under the flamboyant leadership of Commander Evangeline Booth, developed from a nickel-and-dime rescue operation into one of the principal social welfare missions in New York City. And Christian fundamentalists could point with pride to their successful campaign to ban alcohol from the shops and homes of the nation. If America could set a righteous example by banning alcohol, surely the establishment of the Kingdom could not be far off. In the hands of a Billy Sunday or an Evangeline Booth, the campaign against "demon rum" took on all the characteristics of a religious crusade.

Like Sinclair Lewis, American artists of the period also found in the connection between revivalist figures and alcohol a popular subject worthy of explanation. Artists as diverse as George Bellows, Boardman Robinson, Philip Reisman, and Mervin Jules elected to paint Billy Sunday, the Salvation Army, or the crusade against liquor. In so doing, they expressed in their canvases and lithographs a largely negative reaction to America's leading evangelists and the anti-liquor cause upheld by the crusaders.

An elderly woman, provoked into a state of shocked wrath in 1916 upon learning of her favorite nephew's desire to enter the ranks of professional baseball players, no longer needed to entertain undue anxiety as to the precarious state of his soul — according to *Literary Digest.*[1] For in that year the famous Yankee star "Home Run" Baker, along with second baseman Boone, outfielder Cook,

first baseman Mullin, catcher Walters, and trainer Dugan, all "hit the sawdust trail" at the close of evangelist Billy Sunday's campaign to drive the devil from Baltimore. The public, eager for delicious details of this extraordinary athletic performance, would not rest until the normally reticent Baker gave out a personal statement on how this mass conversion came to pass:

> I don't want it understood that we Yankees who attended the Billy Sunday meeting were converted in the strictest sense of the word. . . . Our object in attending was to hear Billy Sunday deliver the message that has made him famous. None of us had ever seen him before. . . . Without any frills or oratory he jumped on the devil with both feet. I have never heard an umpire get the verbal trimming that Bill Sunday gave his satanic majesty. . . . He made religion seem as sane as eating or sleeping or going to the ball game.[2]

A former major leaguer himself, Sunday received these converts with a particular tenderness and sympathy because of their common bond of experience. Happy and excited as a schoolboy, Billy grasped each one of their hands and, with a broad smile on his lips, wished each player a hearty "may God bless you."

As baseball grew from sandlot play into the national game in the opening decade of the twentieth century, its players becoming revered as national heroes worthy of splashy coverage in the pages of the daily press, so, too, did Billy Sunday—the baseball evangelist—transform tent revivalism from a backlot proposition into a national religious phenomenon affecting the lives of countless Protestant folk by 1917. When a nationwide poll conducted by *American Magazine* in 1914 asked the question, "Who is the greatest man in the United States?" Billy Sunday emerged as number eight in the pantheon of American greats.[3] Between 1915 and 1918, Theodore Roosevelt, William Jennings Bryan, and Woodrow Wilson all deemed it expedient to publicly express admiration for Sunday's toil in the Lord's American vineyard. During Warren G. Harding's administration, Sunday even received a coveted invitation to visit the White House, where he was photographed posturing in his by-then famous baseball-slide pulpit pose.

Sunday was big news. The people idolized him and the press loved it. Commenting on the Philadelphia Crusade of 1915—Sunday's most sensational and largest gathering up to that time—the *Atlantic Monthly* succinctly noted that "a man who can command a reception in Washington on a casual visit, second to none given to a president or a national hero is worth consideration."[4] Other popular magazines thought so too. During the same month in which the *Atlantic Monthly* declared Billy Sunday "the most compelling personality in America," a lengthy account, "Back of Billy Sunday," by journalist John Reed with illustrations by George Bellows, splashed across the pages of *Metropolitan Magazine.* The illustrations Bellows created for this exposé of Sunday's 1915 Philadelphia

revival formed the basis for his 1916 painting, *The Sawdust Trail* (see Plate 8), a lithograph of the same subject the following year (Fig. 2.1), and a 1923 lithograph titled *Billy Sunday* (Fig. 2.2).

That Bellows chose to depict Sunday on four separate occasions reflects the artist's personal interest in and preoccupation with evangelical religion and revivalism. Describing his early upbringing in Columbus, Ohio, Bellows wryly remarked, "I arose surrounded by Methodists and Republicans."[5] Anna Bellows, the artist's pious Methodist mother, who fondly hoped her son would grace the ranks of Methodism as a bishop, paved the way for Providence by bestowing upon him the middle name of Wesley. She fortified this intention with a strict Sabbath ritual centered around enthusiastic amen-and-hallelujah-punctuated services at the Columbus First Methodist Church, followed by a rigidly enforced Sunday rest that permitted no activities other than Bible reading, Psalm singing, or drawing. The young Bellows enjoyed this last pursuit immensely. Summers were spent with his parents on the shores of Lake Erie in the placid hamlet of Lakeside, a well-established Methodist camp-meeting ground. Here Bellows not only indulged in the approved pleasures of tennis, sailing, and swimming but also exercised his fine singing voice in the Methodist choir and attended with his parents the frequent Divine Services, and the "love feasts" that followed.

By the closing decades of the nineteenth century, when Bellows attended such gatherings, the Methodist camp meeting—and Methodism in general— found itself embroiled in the controversy between the more established, financially secure, and upwardly mobile ranks of Methodists and the "come-outers," who gravitated toward a "Holiness" persuasion in their longing for a simple theology of primitive Christianity, direct charismatic experience, and the rural itinerant roots of Methodism's past.[6] The physical layout of these outdoor camps, with their rough-hewn benches, rows of tents, and rustic preacher's stand located in a grove of trees, cultivated this nostalgia for Methodism's frontier revival origins.

The youthful Bellows, who summered in exactly such an environment, must have recalled these memories when assigned by *Metropolitan Magazine* to illustrate Reed's story on Billy Sunday. The elaborate camp-meeting tabernacles constructed at those summer retreats provided Bellows with a direct visual link to the sawdust tabernacles popularized by Sunday on a massive scale. Moreover, Sunday, who had inherited the mantle of popular revivalism from Dwight L. Moody, hailed from the rural Midwest as well.

Perfecting his methods in small Iowa hamlets, Sunday capitalized on Moody's earlier appeal to transplanted and alienated rural citizens of newly industrialized cities. Such believers, possessed of a less complicated, homogeneous faith, ex-

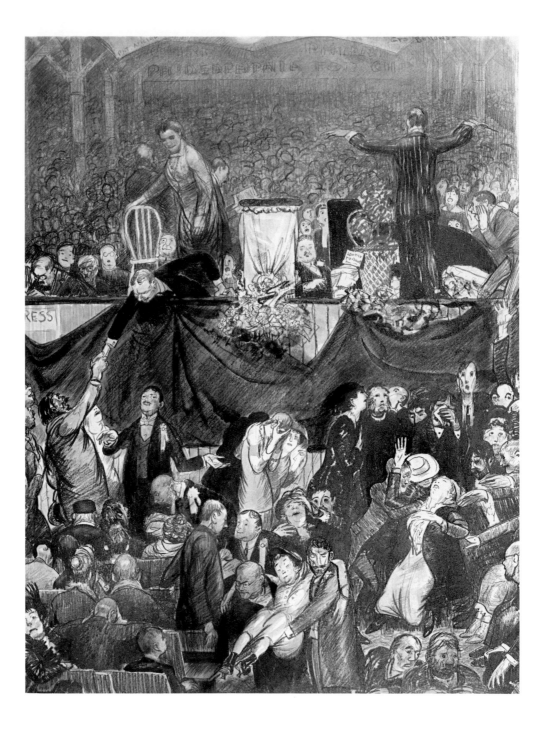

Fig. 2.1. George Bellows, *The Sawdust Trail* (1915). Lithograph. Albert H. Wiggin Collection, Boston Public Library.

Art and Popular Religion in Evangelical America, 1915–1940

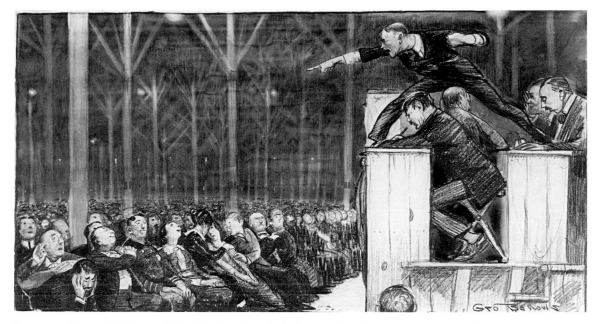

Fig. 2.2. George Bellows, *Billy Sunday* (1923). Lithograph. Albert H. Wiggin Collection, Boston Public Library.

perienced alienation on at least two counts. The culture shock inherent in transplantation to urban areas where the "old rules" of honesty, fair play, and a just wage gave way to competition, exploitation, and social dislocation estranged believers from their accustomed mores. The confusion encountered in urban churches, where large, impersonal congregations, staid forms of worship, and exposure to "modernist" theologies—so very different from the more folksy, familial atmosphere prevalent in rural congregations—further alienated these same individuals.[7] In this context, Sunday's vernacular preaching, his use of popular gospel tunes, and his insistence upon the old virtues and morals conspired to create the longed-for atmosphere of security, acceptance, and self-justification to which many passionately responded. Sunday's emphasis on a literal belief in hell, the devil, and damnation—brought together under a nostalgic wooden tabernacle—proclaimed the faith of childhood memory.

To be sure, by the time Bellows arrived in New York, he had long since jettisoned any formal allegiance to organized church-going, adopting in its stead a sort of philosophical anarchism with strong socialist leanings. But Bellows never gravitated toward doctrinaire politics. He saw no inconsistency in singing for pay at the Broadway Tabernacle while espousing the cause of radicals such as Emma Goldman or "Big Bill" Haywood. Moreover, he always maintained a fond reverence for what he regarded as genuine religious feeling, as indicated

in his sympathetic treatment of nuns in various lithographs. And while eschewing any involvement with his wife's belief in Christian Science, he provided a loving and tolerant atmosphere for her and their two children.

But Bellows did hate hypocrisy and reacted strongly against any form of bigotry or closed-mindedness. In an interview for *Touchstone*, he revealed his attitude about Billy Sunday:

> I like to paint Billy Sunday, not because I like him, but because I want to show the world what I do think of him. Do you know, I believe Billy Sunday is the worst thing that ever happened to America? He is death to imagination, to spirituality, to art. Billy Sunday is Prussianism personified. His whole purpose is to force authority against beauty. He is against freedom, he wants a religious autocracy, he is such a reactionary that he makes me an anarchist. You can see why I like to paint him and his devastating "sawdust-trail." I want people to understand him.[8]

Understanding Sunday meant exposing him to the widest possible audience in as obvious a manner as practicable. A humorous exposé with eye-catching illustrations spread across the pages of a leading popular journal provided the forum for Bellows to reach that audience. The difficulty arose over how to depict Sunday in action. Bellows may have taken his cue from early twentieth-century commercial advertising, in which goods for mass consumption were carefully depicted, their parts labeled with words or brief explanations providing complete familiarity with strange new products. In an analogous way, Bellows provided a labeled blueprint for reading *The Sawdust Trail* in the pages of *Metropolitan Magazine*, naming the actors and explaining unfamiliar details of the setting (Fig. 2.3).

The diagram reads like a "who's who" of Sunday's evangelistic entourage and exposes the participants for the hoaxes Bellows and Reed believed them to be. Juxtaposing Reed's descriptions of their personalities (captured during quick, unguarded moments at various interviews) with Bellows's visual portrayals, the article helped the reader to form quickly an unflattering image of what, indeed, lay behind this evangelistic crusade.

Although Bellows titled his full-page illustration *Billy Sunday on the Job,* it soon became known as *The Sawdust Trail* after the scene it depicted: the evangelist has just finished his harangue, imploring the crowd to hit the trail for Jesus. An endless, steady stream of hysterical people pours forth to shake the evangelist's hand in pledge of their new-found repentance and decision to follow Christ forevermore. The "job" of working the crowd up to this climax involved the coordinated efforts of the entire evangelistic "team," every one of whom, as if on cue, would spring into action on the platform. As Sunday pumps the hands of the saved, beribboned ushers lead them forward to "Glory Benches," where

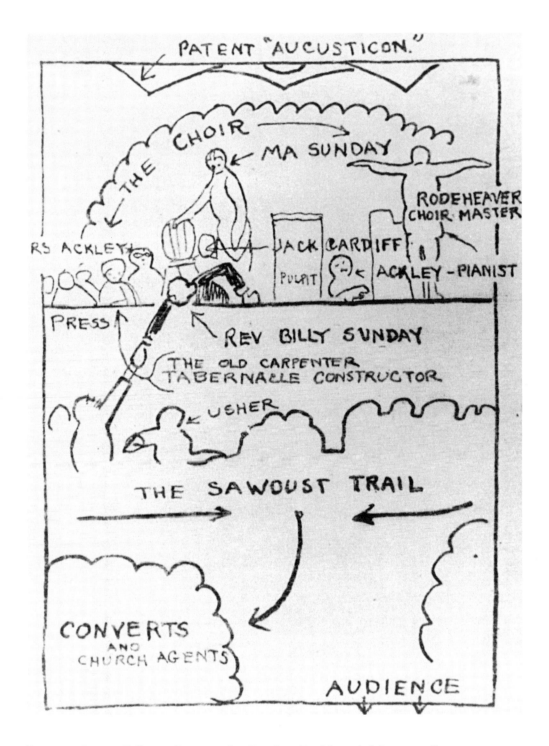

Fig. 2.3. George Bellows, *Diagram for Sawdust Trail* (1915). Magazine illustration.
Metropolitan Magazine 42 (May 1915), 11.

they sign pledge cards declaring their willingness to "accept Jesus Christ as my personal Savior." Gazing down at him in benign vigilance, "Ma" Sunday closely watches the proceedings. Homer Rodeheaver, choirmaster, directs the two-thousand-voice choir in singing appropriate, mood-setting hymns, while Mr. Ackley, pianist, accompanies them on a baby grand. Jack Cardiff, Sunday's body-guard and personal masseur, watches along with Mrs. Ackley. The press furiously takes notes. Everywhere the aisles are clogged with hysterical, fainting people.

Sunday would insist that grace moved sinful Philadelphia to repentance. A closer look at his operation suggests that additional factors powerfully aided the Lord's work. Newspapermen, for example, reported that without Homer Rodeheaver, Sunday would never have succeeded.[9] Rodeheaver's musical talents and savvy ability to manipulate the emotions of tabernacle crowds endeared him to the public—and to Sunday. Bachelorhood undoubtedly aided "Rody" in this endeavor, for during each revival lovesick women mailed their favorite chorister reams of letters. The press, however, with a greater appreciation for business acumen, penetrated Rody's all-too-unctuous façade. Visiting Sunday's headquarters on Spring Garden Street, Reed and Bellows encountered "a short, stocky man with a deep sanctimonious voice, suspicious eyes, and the kind of clammy hand that won't let yours go."[10] This was Homer Rodeheaver, stalwart Christian, who had been sued for "alleged breach of promise" only a year before.[11]

At the tabernacle, Rody would bound onto the platform with a circus trombone to pep up the crowd. "Glad to see you fellows. What hymn would *you* like?"[12] Visiting college students heard their football "fight" songs; delegations of Elks or Rotarians had their requests honored; and Rody conveyed special greetings to Irish firemen, Swedish benevolent societies, and delegations from the Chamber of Commerce.[13] Excelling in musical games, he had the crowd alternate antiphonally, competing with the choir or other parts of the assembly for special effect. The choir of more than two thousand voices, massed behind the tabernacle platform, performed virtuoso feats designed by their director to wow sinners to repentance. Rodeheaver's jazzy style reaped a spiritual harvest in souls for the Lord. The chorister's use of hymns and songbooks published by Rodeheaver Company managed to produce still more tangible benefits. In Bellows's picture, his arms extended to reveal large, "clammy" hands glistening under the glow of electric lights, Homer Rodeheaver blissfully directs the massive choir in the right middle ground as sinners hit the sawdust trail toward Sunday and salvation.

B.D. Ackley, rotund face peeking out from behind the piano, excelled at writing many of the hymns popularized during Sunday's revivals. Titles such as "Sweeter as the Years Go By," "Jesus, I Am Coming Home Today," and "If Your

Heart Beats Right" indicate the hopeful tenor of Ackley's tunes. The emphasis placed upon feeling over doctrinal content gave Ackley's melodies a lucrative advantage in the growing phonograph business, with receipts from record sales outselling printed sheet music by 1916.[14]

Because Sunday aimed for maximum popular appeal, his preaching frequently lambasted the social evils of the day in colorful, down-to-earth language. Not that Sunday concurred with the Social Gospel movement or the aims of Progressivism in politics, for he upheld the strict fundamentalist position on the uselessness of social reform unless preceded by individual moral regeneration. But Billy berated card playing, dancing, women's fashions, and booze as evils emanating from the foulest regions of hell. Raising a factory worker's wages, he reasoned, only led to a desire for more money and greedy self-seeking. Better to take away booze, the true curse of the working man. With the money saved, money which otherwise would have gone for liquor, the worker could sober up, regenerate himself, and purchase bread for his family, clothes for his wife, and shoes for their children. The chief weapons in Sunday's arsenal against the damnable liquor traffic consisted of the ever-popular "Booze Sermon," juxtaposed to Rodeheaver and Ackley's temperance hymns.

> Gambling houses and houses of prostitution are usually so closely allied with the saloon, that when the saloon is driven out, they go. The saloon is usually found in partnership with the foes of good government. . . . If you believe in better civic conditions, if you believe in a greater and better city, if you believe in men going home sober, if you believe in men going to Heaven instead of Hell, then down with the saloon.[15]

The anti-alcohol message in Sunday's "Booze Sermon" climaxed in stirring cadences, pounded out on the piano by Ackley. As Ackley played, Rodeheaver directed the choir in "De Brewer's Big Hosses," a rousing temperance hymn sung in Negro dialect. For a dramatic effect, the male voices imitated the sound of escaping steam and whistled, while the female voices sang the last two lines of the chorus. Ironically, Ackley, who delighted in putting heart and soul into each performance at these anti-booze rallies, publicly denounced his partner Rodeheaver while himself suffering from depression brought on by chronic alcoholism.[16]

Bellows pictures Ma Sunday as a substantial presence on the platform. In fact, she was such a force, not only by virtue of her physical girth but also because of the weighty influence she exercised over Sunday and the entire campaign operation. A photograph in Ellis's biography of Sunday portrays the pair as a contented, middle-class couple. Such visual evidence corroborates the popular image of Ma disseminated in pro-revival tracts. *The Jawbone*, "published every now and then in the interests of righteousness," praised Ma as "a splendid Chris-

tian woman" and "an ideal helpmate for her strenuous husband," while lauding her "coolness" and "foresight."[17] Ma acted anything but cool and collected when she met Bellows and Reed:

> "You're the magazine boys, aren't you?" she said. "Well, what do you want?"
> We said we wanted to see Billy.
> "What do you want to see him about?"
> "We wanted to get acquainted with him and ask him questions."
> "What kind of questions?"
> "Well, I don't know; about himself; about his work."
> "Well, you can't see him today," said Ma. . . .
> "Well can't we talk with you, then, for a little while?"
> "I can give you boys five minutes," she said suddenly. . . .
> "I am very curious," I said, "to know what it is that induces Mr. Sunday to come to a city."
> "Well, in the first place, the Citizens' Campaign Committee must guarantee the expenses of the campaign — in Philadelphia $50,000 — —"
> "I mean the spiritual reason," I said.
> She picked up my hat, crushed it, and dropped it. "Are you a Christian man?" she asked suddenly.
> "I am not," I responded.
> "Then," she said firmly, "I can't discuss those things with you. All I can say is that every one of Mr. Sunday's movements — and mine — are directed by God."
> We digested this. . . .
> "What is the effect of a Sunday campaign on the industrial conditions of a city? Does it help to solve the question of unemployment, for example?"
> She fixed me with a steely eye. "The poor you always have with you, the Old Testament says. And you can't go against the Old Testament . . . " She hastily quitted us, for there was a delegation of ministers from Richmond, Va., waiting to be led upstairs to see Billy. . . . "Say, don't you gentlemen speak a word to those two reporters. They're slick."[18]

Outflanked by Ma, the two journalists eventually finagled their way into Sunday's presence through the simple trust of Jack Cardiff, "ex-prizefighter, ex-actor and now physical trainer and rubber-down to the evangelist."[19] Reed described Cardiff as extremely shy, having the face of a child who blushed when Bellows asked to sketch him. In Bellows's lithograph and painting, this innocent soul, well on his way to the welterweight championship of the world when converted by Sunday, appears sandwiched between the looming presence of Ma, her now-vacant chair, and Sunday's crouched body. His round, boyish face seems lost in the vicelike grip of evangelism which literally and figuratively surrounds him.

The press, seated in the box behind Sunday, strained for superlatives to describe the frenetic antics going on before their eyes. Taking their cue from the

baseball evangelist himself, they found that America's national game served as the only metaphor capable of capturing the flavor of that moment. Bruce Barton, soon to portray Jesus as the quintessential businessman, heralded this trend by proclaiming, in the pages of *Collier's*, that "out in the Middle West another inning is closing in the continuous game which Billy Sunday calls his 'Fight with the devil.' For sixteen years he has moved from town to town pitching the ball straight at the enemy's head, and when his turn at the plate came, batting hard to bring the runs home. Score keepers differ as to the number of 'errors' the Rev. Billy has made, but they are agreed that his hits measured in influenced human lives, total nearly 200,000."[20]

Barton's article underscores his baseball analogy by placing Sunday action photos throughout the text. Other reporters quickly followed suit. New York correspondents covering the Philadelphia campaign wired back that "Billy Sunday scored two more home runs today in his spectacular game against Philadelphia's smug, self-satisfied church folk, and he did some tremendous 'stick-work' with his bat against the devil and all Beelzebub's works."[21] Reporters noted that at the conclusion of his sermon "for men only," Sunday parodied the popular poem, "Slide, Kelly, Slide," making a running dive across the platform on his stomach in mock imitation of a baseball player trying to steal home. Quickly jumping up to play "the Great Umpire of the Universe," Billy yelled, "You're out, Kelly!" after which he related how his former teammate had degenerated into a hopeless alcoholic, thereby failing to "get home" to heaven.[22]

Press cartoons accompanying these stories afforded humorous glimpses of Sunday in motion. Yet these same caricatures, reproduced in quasi-official biographies of the evangelist, became badges of pride, proof of Sunday's manly athletic powers, a veritable lexicon of body English immediately understandable to the common folk.

Aware that Sunday's vulgar style appealed because of its unconventional and unexpected use of acrobatics, magazine illustrators attempting to picture this dynamism walked a fine line between caricature and simple cartooning. If an artist's sympathies took a decidedly anti-Sunday slant, as in the case of Bellows, the task of expressing that attitude before a wide (and probably pro-Sunday) audience became complex indeed.

One possible solution, adopted by noted newspaper cartoonist and artist Boardman Robinson, portrayed Billy Sunday in a variety of actions and postures, set off with appropriate quotations from the evangelist's most blistering sermons (Fig. 2.4). Like stills out of a Biograph movie, these sketches for *McClure's Magazine* freeze bits of the action, capturing Billy in his most acrobatically awkward moments. By creating the illusion of suspended action, Robinson encouraged the reader to study at length what could only be fleetingly glimpsed

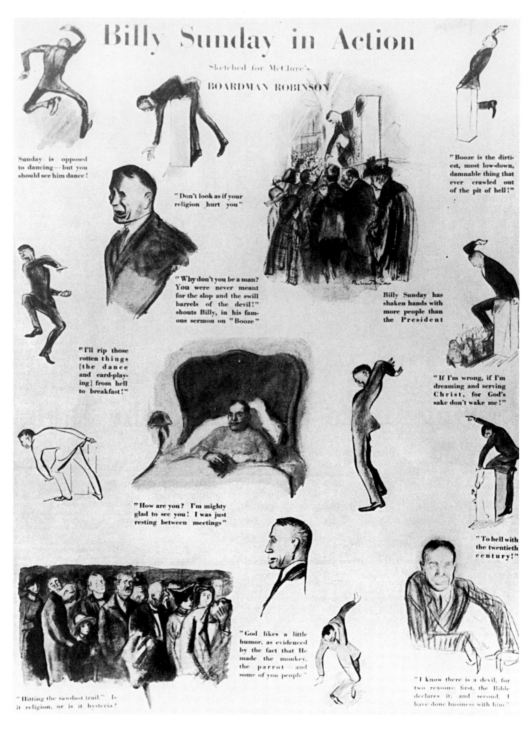

Fig. 2.4. Boardman Robinson, *Billy Sunday in Action* (1915). Magazine illustration. *McClure's* 45 (May 1915), 13.

Art and Popular Religion in Evangelical America, 1915–1940

during the revival meeting itself. The evangelist appears ludicrous when rendered through Robinson's rapid drawing style, a style that underscores Sunday's dancelike poses.[23] Paired off with quips by the artist which, in turn, play off of Sunday's stock phrases, these sketches revealed a previously unseen image of Billy Sunday.

Running bowlegged along a platform, arms flailing the breeze, Sunday, who blasted the tango as "the rottenist, most putrid, stinkingest dance that ever wriggled out of the pot of perdition," appears caught up in his own bizarre jig.[24] Below this sketch Robinson quipped, "Sunday is opposed to dancing but you should see him dance!" "Don't look as if your religion hurt you," the evangelist frequently admonished his audience. Yet Robinson's drawing shows Billy doubled over the podium, straining his legs outward while stretching his right hand down toward some unseen person below. Burlesquing Sunday's anti-evolution stance, the artist pictures him executing a curious, knee-clanking pirouette, arms spread wide. "God likes a little humor, as evidenced by the fact that He made the monkey, the parrot—and some of you people," declares Billy. Looking at Robinson's picture, the reader might well wonder to whom this remark applied.

Robinson's antipathy for Sunday only crystallized as a result of his wartime experience in the Balkans. Denied visas because of Theodore Roosevelt's denunciation of them as radicals, John Reed and Boardman Robinson infiltrated the war zone through Italian lines. Their depiction of the horrors they witnessed—the death, carnage, and destruction of trench warfare, the mustard gassings, and the pitiful plight of refugees—brought home to Americans on the pages of *Metropolitan Magazine* the ugliness and pain of modern combat.

Returning to the states, Robinson joined the staff of the *Masses*, to which Bellows frequently contributed drawings. The fact that both Bellows and Robinson knew and worked with Reed, participated in projects for *Metropolitan Magazine* in 1915, and sold cartoons to the *Masses* raises the possibility that the two artists also exchanged opinions as to the character of Billy Sunday. At any rate, both men found the evangelist a worthy subject for study in 1915. Sunday's wartime jingoism must have seemed personally repugnant to Robinson in light of his own experience in Eastern Europe.

The Sunday issue gained in urgency when, shortly after the United States declared war, the evangelist opened his New York campaign, updating his tried-and-true sermon, "God's Grenadiers," with a jingoistic call to arms: "The soldier who breaks every regulation, yet is found on the firing line in the hour of battle, is better than the God-forsaken mutt who won't enlist, and does all he can to keep others from enlisting. In these days all are patriots or traitors, to your country and the cause of Jesus Christ."[25] Billy closed this opening rally by climbing onto the pulpit and wildly waving the American flag while the audience whooped

and cheered. Only when Rodeheaver began to lead the choir in a rendition of "America," followed by "Battle Hymn of the Republic," did a semblance of order prevail.

This opening rally set the tone for Sunday's New York revival (April 1917). No one knows how many men received the inspiration to enlist from Billy's rhetoric. According to one *New York Times* account, a "fair percentage of the trail hitters were National Guardsmen, young fellows who had recently enlisted and who were not entirely at ease in their new uniforms. These filed past the evangelist as if they were going to battle, heads erect, eyes front, and determination writ upon their faces."[26]

The June 1917 issue of the *Masses* revealed Robinson's response to Sunday's New York rally. Dressed in a laborer's outfit, complete with cap and vest, suspenders flapping loosely in the breeze, a jubilant, high-stepping Billy Sunday calls out in glee, "I got him! He's plum dippy over going to war!"[27] The "him" resembles Jesus Christ, hands tied behind his back, led by a rope around the neck—unwilling victim of a Sunday acting as recruitment officer (Fig. 2.5).

The war also brought unexpected changes for Billy Sunday. Material restrictions brought on by that conflict curtailed tabernacle building, a distinctive feature of the evangelist's style. Crowds once motivated by the emotional appeal to "hit the sawdust trail" now experienced a more urgent tug at their psychic resources in the hoopla surrounding war bond rallies, Red Cross appeals, and army recruitment campaigns. The disillusionment with the Peace of Versailles and the experience of the war caused many to turn away from the enthusiastic rallies of mass revivalism.

As wartime hysteria gave way to the "normalcy" of the Harding and Coolidge years, Sunday's sermons focused on new scapegoats. In a world made safe for democracy, with Prohibition the law of the land, bootleggers felt the heat of Billy's wrath. Lumped together with "modernists" and "Bolshiviki," this unholy trinity now emerged as a distinctly un-American class in the evangelist's postwar preaching.

Venting his wrath in a sermon titled "The Ten Commandments," the evangelist warned of a "new class" arriving in America bringing "dangerous heresies" and "continental customs." Societal changes in the Soviet Union caused Sunday to view every immigrant as a potential atheist and every proponent of birth control as a budding Communist.[28] In a sermon labeled "What Think Ye of Christ," the evangelist blasted immigrant labor as "promiscuous importations" and "dangerous radicals," worthy only of immediate expulsion. Recognizing the failure of his revival program to reach these groups, much less convert them into "decent Protestant Americans," Sunday rejected them as "hotdog, spaghetti . . . limburger and garlic breath . . . crummy-buggy blanket . . . men," who cheapened the sta-

tus of American citizenship.[29] Failing in his appeal to the common man, incapable of accepting new immigration, and having already dueled with the devil in New York—America's "wickedest" city—without converting it as promised, Sunday's star began to sink back into the west. The heightened stridency in Billy's rhetoric after the war reflects the evangelical failure of his earlier program.

Demoted from major league status to the farm club circuit of the Midwest where he began, Sunday's ravings in the 1920s still made him a worthy oppo-

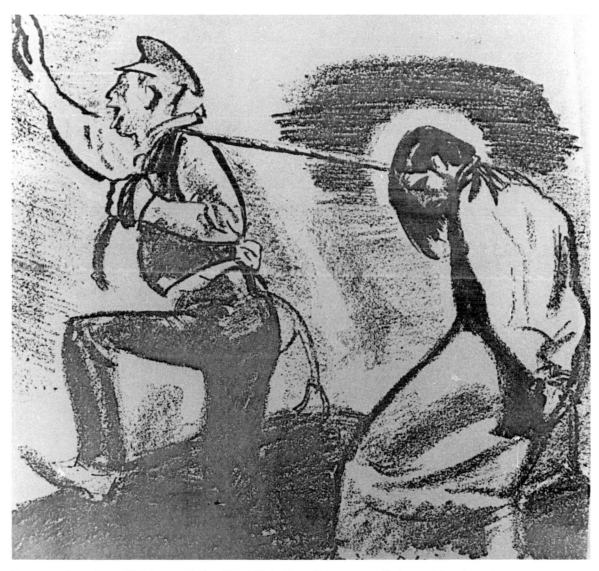

Fig. 2.5. Boardman Robinson, *I Got Him! He's Plum Dippy over Going to War* (1917). Magazine illustration. *Masses* 9 (June 1917), 13.

nent. As a befriender of Emma Goldman and Big Bill Haywood, a philosophical anarchist, and the intimate of prominent socialist artists, George Bellows could not sit idly by in the face of such vitriolic attacks. In 1923 he reissued as a lithograph the drawing *Billy Sunday*, which had originally appeared in the 1915 *Metropolitan Magazine* story on the evangelist (Fig. 2.2). Straddling the press boxes, Sunday lunges forward to point an incriminating finger into the dark cavernous space filled by the tabernacle audience. Seeming to single out particular persons or groups as the object of this righteous wrath, Sunday backs up his accusations with a walloping punch. Yet his words and gestures, however violent, fail to galvanize the crowd. Rather, they reproduce a variety of reactions ranging from despair, boredom, and anger, to smug self-satisfaction. Only one young girl, comforted by her parents, remains physically shaken. This failure to obtain a unified response from the crowd might well suggest Billy Sunday's waning power to convince and convert in 1923. In issuing this lithograph, Bellows could make a direct swipe at the gospel preacher, exposing his venomous rhetoric, while subtly suggesting the hollowness of the evangelist's words. No longer capable of producing their desired effect, Sunday's harangues remained nothing but a booming gong and a clashing cymbal.

Gongs, cymbals—and brass drums, too—attracted Bellows's attention in late 1923 and 1924. Responding to an offer from *Good Housekeeping* magazine to illustrate a feature story on the Salvation Army, the artist, writing from his summer retreat at Woodstock, New York, requested the editors to forward a copy of the manuscript. "It might suggest something to me," Bellows wrote, adding a special plea for detailed photographs of Salvation Army equipment.[30]

H. Addington Bruce's story, "With God's Help," subtitled "How the Salvation Army Energizes the Broken by Putting Them in Touch with that Store of Latent Energy which Is the Common Heritage of Mankind," painted a sympathetic psychological profile of Salvation Army goals and methods. Offering dramatic accounts of the conversions of hopeless boozers, "sodden with drink, vicious, brutalized, in every way debased," Bruce wove a dramatic tale of heroic Salvation laddies and lassies, toiling on behalf of "the lowest of the low." By awakening in the convert a latent desire for betterment, coupled with the gradual dawning of faith in his ability to achieve improvement, the Army seemed to bring drunkards miraculously to discover the wherewithal to transform themselves from despairing rummies into individuals "energized bodily, intellectually, as well as morally."[31] Evidently, Bellows viewed this psychological religion with a great deal of irony for he titled his drawing for *Good Housekeeping, Energizing the Broken* (Fig. 2.6).

Enduring almost daily exposure to his wife's strong Christian Science con-

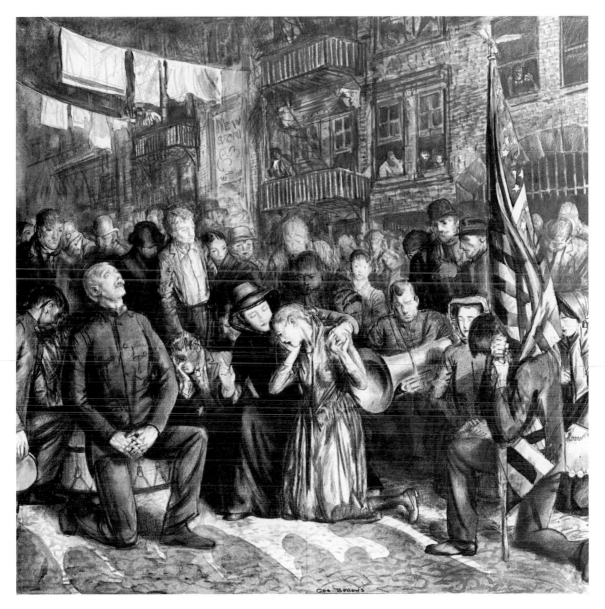

Fig. 2.6. George Bellows, *Energizing the Broken* (1924). Multi media drawing. Albert H. Wiggin Collection, Boston Public Library.

victions, along with her spiritual admonitions that suffering and disease simply reflected illusion, Bellows likely relished Bruce's equation of Salvation Army strategies with the techniques of modern religious psychology, widely publicized by William James. In the manuscript submitted to Bellows, the author de-

scribed the hypnotic means employed at Salvation Army meetings to effect a conversion:

> At the end of the service people were invited to come up to the mercy seat on the stage in order to seek consecration. On the stage one of the leaders was repeating in confident and slightly monotonous tones: "Jesus calls you. Come. Come. Come now. Come. Come now. . . ." The congregation was asked to bow their heads and to sing with their eyes closed. The closed eyes, the monotonous singing, and the repetition of the word "come" on the stage, all tended to produce in the audience a state approaching the hypnoidal. . . . The effect of this suggestion was a powerful one, and it succeeded in breaking down the resistance of several of the congregation to the act of making a public declaration by stepping onto the stage.[32]

If the modern methods employed by the Salvation Army to redeem the lost appealed to the 1920s generation through the claim that people could maximize their energies and get "as much out of life as they were meant to accomplish and get," this same popular notion reached a wide audience in movies, stage plays, and on the pages of the daily press.

Salvation Nell, Edward Sheldon's hit drama about slum life, the vices of alcoholism among New York's Irish of the Cherry Hill district, and the Salvation Army's role in their redemption, played to capacity audiences in 1908. Revived as a film in 1915, the plot proved engrossing enough for a second filming in 1921 and for a less popular refilming as a talkie in 1931. Nell, the heroine, works as a scullery maid at McGovern's Empire Bar in order to support her indolent lover, Jim Platt, a "booze-soaked bum." As the action unfolds, we learn that Nell is pregnant (and thrown out by her landlady as a result) and secretly living in the basement of the bar after working hours. Jim, now unemployed due to his chronic drunkenness, faces eviction from the saloon for the last time, as Nell pleads with him to stick by her.

A comely Salvation Army lassie, affectionately derided as "Salvation Maggie" by the saloon regulars, enters seeking converts. Hoping to comfort the despondent Nell, she gently encourages her attendance at an open-air meeting conducted by the handsome Captain Williams. In the meantime, Jim has gone off to watch a police raid at Cloquette's, a nearby whorehouse. Maggie gently entreats Nell with Christ's words, "Come unto me all ye that are heavy laden and I will give ye rest." As Nell appears to respond to this message, Myrtle Hawes walks into the bar, having just escaped from the raid on Cloquette's, clad in a scanty, spangled evening gown. Jim follows her in. Despite McGovern's previous warning and Nell's pleading, he orders more whiskey. As the drinking continues, one of the men at the bar, in the heat of passion, grabs Nell and, in spite of her struggles, roughly manhandles her. Jim throws the drunk onto the ground,

savagely kicking him about the head, and threatening to kill any man who would "lay for my gal." Jim pummels the helpless victim until subdued by the police, who lead him away in handcuffs. The law officers now threaten Mc-Govern with the loss of his license, and, in a fit of misdirected anger, the bar owner orders Nell to get out for good.

In the dramatic conclusion to Act I, Nell appears clad in a shawl, pregnant and now homeless. Salvation Maggie and Myrtle Hawes offer to help her. Myrtle encourages Nell to join the girls at Cloquette's, while Maggie says, "Catch hold of His hand, Nell. He'll save you." Nell breaks down crying as she is hugged by Maggie. The gathered Salvation Army forces burst into "Glory, Glory Hallelujah! Our Lord Was Born Today," as the curtain descends on Act I.[33]

Whether or not Bellows ever saw the play or the film version of 1921 (more likely), his drawing for *Good Housekeeping* bears a striking resemblance to the closing scene of Act I as well as to the tenement setting of the film's climax. Bellows depicted a crowd of unfortunates surrounding a Salvation Army band, amidst a slum district of decaying brick row houses replete with hanging wash and the ever-present occupants peering out of darkened windows. Their curiosity aroused by drums, tambourines, and the Sousaphone, and by the uniformed laddies and bonneted lassies, the denizens of this tenderloin district look on as a conversion takes place. Kneeling on the cobbled street, a solicitous Salvation lassie places her arm about a distraught young woman and points her right hand heavenward. As in the play, the penitent woman, draped in a shawl and kneeling, appears to wipe away tears as other members of the Army join in prayer and song.

Bruce's popular religious psychology and the pro-temperance Broadway dramas were not the only sources Bellows may have drawn upon for *Energizing the Broken*. Sensational press accounts of Salvation Army activities and difficulties most probably furnished the necessary catalyst for Bellows's decision to depict a Salvation lassie hard at work convincing a fallen sinner to repent. Interestingly enough, while his lithographs satirizing Prohibition and church-going are sharp and ascerbic, Bellows drew a fairly objective, albeit somewhat melodramatic, view of Salvation Army activities themselves. This seeming inconsistency of approach indicates that, although Bellows was not supportive of conservative Christian social attitudes, he could nevertheless admire from afar the remarkable energy and drive of such noteworthy activists as Evangeline Booth.

Thriving under Booth's dynamic leadership, the Salvation Army in America grew from a small organized band of expatriate Britishers into a massive religious machine, possessing assets in excess of $23 million by 1923.[34] Commander Booth made good news copy for any savvy editor. Of striking appearance, with flowing auburn hair and flashing eyes, possessed of a voice like that of Sarah Bern-

hardt, Evangeline Booth pioneered novel methods for her American Salvationists.[35] Appearing on stage with urchins dressed in rags, she made impassioned speeches on the conditions of the poor and the Army's relief work on their behalf, all the while enforcing her message with dramatic stage lighting and tableaux vivant. Her doughnut-and-apple-pie brigade in the trenches of France during World War I sealed her love affair with the American people.

In May 1919, Commander Booth launched her "Home Service Fund Campaign." Posters by prominent artists and a widely reprinted booklet advertised the event; the press responded with pro-Salvation Army editorials and numerous cartoons backing the work of the Army on the pages of the nation's dailies. The press continued to applaud when, in October 1919, Booth received the Distinguished Service Medal.

Newspaper reporters likewise relished news of an impending "insubordination" in the ranks. In October 1922, the story broke that General Bramwell Booth had recently ordered Evangeline's recall to London. The Philadelphia *Public Leader* flatly stated that Bramwell had "no understanding of American sentiment, or else thinks that it can be disregarded."[36] Commander Evangeline held her ground, aided by the rising tide of public opinion and outcry from the nation's press. She continued to serve as Commander of the Army in America until elected worldwide Commander-in-Chief of the Salvation forces in 1934.

The publicity generated by internal Salvation politics received almost as much attention as their leading crusade of the period — prohibition — most obviously evidenced in the famous "Boozer's Convention."[37] In the days preceding national Prohibition, this annual event gained a place on the pages of nearly every major American city newspaper. Held on Thanksgiving Day, the "convention" consisted of a free meal for Bowery drunks, preceded by a parade to the mess hall. Floats for the spectacle consisted of a ten-foot-high walking whiskey bottle, at the base of which chained men hopelessly floundered, and various tableaux depicted family scenes showing the evil effects of liquor on domestic harmony. One highlight included a "water wagon" with a score of inebriates perched on top. Salvationists marched along the side with a sprightly gait and kept boozers from falling off the wagon. The papers had a field day. Presidents Wilson, Harding, and Coolidge (and later Hoover and FDR) all received Evangeline Booth at the White House. She emerged as a leading popular spokeswoman for women's suffrage and prohibition, pioneering in the use of lantern slides and movies to illustrate the evils of demon rum.

Bellows's sympathies obviously lay with the "wets." Chafing under the prohibitionist yoke by 1921, he created a lithograph which serves as an anti-temperance statement as much as an oblique commentary on the Ohio Methodism of his youth (Fig. 2.7). Writing about *Sunday Going to Church* (which in-

cludes a self-portrait of the artist as a young man), Bellows revealed that "much against his will the artist, as a young man [is] being called to church in the family rig. The Reverend Purley A. Barker, first president of the Anti-Saloon League, is saluted in passing."[38] The young man's twisted body and uncomfortable expression, his physical turning away from his father's greeting, and his refusal to acknowledge the Rev. Purley's presence all combine to indicate Bellows's 1921 attitude toward evangelical Methodism and Prohibition, which the Methodist Church staunchly supported. The Anti-Saloon League waged a relentless attack upon the urban saloon, claiming a direct corollary existed between urban vice, poverty, and crime and the prevalence of drinking establishments. Led by a staff of full-time professionals, such as Rev. Barker, the League focused its resources upon electing "dry" candidates of either party to office. Financed by John D. Rockefeller and S.S. Kresge, the Anti-Saloon League received additional

Fig. 2.7. George Bellows, *Sunday, Going to Church (Sunday in 1897)* (1921). Lithograph, 12⅛ x 14⅞ inches. The Cleveland Museum of Art. Gift of Mr. and Mrs. Malcolm McBride.

support from countless contributors in small, evangelical congregations, so that by 1915, forty thousand Methodist, Baptist, Presbyterian, and Congregationalist churches supported the League's efforts.[39]

Once before, Bellows had taken direct aim at the absurdities of fundamentalism's political crusade to ban sinful alcohol from virtuous American homes. The frontispiece for the February 1916 issue of *Masses* pictured an inebriated young man, bow tie askew, Panama hat resting jauntily on his head, accosting a younger, Horatio Alger type (Fig. 2.8). A member of the Young Men's Christian Association, this tipsy sport actively seeks to evangelize his new comrade in the fundamentals of wholesome Christian city living, as espoused by groups such as the "Y." The original Boston Constitution of this club clearly stated its evangelical mission.

> A social organization of those in whom the love of Christ has produced love to men; who shall meet the young stranger as he enters our city, take him by the hand, direct him to a boarding house where he may find a quiet home pervaded with Christian influence, introduce him to the Church and Sabbath school, bring him to the rooms of the association and in every way throw around him good influences so that he may feel that he is not a stranger, but that noble and Christian spirits care for his soul. . . .[40]

The one-hundred proof spirits acting at the moment move this *YMCA Sport* to proclaim his devotion to the principles of the American Fundamentalist Party, whose members hold a street rally in the background. Over the din of the placard-carrying throng cheering the harangue of a street evangelist-politician, this tipsy crusader questions the moral fiber of his recent acquaintance:

> Let me ash you, Young Feller — Do you b'lieve in the teachings of Jesus Christ? — Well le' me say to you, tha' when you're arguin' with me, you're up against it — when you're arguin' with me, you're arguin' with a CHRISSIAN.[41]

This drunken spiel exposes to ridicule the teetotaling platform of the Anti-Saloon League and the YMCA. The threat to personal liberties posed by such a mixture of politics and personal religious conviction, however, appeared all too real to Bellows by 1916, when he drew this lithograph. In 1913, the Webb-Kenyon Act, prohibiting alcohol shipments through the mails and by common carriers from wet states into dry ones, passed the Congress over President Taft's veto. This congressional action spurred on Anti-Saloon forces to bombard the public with a successful propaganda campaign. Within four years a total of twenty-six states had gone dry. The Volstead Act lay just around the corner.

Despite his own anti-Prohibitionist sentiments, Bellows elected to draw a fairly straightforward scene of a Salvationist street meeting. Other artists made

Fig. 2.8. George Bellows, *YMCA Sport* (1916). Magazine illustration. *Masses* 8 (Feb. 1916), 4.

less sympathetic portrayals of Army activities, focusing particular attention upon its highly visible music ministry. Philip Reisman's 1936 painting *Salvation Ann* (Fig. 2.9) and Mervin Jules's painting *O! Promise Me* (Fig. 2.10), done the following year, endeavor to ridicule this system of syncopated soul-winning for the Lord.

A streetwise immigrant kid from New York's lower East Side, Philip Reisman faced a constant battle against poverty during his youth. Working as a soda jerk by day and attending night classes at the Art Students League (when he could afford them), Reisman only began to feel economically secure after ten years of struggle, when he was promoted to night manager at a local Happiness Ice Cream Store.[42] Occasionally landing commissions for *Collier's Weekly*, Reisman produced a number of fine etchings before abandoning this medium for painting by 1933. His early poverty, compounded by the oppressive weight of the Great Depression, caused the artist to adopt as his own the denizens of New York's Bowery and Lower East Side. Reisman spoke passionately for these forgotten, broken people, victims of America's greatest city in the 1930s:

> I do not see any romance or poetic sentiment in this very harsh economic system. . . . I have tried to paint things as they are and I am very dissatisfied with things as they are. They are destructive to civilization. It is inevitable that some of that feeling should go into my painting. My art is not genteel art. It is an artist's attempt to identify himself with contemporary society and to use his intelligent symbolism to depict that society.[43]

In the Depression year of 1930, "that society" increasingly felt the strain of meeting even minimal social service requirements. Nurses and social workers accustomed to conditions of urban life in New York reported that distress increased everywhere: lack of sufficient food and malnutrition emerged as a commonplace health menace; families, in desperate efforts to conserve resources, moved to smaller apartments or back into old-law tenements without heat, hot water, or private toilets.[44] The more fortunate of the lower classes managed to "double up" with relatives, and reports of three or more families living together were not uncommon. The poor and unemployed abandoned even rudimentary health care, saving the scarce twenty-five-cent fee normally charged by New York public health agencies. Undernourished, lacking adequate health care, ragged or barefoot, many children suffered the loss of educational opportunity by leaving the public schools and securing scarce jobs in order to contribute to a depleted family larder.

In the midst of this social calamity, the Salvation Army celebrated with great extravagance its Golden Jubilee Congress, highlighting the event with a massive parade of three-thousand Salvationist marchers and musicians from the

Fig. 2.9. Philip Reisman, *Salvation Ann* (1936). Oil on canvas (dimensions unknown). Present location unknown. From: "Promising Painting by Philip Reisman." *Art News* 34 (April 18, 1936): 8.

Battery to the 71st Regiment Armory on Park Avenue.[45] Through the shower of ticker tape, twenty brass bands blared away while Evangeline Booth waved to the crowd from the back seat of an open automobile. John Philip Sousa conducted the massed bands in his own "Salvation Army March," composed especially for the event. Commander Booth herself addressed the mass gathering, presenting numerous awards to the lucky winners of a national music competition sponsored by the Army. Following her speech, the commander reviewed a national parade up Broadway in the company of Field Major Emma Westbrook, one of the original band of seven "hallelujah lassies" who had landed at Castle Garden on March 10, 1880.

The Broadway parade revealed just how Americanized the Salvation Army had become by 1930. Each section of the nation sponsored its own float or marching unit. Miss Los Angeles appeared perched atop a giant orange, throwing fragrant orange blossoms to the spectators; Florida Salvationists responded with a Ponce de León float complete with Spanish conquistadores. The Kansas contingent, paying respects to local daughter Carry Nation, bore a banner emblazoned with the words, "Prohibition Produces Prosperity." In a scene more representative of Depression America, another float depicted a Salvation laddie and lassie aiding a tramp on a park bench. No American parade would be truly complete without cowboys and Indians, and the Salvationists had them—carrying red, white, and blue umbrellas. The grand climax to these week-long festivities included a "United Holiness Meeting," a gala gathering at the Metropolitan Opera House, and the dedication of the new American Headquarters Building at 122 West 14th Street.

This costly celebration, held amidst the grimness of life in Depression-shocked America, goaded Reisman into action. In fact, the features of Reisman's *Salvation Ann*—pudgy nose and flabby jowls—clearly resemble those of Field Major Emma Westbrook, pioneer lassie and honored guest at that Golden Jubilee parade and music fest.

Emma Westbrook's cockney accent could scarcely have sounded more pronounced than on that fateful day when she was interviewed by *Collier's* at the close of the 1920s:

> Oh we're all sinners. Some 'as religion, an' some 'asn't, and even those that 'as it's likely to be mechanical like. It's not until you really see the Light and *feel* religion that you're truly converted. . . . We don't get the sinners in now that we used to. The movies and the automobiles are taking them away from the churches. . . . [46]

Undaunted by commercialized America, stalwart in her conversion to Salvation Army life, proud of the fact that she had never attended a movie and

remained wholly innocent of jazz, Field Major Westbrook devoted her waning years to shaking her tambourine on crowded New York street corners and prose-lytizing everywhere of new life in Christ. Bundled up against the autumn chill in greatcoat and Salvation bonnet, ribbons fluttering in the breeze, she softly sang hymns or reminisced about how the original band sang to guitar and bass drum accompaniment at Harry Hill's Gentlemen's Sporting Theatre, Billiard Parlor, and Shooting Gallery on Houston Street. Reisman's *Salvation Ann*, like her real-life counterpart, stands in ankle-length uniform, bundled against the chill. Clanging her cymbals and beating her drum, she points heavenward to-ward a cross-shaped cloud forming from her frosty breath on the autumn air.

New Masses art critic Isidor Schneider gleefully commented on the "hymn-howling" Salvationist with the "anguished look" and "deluded face." "Here is pro-letarian art achieved without straining in the simplest and most direct fashion. It needs no labeling," he wrote.[47] Representing a more pro-capitalist point of view, the *New Yorker* concurred that Reisman's picture was "the outstanding paint-ing" in the Artist's Guild Art Gallery exhibition (an independent organization of free-lance artists).[48]

Five years elapsed between the hoopla surrounding the Golden Jubilee cele-bration and Reisman's decision to paint his experience of the Salvation Army. During that interval, Salvationists emerged as a quasi-political lobby, vocifer-ously and publicly defending Prohibition, which hit hardest at the poor and the working classes. These folks, unable to stock up on pre-Volstead Act booze or openly flaunt the law at speakeasies, felt the full effects of the crusade to rid America of vice by keeping her dry. By 1932, the country seemed ready to admit the idea had been a bad one—but not the Salvation Army.

The storm clouds gathering for further battle disbursed in November 1932, when FDR swept into office and Prohibition was swept forever into oblivion. With booze eliminated as an issue for Salvationists, the controversial person of Evangeline Booth rose to the fore in the public eye. Three times previously this dynamic woman had received her "marching orders" to London and three times she successfully resisted. In August 1934, however, Commander-in-Chief Hig-gins resigned, paving the way for a General Council to choose a successor. Evan-geline emerged as a prime candidate for that office. Accounts of the secrecy and the maneuvering by the delegates read like some strange medieval tale of a con-clave assembled to elect a pope. At dusk on the fourth day, the deadlocked members tried for one final vote, naming Evangeline Booth the new worldwide head of the Army. The American press quickly flashed the story to its readers.[49]

Although mindful of all this Salvationist fanfare on the part of the press, Mervin Jules meanwhile quietly pursued his studies with Thomas Hart Benton at the Art Students League. Described by critics as another Bosch or Brueghel

for his deliberately exaggerated distortions and "taffy-like figures yanked out of shape in all directions," Jules, like Reisman, endured the struggle for daily existence in New York.[50] After an initial period of study at the Maryland Institute of Fine and Practical Arts, Jules succeeded in obtaining a library job at the Art Students League. The meager salary, which barely covered tuition, forced him to subsist on $8.50 a week during the bitter winter of 1933–34, while painting from memory familiar New York street scenes.[51]

In November 1934, Evangeline Booth bid farewell to New York before an

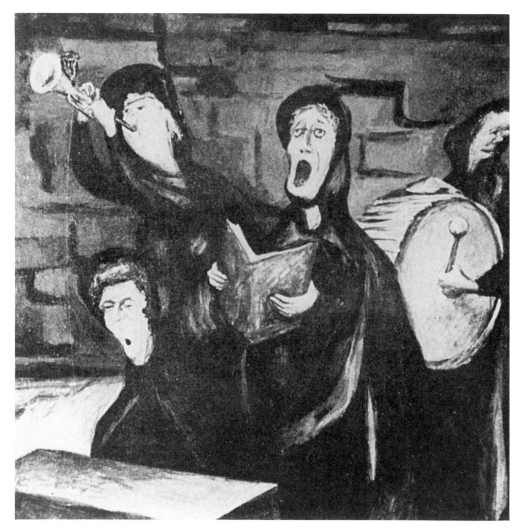

Fig. 2.10. Mervin Jules, *O! Promise Me!* (1939). Oil on canvas (dimensions unknown). Present location unknown. From: "Boschesque Satire by Mervin Jules." *Art Digest* 13 (Feb. 15, 1939): 17.

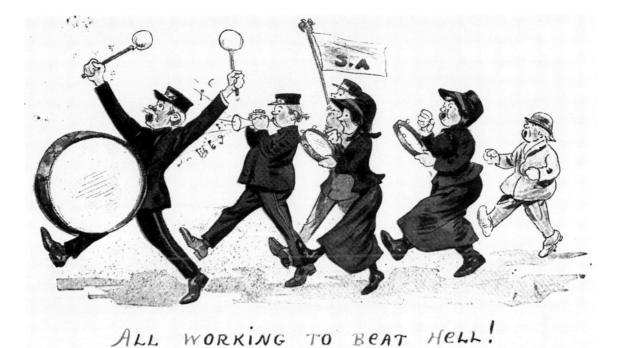

ALL WORKING TO BEAT HELL!

Fig. 2.11. *All Working to Beat Hell!* (1912). Colored trade post card, T.P. and Co., Series 822–3. Courtesy of the Billy Graham Center Museum.

assembled mass of twenty-thousand souls at Madison Square Garden. Mayor Fiorello LaGuardia, Bishop William T. Manning, United States Attorney General Homer S. Cummings, and even the reclusive Helen Keller turned out to pay their worshipful good-byes. General Booth reviewed a final grand parade in her honor, FDR cabled a message of warm greeting, and the tribute climaxed with the People's Chorus of New York singing popular Salvationist hymns. Press accounts covering the new general's election had reported on the $50,000 cost required to assemble the conclave. They discreetly avoided mention of the financial drain on New York City's hard-pressed resources in staging this farewell tribute. The public, however, especially the poor — the recent disclosures of the cost of the Salvationist election still ringing in their ears — could not avoid grumbling over this squandering of scarce public funds.

With music playing a key role in the Salvationist festivities, it is not surprising that Jules elected to focus upon the Army's music ministry in his painting of the scene (Fig. 2.10). Four spinsterish lassies, their faces shriveled and distorted like wrinkled prunes, have perched upon a city street corner. One bangs a drum, another blows a cornet with all her might, while a third, seated behind a portable concertina, joins with the fourth in singing a hymn. Jules, drawing

on the work of his mentor, Thomas Hart Benton, may have taken the singing Salvation lassie in Benton's New School for Social Research mural as his model. At any rate, he adopted as the title for his painting *O Promise Me!*, presumably the musical selection chosen by these four lassies:

> O promise me, that someday you and I
> Will take our love together to some sky
> Where we can be alone, and faith renew,
> And find the hollows where those flowers grew,
> Those first sweet violets of early spring,
> Which come in whispers, thrill us both and sing
> Of love unspeakable that is to be;
> Oh promise me! Oh promise me![52]

A popular hymn frequently requested at weddings, this love song takes on an undercurrent of irony when sung by these withered women. Their pursed lips express their desire for a "love unspeakable" in some far-off celestial paradise. The fact that they halt on some shabby New York street corner, crooning to every passer-by, but especially to Bowery bums, makes the implications of their musical invitation all the more repulsive.

Satires of Salvation Army musicians also enjoyed a long tradition in pocket-sized colored trade cards (Fig. 2.11). These trade cards regularly lampooned subjects of popular interest, such as suffragettes, Negro preachers, Prohibition, and candidates for public office. Inexpensively priced, or offered free as novelties and premiums, such cards appealed to a broad range of people. Their transparent slapstick humor aided in conveying the intended message. *All Working to Beat Hell* depicts, in typical clownish fashion, big-footed Salvation lassies pounding tambourines as pot-bellied laddies blare away on trumpets, pound bass drums, and carry a banner initialed "S.A."—for "Salvation Army." The pun conveyed through the caption below this cartoon makes the point that Salvation Army music sounded freakish and nothing short of hellish to persons of a different religious sensibility. Such cards may well have furnished an additional source for Reisman's own satire on the Salvation Army.

Whether couched in the language of baseball or played to the sprightly tunes of a mission band, popular religion in America held out the promise of a bright and gleaming future for redeemed sinners. For many American artists, however, the future longed for by revivalist preachers appeared as anything but desirable. The work of Bellows, Robinson, Reisman, and Jules, for example, presents a predominantly satirical view of preachers and the causes they espoused. Bellows and Robinson created images that were widely circulated and enjoyed

popular acceptance. Their depictions ranged from the amusing to the bitterly humorous. Having no particular religious convictions, yet passionately committed to social justice issues, Mervin Jules and Philip Reisman, spared no effort to satirize the Salvation Army's work. Jules made use of pronounced figural distortions in the tradition of Thomas Hart Benton, while Reisman juxtaposed familiar religious imagery with contemporary revivalist figures to ridicule the shortcomings of the latter. These two artists, both slightly younger than Bellows, demonstrated a greater willingness to criticize overtly those influences they believed to be detrimental to the reordering of social priorities in the Great Depression. In this respect they displayed a greater aloofness to the religious underpinnings of American society than was possible for artists like Bellows, Benton, Curry, and Wood.

Chapter Three

Prohibition, Politics, and Prophets

Drier than an Oklahoma wheat field during the great Dust Bowl era of the early thirties, Prohibition America remained morally obsessed with alcohol. Members of the National Economic League, polled for their opinions on the "Paramount Problems of the United States" in two successive years, January 1930 and 1931, ranked Prohibition as the paramount concern facing the nation.[1] This curious unwillingness by government watchdogs to acknowledge forthrightly the serious economic plight of the country while at the same time upholding moral solutions to perceived domestic ills finds an exact parallel in the slowness of the religious press to address the more immediate concerns of their readership. Several church journals continued to give more attention to the Prohibition issue while ignoring economic woes even after three full years of unmitigated distress.[2]

Among nondenominational fundamentalists, the Moody Bible Institute of Chicago played the role of a modern-day, midwestern John the Baptist. Crying out to his readers that the Eighteenth Amendment upheld God's holy ordinances, making the way plain for all, columnist J.T. Larson equated the Volstead Act with the new dispensation: "God established a law to prohibit this liquor traffic thousands of years ago! So it is not a new law, although it has been effective now in the United States for eleven years. . . . Be a loyal citizen by becoming a Christian and abiding by the Bible's teaching which teaches the prohibition law."[3] Even after the repeal of the Eighteenth Amendment, editors of the *Moody Monthly* continued to demand proof that the social decay of society and an increase in crime had not resulted from termination of Prohibition. As late as 1938, fundamentalists could read about the journal's challenge, hurled at what it regarded as an inebriate American society: "Where are the people who assured us that moral conditions would be much improved with the repeal of prohibi-

tion?"[4] Concurring with the *Moody Monthly's* analysis, the *Pentecostal Evangel* added that " . . . we know that it is not the repeal of the legal laws that the people need. The United States needs a revival of 'old fashioned' religion."[5]

The call for an "old-time religion" found a response from a host of leaders, prophets, and native messiahs who emerged to lead their troops in an assault against the evils threatening the moral fabric of America. Evangelists as diverse as Aimee Semple McPherson, Carry Nation, and Father Charles Coughlin preached to thousands of Americans. To the extent that Americans heeded their call, and to the degree that American artists of the 1930s found these preachers worthy of artistic notice and expression, their message deserves closer scrutiny.

The Women's Christian Temperance Union, meeting in annual convention at Cleveland, Ohio, in 1934, used the theme of a call back to the old-time religion to celebrate their sixtieth anniversary. The program at that gala celebration—much-needed in light of the stinging rebuke that repeal had dealt the Prohibitionist cause—featured a nostalgic retrospective, consisting of historical tableaux of the original WCTU organizational meeting, also held in Cleveland, on November 18, 1874. Convening in the marble-walled Second Presbyterian Church auditorium, national temperance women pulled out all the stops in a heroic effort to resurrect those first glorious days when their cause seemed so hopeful.[6] At the appointed hour, bugles blared at the entrance foyer as young women, garbed in white and gold Grecian robes, led a procession of WCTU officers down the aisles. Under the capable direction of Mrs. Flora Kays Hanson, National Director of Exhibitions, women clad in the dress of 1874 impersonated the original band of temperance advocates. This re-creation from the pages of WCTU history culminated in the singing of the Crusader Hymn, official victory anthem of their movement.

Victory had, indeed, come for the WCTU with the passage of the Eighteenth Amendment, and throughout the 1920s the Union fostered a vigorous program of temperance education, coupled with Christian Evangelism. Gospel Temperance Meetings, conducted in the streets, pool halls, or in churches, formed a key tactic of the WCTU. Getting people to come forward and sign the temperance pledge (to the tune of "Jesus, Lover of My Soul") invested the act with all the solemnity and enthusiasm of a religious service. Following the banning of alcohol, the national leadership of the Union engaged in highly dramatic acts to keep the ideal of a dry America alive. During the fall of 1923, for example, the officers celebrated their Golden Jubilee with a five-thousand-dollar whiskey spill à la Carry Nation.[7]

When repeal dashed their hopes and efforts, WCTU women rallied as best they could, electing Mrs. Ida B. Wise Smith to lead them as their new president in 1933. Nicknamed "Iowa's Voice to the World," Mrs. Smith received the title

of "one of the ten most distinguished women in Iowa history" from the Iowa governor's council in 1923. Under her leadership, WCTU members undertook a fervent pledge to attack alcohol consumption by means of a vigorous program of temperance education in all Protestant denominations. In December 1933 her organization published and distributed *A Syllabus in Alcohol Education*, which soon went through seven editions of almost 140,000 copies. Although John Barleycorn had gained a new lease on life by the mid 1930s, the pointed and wide-ranging efforts of the more militantly anti-alcohol Protestant fundamentalists, as evidenced in such church journals as the *Moody Monthly*, combined with the highly visible antics of the WCTU, provided fertile ground for American artists.

The same year that witnessed WCTU women costumed as 1874 matrons crusading for temperance in Cleveland saw Ben Shahn busily preparing a Public Works of Art project (PWAP) decoration for the Central Park Casino in New York City.[8] Shahn's original conception — never carried to completion — included a series of eight tempera-on-masonite panels on the Prohibition theme. The most notable work in this series, *WCTU Parade* (Fig. 3.1), reveals Shahn's keen awareness of the unceasing public propaganda generated by the WCTU and its fundamentalist allies. This painting exhibits a close stylistic relationship to Shahn's previous attempts at painting murals and shares with these abortive mural projects the artist's keen social conscience.

Raised in an Orthodox Jewish immigrant family, Shahn rejected early on the strong religious heritage and suffocating ties of his family. Later in his career, the artist stated to friends that he considered himself "not in the least religious."[9] Yet, while not subscribing to any fixed creed, Shahn consistently displayed a deep humanitarian concern for the common man, as evidenced by his belief that the injustice perpetrated by government officials in the Sacco-Vanzetti case constituted nothing less than a twentieth-century Crucifixion.[10] His conviction that the voiceless poor possessed a spiritual integrity often lacking in institutions with vested interests to maintain informed Shahn's work throughout the early 1930s.

Beginning in the spring of 1932, Shahn spent seven months completing twenty-three gouache paintings of the events surrounding the arrest and celebrated trial of two Italian immigrants erroneously accused of killing a payroll guard in Braintree, Massachusetts. Exhibited at the Downtown Gallery, *The Passion of Sacco and Vanzetti* received enormous acclaim from Henry McBride of the *New York Sun* and Matthew Johnson of the *New Republic*.

Impressed with these works, Lincoln Kirstein, editor of *Hound and Horn*, approached the artist with the idea of his participating in a mural show at the Museum of Modern Art. Each artist exhibiting in this show agreed to submit a scale drawing of his mural together with a full-scale detail. Shahn's model con-

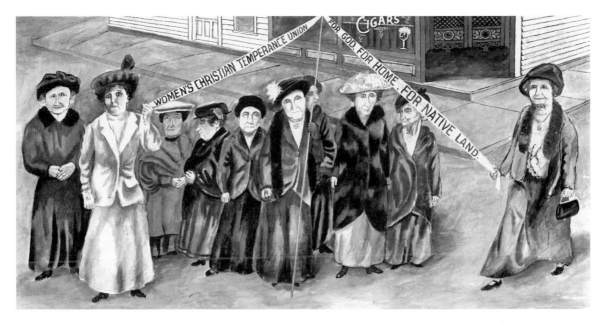

Fig. 3.1. Ben Shahn, *WCTU Parade* (1933–34). Gouache on masonite, 31¾ x 16½ inches. Museum of the City of New York.

sisted of a three-picture montage from his Sacco-Vanzetti series plus a full-sized version of his Lowell Committee panel, which depicted the socially prominent members of the Sacco-Vanzetti trial review committee. Alfred Barr, director of the Museum of Modern Art, enthusiastically praised Shahn's entry, but the Lowell Committee panel, which satirically portrayed President Lowell of Harvard, President Stratton of M.I.T., and Governor Fuller of Massachusetts clad in top hats and holding mourning lilies while standing before the open coffins of Sacco and Vanzetti, drew protests from gallery visitors. Informed that a wealthy patron wanted to purchase the offending panel for two thousand dollars, providing she could have it right away, Shahn realized that in effect this generous offer constituted a bribe to prevent the panel from being displayed publicly, and he refused the offer. The painting remained in the May show.

Apparently Shahn had been thinking about executing a mural series even before participating in the Museum of Modern Art exhibition. Before receiving Kirstein's invitation, the artist had spent the summer painting a series of small gouache studies on the subject of California labor leader and organizer Tom Mooney. Shahn adapted one tempera panel from this series into a proposed mural study. The panel, actually a triptych, depicts the Supreme Court of California on the left, the falsely accused Mooney in the center, and a crowd demonstrating for Mooney's release — the labor leader's mother among them — in the

Prohibition, Politics, and Prophets [75]

right panel. This third scene includes a large watch which had actually been photographed, along with Mooney, on a San Francisco rooftop at the exact moment a bomb went off during the Preparedness Day Parade in San Francisco. This photo had figured as a prominent bit of evidence introduced by the defense to establish Mooney's whereabouts at the time of the bombing. By including this in his canvas, Shahn revealed his own sympathy for Mooney and the cause of organized labor.

Shahn's first venture into actual mural painting, however, came when he served as assistant to Diego Rivera on the Mexican artist's RCA Building mural titled *Man at the Crossroads.* The subject of this mural, the evolution of science, purported to show the beneficent versus the destructive uses of modern technology. Rivera, however, precipitated a crisis when he painted the head of Lenin into his composition at the last moment. This detail met with an irate response from Nelson Rockefeller, Rivera's patron for this project, who insisted that the artist agree to cover the offending detail or else he would have the mural removed from the walls. In the ensuing debate over the mural's fate, Shahn organized a parade to save the painting. This protest proved unsuccessful, and Rockefeller eventually ordered the mural expunged from the walls of the RCA Building.

Shahn's hope of actually painting a mural with a social theme finally began to take concrete form when a New Deal relief project, the PWAP in New York, under the direction of Mrs. Juliana Force, invited him to submit designs for a mural project. In keeping with his desire to paint a theme of social significance, Shahn seized upon recent press reports in the *New York Times* heralding the end of the Prohibition Era, signaled by FDR's decision to sign a bill legalizing 3.2 percent beer. The new administration in New York, under the leadership of Mayor Fiorello LaGuardia, proposed to celebrate this occasion by opening beer gardens throughout the city. The mayor sent a directive to that effect to the newly appointed Park Commissioner, Robert Moses, who promptly announced plans for converting the old Claremont Inn at Riverside Park into a beer garden. The first step in a long-range plan, the Riverside Park beer garden soon would be followed by additional beer gardens in Carl Schurz Park, Jones Beach, Long Island, and Central Park.[11]

Enthusiastic over this social experiment ushered in by the New Deal, Shahn immediately set to work on a series of eight gouache drawings highlighting the Prohibition theme and sent a personal letter to Lloyd Goodrich, a member of the New York PWAP Committee. He followed this letter to Goodrich with a personal note addressed to Juliana Force in which he outlined his architectural scheme for the murals.

Shahn conceived of eight panels to be located in a public beer garden in one of the city's parks. He suggested the Central Park Casino but noted the

scheme could readily be adapted to "any exciting place." The artist's letter to Mrs. Force furnishes a fairly complete idea of the intended eight-panel program. Shahn decided to portray the "great error" of Prohibition by depicting federal agents raiding respectable hotels and emptying booze into the gutter.[12] The futility of this stratagem would be underscored by presenting the equally devious stratagems of elegantly attired society swells resorting to speakeasies and bathtub gin to slake their thirst.

Shahn's reference to Prohibition as a "great error" and his plans to depict bootleggers and the hypocrisy of well-to-do speakeasy clientele in his mural—all these choices illustrate his conviction that art should reflect the social and political reality of contemporary America. Shahn's Prohibition mural shares an aesthetic vocabulary with his previous mural designs for the *Passion of Sacco and Vanzetti* and *Tom Mooney* series.

Nevertheless, his treatment of the Prohibition theme is not without humor. Shahn's deliberate decision to depict the women marchers in *WCTU Parade* (Fig. 3.1) as figures from the past reinforces the notion that he intended to create a comic satire on the then-current efforts of the WCTU to lionize their founders at the 1934 Cleveland convention. In *WCTU Parade*, the delegates, their costumes reflecting a bygone era, undergo a transformation similar to that of the members of the Lowell Committee or the California Supreme Court Justices in Shahn's earlier mural works. By using flat commercial colors, set off by the sharp-edged line of billboard graphics, the artist provided the viewer with a widely accessible image of the sort made familiar through modern advertising.

Apprenticed at fourteen to a New York lithographer, Shahn spent long hours mastering this craft while developing a keen awareness of the expressive potential of line and lettering.[13] In *WCTU Parade*, the Union motto printed across the white ribbon banner vies in legibility with the carefully observed and accurately recorded pane of commercially etched window glass. The unevenly sized, spindly letters which form a protective canopy over the massed marchers seem like the shaky scrawl of an unstable hand. Juxtaposed against the expressive scrolls and inviting curves etched upon the saloon window with its frothy glass of nickel beer, the contrast between the two worlds appears all the more telling. The comparison seems lost upon the oblivious women who hold their standard aloft to form a giant arrow which directs our attention—as vicarious participants in the WCTU demonstration—toward the saloon in the background. Painted a brilliant red, the windows and doors of this establishment warmly beckon us to explore the delights within. Far from inhibiting us, the architectural setting serves to diminish the human figures, creating an expressive pattern which tempts the eye as well as the palate.

The contrast between the hospitable saloon facade and the deeply lined

faces of the WCTU women further reveals Shahn's hostile attitude toward this religious organization. Encouraged to take up photography by his friendship with Walker Evans, Shahn carefully studied the artistic possibilities inherent in this media. He frequently took candid shots of New York street scenes and later obtained employment as a photographer for the Farm Security Administration. Several of his photographs accompanied the text of the Federal Writers' Project *Guide to Ohio.* Taking a cue from the 1934 WCTU convention theme, Shahn focused on historic photographs of early WCTU presidents. In the days before cosmetics, lines and wrinkles around the mouth and eyes showed up plainly under the camera's penetrating eye. The harshness of facial irregularities in such photographs are exploited by the artist in his painting. Wrinkles appear as acid-thin lines and wire-rimmed spectacles as dark circles surrounding beady little eyes. By giving these women grotesque faces, deforming their posture into stunted, truncated shapes, and covering them from head to toe in drab, Victorian coats, Shahn drew a humorous comparison between the vociferous, costumed delegates at the 1934 convention and their defunct forebears.

Unfortunately, the authoritarian methods followed by Juliana Force, chair of the New York Public Works of Art Project, and the arbitrary decisions of the New York Art Commission, under the conservative influence of Isaac Newton Phelps Stokes, spelled doom for Shahn's mural project. As director of the Whitney Museum of American Art, Force had gathered several leading museum directors to serve with her as the New York PWAP Committee. This group soon ran into difficulties over the procedures for selecting qualified artists for employment under PWAP guidelines. Assistant Secretary of the Treasury Robert insisted that since money for the PWAP had come from CWA funds, the regional committees should select candidates from a pool of all those who met the single criterion of unemployment. Yet both he and PWAP Secretary Bruce expected that the most qualified artists in a region would receive priority in employment. At the same time, Bruce insisted that the "American Scene" should constitute the dominant type of art produced under PWAP auspices. To aid her in the selection of employable artists under these confusing directives, Mrs. Force sent a form letter requesting lists of unemployed artists to every art organization in New York City—with the exception of the Unemployed Artists Group.

Founded in 1933, the Unemployed Artists Group included artists from the Communist Party's cultural organization, the John Reed Club, and its art division, the Artists Union, joined together with other sympathetic artists. Hoping that collective action would secure further state assistance for artists after the New York State Emergency Work Bureau had phased out such aid, the UAG sent an unsolicited roster of artist-candidates to Mrs. Force.[14] Her committee virtually ignored the names that appeared on that list. Force peremptorily attempted

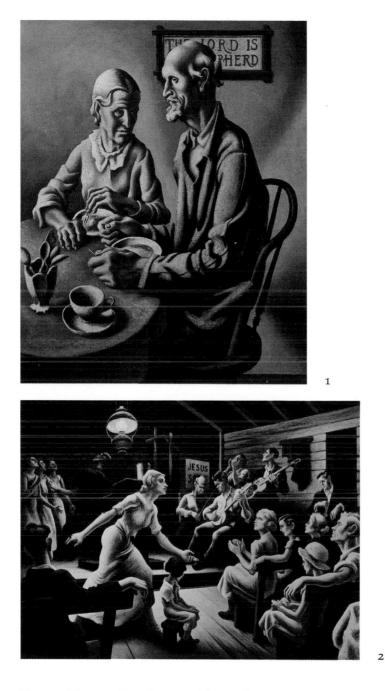

Plate 1. Thomas Hart Benton, *The Lord Is My Shepherd* (1926). Tempera, 33¼ x 27¼ inches. Collection of the Whitney Museum of American Art. Acq. # 31.100.

Plate 2. Thomas Hart Benton, *Lord Heal the Child* (1934). Oil and tempera on canvas, 42 x 56 inches. Collection of John W. Callison, Kansas City.

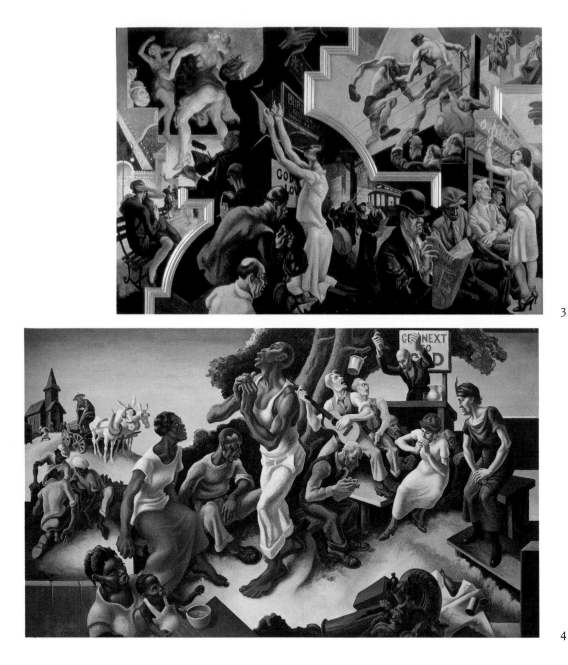

3

4

Plate 3. Thomas Hart Benton, *City Activities* (1931). Egg tempera and distemper
on linen mounted on panel, 91 inches x 26 feet 10 inches. Courtesy of the Equitable
Life Assurance Society of the U.S.

Plate 4. Thomas Hart Benton, *Arts of the South* (1932). Tempera with oil glaze
on linen mounted on panel, 8 x 13 feet. From the Collection of the New Britain
Museum of American Art. Harriet Russell Stanley Fund. Photo: E. Irving Blomstrann.

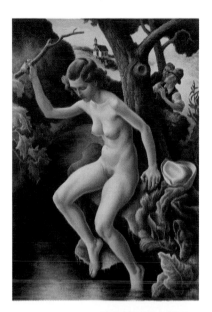

5

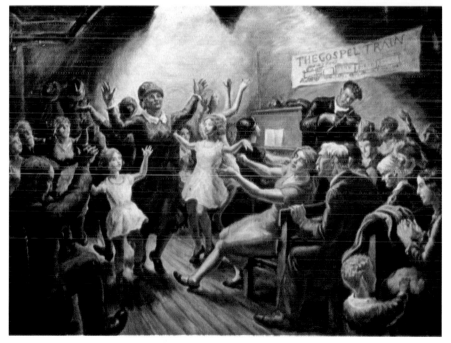

6

Plate 5. Thomas Hart Benton, *Susannah and the Elders* (1938). Oil and tempera on canvas mounted on panel, 60 x 42 inches. The Fine Arts Museums of San Francisco. Anonymous gift.

Plate 6. John Steuart Curry, *Gospel Train* (1929). Oil on canvas, 40 x 52 inches. Courtesy of the Syracuse University Art Collections.

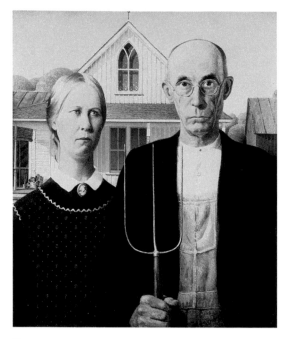

7

8

Plate 7. Grant Wood, *American Gothic* (1930). Oil on beaverboard, 29⅞ x 24⅞ inches. The Art Institute of Chicago. Friends of American Art Collection.

Plate 8. George Bellows, *The Sawdust Trail* (1916). Oil on canvas, 63 x 45⅛ inches. Layton Art Collection, Milwaukee Art Museum, Milwaukee, Wisconsin.

Plate 9. Edward Laning, *Reunion at Kansas City* (1947). Oil on canvas mounted on panel. United Missouri Bank of Kansas City, N.A.

Plate 10. Barse Miller, *Apparition over Los Angeles* (1932). Oil on canvas, 56 x 66 inches (framed). Collection of Mrs. Barse Miller, Plandome Manor, New York.

11

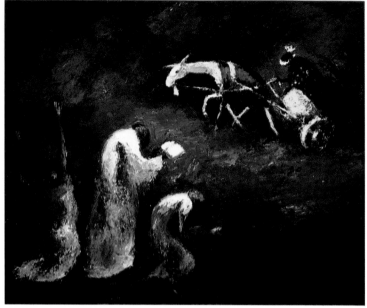

12

Plate 11. John McCrady, *Judgment Day* (1938). Multi-stage on panel, 30 x 23 inches. The Kercheval Collection.

Plate 12. Dan Lutz, *Swing Low Sweet Chariot* (1940). Oil on canvas. Courtesy Gary Breitneiser, Santa Barbara, California.

Plate 13. William H. Johnson, *Swing Low Sweet Chariot* (1939). Oil on paperboard, 28¾ x 26¾ inches. National Museum of American Art, Smithsonian Institution. Transfer from the National Museum of African Art.

Plate 14. John Steuart Curry, *Baptism in Kansas* (1928). Oil on canvas, 40 x 50 inches. Collection of the Whitney Museum of American Art. Acq. # 31.159.

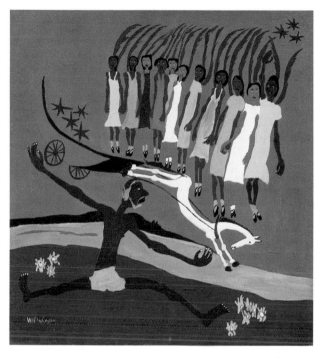

13

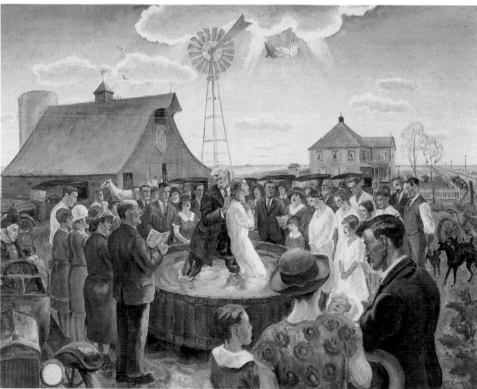

14

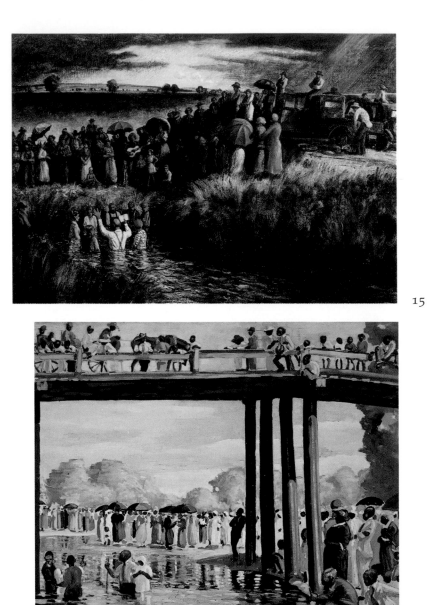

15

16

Plate 15. Peter Hurd, *Baptizing at Three Wells* (1937). Tempera and oil on masonite panel, 21 x 29⅝ inches. Georgia Museum of Art, The University of Georgia. Eva Underhill Holbrook Memorial Collection of American Art. Gift of Alfred H. Holbrook.

Plate 16. John Kelly Fitzpatrick, *Negro Baptizing* (1930). Oil on canvas, 42⅛ x 49½ inches. Montgomery Museum of Fine Arts, Montgomery, Alabama. Gift of the Artist, 1930.23b.

to protect herself from charges that the New York PWAP Committee had discriminated against UAG artists by stating to the press that Washington had ordered the words "needy" and "relief" eliminated in any criteria used to evaluate candidates and insisted that only the best available artists would receive employment.[15] Refusing to accept this excuse, a delegation of fifty UAG members led by Bernarda Bryson (the future Mrs. Ben Shahn) held a demonstration at the Whitney on December 28, 1933.

Bryson actively supported the efforts and activities of the Communist Party. Born into a wealthy, but politically liberal Ohio family, she joined the Communist Party in 1932 and then moved to New York at the behest of the Party to head the newly organized Artists Union.[16] Soon after her arrival she attended Shahn's Sacco and Vanzetti show at the Downtown Gallery. Deeply impressed, Bryson approached the artist and asked him to join the editorial staff of *Art Front*, the Artists Union's magazine.

Under Bryson's growing influence, Shahn edited five issues of *Art Front*. His involvement with the Artists Union may have jeopardized final approval of his mural project for the Central Park Casino. Upset by the increasingly confrontative tone of the Artists Union's demands, Mrs. Force abruptly terminated the December 28, 1933, protest meeting led by Bryson, in effect throwing the artists out of her office. Two weeks after this incident, one hundred militant artists descended on the Whitney with placards and signs reading "the word 'need' is not in my vocabulary, says Mrs. Force," while inside the Museum a second meeting proved equally fruitless.[17] Quota cuts in February 1934 in the number of employable PWAP artists further angered the UAG, and demonstrations continued into March.

At this time, Shahn's proposed mural design on the Prohibition theme had only progressed to the preliminary stage of gouache studies. The rejection of these designs by the New York City Art Commission, which had to give its final approval to any PWAP project placed on New York City property, may, in fact, have resulted from Shahn's and Bryson's activism and the left-wing political cause they espoused. Such activism was anathema to the politically conservative and financially secure Juliana Force and Isaac Newton Phelps Stokes, the latter a leading figure on the New York City Art Commission.[18] Shahn simply received official notice of the rejection of his plans and design for his proposed Prohibition mural project.

The most notorious figure the WCTU ever produced, and one capable of inspiring heroic deeds in legions of female followers who revered her with a cult-like reverence, died in 1911. Carry A. Nation rose out of the Middle West, swinging her hatchet across countless states to perform what she called "hatchetation" for the Lord. As jail evangelist for the local WCTU chapter in Medicine

Lodge, Kansas, Carry, believing herself elected by God, began holding prayer meetings in front of local saloons. At these gatherings she loudly saluted known liquor vendors with a "Good morning, destroyer of men's souls," or a "How are you this morning, rummie?"[19] Emboldened by her example, other local women rallied to Carry's support, harassing the local sheriff to do his duty in closing down illegal "joints," and wheeling portable hand organs about the streets to accompany their hymn-singing stands in front of local beer halls.

In her extremity, Carry Nation prayed a half-dozen times a day, fasting for days at a time; still not satisfied, she wrapped her body in sackcloth and dabbed her forehead with ashes while engaging in the practice of bibliomancy. Searching for a heavenly sign, Carry Nation awoke early one morning to the sound of a musical voice ringing in her ear. Three times the voice advised her to "Go to Kiowa," after which she felt both her hands lifted and thrown down in a chopping motion. Carry had no further doubts about her divine mission. All that morning she busied herself collecting missiles and stones, which she wrapped in newspapers, disguising them to look like packages. Placing these under the seat of her buggy, Carry hitched up her horse Prince and drove down the long, dusty road to Kiowa, praying all the way. What happened next convinced Carry that she had been born to fulfill the prophecy of Isaiah, as God's chosen one:

> Her imagination was vivid because of her prolonged fasting and praying, and as the buggy rattled over the bridge a mile south of town and onto the long dirt road to Kiowa, a mob of grimacing creatures, man-shaped but with horns and cloven hoofs, blocked her way, brandishing prongs. She threw up her hands imploringly: "O God, help me! Help me!" . . . A giant figure with a shining gold halo, mounted on a great white horse, appeared in a dazzling rent in the dark clouds and made an imperious gesture. The diabolical figures fled in terror. "They are real devils," she said later, "who knew . . . I was going to fulfill the prophecy of Jesus. . . . Satan knew this was the death blow to all his evil kingdom."[20]

Intrigued by the folklore of his native Midwest, Edward Laning decided in 1938 to portray this incident from the life of the Kiowa smasher in a painting titled *The Passion of Carry Nation* (Fig. 3.2). Shortly after the Second World War, he painted her a second time in *Reunion at Kansas City* (see Plate 9), a large mural commission for the City National Bank of Kansas City.

The Passion of Carry Nation shows the evangelist en route to commencing her first joint-smashing episode at Kiowa. Plodding along the deeply rutted road, Prince pulls the evangelist's buggy slowly over a rise in the path. She is dressed in her customary black alpaca dress and poke bonnet, a costume which became as much her trademark as the hatchet she frequently carried. This implacable foe of the saloon is shown confronting a pack of cavorting, naked

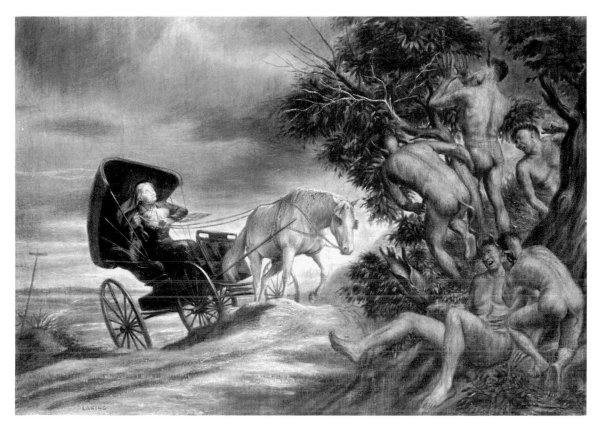

Fig. 3.2. Edward Laning, *The Passion of Carry Nation* (1938). Oil on masonite, 24⅞ x 35⅝ inches. The Metropolitan Museum of Art. Gift of D.C. Allen, 1965 (65.230).

devils. Appearing as a group of virile males — except for their telltale horns and tiny tails — they snarl, make lewd gestures, and expose themselves to her view.

Carry continued her joint-smashing activities in Wichita, inspiring countless women to take arms against the saloon with her bold rhetoric. Speaking to the Wichita chapter of the WCTU, she built up to a striking climax. "Who will be a sacrifice unto the Lord?" she asked. Nearly every woman in the audience rose to her feet as Carry shouted, "Praise God, women! We may all die for the cause!"[21] Three excited WCTU women then proceeded to join Carry in smashing James Burns's saloon to bits before their eventual arrest. Released on their promise to forego further smashing, the four women drove triumphantly around town. Addressing a crowd of curious onlookers, Carry rolled her right sleeve up to her elbow and in a gesture of extreme determination clenched her fist, raised it heavenward, and shouted, "Men of Wichita, this is the right arm of God! I am destined to wreck every saloon in your city."[22]

Laning recorded this second spectacular episode in the mural he painted for the City National Bank of Kansas City, Missouri, during the time he served as director of painting at the Kansas City Art Institute and School of Design. *Reunion at Kansas City* (Plate 9), intended as a broad midwestern mythology, united in one colorful story the great and eccentric figures that Laning felt helped give Middle America its unique flavor and character. Hatchet raised in the air, Carry attacks a keg of beer. A brochure printed by the City National Bank reveals that Laning had the Wichita smashing episode in mind:

> Cried Carrie [*sic*] Nation, "Men of Wichita, this is the right arm of God! I am destined to wreck every saloon in your city! God intended to make me a sacrifice as He did John Brown. Praise God, women! We may all die for the cause.[23]

These lines repeat almost exactly the words the notorious saloon smasher uttered after her successful destruction of Burns's Wichita bar. Laning's inclusion of the image of John Brown in his mural may indicate his familiarity with

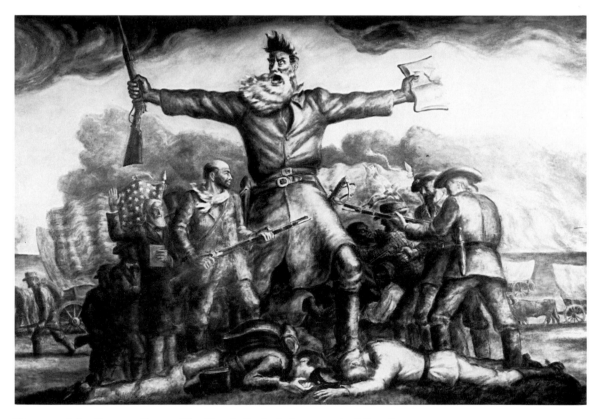

Fig. 3.3. John Steuart Curry, *The Tragic Prelude* (1937–42). Oil and tempera on canvas. North Wall of the East Corridor, Kansas Statehouse Murals. Kansas State Historical Society.

John Steuart Curry's depiction of that nineteenth-century abolitionist in his Topeka Capitol murals (Fig. 3.3). Curry's conception is of a ten-foot tall John Brown, outstretched arms clutching a Sharp rifle in one hand and a Beecher's Bible in the other. The abolitionist is venting a fratricidal fury against all slave-holding Kansans. The uniqueness of Curry's depiction of Brown, so very different from the prevailing sentimentalized portrayal of the preacher, makes it seem almost certain that Laning used Curry's John Brown as a model for his own similar figure of the abolitionist in his City National Bank mural, painted only a few years later.[24]

Laning's inclusion of John Brown in his mural may also reflect the artist's awareness of a source of popular Kansas history known to Curry as well. Charles Driscoll's article "Why Men Leave Kansas" depicted Kansas as home to a lunatic fringe of do-gooders:

> The heart and core of the Kansas Complex is a pathological desire to do good, to wreak good upon humankind, regardless of the means . . . to do good in spite of all hell and all humanity. Mixed with this determination there is always a highly religious and emotional temperament.[25]

Possessed of the emotional temperament described by Driscoll, Carry Nation appeared as the ideal twentieth-century counterpart to the fanatic nineteenth-century John Brown in Laning's mural. Carry Nation afforded visible proof that twentieth-century Kansas continued to provide the spiritual descendants of John Brown with a hospitable environment for eccentric religious behavior.

Laning made his reputation in New York as a painter closely allied with the teaching of Kenneth Hayes Miller and the 14th Street School. Early in his career, he studied at the Art Students League, familiarizing himself with the methods and advice freely offered by John Sloan, Thomas Hart Benton, and Kenneth Hayes Miller.[26] The young midwesterner developed a particularly close association with Miller, substituting for him as instructor at the League for a full year. The artist had observed on a daily basis Diego Rivera's mural work on the Rockefeller Center project, where he most certainly had occasion to meet Ben Shahn and exchange ideas with him.[27] In the early 1930s, Laning briefly joined the John Reed Club, serving on the board of their newly formed art school. He soon grew bored, however, and withdrew from active involvement. Yet he remained an avid reader of Bukharin's *Dialectical Materialism*, professing to discover in its pages a renewed love for Baroque aesthetics as exemplified by Rubens. In 1933–34, Laning painted a mural depicting St. Illuminator for the Baptistry of the Armenian Apostolic Church in New York City, and during 1938–42 he painted a series of murals for the New York Public Library under PWAP and later WPA auspices. The New York Public Library murals depict the *History of the*

Written Word and contain certain religious themes, such as Moses and the Ten Commandments, the printing of the Bible for the pious Elector of Saxony, and monks copying manuscripts in their sciptorium. In 1937 Laning also painted for the WPA a series of murals depicting *The Role of the Immigrant in America* for the Immigrant's Dining Room on Ellis Island.

Laning's history of mural painting and his willingness to make use of religious subject matter, his involvement in the politics of the John Reed Club and flirtation with its Communist ideology do not fully explain why the artist decided to paint Carry Nation on at least two occasions. A letter written by Laning's friend Dorothy Allen, who then owned *The Passion of Carry Nation* (which she later bequeathed to the Metropolitan Museum of Art), provides an important insight as to why this subject so intrigued the artist:

> Mr. Laning has been interested in the stories of the Mid West and folklore since, as a child, his father and grandfather took him with them exploring the prairie country and the "Rockies." His interest was revived during his residence in Kansas City in the forties when the Lanings taught painting in the Museum School of Painting. While there, he came across a tiny volume about and by Carrie [*sic*] Nation herself. A painter friend visiting Kansas City a year ago found a copy of this in the library, borrowed it on his card to bring it to New York for us to see. It is quaint indeed.[28]

The "quaint" volume referred to in the letter, *The Use and Need of the Life of Carry A. Nation, Written by Herself*, published in 1905 in Topeka, Kansas, had an initial printing of 25,000 copies. Containing factual information interspersed with descriptions of Carry's ecstatic visions and lively photographs of her posed with hatchet or Bible, the book also boasted a collection of poems dedicated to the glorious deeds of the saloon smasher. These poems compare her to a female George Washington, wielding her little hatchet—not to cut down cherry trees—but as a sign of her integrity and honest effort to defend the liberty of American homes from the tyranny of demon rum. This mythic recasting of the homespun Carry Nation must have appealed greatly to Laning, who never fully rejected the democratic roots of his midwestern boyhood.[29]

While living in New York, Laning developed a close friendship with Edgar Lee Masters. Author of *Spoon River Anthology*, Masters hailed from Laning's hometown of Petersburg, Illinois. Laning's paternal grandfather had, in fact, served as the model for the character of Lambert Hutchins in Masters's poem.[30] This acquaintance with Masters in the early thirties must have rekindled childhood memories of the Midwest for Laning at the very time when the artist was actively participating in the John Reed Club Art School and watching Diego Rivera and Ben Shahn at work on the Rockefeller Mural project.

Never fully disposed to accept Masters's pessimistic outlook, Laning's conversations with him nevertheless rekindled painful childhood memories. When his mother died and his father abandoned him, Laning's maternal grandparents— he called them Papa and Mama Smoot—raised him. Like a character in Masters's poem, Mama Smoot complained gently to Laning about her husband's failure to make it big in Kansas, home state of Carry Nation. "If he had stayed in Kansas instead of coming back when his father died, he'd have gone on to become governor," she often reminded Laning.[31] Unfortunately, Papa Smoot had only risen to the rank of state's attorney and fundamentalist teacher of the men's Sunday school class. As keeper of Petersburg's morals, Papa Smoot staunchly defended Prohibition when it became law in 1920. The young Laning just as staunchly opposed it, and the two often argued over the subject. Recalling these incidents from his past, Laning reminisced, "I guess they were all restless and dissatisfied, and that's why they sought consolation in moral superiority."[32]

Evidently religion preoccupied the artist for some time before he settled upon Carry Nation as the type of personality who best expressed his feelings about the scrupulous consciences of Petersburg folk. In 1937, the year before he did *The Passion of Carry Nation*, Laning painted *Camp Meeting* (Fig. 3.4). Under an open-air tabernacle, on a hot summer night, a revival meeting reaches a hysterical climax. Moaning, sobbing figures kneel on the grass, faint in emotional ecstasy, or shout in agony, gesticulating with outstretched arms. Upon the platform the preacher folds his hands in prayer while those unmoved by the call to repent repose languidly upon wooden benches, fanning themselves to keep cool, or lounge about as curious spectators watching the goings-on. A discarded revival flyer under one of the benches reveals that the topic for the evening's meeting focused upon the sin of adultery. The format of this revival meeting would be typical for that followed in countless meetings held all across the United States. The banner strung above the rostrum, however, reveals that Laning has painted a meeting that took place in Petersburg, Illinois, his boyhood home.

Already in 1937, then, Laning had begun to explore the role religion had played in shaping his past. Dorothy Allen's letter suggesting that Laning developed the idea to paint Carry Nation only in the 1940s contains an obvious inaccuracy. Laning certainly decided to paint *The Passion of Carry Nation* by late 1937 or early 1938. An article in the May 1938 issue of *Magazine of Art*, which reproduced Laning's painting, confirms this fact. Laning could have learned of the demonic appearances associated with Carry Nation's Kiowa road trip as early as 1929, the date of Herbert Ashbury's biography of Nation. This book contains a vivid description of the appearance of Lucifer's legions to the famed saloon-smasher. Later, in 1938, far removed from midwestern fundamentalism

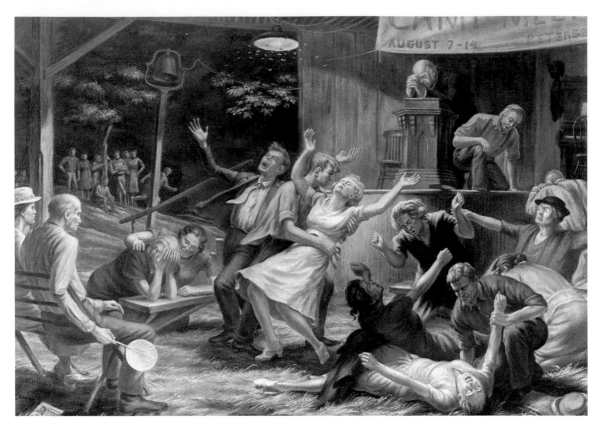

Fig. 3.4. Edward Laning, *Camp Meeting* (1937). Oil on canvas, 33¼ x 48 inches. Collection of the Wichita Art Museum, Wichita, Kansas.

and the moral strictures of his youth, the artist relived these memories through his friendship with Masters. His involvement with Ben Shahn, who had already painted his Prohibition series in 1934, combined with the public efforts of the WCTU and church groups to bring back Prohibition through moral education campaigns, provided the artist with the necessary link to the Prohibition theme. Laning's discovery of Carry Nation's autobiography provided him with a colorful midwestern type, embodying all those frontier vices in matters religious which seemed to thrive in America's heartland. She served as a figure who could unite the various strands of Laning's past, transforming them from the purely personal into a painting that commented upon a pertinent issue in contemporary American society.

Laning's final conception of Carry Nation in his mural *Reunion at Kansas City* (see Plate 9) acts as a testament to the importance of the frontier in shaping the American character and the ability of Americans to change to meet new and challenging circumstances. Above a glorious plain, with the Missouri River

winding in the background, a trail of cattle drivers moves past the future site of Kansas City. The golden promise of its greatness, revealed in the modern city upon a hill in the upper right corner, finds confirmation in the heavenly figure of Columbus pointing in the direction of India. Near the site of Kansas City below, a tiny, gleaming train streams westward. Out of this raw, magnificent land, Laning selected five principal figures to present his grand scheme of Kansas City as a link between East and West.

Daniel Boone, who blazed a trail for millions, steps out of the canvas, wistfully glancing over his shoulder. Clad in buckskin and coon cap, he's bound for moving on before civilization overtakes him. Missouri's first senator, Thomas Hart Benton (grandfather of artist Thomas H. Benton), represents the spirit of frontier politics, creating a climate conducive to wider settlement and homesteading. Occupying the center of the mural, the figures of John Brown and Carry Nation characterize the uniqueness of frontier religion. Brown, rifle in hand, has just slain a slaveholder, whose former chattel flees in terror at the looming figure of Brown. Laning juxtaposes this vignette of nineteenth-century religion with its twentieth-century counterpart—Carry Nation busily engaged in destroying a keg of beer. This panorama ends with a cowpoke scratching his head, as if wondering at the strangeness of these folks.

Laning took the model for the dress worn by Carry in the mural from a photograph which appeared in Asbury's 1929 biography, a detail which indicates the interrelatedness of the mural with the book. But in the mural, Carry Nation no longer appears as a lone eccentric moved by heavenly voices. The artist presents her as one among five figures, movers and shakers who gave Middle America its unique, dynamic character, a character that appeared very much on the defensive in the 1940s. In a world at war, Americans needed to see clearly what the stakes were, needed to be reminded of the dreams and visions—no matter how eccentric—from *their* past. In Missouri and Kansas, that past included some very odd, yet for all that, uniquely American figures, who helped shape the national history for better or worse. As a national figure who single-handedly galvanized American women into action everywhere, Carry Nation could serve as an appropriate symbol in Laning's bank mural, painted shortly after the close of the war in the lingering afterglow of the spirit of self-confident triumph.

The WCTU and Carry Nation did not exhaust the supply of female evangelists who captured the attention of Americans in the 1930s or 1940s. As the effort to repeal Prohibition swung into high gear in 1932, far across the country, in Los Angeles, California, a campaign of quite a different order was waged across the pages of the *Los Angeles Times.* Female evangelist and founder of the Four Square Gospel Church, Aimee Semple McPherson stirred up Californians with her successful effort to have Barse Miller's award-winning painting *Apparition*

Over Los Angeles (see Plate 10) barred from public exhibition. Awarded the Clara B. Dyer prize by the Los Angeles Museum for the outstanding work inspired by a local theme, Miller's two-thousand-dollar painting was a free-wheeling depiction of southern California's premiere cult leader.[33]

Aimee Semple McPherson's unique brand of religion combined the simple faith learned from the Salvation Army, doctrines absorbed from a local group of "Holy Rollers"—such as Spirit Baptism and glossolalia—with an evangelical preaching style practiced by her first husband, missionary Robert Semple. When he died in China, Aimee returned to the United States with their child. A second unhappy marriage to Harold McPherson resulted in divorce, as Aimee continued to feel herself called to preach in tent revivals up and down the East Coast. Reduced to desperate poverty and with two children to support, she soon discovered she possessed the gift of healing. Hundreds flocked to her for cures, financial contributions increased dramatically, and the evangelist soon set up her own tent revival circuit complete witih her own publication, *The Bridal Call Foursquare.* Sister Aimee Semple McPherson, as the evangelist now styled herself, sent for her mother to act as business and financial manager. Soon they made elaborate plans for a triumphant cross-country tour.

Arriving in Los Angeles on Christmas Eve in 1918, Sister Aimee achieved almost instantaneous stardom. Preaching in a room at Victoria Hall Mission under the auspices of the Assemblies of God, she expounded the four tenets of her faith: Regeneration, Baptism in the Holy Ghost, Divine Healing, and the Second Coming of Christ.[34] By the end of the decade, Sister McPherson had founded her own denomination, the International Church of the Four-Square Gospel. She maintained a magnificent headquarters building, the Angelus Temple, and established her own radio network, KFSG (Kall Four Square Gospel). Her church could boast over twelve thousand followers in Los Angeles, plus an additional thirty thousand in the surrounding territory.[35]

Angelus Temple served as the focal point for Sister Aimee's ministry. Dedicated on New Year's Day 1923, the coliseum-like structure rivaled in gaudy magnificence the grand movie palaces then springing up all over America. The temple contained an immense dome gleaming with crushed sea shells set into the concrete. Its interior curve, painted a deep blue, created an illusion of a cloudless southern California sky. Accommodating up to five thousand worshipers at a time, the pie-shaped interior contained banks of comfortable theater seats which sloped along a gentle incline toward the proscenium arch stage. Boasting room enough for massed choirs and stage space in which to conduct dramatic pageants, the main temple platform also contained a sunken pool at which Sister Aimee conducted total immersion baptisms.

Sister McPherson's Sunday services conducted from the Angelus Temple

stage offered her a captive audience. While denouncing the theater as a den of sin and iniquity, Aimee cheerfully provided her followers with all the spectacle of theater-going or movies with none of the stigma attached to those amusements: dressed as Priscilla Alden, she stood at the wheel of a make-believe Mayflower to preach her Thanksgiving Day sermon; masquerading as a football player, she carried the ball safely across the goal line of Angelus Temple as Jesus ran interference; and bedecked in roses, she delivered her famous "Rose of Sharon" sermon, in which she compared the Blood of Jesus to the fragrant perfume wafting throughout the temple.

Aimee Semple McPherson assured a national reputation for herself, however, only when the details of her personal life began to rival her preaching antics in dramatic absurdity. In mid 1926, against a background of rising scandals centering around control of temple finances and rumors of a covert romance with temple radio technician Kenneth Gladstone Orminston, Aimee set off on a preaching tour of England. The evangelist returned, seemingly vindicated by her triumphant appearances, only to set off a national furor in the press with her disappearance on May 18, 1926.

For over a month, newspapers kept the mystery of her whereabouts before the public eye. But when the evangelist suddenly reappeared on June 22 with barely a suntan, claiming to have escaped her kidnappers by walking across the southern California desert, ugly rumors began to circulate once more. The press openly speculated about a secret seaside cottage at Carmel, about the man and woman who had occupied that place, and about descriptions of the couple which matched Orminston and Aimee. Worst of all, speculation grew as to the large memorial fund raised in Sister's memory only two days before her miraculous reappearance.

The date set for a trial before the district attorney, to determine if any impropriety had been committed in the management of temple funds, met with continual postponement. Meanwhile, Aimee demanded from her mother—and got—thousands of dollars from temple funds without offering any explanation of their use. On January 10, 1927, the last possible date for a trial, District Attorney Keyes testified that the evidence appeared so riddled with contradictions and rebuttals as to prohibit a successful prosecution of the case. All charges were dropped.

No sooner had this controversy subsided than a new furor arose concerning Sister's succumbing to "worldly ways," something strictly forbidden by the sect's conservative creed. She had bobbed her hair and openly sported the short-style skirt of the flapper era. In a fit of righteous indignation, temple band leader Gladwyn Nichols resigned, leading the choir, band, and about three hundred members in an open secession from Angelus Temple.[36]

Sister might have weathered this crisis with little adverse effect had not a more serious financial scandal followed. Distraught over inconsistencies and outright lies from Aimee over the temple's need to erase a $25,000 debt—where none, in fact, existed—Rev. John D. Goben, general field secretary for Angelus Temple's branch churches, began to monitor Aimee's financial dealings. Rumors about the evangelist's double life and her secret midnight rendezvous in darkened bungalows with Cromwell Ormsby, her legal counsel, increased his suspicions. Her brazen attempt to alter the articles of incorporation of her branch churches, thereby gaining sole financial control of these organizations, finally drove Goben to visit the District Attorney's office and force a Grand Jury examination of temple finances in October 1929. Like the previous financial scandal, the intricacies of temple bank accounts so baffled the experts that the investigation languished and died. But lawsuits continued to plague Aimee into the 1930s.

When troubles assailed her, Aimee did what she did best—she disappeared. Undertaking a grand pilgrimage to the Holy Land, Sister detoured to Paris, where she reportedly took ill. Rumors immediately circulated that America's premiere evangelist had undergone a facelift, a gravely sinful concession to worldly vanity in the eyes of many religious fundamentalists. Yet upon her return to New York on May 12, 1931, Aimee, looking radiant as ever, brushed aside this latest brouhaha.[37] Shortly after her triumphant return to Los Angeles, however, the evangelist dropped her latest bombshell. Despite the tenets of her church forbidding divorced persons to remarry as long as both partners still lived, Aimee was married, on September 13, 1931, to David L. Hutton, Jr. Their honeymoon bliss was short-circuited when revelations broke in the press that a California masseuse, Myrtle Joan St. Pierre, had made David Hutton the subject of a $200,000 breach-of-promise suit three days later.

As an artist vitally interested in painting the American scene—which for him meant Los Angeles—Barse Miller could scarcely avoid noticing the furor raised in church circles and in the public press over Sister McPherson. In an interview with the *Los Angeles Times* on April 19, 1932, Miller noted his interest in painting contemporary America: "I decided in 1923 to be an American artist painting for Americans. The stamp of Parisian approval is old stuff. I am much more interested in what my own countrymen think."[38] A student of the National Academy of design and fellow of the Pennsylvania Academy of Fine Arts, Miller had begun his painting career by following the traditional course of studies offered at these institutions. He completed his art education in 1923 by traveling to Paris on an art scholarship. Upon returning to America, however, Miller, like his contemporaries Thomas Hart Benton, Grant Wood, and Edward Hopper, soon abandoned the academic and French-inspired subjects. Establishing him-

self in Los Angeles, with summer headquarters at Gloucester, Massachusetts, Miller devoted himself to painting the "American Scene." For Miller this meant scenes typical of California, such as the Culver City movie sets. For the Treasury Section of Fine Arts, Miller painted in 1940 a mural for the Burbank Post Office titled *People of California.* He also tried his hand at book illustration, drawing pictures of famous California personages and events for the book *Ballads of El Dorado,* a special offering from the Book Club of California in 1940.[39]

Intrigued by the make-believe world of movies and by the colorful characters from California's past, Miller decided to paint Sister McPherson and her famous Angelus Temple as his offering for the 1932 Los Angeles Museum of Art's Annual Show. In *Apparition Over Los Angeles* (Plate 10), Miller incorporates numerous references to the events surrounding Sister Aimee McPherson's flamboyant career. Angelus Temple — familiar from press photos, postcards, and birthday publicity shots featuring Aimee as a country lass posed beside a temple-shaped cake — occupies the center of Miller's painting. The unique silhouette of this home of the Four Square Gospel even includes the two radio transmission towers of station KFSG. Piercing the clouds, whose lower misty regions resemble sacks of money, the towers unite the temple scene below with the heavenly vision above.

Occupying center stage, a position which Aimee customarily took at the Angelus Temple, a haloed female figure looms dramatically out of the canvas in a position reminiscent of the Ascension of Christ in a Baroque painting. This female deity sports a dark cape, a familiar part of Sister McPherson's uniform. Clad in a revealing, diaphanous robe, she appears as a golden-haired siren floating above Angelus Temple. Sister Aimee herself received the nickname "The Siren of Echo Park" from members of the press corps as a result of her sultry good looks and numerous love affairs.[40] Her open flaunting of church regulations concerning propriety in dress, the use of modern surgical techniques to improve her appearance, the bobbing and coloring of her hair, and her remarriage after divorce are all cleverly represented in Miller's painting.

The press grasped Miller's satire immediately. Engaging in a sly bit of rhetorical analysis, the *Los Angeles Times* asked about the central, red-haired figure: "Wonder who she could be?"[41] Four days later the same newspaper answered its own question: "The picture depicts Mrs. McPherson-Hutton, flanked on one side by a debonair male clad in business suit and straw hat and on the other by a nude figure of the Venetian Venus type which is not boyishly slim."[42]

This older and plumper "Venetian Venus" could refer to Mrs. Minnie Kennedy, Aimee's long-suffering mother, who managed the temple's finances. A more likely explanation would be that this figure, clad in the spirit, is the original Aimee Semple McPherson. Upon her arrival in Los Angeles in 1918, Aimee

sported piles of dark auburn hair, a plump and matronly figure, a large bulbous nose, and a broad double chin. Compared to the glamorous, blonde, svelte image she soon projected with the help of the beauty parlor and modern surgical technology, as evidenced in her official portrait painted for Angelus temple, the difference is striking. By contrasting these two females in his painting, Miller literally exposes Sister McPherson's transformation to public view. The artist portrays the former Aimee Semple McPherson as a recumbent figure, imitating the posture of Adam in Michelangelo's Sistine Chapel ceiling fresco. He then suggests, with tongue in cheek, the emerging potential of the new evangelist, acting as God, to transform herself into "The Siren of Echo Park."

Nor did Miller ignore allegations of secret love affairs in hideaway cottages with Kenneth Orminston and Crowell Ormsby. The foreground of the canvas, flanked on either side by a bungalow, functions as a kind of elaborate coulisse. As the first objects encountered, the buildings force themselves upon the viewer and serve as the means for our eye to enter the pictorial space. Imitating in appearance the notorious Carmel beach house mentioned so often in the press, these bungalows appear to rival in scale and importance Angelus Temple itself.

The debonair gent, soaring through the air with the greatest of ease, resembles Sister Aimee's latest heart throb, David Hutton. Acknowledging to the press that the figure did, indeed, look like him, Hutton raved that the finished painting was "the work of a lunatic" and derided Miller as a "fanatic."[43] Never slow to report a good story, the Los Angeles Times seized upon these outbursts as a pretext to invite noted psychiatrist Victor Parkin to examine the painting. Dr. Parkin pronounced it "a fine painting by a man with a well ordered mind and a powerful imagination. . . . If Miller is a lunatic I hope to meet many more of his kind."[44]

Aimee Semple McPherson and her husband were not amused when informed of the exhibition of Miller's painting at the Los Angeles Museum. They immediately intimidated the director, Dr. William Alanson Bryan, into removing the picture, by threatening a lawsuit on the grounds of libel by caricature. Despite its award-winning publicity, the painting disappeared from public view. "I have given much thought to this affair and believe the subject matter of this picture to be too controversial for exhibition in a county institution. Any flareback in the matter will hit the museum," Dr. Bryan weakly explained.[45] Not one to give in easily, Miller succeeded in having the California Art Club issue him an invitation to exhibit the controversial work for two weeks.[46] Triumphantly, Miller proclaimed his hope that this painting would generate the impetus for a movement to create a "Temple of Art" in Los Angeles and suggested that all admissions collected during the public showing be used to start a fund for this purpose.

Aimee fought back. "I have always forgiven and forgotten. But there is a limit to what a person will stand," she declared.[47] Promptly the evangelist and her new husband left town! Aimee needed the rest. She had recently undergone the twenty-fourth operation on her nose for removal of a carbuncle. The newly-weds departed for a restful trip in the Southwest, leaving all legal matters in the hands of their attorney, Benjamin M. Goldman. Goldman attempted to soothe the riled artist's ego in a private meeting, but Miller would have none of these shady dealings. The artist promptly engaged attorney E.E. Leighton to defend him in any action brought by Sister McPherson and Angelus Temple and announced to the press his acceptance of an additional offer to exhibit the painting at the California Palace of the Legion of Honor in San Francisco. The "Battle of the Apparition," as the newspapers termed the affair, only increased the public's desire to view the painting. Art lovers and curiosity-seekers flocked to the California Art Club, especially after the announcement of the upcoming tour of the painting to San Francisco reached the public.

But, like the sensational grand jury investigations over Aimee's financial dealings, the case of the Apparition disappeared from public view. Perhaps Attorney Goldman, try as he might, could not quite uncover sufficient legal grounds to justify bringing the suit to court. Perhaps, upon careful reflection, the plaintiff deduced that the two-month absence of the painting during its northern California stay would serve to erase the notoriety of the affair from the public mind. More than likely, the suit met a premature death because public and press alike soon focused with greedy attention upon the salacious details of Myrtle Joan St. Pierre's $200,000 breach-of-promise suit against David L. Hutton. Barse Miller, who featured Hutton floating above clouds shaped like sacks of money, their tops held by tiny winged cupids in top hats, could look upon the scandal-provoking events of the grand jury investigation and St. Pierre's breach-of-promise suit and smile in satisfaction.

Far across the country in Detroit, Father Charles E. Coughlin, known as the Radio Priest, did everything but smile as he used the air waves to beguile countless millions with his "Golden Hour of the Little Flower." From a first broadcast in 1926 over a local Detroit radio station (which earned him a mail response of eight letters), Fr. Coughlin's operation had expanded by 1935 to include an independent network embracing thirty-one stations, a weekly radio bill amounting to $14,000, three million correspondents a year, and a paid clerical staff of over two hundred.[48]

Starting as a humble priest in charge of a small church with an enormous debt, Fr. Coughlin hoped to convert this parish into a shrine to his patron saint, Thérèse of Lésieux. Deeply committed to social justice issues, inspired by long study of Leo III's encyclical *Rerum Novarum* and Pius XI's *Quadragesimo Anno*,

the priest found in these nineteenth-century church documents solutions to meet the economic crisis of the 1930s. Coughlin felt the popes' references to those "pestilential evils" of "rapacious usury," the "hardheartedness of employers," the "greed of unchecked competition," and the "covetousness of grasping men" were applicable to American bankers and industrial magnates.[49] Citing the encyclicals to his own ends, the priest frequently linked his own reform schemes to the word of the popes. In this way, Coughlin could advance his own program while building a broad base of popular support.

Coughlin's radio sermons, ostensibly aimed at applying the implications of the gospel to economic conditions, attracted thousands of listeners of all faiths. Although Fr. Coughlin did not conform to the doctrines of fundamentalism proper, his bombastic sermons and willingness to seek a political platform for his religious convictions align him with evangelical figures active in pre–World War II America. The result of his simplistic analysis of the cause behind the nation's worst economic crisis, his sermons deftly blended a solicitude for the poor with ringing passages of scriptural oratory, delivered with enormous control of vocal inflection. The growing response to his "Golden Hour of the Little Flower" soon convinced the priest that the people agreed with his often contradictory analyses. Coughlin's speeches became less religious sermons, offering practical advice on Christian living in hard times, and more political in tone. A key issue, in which the priest had important financial investments, centered around the remonitization of silver. In a vitriolic radio sermon, "Gold and Silver," he declared:

> Those who were responsible for the destruction of the silver standard have likewise been greatly responsible for the idleness, the poverty, the discontent and the suffering of our present day. Thus, greedy for the blood and the wealth of nations, they have raised their voices until the clamorous shout has gone mocking to heaven: "Give us Barrabas—The Barrabas of gold begotten of greed!" And today, Christ's millions of brothers are treading their weary way from Pilate's Hall to the heights of the crimson Calvary. Their brows are imbedded with thorns of worry. Behold them as they stumble and fall and rise again while they carry the cross of gold upon which civilization shall be crucified. Alas, only too late shall some one from the motley crowd cry out: "Indeed this Man was the Son of God!"[50]

The remonitization of silver probably had less support among the nation's economists than any other proposal for monetary reform. For this reason, silverites needed to drum up widespread popular appeal for their cause. Father Coughlin's ability to generate from among his supporters thousands of letters to congressmen and senators convinced the silver forces to use the priest's voice on behalf of their cause. Pro-silver politicians offered the cleric every opportunity

to speak. The *New York Times* reported that, "From mid October to late January [1934] Fr. Coughlin each Sunday urged the remonitization of silver in his radio addresses. So influential were his talks regarded that some persons described them as constituting the chief support of the price of silver."[51] In January 1934, Fr. Coughlin traveled to Washington to advise the House of Representatives to have the Treasury buy all speculatively held silver stocks. A battery of cameras recorded the priest's arrival, as Congressman Somers, chairman of the House Coinage Committee, introduced Coughlin as "one of America's best authorities on finance."[52] Coughlin repeated this performance a short time later, and on March 19, 1934, the House passed the Dies Silver Purchase Act.

President Roosevelt and Secretary of the Treasury Morgenthau, believing the measure to be dangerously inflationary, had no alternative but to oppose the bill vigorously when it came before the Senate. Sensing that pro-silver forces might also secretly engage in personal speculation—buying up silver certificates in expectation of reaping huge profits after remonitization—Roosevelt directed Morgenthau to release the names of silver certificate holders. On April 24, 1934, the administration began releasing lists of the large-scale holders of silver certificates. One name on that list, A. Collins of 331 Dewey Avenue, Royal Oak, Michigan, held 500,000 ounces in silver features. Upon investigation, the press broke the story on April 28 that A. Collins served as Fr. Coughlin's private secretary. When pressed to explain her action, Miss Collins offered an incredible tale of how, without Fr. Coughlin's knowledge, she withdrew $20,000 from the Radio League treasury and offered the money to Harris and Vose Co. for speculation in silver. She hoped the future profits would cover the costs of Coughlin's radio network broadcasts, as well as those of the shrine building programs. Astute observers knew better than to believe an office secretary could gain access to such large sums of cash without direct approval from Fr. Coughlin, who eventually confessed that it had not been Miss Collins's decision to invest the cash.

The behind-the-scenes political role Fr. Coughlin exercised in these events led lithographer Hugo Gellert to draw two biting satires of the radio priest in action. Like many American artists and intellectuals in the 1930s, Gellert shared a deep sympathy with the cause of the Communist Party. As a card-carrying Party member, Gellert played an active role in the Art Union, contributed illustrations on a regular basis to the *New Masses*, and participated in the first American Artists Congress in 1936, where he spoke on "Fascism, War and the Artist."[53]

The same year which saw Fr. Coughlin roil the air waves over the silver question witnessed the publication of Karl Marx's *Das Kapital* in picture format by Gellert. Titled *Karl Marx's 'Capital' in Lithographs*, the volume contained sixty plates which alternated with brief passages of text from Marx's original *Das Kapital*. Drawn in a slick modern style, the lithographs contributed to a

handsome volume in which the political ideas were easily grasped through the accompanying illustrations.

The success of his version of Marx's political thought inspired Gellert to issue similar volumes patterned after Jonathan Swift's political satire *Gulliver's Travels* and after *Aesop's Fables.* Gellert presented his Marxist interpretation of these two books in his own versions, respectively titled *Comrade Gulliver: An Illustrated Account of Travel into that Strange Country, The United States of America* and *Aesop Said So.*

Wandering about the strange capitalist land of America, Comrade Gulliver reveals through his journal the intricate workings of capitalism. *Silver* (Fig. 3.5), which illustrates one episode in *Comrade Gulliver,* pictures an angry Fr. Coughlin, garbed in Roman cassock, seated before piles of silver coins. Waving a flabby finger at Christ on the cross, who glares down at the priest in anger, Coughlin appears to preach the very lines from his silver sermon which accused those responsible for the destruction of the silver standard of crucifying the Son of God.

The title of Gellert's lithograph refers, of course, to Fr. Coughlin's exposure as a silver speculator by the U.S. Treasury Department. Other illustrators for the *New Masses* also found Coughlin vulnerable on this point. In "The Silver Tongued Orator," an article for the May 8, 1934, issue of the *New Masses,* an anonymous author in no uncertain terms links Coughlin's silver speculation with the Jew-baiting fascists of Nazi Germany:

> Those who are at all familiar with the financial machinations of the Catholic Church will not be surprised at the news that Father Coughlin, through his Radio League of the Little Flower, owns on speculative margin 500,000 ounces of silver or about $250,000 worth. . . . Like the good fascist he is Coughlin in his statement of extenuation tried to blame it all on the Jews. . . . He went on to identify gold as directly connected with the international bankers as being the European Warburgs and Rothchilds. In short, what Coughlin meant, was that international bankers and capitalists are Jews, that capitalism is a Jewish yoke on the necks of 100 percent Americans.[54]

A sketchy illustration accompanying this article pictures a beady-eyed Coughlin speaking his praises for silver into a microphone whose amplifier resembles a swastika surmounted on a disc on which the word "silver" appears. Silver coins float out from this central disc. The general pose and attitude of the cartoonlike figure accompanying this article resemble Gellert's full-page lithograph of Coughlin in *Silver.* The motif of the silver coins also appears in both the journal cartoon and in Gellert's lithograph. Concurring with the *New Masses* article in branding Coughlin a fascist, Gellert aimed to satirize the Radio Priest as well. Coughlin's vitriolic anti-Communist tirades over the radio, influential for many

Fig. 3.5. Hugo Gellert, *Silver* (1935). Book illustration: *Comrade Gulliver, an Illustrated Account of Travel into that Strange Country, the United States of America* (New York: Putnam, 1935), facing 36.

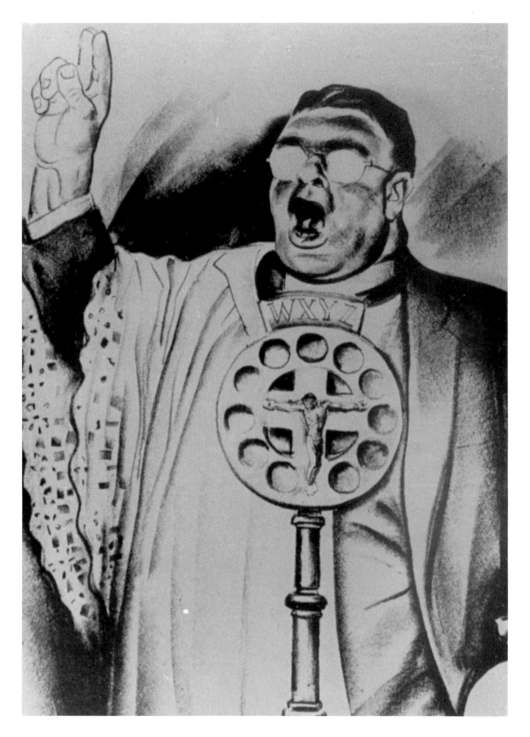

Fig. 3.6. Hugo Gellert, *Fr. Coughlin and His Flock* (1936). Magazine illustration. *New Masses* 11 (May 8, 1934), 6.

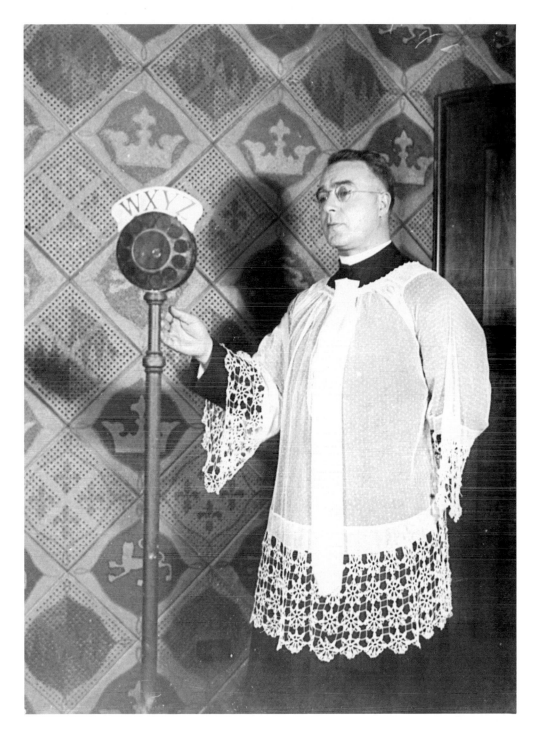

Fig. 3.7. *Rev. Charles Coughlin Speaking over Station WXYZ* (1934). Photograph. AP/Wide World Photos.

listeners in the 1930s, made him a prime target for Gellert's lithographic crayon. The priest's exposure as a silver speculator provided the artist with a powerful opportunity.

Gellert followed *Comrade Gulliver* with *Aesop Said So.* Beside the fable of the blind man and the wolf's cub, the artist placed his lithograph *Fr. Coughlin and His Flock* (Fig. 3.6). The fable succinctly commented on the drawing:

> A blind man was able to tell any animal by merely touching it with his hands. Once they brought him a wolf's cub. He felt it all over, and being in doubt, said: "I know not whether thy father was a dog or a wolf; but this I know, that I would not trust thee among a flock of sheep."[55]

Before a radio mike labeled "WXYZ" in reference to Coughlin's multi-network broadcasts of the "Golden Hour of the Little Flower," a tiny, crucified Christ stretches out his arms. Suggesting that the priest's words do more to crucify the Lord than to advance the Christian cause, Gellert exposes Coughlin's true mercenary nature in the dual uniform the priest is wearing. Like the dog/wolf of the fable, Coughlin, clad half in surplice and half in business suit with Roman collar, raises his right arm in a gesture of benediction while in his left he clutches a sack suspiciously resembling a bag of coins. Gellert modeled his lithograph after a publicity photo taken by the Wide World Press Service in 1934 (Fig. 3.7), altering the pious image of the photograph so that Coughlin's pose resembles those of the grasping capitalist hoarding a sack of money, as pictured in the New School murals painted in 1932 by fellow Communist Diego Rivera.

Gellert's lithograph prominently features two opaque white circles where Coughlin's eyes should appear behind his spectacles. Suggesting his blindness or inscrutability, these glasses render Coughlin as an untrustworthy shepherd for his flock. This same lithograph also accompanied "The Coughlin Convention" in the August 25 issue of the *New Masses.* This article consisted of a vigorous denunciation of Coughlin, of William Lemke, Coughlin's presidential candidate for the Union Party in 1936, and of Rev. Gerald Smith, who urged his parishioners not to vote for Roosevelt because of the president's "Red" affiliations.

The overwhelming vote of confidence that Americans gave FDR and his New Deal policies in the 1936 presidential election spelled doom for Fr. Coughlin and his National Union for Social Justice, under whose banner the priest attacked bankers and New Deal programs and FDR's alleged sympathy for Communists. By 1943 Fr. Coughlin stood in disgrace, not only in the eyes of his church superiors, but with most Americans as well.

As the United States inched toward war, Coughlin grew staunchly isolationist. After Pearl Harbor, the priest continued to remain opposed to American

involvement, stating that America had become the dupe of a "British-Jewish-Roosevelt" conspiracy to solidify Jewish power and build up a New Deal bureaucracy. Coughlin's magazine *Social Justice*, which had begun to reprint speeches by Goebbels, was cited in April 1942 by Attorney General Francis Biddle for violating the Espionage Act and subsequently barred from the mails. Radio stations, reluctant to carry the broadcasts of an anti-war agitator, began to drop the evangelist from their programming. Biddle also sent an emissary to Bishop Mooney of Detroit warning the bishop that unless he put a stop to Coughlin's activities, a public sedition trial would result. Mooney complied with Biddle's suggestion, silencing Coughlin and forcing him into an obscure retirement.

As a highly visible feature of American life in the 1930s, religious cult leaders presented fertile ground for the efforts of a number of artists. It is difficult to know whether any of the paintings or lithographs these artists produced influenced the followers of the various American religious personalities depicted. However, that these paintings appealed to enemies and detractors of these cult leaders, as in the case of Barse Miller's *Apparition Over Los Angeles* and Hugo Gellert's *Silver*, remains undeniable and proves the artists' ability to communicate their anti-revivalist message.

Chapter Four

Dixie Divines
and Harlem Heavens

White evangelists did not possess a monopoly on the techniques of revivalism or on the dynamic, flashy preaching which made revivalists important subjects for artists' canvases and lithographs in the 1920s and 1930s. Small, independent Negro congregations, black Baptist Conventions, African Methodists, and cult organizations of various kinds all made extensive use of revival-inspired methods in their preaching, worship services, and prayer meetings. During the twenties and thirties, when American musicologists, playwrights, sociologists, and officials at the Federal Census Bureau undertook intensive study of black religious life and behavior, American artists also explored this theme. Academic painters such as Wayman Adams and Regionalist artists John McCrady, Caroline Durieux, and Prentiss Taylor all depicted black people engaged in "getting religion."

In part, this new interest in the Negro arose as a result of increased northern and urban migration by black Americans. Between 1890 and 1930, more than 2.5 million black people left the South for the North.[1] By 1930, blacks emerged as a highly visible component in the work force of northern cities, substituting for the European immigrants whose numbers had been reduced drastically by the First World War and later by restrictive immigration quotas.

As black migration to northern cities increased, black churches mushroomed in number. New York City, which before the exodus had only thirteen black churches, possessed over two hundred by the 1920s.[2] The 1926 census, which contained specific data on religion, appeared to support these figures. According to its findings, twenty-four entirely black denominations operated in this United States, the largest being the Negro Baptist Convention, which included 2,914,000 members.[3]

Offering an explanation as to why religion and the Negro religious cults

Art and Popular Religion in Evangelical America, 1915–1940

of the urban North so attracted displaced southern blacks, sociologist Arthur H. Fauset noted that storefront churches and small black congregations performed an important function by facilitating the adjustment of rural southern blacks to life in the urban North.[4] They offered a congenial meeting place where once-rural blacks could make new friends and cultivate a sense of security, involvement, and importance amidst the unfamiliar and often harsh conditions of ghetto life.

This sizable increase in the number of black churches in northern cities reflected only one aspect of the flourishing of Negro culture throughout the first two decades of the century. During those years, Harlem emerged as the principal center where black artists, writers, musicians, and dancers congregated and began to conceive of themselves as agents for fostering the cultural and intellectual rebirth of blacks recently freed from the oppressive structures of their southern homeland.[5] In Harlem, black writers like James Weldon Johnson found inspiration in writing poetry. In 1927, Johnson published *God's Trombones*, a series of poems that conveyed the unique sermonizing style of black preaching.[6] Two years earlier, he had collaborated with his brother, J. Rosamund, in editing the *Book of American Negro Spirituals*.[7]

W.E.B. Du Bois, although raised in the North, had gained considerable first-hand exposure to black life in the South while a student at Fisk University. Engaged as an instructor at Atlanta University, Du Bois published *Souls of Black Folk* in 1903, in which he eloquently commented upon the condition of the Negro in America. An essay from this volume, "Of the Faith of our Fathers," vividly describes a southern revival meeting: "Depravity, Sin, Redemption, Heaven, Hell and Damnation are preached twice a Sunday with much fervor . . . and few indeed of the community have the hardihood to withstand conversion."[8]

Paralleling this growing interest by black authors in exploring and explaining their cultural past, a host of American sociologists, folklorists, and musicologists began to examine black religion and mythology as revealed in Negro spirituals and folksongs. Interested in the cultural meanings contained in Negro songs, Howard W. Odum collaborated with Guy B. Johnson in 1925 to publish *The Negro and His Songs*.[9] The following year sociologist Newbell N. Puckett produced his comprehensive volume titled *Folk Beliefs of the Southern Negro*, and in 1928 Newman I. White, working at Duke University, wrote *American Negro Folk Songs*.[10]

The 1920s also witnessed a wave of literary activity on the part of white authors presenting the Negro in sympathetic terms. Several of these plays and movies depicted revival scenes as part of their portrayal of black life. The trend began with Eugene O'Neill's 1921 drama, *The Emperor Jones*, which featured the black actor Charles S. Gilpin in the title role. Although no actual revival

scene is shown, the action of the play revolves around the magic and talismans associated with voodoo, the credulity of Brutus Jones with regard to "ha'nts" and "spirits," and Jones's confidence that as a "member in good standin' of the Baptist Church" he will find protection against such spirits, even though he had found it expedient to "lay . . . Jesus on de shelf for de time bein'."[11]

O'Neill's drama set the tone for the continued portrayal of blacks as naturally religious and inclined to emotional behavior. During the 1926–27 theater season, Paul Green won a Pulitzer Prize for his depiction of North Carolina Negro life in his play *In Abraham's Bosom*. At the dramatic conclusion, Abe, the protagonist, about to be murdered by a white mob lurking outside his cabin, falls on his knees before his wife and prays:

> Blast me, Lawd, in yo' thunder and lightning, if it is yo' will! Ketch me away in de whirlwind, foh I'm a sinner. Yo' will, yo' will, not mine. Let fiah and brimstone burn me to ashes and scatter me on de earf. (Gasping) I've tried, I've tried to walk de path, but I'm po' and sinful. . . . Give me peace, rest—rest in yo' bosom—if it is dy will. Save me, Jesus, save me! (He falls sobbing to the floor.)[12]

The following season the Theatre Guild offered to Broadway audiences Dorothy and DuBose Heyward's *Porgy*, in which a cast of fifty-three Harlem actors vividly portrayed life on Catfish Row in Charleston, South Carolina. In the course of the play, a Negro funeral takes place, complete with moaning, swaying bodies, and the singing of mournful spirituals. Their emotions rising to a fever pitch, all the people present at the wake jump to their feet and begin to "shout" as the Spirit moves them, "swaying, shuffling and clapping their hands."[13]

Marc Connelly's *The Green Pastures*, produced on Broadway during the 1929–30 season, quickly became the most popular play featuring an all-Negro cast. Attempting to depict stories from the Old Testament as seen through the eyes of children in a black Sunday school class in the rural South, Connelly's fable pictured heaven as a great fish fry, complete with white-robed, winged seraphs and a black deity garbed as a country preacher. In 1935, Warner Brothers brought *The Green Pastures* to the screen, preserving fidelity to the original play by inviting Connelly to direct the film.

The enthusiasm with which playwrights presented Negro religious and folk beliefs to an appreciative public, the growing attention paid to the content of spirituals by musicologists and folklorists, the official efforts by government and private sociologists to compile accurate statistics on black churches, and the accomplishments of black intellectuals gathered in Harlem—all of these factors influenced American artists of the period to depict black revival services.

This interest in painting the Negro inspired academically inclined artists as well as American Regionalist painters. Wayman Adams, noted for his society

portraits in the manner of John Singer Sargent, executed several lithographs of black church services between 1929 and 1931. *The Offering*, of 1929 (Fig. 4.1), and *The Hymn*, of 1930 (Fig. 4.2), served as Adams's inspiration for the life-size *Negro Revival Mural* (Fig. 4.3), which the artist painted in 1934 as a party decoration for the Salmagundi Club in New York City. In addition, Adams painted several more genre sketches of Negro life during his frequent visits to New Orleans.

Born in Muncie, Indiana, in 1883, Adams began his art studies in Indianapolis at the age of twenty-three, attending evening classes at the John Herron Art Institute. After three years of study, he had the opportunity to view a touring exhibition of paintings by William Merritt Chase. "I was struck by his skill, his brush work. So broad, so fine, accurate! I wanted to get my ideas onto canvas with similar ease," raved the young artist.[14] Inspired by Chase's skill, Adams exhausted his savings and borrowed an equal amount from a bank in order to study with him in Florence, Italy. Upon his return to the United States, Adams set up a studio in Indianapolis. In 1912, however, he again journeyed to Europe, painting in Spain under the guidance of Robert Henri. Heeding Henri's advice to "paint like a fiend when the idea is upon you," Adams achieved his first success in 1914 with a portrait of Alexander Ernestinoff, director of the Indianapolis Symphony Orchestra. This portrait, characterized by facile brushwork and a disregard of nonessential details, marked the artist's mature style and led to a successful career as a portrait painter.[15]

Adams earned a comfortable living with his portrait commissions. But a lifelong fascination with Negro subject matter was born when he undertook a sketching trip to New Orleans in 1916. From then on, the artist made an annual hegira to draw and paint the black folk of the South.[16] At first his work included careful genre paintings in the manner of Winslow Homer. Critics prized *Old New Orleans Mammy*, painted in 1922, because of the local color, "the vivid pink of the oleander . . . and the red and green interwoven in the pattern of the bandanna handkerchief."[17] Later, Adams began to experiment with watercolor and lithographs in order to capture the more fluid effects of the strong southern sunlight and the striking possibilities offered by the black-and-white contrasts of the lithographic stone. The artist exhibited his watercolors of black people, with titles such as *Little Lily, Sho Nuf, Mouthing*, and *The Wash*, at the Newhouse Galleries in New York City in 1930.[18]

The lithographic process made possible chiaroscuro effects that enabled Adams to give *The Offering* (Fig. 4.1) and *The Hymn* (Fig. 4.2) a dramatic intensity suited to their religious themes. These two lithographs illustrate the more sedate goings-on of a typical plantation revival service, one the artist could have witnessed in his yearly journal to New Orleans.[19] The events that Adams portrayed — the singing of a Negro spiritual, the collection taken by the deacon, and

Fig. 4.1. Wayman Adams, *The Offering* (1929). Lithograph, 10 x 8¼ inches. Indianapolis Museum of Art. Gift of the Artist.

Art and Popular Religion in Evangelical America, 1915–1940

Fig. 4.2. Wayman Adams, *The Hymn* (1930). Lithograph. Photo: Library of Congress.

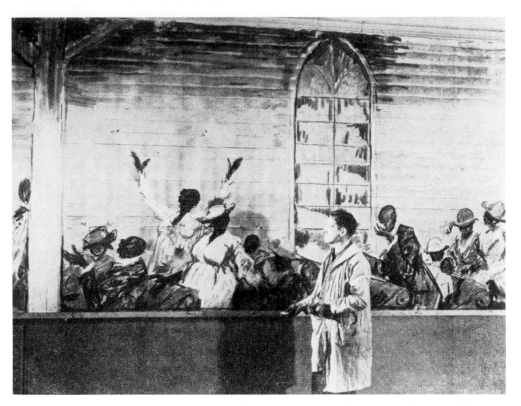

Fig. 4.3. Wayman Adams, *Negro Revival Mural* (1934). Oil on paper (destroyed).
From: "Mural Turns Gallery into Negro Church." *Art Digest* 8 (March 1, 1934): 25.

the fervent exhortation by the preacher — were interpreted by Howard Snyder in an article for the *Yale Review* in 1920.[20] Reporting on the religious customs of rural southern blacks, complete with interviews recorded in Negro dialect, Snyder's account offers a serio-comic look at a revival he attended at Magdalene Church on a Mississippi plantation. The details of the church edifice, described as a "frame building, unpainted inside or out, unpapered, unplastered," parallels the church setting Adams employed as a backdrop in his lithographs.[21] Apparently, curious white observers could attend such revivals, for Snyder recorded that to the left of the church door the congregation set up a bench "for de white folks."[22] This explains how Adams witnessed the revival service on which he based his lithographs. Snyder recorded the following sequence of events:

> Presently, they will begin to sing, anyone who wishes starting the hymn. Little at-
> tention is given to the words, it is the melody that is important. Oh, how they
> sing! A mile and a half away this little congregation can be heard. Strangely sweet
> and plaintive are the old folk songs — sorrow songs they are — born long ago in

the suffering hearts of black slaves. Soprano voices as silvery as a bell rise clear and high, while contraltos, as soft as rippling water, and great heavy basses add volume and round out the rhythmic cadence and harmony that can be heard only from our dark-skinned brothers of the South. Some of their songs will be new to a Northerner, but sooner or later in the service they will sing those incomparable old hymns, "Swing Low Sweet Chariot" and "Roll, Jordan, Roll."

As the congregation sings the collection is taken up or rather is offered up. The purpose for which it is to be used is first announced — a new saddle, or a pair of shoes, or flour and bacon. Of course, these are for the parson. . . . Uncle Albert is adept at this; in a loud voice he calls for nickels and dimes, and on receiving a coin he assures the donor of a seat by St. Peter in the heavenly city. . . .[23]

In *The Hymn* (Fig. 4.2), the congregants appear clothed in their Sunday best. Like the women of Snyder's article, garbed in "white silk dresses trimmed in bright pink and green," these worshippers are depicted by Adams in flowing skirts and wide-brimmed hats as they rise to their feet, moved by the cadence of the hymn.[24] One young man, caught up in the mounting rhythm, throws back his head as if to shout in ecstasy. In *The Offering* (Fig. 4.1), the deacon, symbolically dressed in white to indicate his status as one consecrated to do the Lord's service, passes the collection plate to figures in the pews.

In these two lithographs Adams presents a sympathetic picture of a Negro revival meeting. Refraining from depicting caricatures of figure or face or of the more exaggerated manifestations of behavior (such as the hand-waving and body-jerking frenzy common to many revivals), the artist chose instead to convey an atmosphere of calm, but intense, fervor.

Adams may have been influenced in this aesthetic choice by his contemporary, Doris Ulmann. Born into a wealthy New York family, Ulmann developed a lifetime interest in photography when, in 1914, she enrolled in an art of photography course taught by Clarence H. White at Columbia Teachers College. From 1918 until her death in 1934, Ulmann devoted her talents to photographing "certain human types that . . . portrayed a quality of life Americans were about to lose and forget — a quality measured not by wealth or achievement but by human character."[25] To Ulmann this meant photographing primarily Appalachian craftsmen and southern blacks. The majority of Ulmann's studies of black people were taken between 1929 and 1933 on the Lang Syne Plantation in the South Carolina backwater country.[26] These photographs appeared in 1933 in a volume titled *Roll, Jordan, Roll.*[27]

One photograph from the book (Fig. 4.4) depicts blacks at a plantation revival service and closely resembles, in its details and overall tonal effects, Adams's 1939 lithograph *The Hymn* (Fig. 4.2). Both Ulmann's photograph and Adams's lithograph show black women in long white dresses and wide-brimmed

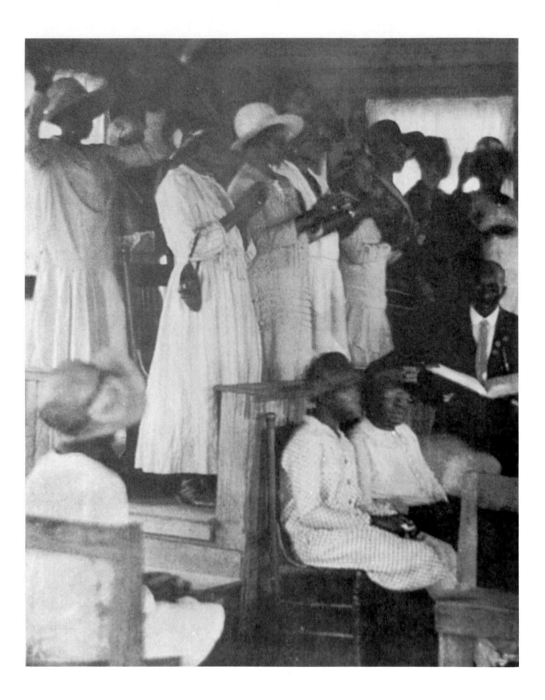

Fig. 4.4. Doris Ulmann, *Negro Revival* (1929–33). Photograph. Reprinted with permission from *The Darkness and the Light*, Aperture Foundation, Inc., 1974.

Art and Popular Religion in Evangelical America, 1915–1940

straw hats. In each work the brilliant white of these skirts creates a strong focal point that draws the eye to the center of the composition and obscures details of facial expression. The fervent undercurrent of emotion moving the worshiper is subtly suggested by the upraised, silhouetted head of the figure furthest to the left in both pictures.

These similarities indicate that while Adams may not have worked directly from Ulmann's photo, he shared with her a concern for presenting in a sympathetic manner the religious lives of rural southern blacks and the inner strength they manifested. This sympathetic approach did not escape the notice of the critics. When Adams exhibited his lithographs at the Second International Exhibition of Lithographs and Woodcuts at the Art Institute of Chicago in December 1930, art critic Alice Lee Parker noted that "here instead of . . . unfeeling satire . . . there is an understanding and sympathy for the 'darkie' of the old South which in literature has its conterpart in the characterizations of Dubose Heyward."[28]

It would be more accurate, however, to invoke Heywood as a probable source for Adams's life-size *Negro Revival Mural* of 1934 (Fig. 4.3). Heyward's play *Porgy* contained several scenes in which the Negroes of Catfish Row have recourse to prayer, sing mournful spirituals, or work themselves into a religious ecstasy. In the funeral scene from Act I, for example, not only do the characters sing a series of three different spirituals, but they also engage in a frenzy of swaying and shouting. Appearing on Broadway during the 1927–28 season, *Porgy* could have provided Adams with the visual themes he later developed in his *Negro Revival Mural*.

Additionally, Adams could have been influenced by Hall Johnson's play *Run Little Chillun'*, which enjoyed a successful Broadway run in 1933, scarcely a year before Adams painted his mural. Johnson, a talented black musician and composer, served as director of the famed Hall Johnson Choir, which provided the music and acted as the heavenly host in Connelly's *The Green Pastures*. The plot of *Run Little Chillun'* revolved around the contest for souls between members of the Hope Baptist Church—a small, black parish in the deep South—and the cult of the New Day pilgrims. In order to increase their numbers and win back their wayward members, especially the minister's son Jim, the Hope Baptists have undertaken a month-long revival campaign. The dramatic climax of the play depicted an accurately staged rendition of a church revival meeting:

A steady stream of testifiers, together with the rest of the congregation, sing, pray, hum, sit, stand, walk around, applaud, greet each other, congratulate, shake hands, scream, gesticulate, laugh, wave their arms and rock rhythmically, proclaim broth-

erly love, shout at the devil, throw fits, faint, fan each other, holler hallelujahs, and achieve several spiritual possessions.[29]

Adams's mural, meant as a temporary decoration for a holiday party, covered all four walls of the main gallery of the Salmagundi Club at 47 Fifth Avenue in New York City.[30] The custom of decorating the walls of the Salmagundi Club with humorous sketches seems to have begun on January 17, 1890, at a reception given for Edwin Austin Abby on his return from London. At that party the walls of the club were decorated with two satirical murals lampooning Millet's *Angelus* and a Turner landscape.[31] Adams's mural shares with these early decorations a spirit of lighthearted mockery. The artist painted nearly one hundred life-size figures in various attitudes of repentance or jubilation such as they might conceivably have experienced during a revival meeting in a black church in the deep South. The mural was executed on large sheets of heavy paper with broad strokes of paint and covered the wall space from the ceiling to the dado. Depicting black church-goers situated among the pews, the mural creates for anyone standing in the center of the room an almost perfect illusion of suddenly finding oneself in the midst of a black revival. The effect obviously pleased Frederick Van Wyck, aristocratic New Yorker, antiquarian, and author, who praised the artist's mural, remarking, "Compare the life and action in the figures with any you know. Has there ever been such a marvelous work done in modern times? And they import artists to decorate Rockefeller Center!"[32]

The artist's mural differs from the more subdued and reverent images of black worshipers in his lithographs. Perhaps this disparity between mural and lithograph is explained by the fact that the artist intended the mural to serve only a temporary decorative function, a festive backdrop for the elaborate dinners and receptions held at the club. As such, Adams could allow himself greater flexibility and a more relaxed approach to the subject matter than would be possible in his usually sensitive depictions of the religious atmosphere of a black worship service.

Adams may also have referred to the nineteenth-century tradition of Negro genre painting familiar to him in the canvases of such artists as William Sydney Mount and Eastman Johnson. Mount's *The Power of Music* (1847) and Johnson's *Old Kentucky Home* (1859) not only depicted a variety of Negro physical types (similar to the characters in Adams's mural) but also illustrated the emotional impact of music upon rural blacks, paralleling the response generated in Adams's congregation by fervent hymn singing and revival preaching.

Similar sources of imagery also influenced John McCrady and Caroline Durieux in their depictions of black religious life. The seventh child of an Episcopal priest, John McCrady spent his childhood moving between various mis-

sion parishes in Mississippi and Louisiana until his father received an appointment as dean of the philosophy department at the University of Mississippi and rector of St. Paul's Episcopal Church in Oxford, home of the university.[33] McCrady's childhood recollections centered around memories of his family gathered for evening prayer in the nearly deserted Episcopal church and an appreciation of his father's role as one of the more important southern thinkers on the relationship of evolution to the Christian faith.[34] Already a teenager when the Scopes evolution trial took place in Dayton, Tennessee, during the summer of 1925, McCrady could not have remained oblivious to the delicate balancing act his father carried out as a priest-philosopher of evolutionary thought and dean at a university in a state that passed an anti-evolution law in 1926. Recalling these incidents, the artist noted that as far back as he could remember he had always been interested in depicting a "human element" in his canvases, especially man's relationship to the God of the New Testament.[35]

McCrady left the University of Mississippi in 1932 to begin formal art training at the New Orleans Art School. From the very beginning, the artist showed an interest in depicting the local life he knew as a boy in Oxford. In 1933 he submitted a portrait sketch titled "Negro Head" as his competition entry for a one-year scholarship at the New York Art Students League—a contest he won.[36] McCrady spent the 1933–34 academic year in New York cold, depressed, and longing to return to Mississippi; but the experience influenced his future career as a painter:

> I wanted the country, high rolling hills. I could see Oxford on the top of one of these hills, with its towering church steeples, its courthouse in the center of everything, the sound of the tolling of the courthouse clock that could be heard for miles away in the cotton fields where the Negroes were sweating in a boiling sun, laughing and singing songs about their work, songs about the world hereafter, the Negroes' heaven and the Negroes' hell. How different this Negro and his simple superstitious philosophy was from his brothers in Harlem. And how different he was from the grand old darkies who were slaves and sons of slaves.
>
> It was here that I realized for the first time that something had been in the back of my mind for a long time, only it took the complete opposite, New York, to bring it out. Then I began to paint.[37]

While in New York, the artist continued to sketch black models. The pronounced racial characteristics of these sketches indicate that even before McCrady returned to the South, he had already seized upon the Negro as a uniquely expressive type that could serve as his vehicle for communicating the unmistakably regional aspects of small-town southern life. After returning to New Orleans, where he rented a small studio at 622 Dumaine Street, the artist devoted his time

to depicting the local scene in and about Oxford, painting canvases with titles such as *Self-Portrait on the Levee, Mississippi Storm,* and *Political Rally.* However, McCrady captured national attention only when he turned to painting black religious subject matter. In 1937, *Swing Low Sweet Chariot* (Fig. 4.5), based on the Negro spiritual by that name, earned the artist rave reviews. When the Boyer Galleries in New York City gave McCrady a one-man show in October 1937, *Time* compared the artist to a "star risen from the bayous . . . shining brilliant," while *Life* carried a five-page spread that included a full-page color reproduction of the painting.[38] *The New Republic, Newsweek,* and the *New York Herald Tribune* favorably compared McCrady's picture to Marc Connelly's *The Green Pastures.*[39]

McCrady revealed that the decision to paint *Swing Low Sweet Chariot* evolved gradually during a sketching trip he took in northern Mississippi. Dur-

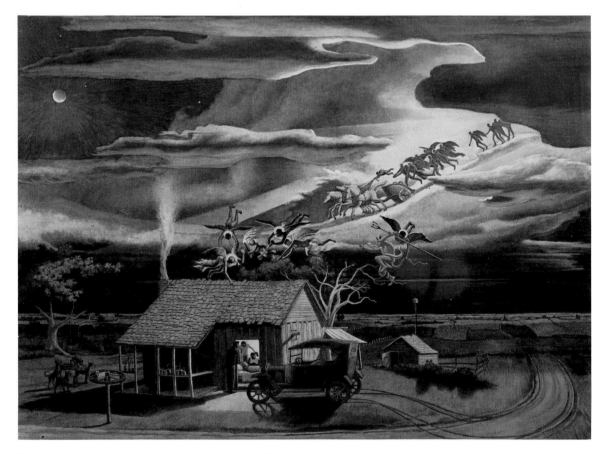

Fig. 4.5. John McCrady, *Swing Low Sweet Chariot* (1937). Multi-stage on canvas, 37 x 50¼ inches. The St. Louis Art Museum. Eliza McMillan Fund. 7:1938.

Art and Popular Religion in Evangelical America, 1915–1940

ing that excursion the artist drew the Negro cabin pictured in the painting and had a long talk with the old man who lived there. McCrady returned several weeks later to sketch this man and found that he had died. Years later in New Orleans the artist painted *Swing Low Sweet Chariot*, using this sketch of the cabin and drawing the old man and his family as he remembered them.[40]

McCrady also drew upon images from the silver screen. In 1935, one year before the artist painted his famous canvas, Connelly's play reached a national audience through Warner Brothers' filming of *The Green Pastures*. The film opens in a rural southern black community as children gather for a Sunday school lesson to study the book of Genesis. In their imaginations, they envision a heaven populated by winged black angels gathered for a fish fry with God as their kindly pastor. God descends to earth to create Adam, a strong black field hand, and Eve, a young Negro woman clad in a gingham dress. After returning to his "office" in heaven, God decides to take a vacation from his many chores to see how things are going on earth. The sins of humanity, revealed in scenes of a female blues singer, a crap game, and a shantytown street populated with "riffraff," so anger the Lord that he nearly despairs of finding any holy people. However, he arrives at a modest preacher's cottage where Noah and his family live. God decides to try again; when he hints to Noah of his plan to bring about a deluge, the preacher gets a powerful twinge in his knee.

Forced to rescue sinful humanity a second time, God comes down to earth to visit Moses, a poor dirt farmer, and commands him to free the Lord's people from Pharoah's power. The film pictures the Egyptian court as a Negro lodge decorated with banners and Masonic symbols. Although they are released from Egypt, the people's continued unfaithfulness and sins result in their exile and apostasy in Babylon. Babylon appears as a cheap dancehall complete with tawdry decorations and blues music. When a "prophet," appearing much like a street evangelist, warns the sinners that they're all "wallowin' like hogs in sin," he is shot dead by a gangster. The final scenes represent the "Saving Remnant" of Israel through the apocryphal tale of Hezdrel leading the Hebrews into battle against the enemies of the Lord. When the Lord appears and challenges Hezdrel's faith, the latter discloses his trust in a God of love and mercy, declaring that the chosen people have matured in their faith "through sufferin'." The film concludes with the black angels in heaven looking down at earth through the gates of paradise to witness the Crucifixion. But the sun comes out, heaven is radiant, and the assembled angels break into a joyous Negro spiritual.

Taking a cue from the free juxtaposition of Negro folk beliefs, revivalist religion, and Biblical imagery found in Connelly's film, McCrady gave *Swing Low Sweet Chariot* (Fig. 4.5) a specifically regional setting. The action of the

painting unfolds under a moonlit sky in the Mississippi countryside. As Gabriel blows his trumpet to summon the dying man's soul, a group of angels descends from heaven in a golden chariot pulled by three white horses. A pack of mongrel dogs barks wildly at this strange sight, while a crimson Lucifer wrestles another angel in a last vain attempt to win the dying man's soul. Unable to perceive these supernatural goings-on, the grieving relatives gather about the bedside as a neighbor, having recently sped up the muddy road in his Model T, peers in from the cabin door.

Heartened by the reception given *Swing Low Sweet Chariot*, McCrady expanded his horizons to include not just one dying black man but the entire population of the world when, in 1938, he painted *Judgment Day* (see Plate 11). His conception of a Negro version of the Last Judgment, as it might be preached during a Mississippi revival meeting, the canvas included nearly five hundred figures in various attitudes of ecstasy, horror, joy, and woe.[41] For his painstaking work, the artist received first prize in painting from the Arts and Crafts Club in New Orleans and national recognition from *Time*, which termed the picture "the purest example of regional art that turned up during the year."[42] While the painting hung in the prestigious Annual at the Pennsylvania Academy of Fine Arts, the *Philadelphia Record* carried a reproduction on its arts page, and Dorothy Grafly, art critic for the paper, noted Northern Renaissance features in the "flow of figures punctuated with Breughelish individual characterization."[43]

The parade of naked black figures at the bottom of the canvas, tripping over each other in their blind pursuit of Satan, who lures them with a bag of coins and home-brewed liquor, does, in fact, vaguely resemble Pieter Brueghel the Elder's *The Blind Leading the Blind*. References to earlier depictions of the Last Judgment also exist in the stone-like grotesques painted at the top of the canvas and reminiscent of the carvings on the west tympanum of Autun Cathedral. But McCrady may not have had any high art precedents in mind at all. It seems more likely that his *Judgment Day* was inspired by black religious drama, sermonizing, and perhaps from black films of the period, sources that retain a closer fidelity to McCrady's declared intention to paint the local southern scene.

One may ascertain that McCrady's familiarity with black religious drama is a source for his painting by comparing *Judgment Day* with the black folk operetta *Heaven Bound*, which it resembles in several respects. McCrady admitted to seeing this operetta acted out several times "in Negro churches all across the land."[44] But he may also have attended the elaborate production staged by the Negro unit of the Federal Theatre Project in Atlanta, which opened August 10, 1937, and ran until January 8, 1938.[45] In this version of the play (normally performed as part of the church service) men and women costumed in white

robes to represent the souls of the deceased proceeded through the aisles singing with the congregation the various spirituals that told of salvation. A member of the parish dressed as the devil suddenly appears to tempt the souls with liquor, pearls, lucky dice, money, or other goods, and forces them to choose between salvation and these temptations. Waiting in the sanctuary, a man dressed as Saint Peter holds the keys to heaven while the various souls of the deceased approach. The saint opens the Gates of Paradise to those who remain faithful to the last, while Satan carries off those who give in to temptation.

Just as in this operetta, the essential theme of *Judgment Day* revolves around the judgment of souls. A red Lucifer, sporting horns and tail, employs all the wiles at his command to tempt souls at the last possible moment with gifts featured prominently in the drama—money and liquor. The person of Satan remained a vivid reality to a number of fundamentalist Protestants, not just to blacks. But for many rural Negroes, only two or three generations removed from slavery, tales of the devil's doings often remained couched in terms left over from the days when religion helped support the slave system. In a study of the black prayer tradition, Harold Carter shows how the stereotype of a black devil and a white Jesus subtly worked in testimony meetings to reinforce a kind of self-oppression among black people:

> Ah wuz tu'k by a strand uv my hair and shuch over hell, and all de hair broke and Ah wuz about to fall in hell. Ah looked down and there Ah see'd a black man, and Ah know'd dat was de debul, and Ah sed, "Lawd, hab mussy!" And jes' as dat-ah black man wuz tryin' ter ketch me on his pitchfork, Ah see'd a littl' w'ite man an Ah know'd dat wuz Jesus, and Ah sed, "Sabe me, Lawd!" And dat littl' w'ite man tu'k and kicked dat black man in de haid and he fell back in hell, and dat w'ite man tu'k me in His arms, and Ah know Ah's got de 'ligion caze Ah felt lak Ah nebber felt befo'![40]

Whether or not McCrady knew of this intermingling of racial attitudes and black theology, his devil in *Judgment Day*, with its flat nose and broad lips, bears unmistakably Negroid features. Getting religion meant outwitting this "black" devil and avoiding the sins of excess, sins which the poor black could indulge in only occasionally, if at all, but which rich whites could easily afford.

The didactic message of Negro operettas like *Heaven Bound* often found further reinforcement in black preaching. J. Weldon Johnson preserved the feeling of that preaching in *God's Trombones*, a series of eight sermons in verse. A sermon from this collection called "Judgment Day" describes in vivid imagery the story of the end of the world, details of which McCrady also presented in his painting:

In that great day,
People, in that great day,
God's a-going to rain down fire.
God's a-going to sit in the middle of the air
To judge the quick and the dead.

Early one of these mornings,
God's a-going to call Gabriel,
That tall, bright angel, Gabriel;
And God's a-going to say to him: Gabriel,
Blow your silver trumpet,
And wake the living nations. . . .

Oh-o-oh, sinner,
Where will you stand,
In that great day when God's a-going to rain down fire?
Oh, gambling man—where will you stand?
You whore-mongering man—where will you stand,
In that great day when God's a-going to rain down fire? . . .

Too late, sinner! Too late!
Good-bye, sinner! Good-bye!
In hell, sinner! In hell!
Beyond the reach of the love of God.[47]

The artist's recollection of seeing *Heaven Bound* performed in black churches all over the South makes it probable that, on at least a few occasions, McCrady heard preaching similar to that recorded by Johnson. The fire and brimstone rained down upon the earthly city in the background of McCrady's *Judgment Day* is a visual analogue to the fervent black preaching on the Last Judgment which Johnson describes in his verse sermon.

No mere construction of theological language to explain evil in the world, Satan assumed a larger-than-life presence in the minds of many black worshipers, who daily sang about the Judgment Day in their spirituals or heard the devil described and denounced by their preachers in Sunday meetings. Prayer, especially in the name of Jesus, became the one effective weapon developed in black churches for dealing with the power of the devil. Weekly prayer meetings frequently began with scathing denunciations of the Prince of Darkness.

By convincing others that one possessed power to control good or evil spirits, cult leaders virtually assured themselves loyal congregations already familiar with such beliefs from Christian or revivalist sources. In New Orleans, where the mixture of Catholic piety, black fundamentalist theology, and Caribbean voodoo made belief in spirit control particularly common, cult leaders of all kinds flourished.

A native of New Orleans, Caroline Durieux found perfect models for her

satiric lithographs in the black cult leaders active in her city. Durieux was descended from a New Orleans family of Irish-French stock and grew up in a tolerant home where she learned the tenets of orthodox Protestantism from her mother while frequently worshiping at the Cathedral of Saint Louis with her Catholic father. From her father, however, Durieux claimed she gained a critical attitude, learning that "one religion is as good as the next"; the two of them would invariably arrive quite late for Mass and skip out long before it concluded.[48] Although growing up something of a religious skeptic, as a proper New Orleans lady, Durieux could not voice her feelings against the hypocrisies of church and society. "Outright confrontations with parents, teachers and clergy . . . were forbidden. . . . I could not speak out against, but I could draw their pretensions," she later declared.[49]

Her interest in drawing led Durieux to pursue a career in art. She attended Sophie Newcomb College of Tulane University and later studied at the Pennsylvania Academy of Fine Arts. During her college years she absorbed the ideas on political reform propounded by Thorstein Veblen in his *Theory of the Leisure Class* and came to admire the social satires of French artist Honoré Daumier. She also studied the work of John Sloan and George Bellows, whose lithographs may have caused her to realize that American subject matter—especially that which dealt with religious themes—could furnish interesting material for satire.

In 1920 the artist married a New Orleans exporter and undertook a series of extended trips to Cuba, Mexico, and South America. In Mexico she became close friends with Diego Rivera and perfected her satirical style, described by one critic as "politely cruel, charmingly venomous."[50] For his part, Rivera praised her work, declaring that "not since the 18th century . . . have such subtle social chronicles been so ably put on canvas."[51] The paintings to which Rivera referred were Durieux's satiric renditions of Mexico's nouveau riche, members of the rising bourgeoisie on vacation at an art colony. Durieux perfected her lithographic technique with a series of satires that included depictions of a puffed-up Mexican cleric imparting a sanctimonious benediction and ridiculous-looking priests in flowing cassocks and broad-brimmed hats.

The artist also began to direct her attention to New Orleans subjects by the early 1930s. In 1933 Durieux issued a lithograph titled *First Communion* (Fig. 4.6).[52] This lithograph depicts the First Communion outfit of a young black Catholic girl, who is clothed in a white dress, her face covered with a white veil surmounted with white roses. It also provides a hint of Durieux's future interest in portraying the local religious scene of New Orleans, to which she would return by 1936. Most of the black people living in the Vieux Carré district of the city professed Catholicism, unlike the uptown Negroes, who generally adhered to the various Protestant denominations or else participated in one of the many

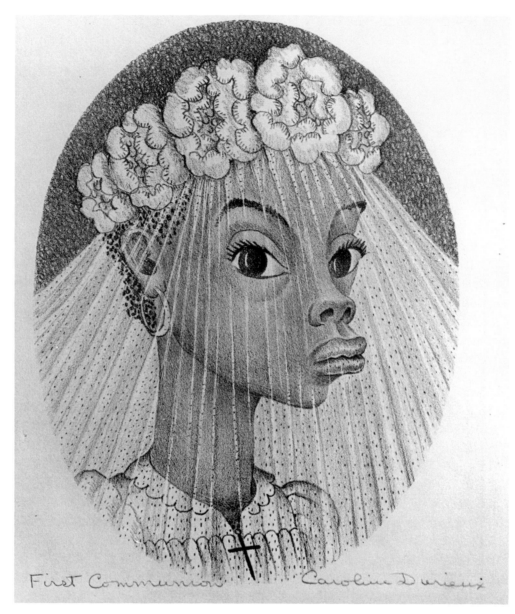

Fig. 4.6. Caroline Durieux, *First Communion* (1933). Lithograph, 11½ x 8½ inches. Anglo-American Art Museum, Louisiana State University.

flourishing cults. In executing this lithograph, Durieux may have recalled the many times she and her father skipped out of church early, refusing to take the ceremonies at the Cathedral of St. Louis seriously. The artist deliberately exaggerated the size of the eyes while elongating the bridge of the nose and pursing the lips of the little girl pictured in *First Communion* in order to convey the fear

Art and Popular Religion in Evangelical America, 1915–1940

and bewilderment of the child. This young neophyte appeared to Durieux as a "trapped, frightened doe . . . looking at us in startled surprise from behind the symbolic bars of a First Communion veil."[53]

Durieux quickly established her reputation as a satirist of note. Her success with lithography earned her an appointment as head of the WPA Federal Art Project for the state of Louisiana. In 1937, while employed by the WPA, Durieux collaborated with Lyle Saxon, state director of the Federal Writers Project, to produce a series of lithographs for the *New Orleans Guide* and *Gumbo Ya-Ya*. In these books Durieux satirized two of New Orleans's leading cult figures, Father James Joseph of the Jerusalem Baptist Church and Mother Catherine Seals. The artist titled the lithograph of Father Joseph *A Cult Leader Exhorting His Flock to Obedience* (Fig. 4.7) and called the drawing of Mother Catherine Seals simply *Mother Carrie* (Fig. 4.8).

Described as the "high priestess" of New Orleans's Negro cults, Mother Seals arrived in the city shortly before 1921, where as a young woman of sixteen she found employment as a cook in the kitchen of a Mrs. Nettles.[54] New Orleans already enjoyed a longstanding reputation as a southern mecca for cult leaders, healers, and prophets of all kinds. But in the early twenties, a white prophet by the name of Brother Isaiah took the city by storm, healing the sick and lame on the Mississippi levee with his "magic touch."[55] Mother Seals approached Brother Isaiah with her plea to be cured of a paralytic stroke she claimed to have suffered after a beating from her husband, but received a cool rebuff on account of her race. This indignity caused the soon-to-be cult leader to pray intensely for grace and good health. Her prayers answered by "a spirit," Mother Seals resolved to found a temple where she could impart cures and blessings to all comers: "De Lawd heahed me. He healed me; Ah heals all colors," she explained.[56] Mother Rita, temple assistant, described the special healing rites revealed to the foundress:

> She cured by "layin' on ob hands an' annointing' dere innards" with a full tumbler of warm castor oil, followed by a quarter of lemon to kill the taste. "You gotta do as I says if you wants to be healed an' blessed," she told those who objected.[57]

On a large plot of soggy ground adjacent to New Orleans's Industrial Canal, Mother Seals erected her Temple of the Innocent Blood, a name chosen because the foundress originally intended to build a hospice for unmarried pregnant women who otherwise would have obtained illegal abortions.[58] She soon abandoned this scheme as impractical and erected in its stead a huge "Manger" and "Church of the Innocent Blood." Mother Seals decorated her church with stations of the cross, colorful banners depicting the Sacred Heart or "The Innocent

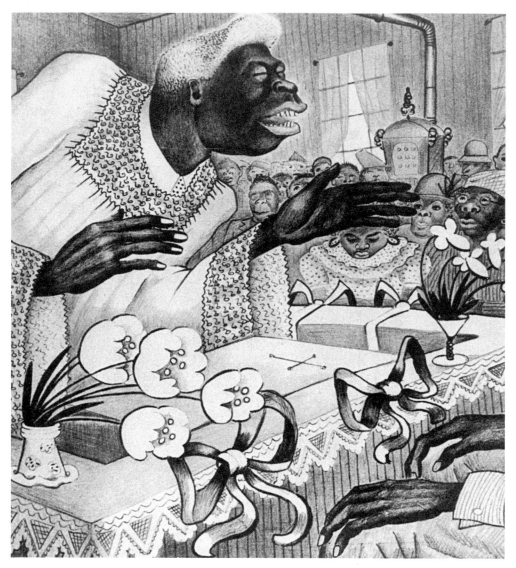

Fig. 4.7. Caroline Durieux, *A Cult Leader Exhorting His Flock to Obedience* (1938). Lithograph for *American Guide Series, New Orleans City Guide* (Boston: Houghton Mifflin Co., 1938). Courtesy Caroline Durieux, Baton Rouge, Louisiana.

Blood," and a large central altar replete with statues, holy cards, and five hundred oil-burning lamps.[59] Mother Catherine's temple uniform varied according to the daily dictates vouchsafed to her by the Lord. Apparently the Lord favored for her a voluminous white dress secured by a blue cincture from which dangled a brass key.[60] Mother covered her head with a long white veil.

In *Mother Carrie* (Fig. 4.8), Durieux portrayed her subject standing behind

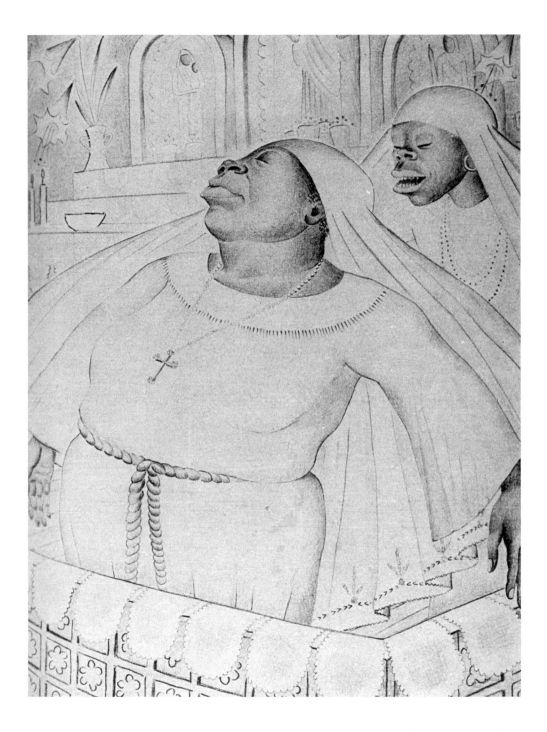

Fig. 4.8. Caroline Durieux, *Mother Carrie* (1937). Lithograph for Lyle Saxon, *Gumbo, Ya-Ya: A Collection of Louisiana Folktales* (Boston: Houghton Mifflin, 1945). Courtesy Caroline Durieux, Baton Rouge, Louisiana.

the lace-draped altar of her Church of the Innocent Blood. Behind her appear Mother Rita and one of the other cult altars crowded with images and figures of various saints, floral offerings, burning candles, and bowls and cups containing castor oil used to "anoint the innards" of devotees. Mother Seals appears clad in her long white temple uniform, complete with veil and waist cord. Her posture—head thrown back, eyes closed, and arms outstretched—indicates that she has just performed one of her healing rituals and is invoking the aid of "spirits" to effect a cure. "Heah me sperrits," Mother Seals would intone, after which she would stand quietly by awaiting a cure.[61]

Durieux achieved her satiric effects through a close analysis of Mother Seals's features, the proportions of which the artist carefully exaggerated in the finished lithograph. She placed Mother Seals near the front of the picture plane, thereby diminishing the distance between the cult leader and the viewer. Positioned extremely close to the viewer, the figure of Mother Seals looms large in importance. Her outstretched hands and voluminous veil magnify the rotund mass of her ample body. These arms and the imaginary line formed by her cincture and pectoral cross function as giant arrows directing the viewer's gaze upward toward her face, which is seen from below. This low vantage point distorts and accentuates the cult leader's full lips and large nostrils, furthering the sense of mockery in the viewer, who is positioned as if kneeling before Mother Seals in fearful supplication.

Durieux employed similar devices in *A Cult Leader Exhorts His Flock to Obedience* (Fig. 4.7). The probability that she modeled the characters in her lithographs after stereotypically slapstick postcards of a Negro revival meeting (Fig. 4.9) indicates that Durieux intended both *Mother Carrie* and *A Cult Leader* to be viewed with humor and sarcasm. One must also note the frankly racist tone common to both the postcard and Durieux's work. As in Durieux's lithographs, the blacks' physiognomy in this postcard appears greatly exaggerated, as does their unique clothing. The peculiar religious behavior engaged in by the Negroes ridiculed in such postcards establishes a further parallel between them and the figures in Durieux's lithograph. The features of the minister haranguing his congregation (Fig. 4.9) bear an especially striking similarity to the cult figure in Durieux's work (Fig. 4.7). Sporting fuzzy white manes of hair, both ministers strain forward, squinting their eyes at their flocks. Their lips are grotesquely enlarged, and they have bare rows of large white teeth and overly large, gesticulating hands.

The scene Durieux pictured transpired in the Jerusalem Temple Baptist Church led by Father James Joseph, whose figure forms the focal point of *A Cult Leader*. Baptist in name only, Father Joseph's church occupied the site of a former neighborhood grocery, "a small, one-room clapboard building furnished with

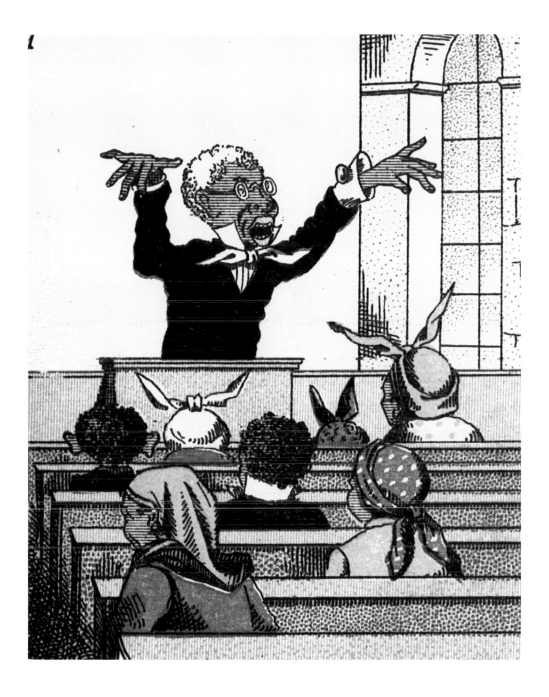

Fig. 4.9. *Negro Revival Meeting* (1882). Color trade card, Sammis and Latham.
Courtesy of the Billy Graham Center Museum.

benches, chairs and a central altar."[62] Durieux accurately captured the atmosphere of this house of worship by placing the figure of Father Joseph behind a central altar covered with lace, huge ribbons, and a mismatched assortment of flowers. As in *Mother Carrie*, the viewer occupies an uncomfortably close position vis-à-vis the preacher, who looms large in the foreground. Apparently seated on a low bench, the viewer is obliged to gaze upward at Father Joseph, who appears all the larger due to the low angle of the roof and the still lower suspension of the stovepipe extending directly over his head and nearly out of the picture plane.

Durieux's depiction of Father Joseph accentuates the description of him furnished in the *New Orleans City Guide:* "tall, very black, and burly. His speech is precise and fluent, accented with frequent bows and smiles."[63] Father Joseph's claim to fame rested upon his ability to perform miraculous cures, a gift which packed great crowds into the tiny space of the defunct grocery store. Durieux depicts this throng in the background of her lithograph and, by placing the hands and knees of an unseen figure in the lower right foreground, indicates that spectators continue to occupy the space around the altar. By implication, the viewer finds himself occupying a space contiguous with this vast gathering of people.

Following the preliminary rites, during which the congregation prays as deacons "pass the basket" with embarrassing frequency, Father Joseph makes his appearance to exhort his flock to obedience:

> Ah guarantee y'all everlastin' happiness if ya stick wid me. Ah'll run ya outta dis church if ya mess aroun'. Don' say Ah cain't run ya. Ah got power! To tell the truth Ah can tell anybody whar to git off at . . . Ah know dere is hoodoos right heah in dis church. . . . Dey come ta see what Ah can do. Ah'm gonna show dem, too. Ah am a healer. Ah kin heal people right fo' ya eyes. . . . Now is the time for dem whut wants ta be healed to come to de front.[64]

After Father Joseph restores the sight of a blind girl in a demonstration of his miraculous powers, the ushers return supplied with armfuls of "blessed candles" which they sell for five cents each. The supply sells out quickly, after which Father Joseph dismisses his flock.

The deep South did not have a monopoly on Negro religious cults. In New York City's Harlem, the Kingdom of God took on concrete form in the person and cult of Father Divine. As with many cult leaders, Father Divine's origins remained obscure. Divine, himself, claimed to have no beginning or end. As "God in the flesh" to his followers, who accepted his word as ultimate truth, Divine's existence could not have resulted from mere human sexual intercourse—a practice strictly forbidden to cult members born again according to the spirit.[65]

Nonbelieving blasphemers, however, discerned that Father Divine had been born in the deep South under the name of George Baker. For his early efforts as a mystic preacher, Father Divine received brutal treatment on a Georgia chain gang. Run out of town and nearly lynched on several occasions, Major J. Divine (as George Baker now styled himself) gradually made his way north, settling in Sayville, Long Island, in 1919.[66]

By that time, Father Divine had already formed his beliefs that living in righteousness should bring about not only spiritual improvement but a betterment of one's standard of living as well, including the abolition of Jim Crow practices.[67] To that end he began to gather a few followers and obtain jobs and lodgings for them. Divine also began to preach that since he refrained from anything contrary to God's will he felt capable of identifying himself with God. To his followers in Sayville, Father Divine assumed larger-than-life proportions. He not only found them jobs, he also provided them with sumptuous banquets — called "Holy Communions" — at which seemingly endless heaps of food passed the length and breadth of the table. Following such feasts, Father Divine customarily gave a brief speech during which his followers, called "Blessed Angels," shouted and sang hymns of praise.

In order to achieve the status of "angelhood," disciples were first requested to surrender all earthly possessions and salaries, which Father Divine freely accepted as tokens of their gratitude. The would-be angels next had to master the secret of "relaxation of conscious mentality." This involved obeying Father's words completely, trusting him to provide for all one's needs, and reading *New Day*, the official organ of the cult.[68] With complete "relaxation of conscious mentality" came rebirth into the angelic state clothed in human form. As the Depression deepened, Father Divine found the number of his followers growing by leaps and bounds. The daily trek of Harlem blacks to suburban Long Island produced a racial backlash among the normally placid middle-class whites of Sayville. Finding it expedient — and profitable — to move his "Kingdom," Father Divine in 1933 established "Heaven" at 29 West 115th Street.[69] His cult continued to flourish there and at numerous rural farms, the most famous of which was located across the Hudson River from FDR's Westchester County estate.

All Humanity in Supplication before Father Divine (Fig. 4.10), the work of an anonymous painter, is a transparent attempt to convince the viewer of the truth of Father Divine's mission. This painting hung in Father Divine's Harlem Heaven and attained a wider audience when a photograph of it appeared in John Hoshor's exposé, *God in a Rolls Royce,* and later in the *Saturday Evening Post.*[70] Father Divine is shown descending a mountain path. Like Moses bringing the tablets of the Law to the ecstatic Israelites, the cult leader appears to bring a new revelation to the frenzied mass swarming about the foot of the mountain.

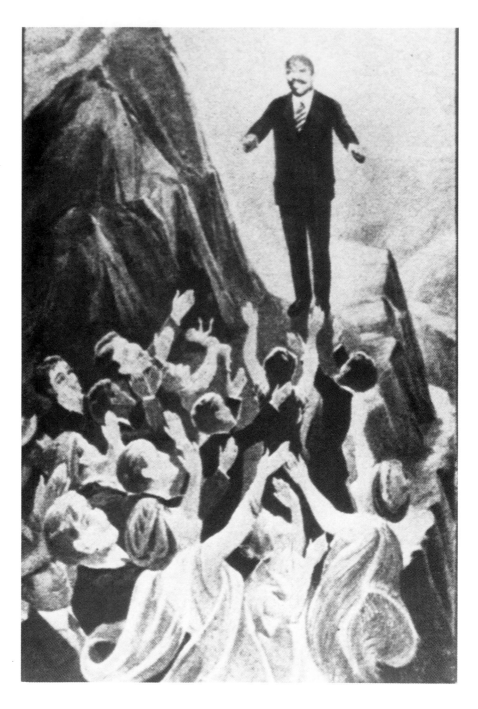

Fig. 4.10. Anonymous, *All Humanity in Supplication before Father Divine* (c. 1936). Oil on canvas. Present location unknown. From: John Hoshor. *God in a Rolls Royce: The Rise of Father Divine — Madman, Menace or Messiah.* New York: Hillman-Curl, 1936. P. 103.

Clad in a three-piece suit with striped tie, Divine approaches the revelers with outstretched arms. Unburdened by any carved stone tablets, however, his empty-handed gesture seems to indicate that his very person constitutes the revelation of God. In response to this new revelation, the faithful believers wave their arms and sway back and forth, much as they would have done at a "Holy Communion" banquet. Further confirmation of Father Divine's beliefs, which stressed peaceful coexistence of the races and the abolishment of all Jim Crow laws, appears in the racially mixed nature of the crowd. Among these revelers, a group of white women clad in flowing diaphanous robes (like Hebrew maidens in Cecil B. DeMille's 1923 film *The Ten Commandments*) appears prominently in the foreground.

Contemporary accounts by observers at Father Divine's banquets often noted the erotic reaction of many of the cult leader's female followers:

> Many of the singers, especially the women, accompanied their songs by looks and gestures of adoration, flirtation, surrender, ecstasy, etc. They would look at the large photograph of Father Divine, throw kisses, smack their lips, make gestures of embrace, and make such exclamations as "Father, you are so sweet," "Father, I love you so," "Sweet Father," "Father, I know you belong to me."[71]

In part, such demonstrations resulted from the strictly enforced rule of celibacy which devotees adhered to upon joining the sect. Since Father Divine decreed that love of God far surpassed all carnal desires, and since he, of course, appeared as God-in-the-flesh to his followers, no greater sexual expression could be conceived than to give oneself completely to Father. Forbidden to engage in sexual activity, many followers sublimated their natural urges in quasi-erotic moans and shakes whenever Father Divine appeared, or relished in publicly proclaiming their past sexual sins at testimonials.

Father Divine did not function alone in New York. Numerous storefront churches (comprising 75 percent of the total number of churches in Harlem by 1930) freely dispensed a salvation that combined the familiar revival practices of black Baptist and Methodist services, the sanctification theology of the Holiness sects, and an independent ecclesiastical structure. Prentiss Taylor aptly captured the atmosphere of one such storefront worship service in his 1936 lithograph *Assembly Church* (Fig. 4.11). Taylor's artistic interest in black religious rites may have received its initial stimulus when, in 1934, he depicted a Negro revival in *Experience Meeting at Massydony A.M.E.* (Fig. 4.12) while employed by the PWAP in New York City.

Descended from an old American family whose roots dated back to the Revolutionary War, Taylor grew up in Washington, D.C. As a child he had few playmates and turned to drawing and painting stage sets for entertainment.[72]

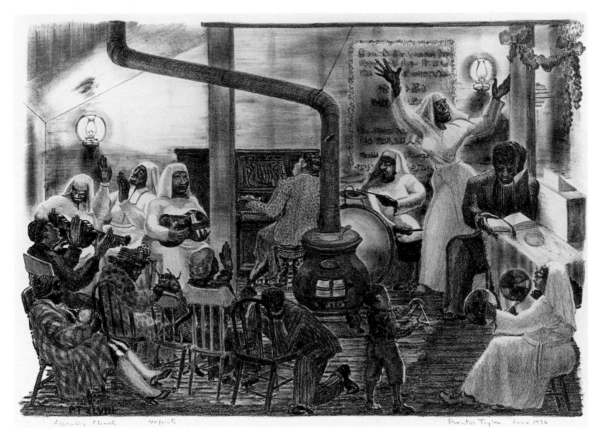

Fig. 4.11. Prentiss Taylor, *Assembly Church* (1936). Lithograph, 10 7/16 x 14 11/16 inches. National Museum of American Art, Smithsonian Institution.

What began as a childhood pastime turned into a lifetime career when Taylor traveled to Provincetown, Massachusetts, to study painting with Charles Hawthorne. He later continued his art training in New York at the Art Students League, where he studied under Charles Locke and developed his skills in lithography. Taylor drew his first stone in 1931. These early efforts, with titles such as *Negro Head, Zulu Chief,* and *Tribal Dance,* demonstrate the artist's early interest in what would develop into an ongoing involvement with Negro subject matter.[73] Outraged at the Scottsboro Case of 1931, in which nine black teenagers falsely accused of raping two white girls in Alabama received the death sentence, Taylor pictured the hypocrisy of the affair in a series of four lithographs.[74] A resident of New York since his days at the Art Students League, Taylor registered with the PWAP in 1934. In this capacity he took a trip south into the Carolinas, drawing a series of lithographs on local Carolina life that included *Experience Meeting at Massydony A.M.E.* (Fig. 4.12).

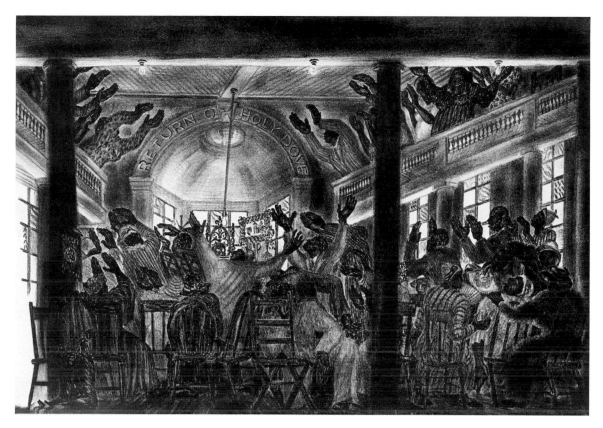

Fig. 4.12. Prentiss Taylor, *Experience Meeting at Massydony A.M.E.* (1934). Lithograph.
Photo: Library of Congress.

Taylor described this drawing on the back of a standard form that he received from the PWAP:

> "Experience Meeting at Massydony A.M.E."—Service at a Southern Negro Church—
> the congregation "shouting"/waving arms and stamping. This sort of little church
> and passionate African service is fast losing hold even in the South—It is frowned
> on by the more earnest Negroes—although they sing hymns more and more it is
> the happy hunting ground for spirituals—size approximately 10 x 14.[75]

Taylor encountered no little difficulty in attempting to convey the "passionate
African service" he witnessed in Macedonia, South Carolina. His reference to
the growing inability of revivalist worship to maintain its attractive power and
his consciousness that the old spirituals would soon be relegated to the "happy
hunting ground" indicate his reasons for taking extra time to plan this litho-
graph. Taylor felt a responsibility to record part of what he regarded as a van-
ishing religious expression.

In *Experience Meeting* the artist depicts a group of black Methodists in the midst of a testimony meeting. Enraptured by their experience of the Holy Spirit made manifest through the oral accounts of believers, the congregation wave their arms, faint into chairs, or jump to their feet. The "A.M.E." of the title, a common abbreviation for African Methodist Episcopal, provides a clue that the scene takes place in an independent Methodist Negro church in the deep South.

Originally founded by black Methodists in response to the practice of providing separate jurisdictions for non-white members, the A.M.E. Church grew rapidly in those states where independent Negro assemblies did not pose a threat to the slave system. Although a branch of the African Methodists organized as early as 1818 in Charleston, South Carolina, the civil authorities stamped out all traces of the church organization by 1822.[76] The only southern city to allow the A.M.E. even a precarious existence prior to the Civil War, New Orleans granted the church a charter in 1848.[77] Under the terms of this license, members agreed to meet in private homes, often gathering in back rooms for fear of the police. Such a system of semi-secrecy could only encourage the perpetuation of "African" worship forms that blended naturally with the revival style of camp meeting Methodism.[78] With the advent of the Civil War, the A.M.E. Church spread rapidly into the South: branches appeared in Charleston by 1863 and thereafter in Norfolk, Virginia; Nashville, Tennessee; and Savannah, Georgia.[79] The expanding church found a new source of converts in former slaves, but this also produced great difficulties for the church administration, which frowned upon the more "heathenish" forms of worship practiced by the newly converted. In their zeal to maintain orthodoxy, A.M.E. pastors generally encouraged the channeling of emotive behavior into more acceptable and familiar forms of piety, such as revivals, prayer nights, and experience meetings.

Experience meetings generally involved the reading of Scripture, exhortation by the deacon or pastor, the singing of hymns, and featured church members rising before the congregation to relate their "experience" of salvation and declare how the Lord manifested his activity in their lives. No mere recapitulation of facts, these oral recitations aimed to re-create in the hearer the actual experience itself. To that end, members shouted encouragement, clapped and swayed, and swooned under the power of the Spirit of the Lord. Taylor recorded all this in *Experience Meeting at Massydony A.M.E.* In the painting several members of the congregation rise while others fall back in a faint, kneel, clap, or throw up their arms in praise. People in the balconies surrounding the nave echo this feeling by clapping their hands as they lean over the railing. Above the chancel in bold letters appears the phrase "Return, O Holy Dove," an invocation to the Spirit of the Lord which descended upon Christ in the form of a dove has to fall afresh upon this congregation.

For those emigrants from the South who chose to cling to these familiar patterns of down-home religion, storefront churches provided a fair substitute. In *Assembly Church* (Fig. 4.11), Taylor depicts this transference of emotional, experience-based religion to a Harlem storefront setting. The U.S. Census of 1936 (the same year in which Taylor drew *Assembly Church*) revealed that the ratio of black to white Pentecostals stood at one to three in the East North Central United States.[80] This ratio reflected the success of the Pentecostal Assemblies of Jesus Christ in organizing many formerly independent black congregations in the years 1926 to 1936.[81] Among these Pentecostal assemblies active in New York, the Way Back to Pentecost Assembly, Mt. Calvary Assembly Hall of the Pentecostal Faith of All Nations, and the Mt. Sinai Holy Church of America all incorporated a Holiness-based theology into their church structure. They also prescribed the wearing of special white clothing for their female members as a mark of "holy dress."[82] Doctrines varied from church to church but generally included belief in a personal God, a conversion experience manifest in the gift of tongues, physical healing, or other visible sign. Most relied heavily on the use of rousing hymns and personal testimonies and proscribed such "sins" as dancing, drinking, gambling, divorce, and the wearing of immodest clothing. The numerous parallels between worship at such storefront assemblies and the experience meetings familiar from their rural southern homeland caused many Harlem Negroes to view storefront churches as an attractive alternative to worship in the more established northern churches.

In *Assembly Church*, Taylor depicts a shabby gathering of men, women, and children in a dilapidated interior. They display varying degrees of enthusiasm for the hymn being performed by the church leaders, who are symbolically clad in long white dresses and veils. Some clap in time with the music or perform on guitars, pianos, drums, cymbals, and triangle, while others kneel in prayer. One of the "saints" silhouetted against a banner inscribed with pious exhortations throws up her arms in praise. The mismatched assortment of chairs, the bare wooden floor, peeling plaster, the two kerosene lamps serving as the only light source, and the portable altar covered with a white sheet provide ample visual evidence that this particular assembly church serves as home to a makeshift, storefront congregation. By including the word "assembly" in the title of his lithograph, Taylor indicates the Pentecostal and Holiness orientation of these believers.

The concern artists evidenced in depicting black religious experiences in America during the 1920s and 1930s paralleled the growing interest that musicologists, folklorists, playwrights, and sociologists demonstrated in studying the various aspects of American Negro religious behavior. At a time when black

society in general began to be noticed outside the South and appreciated as "different" from that of the white Protestant mainstream, artists latched onto black popular religious practices as depicted and interpreted on the stage, in song, or on film, finding them a quintessential expression of Negro life. Although riddled with obvious stereotypes, such portrayals of black Americans appealed to artists precisely because they offered undeniably Regionalist subject matter. Such scenes, although occasionally inaccurate, were uniquely regional in their depiction of the Negro folk culture, yet, because of their religious content, comprehensible to the general public. The fluid cultural situation created by mass black migration and the concomitant explosion of interest in black culture outside the South explain how an academically trained painter such as Wayman Adams could, on the one hand, depict a southern Negro revival with respect and sympathy yet turn around and lampoon a similar revival in New York when it suited his purposes to do so. The mass exportation of black culture to urban centers also explains how southerners John McCrady and Caroline Durieux could approach Negro religion from diametrically opposite viewpoints. McCrady nostalgically seized upon religious stereotypes to celebrate and preserve his identity as a southern Regionalist painter. Durieux employed similar images of blacks at worship to poke fun at a southern society she could not take seriously. Similarly, Prentiss Taylor's depictions of black religious services provide visual equivalents to the sociological investigations examining the role of the "old-time religion" within black society. Taylor's work only hints at the social unrest inherent in this migratory society. His meek efforts contrast sharply with a work such as *All Humanity in Supplication before Father Divine* painted by a cult "insider." It is instructive to note the difference. *All Humanity* clearly and unapologetically sets forth its doctrinal message and in so doing furthers the aims of the cult that offered a real alternative to the alienation, ghettoization, and exclusion from white society experienced by many blacks in the 1920s and 1930s.

Several artists moved beyond merely depicting black society to comment upon the degrading social effects produced by Jim Crowism and ghettoization. They found in the lyrics to Negro spirituals genuine expressions of faith that sustained hope and generated the will to overcome the social inequalities of the day. In canvases based on spirituals, images from revivalist religion are used to expose these inequities in American society. These paintings also serve as testimony to a uniquely American form of religious expression. It is to this aspect of religious painting that we now turn our attention.

Chapter Five

Holy Hymns
and Sacred Songs

The rising interest among American artists in depicting the religious fervor of black religious revivals was paralleled during the 1920s and 1930s by the interest painters demonstrated in using Negro spirituals as the subjects of their canvases. In addition to southerner John McCrady, Malvin Gray Johnson, Coulton Waugh, Dan Lutz, Ruth Star Rose, and William H. Johnson all used the title and lyrics to one hymn — "Swing Low Sweet Chariot" — as the basis for canvases and lithographs conveying the unique piety of black worship. Other painters, such as Henry Botkin, Franklin Watkins, and Charles Shannon, preferred to represent blacks engaged in song during local religious rites at which these artists participated as observers. Coextensive with this new interest in adapting themes expressed in Negro spirituals to the painted subject matter of a canvas or lithograph, several artists — Paul Sample and Lauren Ford, for example — also looked to the white Protestant church tradition of hymn singing as a source of inspiration for their canvases.

When McCrady exhibited *Swing Low Sweet Chariot* in October 1937 at the Boyer Galleries in New York, the rave reviews the artist received catapulted him to national attention. The following year, McCrady selected this same canvas as his entry in a show held at the City Art Museum of St. Louis.[1] Designed to display outstanding works by contemporary American artists, this exhibition resulted in the museum's purchase of *Swing Low Sweet Chariot*. The museum did not act in isolation when it accorded such an accolade to McCrady's Negro religious canvas. In March 1939, the Guggenheim Foundation awarded the artist a three-month traveling fellowship for the purpose of continuing to paint "the life and faith of the Southern Negro."[2] The artist used the grant to travel through the South gathering material for paintings he later exhibited in November 1940 at A New Southern Group Gallery in New Orleans.[3]

In that show, McCrady presented *Heaven Bound*, a painting based on a Negro church operetta, along with *Hush, Someone's Calling My Name* (Fig. 5.1), which, like *Swing Low Sweet Chariot*, adapted the name of a particular Negro spiritual as its title. The lyrics to this spiritual reveal why McCrady evolved the particular conception he did for his painted version of this well-known Negro hymn:

Hush, hush, sombody callin' my name.
Hush, hush, sombody callin' my name.
Hush, hush, sombody callin' my name.
O my Lord! O my Lord! what shall I do? . . .
Early one mornin' death come knockin' at my door.
Early one mornin' death come knockin' at my door.
Early one mornin' death come knockin' at my door.
O my Lord! O my Lord! what shall I do?
Oh, Hush, Hush, Sombody callin' my name.[4]

Upon a barren, almost surreal landscape, a gaunt, skeletal figure supporting himself with the aid of a walking stick leads another equally emaciated man across a parched wilderness. The two pause in mid stride and look heavenward as if listening to the sound of a voice emanating from somewhere in the sky. Directly overhead looms a large cloud form whose shape resembles a pair of hands cupped around an open mouth in a gesture indicative of calling someone from afar. Like the figure knocking at the door in the spiritual, the old man with the walking staff appears to represent death leading a soul through the valley of despair. That soul has apparently undergone a religious conversion, for, like the lyricist of the Negro hymn, he hears the heavenly voice calling him by name.

Elated that the artist decided to return to "the explorations he had successfully made into the rich realm of the Negro's faith and spiritual fantasy" after needless "dillydallying and side excursions," *New Orleans Times-Picayune* art critic W.M. Darling praised *Hush, Someone's Calling My Name* as "another excellent canvas" and noted McCrady's skillful ability to "fill clouds with substance" while allowing them to play a "speaking part."[5] The "dillydallying and side excursions" in which McCrady engaged between 1937, the year he painted *Swing Low Sweet Chariot*, and 1940, when he executed *Hush, Someone's Calling My Name*, did not actually take him far from the picturesque scenes of Negro life familiar from his boyhood days in Oxford, Mississippi. Canvases like *Returning Home* (1937), *Leap Year* (1937), *Going to Town* (1938), and *Oxford on a Hill* (1939) continued to manifest McCrady's ongoing interest in presenting Negro subject matter and exploring the local mores of small-town southern life. However, none of these works achieved the degree of popular recognition previously

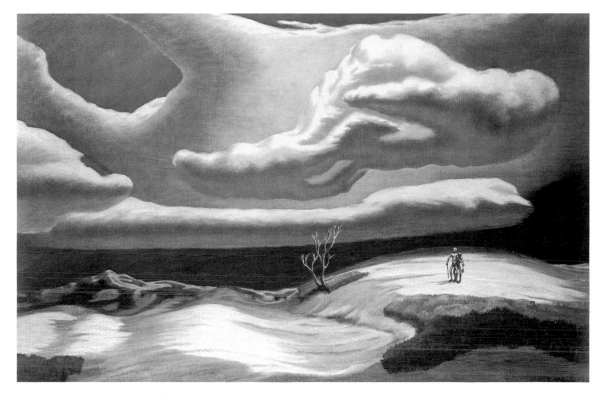

Fig. 5.1. John McCrady, *Hush, Someone's Calling My Name* (1940). Multi-stage on canvas, 22 x 34 inches. The Sheldon Swope Art Gallery, Terre Haute, Indiana.

accorded McCrady's *Swing Low Sweet Chariot*. When, in 1940, the artist finally decided to return to painting canvases with motifs derived from black religious songs, critics like Darling could once more exclaim that "McCrady gets glory into paint," while the newly opened Swope Gallery in Terre Haute, Indiana, praised *Hush, Someone's Calling My Name* as one of McCrady's "very best southern spiritual canvases" and backed up these words of praise by purchasing the painting for its collection.[6]

McCrady's resurgent interest in spirituals reflected his awareness of the importance such music had held for him since childhood. The artist's belief that Mississippi blacks expressed their deepest convictions, their philosophy of life, and the emotional reason for their being in spirituals prompted him to accept the Guggenheim Fellowship in 1939.[7] However, McCrady's interest also may have been aroused by the recognition several other artists attained from their own depictions of "Swing Low Sweet Chariot" on canvas while his own meteoric rise to national prominence in 1937 had slowly faded away. Furthermore, by 1940, serious interest in disseminating and preserving Negro spirituals had developed at all levels of American society, making the topic of Negro music a lively

and vital one for artists interested in commenting upon and reflecting the values of American culture.

Although spirituals originally served a ritual function, the rhythm and cadence proper to many Negro hymns gave them a popular appeal beyond the purely religious sphere. At the height of the "Jazz Age," the ability to play or sing in the distinctive idiom of Negro music provided upwardly mobile blacks with a ready entré into white society. Lester A. Walton, writing for *New Black World*, noted that "Negro music has established itself as one of the season's unique forms of entertainment. Never before has the spiritual attracted such widespread and favorable attention.[8] Walton related how the singing of Negro spirituals on the concert stage provided "a key to unlock the door of opportunity" to many blacks for whom access to the theaters of Broadway, concert halls, and the radio airwaves had previously been denied. By 1926, Roland Hayes regularly included spirituals on his radio program, black actor and vocalist Paul Robeson (star performer in *The Emperor Jones*) could team up with black composer Lawrence Brown to produce a Sunday evening program of spirituals that played to packed audiences in New York theaters, and black universities like Fisk, Tuskeegee, and Hampton prided themselves on their singing quartets.[9] On the eve of the Great Depression, commentators could speak of a national "vogue of the Negro spiritual," numbering such songs among America's greatest artistic achievements.[10]

The popular following attained by spirituals was matched in the scholarly field by numerous books and monographs on the subject. Coincident with the rise of the antiques craze in the 1920s and the rediscovery of a usable American past, as manifest in the growing interest paid to American folk art and folk music, scholars discovered in black spirituals and songs a rich deposit of an authentic American folk tradition in danger of being lost forever. Writing in the American edition of the *Edinburgh Review,* for example, A.A. Chirgwin claimed the growing attention paid to Negro spirituals was part of a new and healthy interest in folk song in general, adding that in America, where the human spirit exhausted itself in mechanisms and commerce, it had been left to the Negro slave to provide "the most beautiful artistic expression born on that side of the seas."[11] From the close of World War I until the outbreak of World War II, while the *Journal of American Folklore* regularly featured scholarly articles on Negro songs, the fruits of such research filtered down to the general public through the pages of the *New York Times* and other leading newspapers.[12] Although journals and periodicals did not always refrain from employing racial stereotypes, they did manage to convey a sense that many commonly sung American tunes owed their origins to spirituals first chanted by black slaves.[13]

These revelations fostered a renewed sense of racial pride among blacks

eager to demonstrate their contributions to American society. At the same time, the increasing popularity of their once-sacred music raised several questions in the minds of many blacks. Negro journals like *Opportunity* and *Southern Workman*, while noting the interest of white scholars in collecting and preserving old hymns, did not hesitate to point out that the true worth of a spiritual like "Swing Low Sweet Chariot" lay in the index it provided to the psychological state of an oppressed race.[14] Albert Sidney Beckham noticed that although conceived of as a palliative, this hymn exerted a powerful influence upon downtrodden Negroes precisely because the music, lyrics, and rhythm generated a cathartic state, in which the inspired singer mentally escaped from his troubles.[15] Such an attitude expressed by Negro writers in the late 1920s and early 1930s explains why black artists like Malvin Gray Johnson turned to painting the great themes found in the spirituals nearly a decade before McCrady ventured to interpret such subjects. Johnson's *Swing Low Sweet Chariot* of 1929 (Fig. 5.2) and *Roll, Jordan, Roll* of 1933 (Fig. 5.3) interpret two Negro spirituals in terms that provide a visual equivalent to the thesis being expounded in black journals.

Born in 1896 in Greensboro, North Carolina, of poor parents whose memories of slavery days remained all too real, Johnson struggled to obtain an education and pursue a career in art. He was aided financially by prize money from the Harmon Foundation and completed a course of study at the National Academy of Design.[16] Although residing in New York, Johnson devoted himself to portraying the life and struggles of the people he knew and remembered from his rural southern upbringing. Watercolors such as *Picking Beans* (1934) and *Thinnin' Corn* (1934) explored the routine of daily toil that constituted the life of many rural Negro sharecroppers. According to Margaret Bruening of the *New York Post*, Johnson interpreted these activities with sympathy as well as with tender insight.[17] However, *Brooklyn Daily Eagle* critic Charles Z. Offin opined that while the artist achieved his most telling effects with watercolors, transforming the squalor and dilapidation of the southern back country into a statement of almost lyrical beauty, "the hauntingly sad undertones of the Negro spirituals" appeared to be deliberately drowned out by brilliant primary hues and broad, flat brushstrokes.[18] Johnson also mastered the palette knife technique of oil painting and executed several fine portraits of black people, working both as an independent artist and while employed by the PWAP in New York. A portrait of Booker T. Washington that Johnson painted for the PWAP hung at the Corcoran Gallery of Art in 1934 during a major exhibition of five hundred works of government-sponsored art previewed by President and Mrs. Roosevelt.[19]

For his efforts at interpreting "Swing Low Sweet Chariot," Johnson received the special prize of $250 at the exhibition of work by Negro artists held at International House, 500 Riverside Drive in New York City, under the auspices of

Fig. 5.2. Malvin Gray Johnson, *Swing Low Sweet Chariot* (1929). Oil on canvas.
Present location unknown. From: "Swing Low Sweet Chariot Will Be Popular."
Art Digest 3 (mid-Jan. 1929): 5.

Art and Popular Religion in Evangelical America, 1915–1940

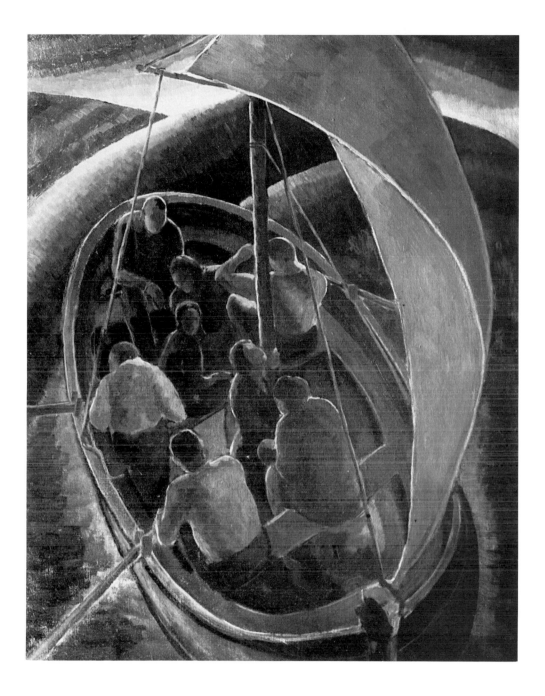

Fig. 5.3. Malvin Gray Johnson, *Roll, Jordon, Roll* (1933). Oil on canvas. Present location unknown. Photo: National Archives.

the Harmon Foundation.[20] The jury reached a unanimous decision in awarding the prize money to Johnson and praised the painting for its theme as well as the fine use of the palette knife technique.[21] A reviewer for the normally staid *Art Digest* asserted that the appearance of Johnson's painting constituted "the most important event in the art world in the last fortnight, or even in a longer time" and confidently predicted that the artist would sell "hundreds of thousands" of color reproductions if he should be fortunate enough to obtain a publisher.[22]

The reviewer went on to locate Johnson's canvas in the highest traditions of American painting, specifically comparing it to the work of Albert Pinkham Ryder, and ventured that the popularity of the canvas resulted from the familiarity of the public with spirituals frequently heard over the radio. Johnson himself spoke modestly of his achievement, describing his intention in the following terms:

> I have tried to show the escape of emotions which the plantation slaves felt after being held down all day by the grind of labor and the consciousness of being bound. Set free from their tasks by the end of the day and the darkness, they have gone from their cabin to the river's edge and are calling upon their God for the freedom for which they long.[23]

Johnson could well have added that the slaves' cry for freedom originally took the form of spirituals like the one indicated in the title of the canvas.

The artist's description, however, does indicate his familiarity with the opinions expressed by the contributors to *Opportunity* and *Southern Workman* that spirituals expressed the restlessness, alienation, and longing of blacks for a better life within American society. At the same time, spirituals served contemporary blacks by fostering a sense of racial pride in a religious art form that white society appreciated on a popular level and undertook to preserve, record, and study. An indication that Johnson attempted to incorporate these attitudes into his painting not only appears in his description of the canvas but also in the resemblance of the figures in *Swing Low Sweet Chariot* to a scene from Marc Connelly's stage play *The Green Pastures*, nearly contemporary with Johnson's painting. Act II, Scene 4, of Connelly's drama portrays a band of Negro Hebrews led by a black Moses fleeing the land of Egypt en route to the promised land. Tired, weary, exhausted from their labors and clad in rags, they carry little bundles and huddle together in groups like their counterparts in Johnson's canvas as they sing:

> Lord I don't feel no-ways tired
> Children, Oh, glory hallelujah!
> For I hope to shout glory

When dis worl' is on fire
Children, oh, glory hallelujah![24]

The object of their journey, of course, is the home promised them by God. Like the worn-out slaves in Johnson's picture who look forward to and sing about a similar reward, their physical exhaustion is alleviated by their singing. It is important to note the reaction of the Negro press upon seeing biblical events enacted on a New York stage in terms familiar to black folk. The recognition and praise Connelly's Negro drama won from white theater-goers was a source of pride and engendered new hope in the promise of black achievement. This response closely paralleled Negro press reaction to the growing popularity of black spirituals and mirrored Johnson's sentiments noted earlier.

The *Art Digest* reviewer had, in fact, indirectly hinted at this hoped-for future—where past injustices would be righted—when he noted a similarity between Johnson's *Swing Low Sweet Chariot* and the painting of Albert Pinkham Ryder. The equation of Johnson's sky effects with "mystical" or "spiritual" elements in Ryder's work calls to mind examples of Ryder's religious canvases such as *Jonah*. In this painting the clouds part above a tempest-tossed sea to reveal God the Father directing a seemingly disastrous event (the swallowing of Jonah by the whale) toward an ultimately beneficial end (the repentance of the Ninevites). Like the chariot of the spiritual—which initially functions as a portent of death but eventually signifies deliverance—the violet sky, storm-wracked boat, and monstrous fish strike terror in the helpless Jonah but will result in his ultimate salvation.

The "mystical" mood in Ryder's canvas, with its swirling forms, chiaroscuro contrasts, and eerie golden highlights, also creates an effect not unlike that found in Johnson's *Roll, Jordan, Roll* (Fig. 5.3). Like *Jonah*, *Roll, Jordan, Roll* establishes its spiritual mood through a carefully balanced series of light and dark contrasts that create a sensation of rolling and yawning upon the water. The painting's title, which imbues the seascape with religious significance, is taken from the well-known Negro "shout":

Roll, Jordan, Roll
Roll, Jordan, Roll
I wanter go to heav'n when I die
To hear ol' Jordan roll.
O bretheren, Roll, Jordan, Roll
Roll, Jordan, Roll
I wanter go to heav'n when I die
To hear ol' Jordan roll.[25]

The "shout" constituted one of the oldest forms of Negro religious song, traceable as far back as the War of 1812, and played an important role in black revivals, after-church gatherings, and at the "watch-night" vigils during Christmas and New Year's Eve.[26] The "shout" consisted of a walk segment, in which the group leader sang a single stanza as other singers marched slowly around in a circle, and a chorus, or "shout" proper. The chorus was sung at a very rapid tempo and repeated by all the members as they broke into a run. The alternating sequence of slow walk and quick "shout" could go on for hours at a time, creating a rhythmic flow not unlike the actual roll and pitch of the sea that Johnson attempted to portray in *Roll, Jordan, Roll.*

Working on his own version of a Negro spiritual-in-paint in 1937, John McCrady may have been cognizant of these earlier attempts by Johnson to depict black religious hymns. Both McCrady and Johnson made "Swing Low Sweet Chariot" their first choice when they decided to portray spirituals. McCrady would have had the opportunity to view Johnson's *Roll, Jordan, Roll* when he studied at the New York Art Students League during the 1933–34 academic year. If, on that occasion, he also saw Johnson's 1929 painting *Swing Low Sweet Chariot,* he may well have been inspired by its theme, especially if McCrady recognized a kinship between Johnson's work and that of Albert Pinkham Ryder. Ryder's paintings remained a great favorite of McCrady's. Marshall claims that McCrady literally "worshipped" Ryder's facility for painting cloud effects and remained strongly influenced by that artist's ability to create intensely dramatic skies.[27] The smoky cloud effect McCrady developed in *Swing Low Sweet Chariot* and continued to explore in 1940 with *Hush, Someone's Calling my Name* are similar to the skies Ryder painted in *Under a Cloud, Moonlight,* and *Moonlight Marine,* indicating that McCrady not only maintained a strong affinity for that artist but also would have been sensitive to Ryder's influence in the work of someone like Malvin Gray Johnson. Johnson's interpretations of Negro spirituals — a subject which vitally interested McCrady — provided an additional point of contact.

Ryder's skies and seascapes, as visualized in *The Flying Dutchman* or *The Race Track,* also tend to convey an element of foreboding in addition to supernatural significance. That McCrady and Johnson were aware of such possibilities in Ryder's paintings is obvious when we realize that the "shout" "Roll, Jordan, Roll" refers to the preparation of a Christian soul for death and the confident expectation that the departed will "cross over Jordan" to the Promised Land. In Johnson's painting, the storm-tossed pilgrims travel from the dark and gloomy waters toward a bright and brilliant horizon indicative of a journey from death to life. McCrady's use of this concept appears most clearly in another of his works from 1940, *Sic Transit* (Fig. 5.4), which depiction of a decay-

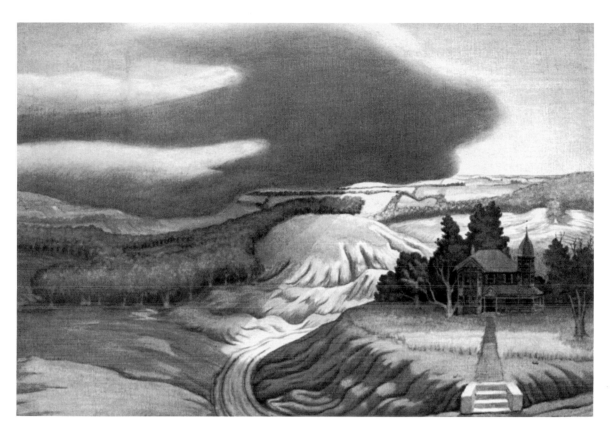

Fig. 5.4. John McCrady, *Sic Transit* (1940). Multi-stage on canvas, 27 x 36 inches. Courtesy Mary Basso McCrady.

ing South ironically won the $250 Blanch S. Benjamin Prize for "the most appealing interpretation of a southern subject" at the Southern States Art League Exhibition held in Shreveport, Louisiana, during April 1941.[28]

Like Scarlett O'Hara's vision of Tara following the devastation of the Civil War, McCrady's painting portrays a ruined antebellum plantation under a cloud-filled sky. The artist brings a religious significance to the scene by borrowing, from Chapter 14 of Ecclesiasticus, the Latin phrase meaning "thus passes away the glory of the world" for his title. The line is from a poem that calls the reader to focus upon true happiness, warning that death and decay will not delay for long and that all the achievements of humanity will pass away into rot and corruption. In the painting a cloud, vaguely shaped like a dusky angelic form gliding over a badly eroded landscape, functions as a portent of death and certain destruction as it lends an eerie, almost surreal presence to the canvas. McCrady's awareness of Surrealist trends can be ascertained from a letter he wrote to Clyde Singer on March 17, 1946:

All the painters of the stories of the bible and Greek mythology were surrealists, but not of the spirit of some of the warped-brained philosophy that is being done today. Any time a man paints an angel floating in the sky, he is painting surrealism. I have certainly done that.[29]

The artist realized this desire to paint the surreal angel referred to in his letter when he reversed the angelic cloud form, using the idea suggested by its shape to create a full-blown, semi-nude Negro seraph gliding above a moonlit Mississippi Delta in *Oh, Them Golden Slippers* (Fig. 5.5). The title derives from a popular Negro song—not a spiritual, however, but a contrived minstrel show tune:

> Oh my golden slippers am laid away,
> Kase I don't 'spect to wear 'em till my weddin' day
> I will wear up in de chariot in de morn.
> An' my long white robe dat I bought las' June,
> I'm gwineter get it changed kase it fits too soon,
> An' de old gray horse dat I used to drive,
> I will hitch up to de chariot in de morn.
>
> Oh, dem golden slippers!
> Oh, dem golden slippers!
> Golden slippers I'm Gwineter wear,
> Because dey look so neat;
> Oh, dem golden slippers!
> Oh, dem golden slippers!
> Golden slippers I'm gwineter wear,
> To walk de golden streets.[30]

McCrady, perhaps unwittingly, paid homage to the minstrel show tradition in the exaggerated racial characteristics he gave his female angel—large breasts, big feet, kinky curls flowing in the breeze—to say nothing of the dandy gold-embroidered slippers fit for prancing about the grandest of minstrel show stages. While certain white reviewers, such as Margaret Bruening of *Art Digest*, remained oblivious to the racial stereotypes inherent in such a canvas, black writers and members of the Communist *Daily Worker* denounced the painting's perpetuation of racial myths. Black opinion had crystallized against such stereotypes long before McCrady painted *Oh! Them Golden Slippers*. Several black musicologists decried the "desecration of spirituals" in commercial theaters or music halls and called for a ban on using these songs in such secular contexts.[31] As early as 1922, the National Association of Negro Musicians put itself on record as being opposed to the use of spirituals as entertainment, while concerned black writers continued to call for the judicious and selective use of

spirituals, hinting that they belonged to a religious and rural milieu and were less appropriate for upwardly mobile blacks.[32]

The appearance of this new racially self-conscious reaction goes a long way toward explaining the offense that a painting like McCrady's *Oh! Them Golden Slippers* could pose to black Americans. While ostensibly presenting a positive image of black faith and devotion, McCrady's painted Negro angels present a vision of black Americans as childlike, faith-filled, simple darkies—the very stereotypes they desired to shed, but which financially secure southern whites unwittingly perpetuated. At the time McCrady was painting Negro themes, the Charleston Society for the Preservation of Negro Spirituals, "a social organization of Ladies and Gentlemen accomplishing an important purpose," busily set about to collect spirituals from the Old South.[33] What intrigued these white people

Fig. 5.5. John McCrady, *Oh, Them Golden Slippers* (1945). Multi-stage on canvas, 30 x 46 inches. Last recorded in the collection of Mrs. Charles M. Blair, St. Croix, Virgin Islands. Present location unknown. From: Keith Marshall, *John McCrady, 1911–1968* [catalogue]. New Orleans: New Orleans Museum of Art, 1975. P. 47.

of quality was the image of Negro slaves presented in spirituals and recorded in the diaries and accounts of wealthy southerners dating from "before the war":

> There is mention made of Mammy Jo's gorgeous spiced apple bread with wine sauce, the treatment prescribed for Unkie Jake's "misery," Black Jennie's rapture at receiving Ela's strawberry-colored silk dress on which a cup of peach punch had been spilled. . . . Praises of splendid cooks, devoted body servants, faithful house boys who all had firm niches in family life in that pageant-like existence of a golden age. . . . The Negroes exaggerated idea of heavenly bliss is a place of golden beds, silver boats, jasper temples, diamond windows. Spirituals are the spirit-gropings of childlike intellects."[34]

The image of the Negroes preserved in such accounts and associated with antebellum spirituals is precisely the one Brawley alluded to when he stated, "the education of [Negro] children . . . is not a matter of the education of young Negroes but of young Americans who happen to be Negroes. In such a scheme the spirituals have little place. They belong to another day."[35] The harshist criticism directed at an artist for painting Negro religious scenes rebounded upon McCrady in the form of an editorial in the May 29, 1946, issue of the *Daily Worker*. Citing *Oh! Them Golden Slippers* as a blatant example of "racial chauvinism," Marion Summers denounced the painting as a pernicious example which fostered "the myth of the Negro as a child-like, kinky-haired savage who goes through life in a kind of religious ecstasy" and claimed that the artist's canvas constituted nothing less than "an outright slander of the Negro people."[36] The review concluded with a strongly worded diatribe against the Associated American Artists Gallery in New York for offering such examples of "bad painting" to the public.

The controversy generated by McCrady's New York exhibition shocked and depressed the artist and nearly destroyed his ability to paint. McCrady attempted to resolve his confusion that same year in a painting appropriately titled *Dilemma* (Fig. 5.6), in which he pictured himself as a split personality: the creative artist seated in front of his sketch pad discussing the merits of his design; the critic seated foremost in the picture plane, leaning over to examine the work more closely; and his whole person standing at the rear of the sofa, gesturing to both these "other" McCrady's as if to urge them not to arrive at a hasty conclusion.[37] That the dispute in point centered around the artist's depiction of blacks — and particularly of black angels — appears confirmed in the band of black cherubs flying overhead like their counterparts in the artist's *Swing Low Sweet Chariot* of 1937 or the angelic cloud form in *Sic Transit*.

In fact, McCrady resorted to the example of *Sic Transit* for the idea of staging his internal debate within the confines of a dilapidated antebellum mansion.

Fig. 5.6. John McCrady, *Dilemma* (1946). Multi-stage on canvas, 32 x 22 inches.
Courtesy Mary Basso McCrady.

With its broken panes of glass, decaying wooden floorboards, and chickens running helter-skelter, the once grand plantation interior of *Dilemma* functions much like its counterpart in *Sic Transit*—as a symbol of a once-glorious past, now dead and decaying. McCrady's personal glorious past had begun when *Swing Low Sweet Chariot* launched his rise to national fame. McCrady eventually resolved his dilemma by abandoning painting for nearly three years and never again returned to portraying Negro religious themes in his work. Ironically, the very year McCrady decided to forego painting blacks, *Time* selected *Swing Low Sweet Chariot* to illustrate its cover story on Marian Anderson and her struggles against racial discrimination while pursuing an illustrious singing career.

The attack by Communist ideologues in the employ of the *Daily Worker* upon what they perceived as "racial chauvinism" in McCrady's canvases did not constitute an isolated protest against the state of American race relations. In 1935, the work of George Bellows, Thomas Hart Benton, John Steuart Curry, Reginald Marsh, and a host of other artists appeared in a special showing headlined "An Art Commentary on Lynching," held at the Arthur U. Newton Galleries in New York from February 15 through March 2. Sponsored by the NAACP, this exhibition attracted over three thousand visitors during its two-week showing, partly as a result of the advance publicity generated when the Seligmann Galleries (the original site planned for the show) cancelled four days before the scheduled opening, citing "political, social and economic pressure."[38] Depicting graphic scenes of blacks being lynched and tortured by white mobs and the Ku Klux Klan, the portrayals of racial hatred prompted the *New York World-Telegram* to assert: "If it [the exhibition] upsets your complacency on the subject it will have been successful."[39]

John Steuart Curry continued to explore the theme of race relations in a commission he accepted in 1936 under the Section of Painting and Sculpture of the Treasury Department to decorate two lunettes on the fifth floor of the Justice Department Building in Washington, D.C. In his design for one of these lunettes, Curry intended to link the themes of European immigration and black emancipation, suggesting that Negro emancipation from slavery and the immigrants' liberation from a life of poverty and oppression could be viewed as analogous.[40] Curry conveyed this message by placing a group of recently freed slaves in the center of his pictures, their heads raised high in a spiritual "shout of jubilation," while off to the right march a group of Civil War soldiers and to the left, against a backdrop of skyscrapers, new immigrants land on American shores. Faced with the Section's rejection of this entire concept, Curry eventually scrapped his original idea.

However, the use of a spiritual "shout" to protest against racial prejudice

and oppression was taken up in turn by artist Coulton Waugh in his 1935 rendition of *Swing Low Sweet Chariot* (Fig. 5.7). Scion of a family of English Quakers, Waugh began art studies under his father, Frederick J. Waugh, painter of "the most popular marines in America."[41] This nautical influence translated itself for the son into a lifelong love of the sea: for a period of time Waugh served as second mate on a whaler and later as commodore of a yacht club. When Waugh began painting in earnest, after completing studies at the New York Art Students League, he followed in his father's footsteps, depicting scenes such as clipper ships, whalers, portraits of old salts, maps, and studies of rigging on famous old vessels.[42] The artist also undertook commissions to design textiles, and in 1934 began to draw the "Dickie Dare" comic strip for the Associated

Fig. 5.7. Coulton Waugh, *Swing Low Sweet Chariot* (1935). Oil on canvas, 27¾ x 35 inches. Courtesy of the Syracuse University Art Collections.

Press.[43] Along with these eclectic pursuits, Waugh began to manifest a strong social conscience in his painting, prompting the *New York Post* to refer to him as an "astonishing Jekyll and Hyde."[44] For his 1938 debut with the Hudson D. Walker Galleries in New York, Waugh presented a staggering assortment of paintings portraying "ladies from 14th Street, whose wistful or arrogant faces are peculiarly indigenous to New York, hungry people, fat people, black, brown and white people, not to mention a sea-gull and a snorting stallion."[45] It was Waugh's interest and concern with American social problems that prompted him to paint his own version of the spiritual *Swing Low Sweet Chariot*, conveying through a seemingly conventional interpretation of this theme his abhorrence of lynch law and the chain gang system common throughout the South.

In the foreground of the canvas Waugh has placed a black male figure in the striped chain gang uniform. His body arched as if in torture, much like the lynched Negro in *Dixie Holiday* (Benton's entry in the 1935 Newton Gallery show), this young black appears on the verge of passing from the slavelike imprisonment of the chain gang system to a new life of freedom. The pick he wields over his arched back slips from his grasp as he spies the figure of a Jeep-driving angel cruising out of the sky to pluck his soul from this earthly imprisonment and carry him home to Paradise. The other convicts remain oblivious to this miraculous event, continuing their grinding task under the watchful eye of a rifle-toting foreman.

The association of the plight of Negro prisoners with the spiritual "Swing Low Sweet Chariot" is not unique to Waugh. Ruth Star Rose also depicted this theme in her 1939 lithograph (Fig. 5.8). A native of Wisconsin, Rose spent much of her youth on the eastern shore of Maryland in a historic residence known as Hope House. Rose turned to the local life and lore of the Maryland shore for the themes found in her art. Later, in the 1940s, she executed a number of serigraphs of cowboys, rodeos, and racehorses, inspired by life on a cattle ranch located in the Custer National Forest.[46] In her *Swing Low Sweet Chariot* Rose depicts a fertile plain where a group of black people kneels in prayer and song. The foremost member of the group lifts his arms in praise and awe, revealing the fact that he, too, is clad in the tell-tale striped uniform of a convict. The object of his attention appears in the form of a heavenly chariot resembling a country buggy pulled by a plow mule in full harness and driven by a white-robed Negro angel. Winged black seraphs uphold the wheels of this rustic vehicle amid a cloudlike whirlwind.

Waugh and Rose may have come to associate the hymn "Swing Low Sweet Chariot" with the plight of convicts through popular collections of Negro spirituals, such as those in J. Rosamund Johnson's *Rolling Along in Song*, as well as through films like King Vidor's *Hallelujah!*, which MGM released on the eve of

Fig. 5.8. Ruth Star Rose, *Swing Low Sweet Chariot* (1939). Lithograph, 10 x 13⅛ inches. Philadelphia Museum of Art, anonymous gift.

the Great Depression. *Rolling Along in Song* appeared in 1937, only two years after the NAACP sponsored Art Commentary on Lynching exhibition. Offering an unusual assortment of spirituals, plantation ballads, minstrel tunes, jail house and work songs, Johnson's book included a special composition titled "De Chain Gang." This musical piece consisted of several black spirituals and jail tunes woven together into what the composer described as "an original musical episode based on traditional Negro idioms."[47] Included among the medley of tunes are the songs "One Mo' Mile to Go," suggestive of the weariness and death brought on by the harsh life on the chain gang. "One Mo' Mile to Go" gives way to the brighter promise of "Rainbow Roun' My Shoulder," whose lyrics voice the hope of divine protection and deliverance:

> Dey hol's me wid ball an' chain,
> Can't get away I'll never see my dear old mother again.
> My feet am sore, my th'oat is dry,
> No use in livin' might as well die.

Holy Hymns and Sacred Songs [153]

I got one mo' mile to go.
Clouds in de eas', Clouds in de wes'
Rain it might fall an' cool my breas',
My tongue is parch'd an' my palate is dry.
If dat water boy don't come along,
I sho'ly will die.
I got one mo' mile to go.

Rainbow, rainbow roun' my shoulder,
I got a rainbow, rainbow roun' my shoulder;
Lawd! it ain't goin' to rain.
Rainbow, rainbow roun' my shoulder;
Lawd! it ain't goin' to rain.[48]

A painted version of these two chain gang songs, Waugh's canvas depicts the transition from the grueling past endured by the chain gang member to a brightly illuminated heaven peopled with angels symbolic of the Lord's welcome protection. Similarly, the despair of the convict in Rose's lithograph changes to awe and praise when he beholds the chariot swooping down onto the plain from out of a brightly lit sky.

King Vidor's film develops a similar connection between spirituals and the chain gang theme. *Hallelujah!* presents the tale of a black tenant farmer who, swindled out of his money, accidentally kills his brother and in repentance becomes a roving evangelist. He later commits a second murder and is sentenced to a chain gang. After serving time he returns to his faithful country sweetheart. Throughout the film Vidor made use of traditional Negro spirituals, including "Swing Low Sweet Chariot." Nearly a decade later—a decade marked by the increasing popularity of Negro spirituals through books, the radio, and the stage, as well as the mass contribution of artists to an exhibition designed to call attention to the plight of blacks—Waugh or Rose's recollection of Vidor's use of this spiritual in connection with the chain gang theme would not be surprising. J. Rosamund Johnson's linking up of these same ideas in 1937 in his popular book, *Rolling Along in Song,* would have furnished an additional precedent for associating these themes in a painting or lithograph. That Waugh and Rose did, in fact, follow this approach is confirmed by comparing their pictures with the themes expressed musically by Johnson and visually and aurally in Vidor's film.

If themes gleaned from spirituals functioned as viable symbols for artists seeking ways to protest racial oppression, they could also serve as symbols of black faith and, as such, unique badges of race identity. Reared on spirituals during his boyhood in Florence, South Carolina, one-time expatriate artist William H. Johnson looked to "Swing Low Sweet Chariot" as a rich resource with which he could proudly proclaim his Negro and "primitive" identity.[49] And in

yet another *Swing Low Sweet Chariot*, in 1940, musician and artist Dan Lutz focused upon the mood and rhythm of black hymns, utilizing a thick impasto, palette knife technique to portray the feeling of religious fervor such a hymn conveyed.

Born in Decatur, Illinois, in 1906, Lutz pursued formal training at the Art Institute of Chicago from 1928 to 1931, receiving the James Nelson Raymond European Traveling Fellowship upon graduation.[50] Following a year of travel to various European museums, Lutz returned to settle in California, where in 1932 he secured a teaching position at the University of Southern California. In 1938 he rose to the position of chair of the painting department, the same year in which his canvas *Revival Church* received first prize at the Oakland Art Gallery's annual exhibition of oil painting.[51] The only unanimous choice of the jury, Lutz's painting portrayed the worn facade of an old meeting house, its doors shuttered against the dark, dank exterior world, which is indicated by the silhouetted forms of a street sign, mailbox, and two telephone poles. The luminescent church portal and belfry, aglow from the light of a single glass globe, lend a powerful effect to this house of worship and stand out in sharp contrast to everything around them, yet they cast deep, dark shadows. The strong relief effects produced by this pattern of light and shade cause the viewer's eye to remain fixed upon the church. Wherever the eye may wander, it always returns to this central facade as the most brilliant spot in the canvas.

The arresting qualities evident in the painting appear to be the product of Lutz's religious upbringing and musical training. The artist hailed from a family of practicing musicians, was himself an accomplished oboist, and knew how to play spirituals. Contemporary reviewers frequently cited his ability to capture the "sound" and "feel" of black music and praised his "understanding and love for the religious and ecstatic side of the Negro spirituals," claiming the artist believed in the "primitive religious ecstasy" of such songs.[52] Extravagant as these remarks appear, they may very well be true. Lutz's intensely religious family had a profound influence on his life. The services he attended and the church music he sang and heard sung as a youth enabled him to recognize in spirituals an equally authentic expression of revivalist religion. In canvases like *Swing Low Sweet Chariot* (see Plate 12), Lutz set about to re-create his personal experience of the sounds and rhythm of spirituals, while also presenting a realistic image capable of generating the appropriate emotional response one would have upon singing such hymns at a revival meeting.

Above a brilliant landscape of green valleys and crimson sky, a golden, mule-drawn chariot slowly wends its way toward three figures at the lower left. Clad in white robes signifying their sanctification, two of these figures sing spirituals while the third raises her arms in a shout of glory. Lutz's interpretation

of *Swing Low Sweet Chariot*, far from conveying the pathos of black existence or the mournful longing for death implied in the lyrics "looking over Jordan" and "coming for to carry me home," presents a lively, almost jazzy, portrayal of this song. Lutz's raucous sense of color—"extremely juicy reds, greens and blues"—transforms the painting from a dour spiritual into a canvas expressive of joy at the bright prospect of salvation.[53]

As a trained musician, Lutz also may have been familiar with contemporary studies of the origins of American Negro music that traced the beat and chant of Negro spirituals like "Swing Low Sweet Chariot" to the tradition of African folk song. Writing in the *Edinburgh Review*, A.M. Chirgwin, for example, used "Swing Low Sweet Chariot" as his model for describing how African singers would listen to their song leader intoning a well-known tale of the tribe and then respond with a repeated refrain like the recurring phrase "coming for to carry me home."[54] The rhythmic sequence of a spiritual patterned after this African model, combined with the emotional fervor generated during the course of a revival or prayer meeting, might well have suggested to Lutz the contrast between the slow cadence of a mule-drawn chariot on the one hand and the staccato punctuation of shouts and spiritual crys on the other. Well acquainted with revivals and fundamentalist religion, Lutz would have seen on the broadsides or printed cards distributed at such gatherings the lyrics to "The Gospel Car," illustrated with pictures of tiny locomotives or chariots similar to the one in his painting. The great popularity of "Swing Low Sweet Chariot"—it was the song asked for most frequently by white audiences attending black religious services or musical programs—makes Lutz's use of it to amalgamate these themes a natural choice.[55]

Black artist William H. Johnson also relied upon similar analogies to create his *Swing Low Sweet Chariot* (Plate 13), *Ezekiel Saw the Wheel* (Fig. 5.9), and *Lamentations* (Fig. 5.10)—all of which demonstrate his sense of racial pride. The offspring of a locally prominent white man and a poor black woman with some Sioux ancestry, Johnson experienced the anti-miscegenation laws of the South as unrelentingly harsh and condemnatory towards his mixed racial background.[56] Manifesting an early interest in art, Johnson frequently looked at newspaper cartoons, often copying their images as a means of training himself to draw.[57] Memories of this experience would serve him well when, in 1939, he returned to the United States and the religious background of his South Carolina boyhood for inspiration in depicting Negro themes in a manner free from overt ties to the modern traditions of European painting. *Swing Low Sweet Chariot, Ezekiel Saw the Wheel*, and *Lamentations* share with newspaper cartoons a vocabulary of flat, solid coloring, outlined forms, and simplified pictorial shapes.

Arriving in New York in 1918, Johnson worked at odd jobs until he earned

enough money to begin his art training at the National Academy of Design, where he studied under and became close friends with Charles Hawthorne. In 1926 Johnson, largely through the efforts of Hawthorne, traveled to Europe. He settled in Paris and had an opportunity to study the works of the Impressionists, Post-Impressionists, and Fauves and came under the influence of the European Expressionists. While on a painting trip to Corsica the artist met and fell in love with Holcha Krake, a Danish weaver, and they were married in 1930.[58] Johnson returned to the United States prior to his marriage in order to visit his mother in South Carolina and to enter his work in an exhibition arranged by the Harmon Foundation, where his canvases received considerable attention from New York critics.[59] The *New York Tribune* noted Johnson's debt to Expressionism in the prize-winning *Self Portrait* he entered in the show.

Although the Harmon exhibition proved an unqualified success for him, the artist's trip to South Carolina rekindled memories of the race prejudice he knew as a boy and also re-established contacts with a black way of life centered around revival meetings and Sunday services. These memories proved the power of their attraction when in 1939 Johnson suddenly abandoned the style he had so carefully cultivated in Europe in favor of the flat, cartoonlike forms and expressive religious themes found in his paintings of Negro spirituals. His version of *Swing Low Sweet Chariot* (see Plate 13) depicts an elderly bearded black man, clad only in brightly colored trunks, stretching out his arms as if to welcome a boat-shaped chariot drawn by horses. Its heavenly glory signified by the four brilliant stars placed within the coach, this celestial vehicle is shown swooping down upon a river landscape to carry home this faithful Christian. He, in turn, "looks over Jordan" to see "a band of angels" coming to lead him to heaven. However, these black female divinities sport bright, knee-length dresses, bobby socks, and patent leather shoes in place of the flowing robes of Biblical tradition.

The artist continued his exploration of Biblical themes with *Ezekial Saw the Wheel* (Fig. 5.9), based on the title of a spiritual taken from the book of Ezekial 1:4–28. Here the prophet describes his experience of Yahweh in terms of winged seraphs pulling a fiery chariotlike form with wheels spinning in all directions at once. Interpreted as an indication of God's active and continuing presence even in his people's exile, this Biblical passage formed the basis for a spiritual that came to symbolize the knowledge that God had NOT abandoned his people. The lyrics of "Ezekial Saw the Wheel" provide a clue to the content of Johnson's painting:

> There's er wheel in de middle of de wheel,
> 'Zekiel saw de wheel;

Fig. 5.9. William H. Johnson, *Ezekiel Saw the Wheel* (1939). Gouache, pen and ink on paper mounted on cardboard, 18 x 13½ inches. National Museum of American Art, Smithsonian Institution. Gift of the Harmon Foundation.

Art and Popular Religion in Evangelical America, 1915–1940

There's er wheel in de middle of de wheel,
'Zekiel saw de wheel.

Well, de little wheel represent Jesus Christ,
'Zekiel saw de wheel;
An de big wheel represent God Himself,
'Zekiel saw de wheel.[60]

Johnson pictures Ezekial as an old, balding black man who appears astonished at this miraculous vision. Having dropped his cane and fallen to his knees, Ezekiel looks up into the sky while he raises his hands in awe. Above his head appear two wheels, or, rather, "the wheel in de middle of de wheel," shining more brilliant than the sun. The artist further indicated the brilliance of this gleaming vision in the streaks of rainbowlike lines emanating from the wheels to the earth below. The emerald throne of God, also mentioned in the Biblical passage, appears as a large greenish circle of color filling up the space behind Ezekiel's right hand and, because of its position behind that upraised hand, reinforcing the sense of the prophet's awe.

In *Lamentation* (Fig. 5.10), Johnson presents one of several versions he painted of the theme of the Pieta. But it is also possible to interpret this particular painting in the light of the tradition of such Negro spirituals as "Oh, Mary, Don't You Weep, Don't You Moan," in which the singer juxtaposes events of the New Testament, such as the lamentation of the three Marys at the foot of the cross, with a theme from salvation history presented in the Old Testament, such as the drowning of Pharoah's army in the Red Sea:

Oh, Mary, don't you weep, don't you moan
Oh, Mary, don't you weep, don't you moan
Pharoah's army got drown-ed
Oh, Mary, dont you weep. . . .[61]

Like the weeping, suffering Mary at the foot of the cross, oppressed American blacks could find relief from sufferings in the hope that God would ultimately deliver them from the trials of existence as he had done for the ancient Hebrew slaves fleeing Pharoah's army. The close identification of blacks with the experience of slavery made such an analogy not only logical but highly personal as well.

Johnson's turning to Negro spirituals for subject matter and the radical change in his style around 1939 resulted from the culmination of feelings and emotions that had been building up within him since the early 1930s. The painful alienation that Johnson and his wife felt upon returning to the United States in 1938, an experience marked by racial discrimination and segregation unknown

Fig. 5.10. William H. Johnson, *Lamentation* (1939). Oil on fiberboard, 29⅛ x 33¼ inches. National Museum of American Art, Smithsonian Institution. Gift of the Harmon Foundation.

to the couple while they resided in Europe, provided the necessary push for the artist to turn to American Negro spirituals familiar from his South Carolina boyhood.

While living in Europe, Johnson had occasion to visit the expatriate black American artist Henry O. Tanner, whose numerous canvases depicting Biblical themes earned great acclaim from French art critics and facilitated Tanner's election as a Chevalier of the Legion of Honor.[62] Tanner's father held a prominent place as a bishop within the African Methodist Episcopal Church, and Tanner developed Biblical themes familiar to him since childhood into unique canvases in which the dramatic effects of contrasting light and dark values of the late af-

ternoon or early evening hours were emphasized. Although Johnson did not follow Tanner's style while he was in Europe, the recognition accorded Tanner as a Negro artist would have meant a great deal to Johnson, whose failure to obtain the National Academy Traveling Fellowship because of racial prejudice would have been fresh in his mind. While in France, Johnson also cultivated his Negro identity, stressing this fact to inquisitive Europeans with a curt "I am a Negro." When the circumstances of his existence in America caused Johnson to look for new themes, Tanner's acclaimed religious canvases may well have come to mind.

In 1930, after nearly three years of study in France, Johnson suddenly felt an urge to visit his mother in Florence, South Carolina. Here he spent most of his time and effort painting Negro portraits (an indication of the seriousness with which he regarded black themes) and where he endured the indignity of being arrested and jailed by the local police for painting in the streets.[63] This renewed contact with southern justice must have strengthened Johnson's determination to continue to paint in a way that not only reflected his black heritage but also conveyed his sense of racial pride.

Johnson deepened this sense of pride during a trip to North Africa in 1932, where he had occasion to visit Kairouan, the largest holy city outside Mecca, and view the Mivo Cave paintings, and where the simple life, deep faith, and peaceful existence of native craftsmen made a great impression on him. Kairouan's position as a religious center may also have caused Johnson to reflect on his own black religious heritage and the role of religion in fostering Negro identity in the United States. When Johnson and his wife returned to America in 1938, these various influences crystallized in his mind, causing the artist to abandon the artistic canons of modern European painting.

Memories of his stay among rural blacks in South Carolina also inspired Henry Botkin, a cousin of composer George Gershwin, in his quest for Negro themes to use in his paintings. Before turning to art as a full-time career, Botkin enjoyed great success as an illustrator, earning the comfortable sum of $12,000 per year in the early 1920s for drawings he contributed to *Vogue* and *Vanity Fair*.[64] Accumulating sufficient income by 1925 to retire from commercial advertising, Botkin devoted full time to painting. In his desire to gain recognition as a serious artist, Botkin left the United States and settled in Paris.[65]

There Botkin began to act as art dealer for his cousin George Gershwin and eventually persuaded the composer to take up painting and art collecting as a hobby.[66] The two men developed an extremely close friendship, resulting in Gershwin's insistence that Botkin accompany him to South Carolina during the summer of 1934 while he researched authentic black musical themes and spirituals for his "Negro Operetta" *Porgy and Bess*. The time spent on Folly Island, a primitive

sand bar ten miles down shore from Charleston that was home to a group of Gullah Negroes, inspired both the composer and the artist to do their best work. During their two-and-a-half month stay in a small cabin furnished only with an old cast-iron bed and small washbasin, and lacking in potable water or modern sanitary facilities, Botkin and Gershwin visited black revival services, attended prayer meetings and "shouts," and talked freely with the natives.[67] Dubose Heyward, author of the stage play *Porgy* accompanied them while they attended Negro religious ceremonies and recorded Gershwin's reaction:

> The Gullah Negro prides himself on what he calls "Shouting". This is a complicated rhythmic pattern beaten out by feet and hands as an accompaniment to the spirituals, and is undoubtedly of African survival. I shall never forget the night when, at a Negro meeting on a remote sea island, George started "shouting" with them. And eventually to their huge delight stole the show from their champion "shouter." I think he is probably the only white man in America who could have done that.[68]

Botkin reacted with equal enthusiasm to the Negro "shouts" he heard, combining his interest in Gershwin's musical play with personal impressions to paint *Revival Meeting* (Fig. 5.11) in 1934–35. This painting depicts a group of five blacks in a humble shanty setting. Women clasp hands and shout as they move about in a trancelike state. In the background three figures throw back their hands and faces in an intensely emotional outpouring. The scene depicted may refer to the incident described by Heyward. The process of arriving at this visual analog in paint was a similar one for both artist and composer. During the mourning scene of Act I from Gershwin's operetta, the composer musically established the impact of a murder by combining a mournful rhythmic cadence with the repetition of the word "gone:"

> *Woman:* Where is brudder Robbins?
> *All:* He's a gone, gone, gone, gone, gone, gone, gone.
> *Woman:* I seen him in the mornin' wid his work clo'es on.
> *All:* But he's a gone, gone, gone, gone, gone, gone, gone.
> *Man:* An' I seen him in the noontime straight and tall,
> But death come a-walkin' in the evenin' fall.
> *Woman:* An' death touched Robbins wid a silver knife.
> *All:* An' he's gone, gone, gone, gone, gone, gone, gone.
> *All:* An' he's gone, gone, gone, gone, gone, gone, gone.
> *Woman:* An' he's sittin' in de garden by de tree of life.
> *All:* An' he's gone, gone, gone, gone, gone, gone, gone. Robbins is gone.[69]

Gershwin borrowed the repetition of the word "gone" from a Negro mourning hymn commonly sung in the South Carolina low country and recorded in Augustine Smythe's 1931 anthology of South Carolina spirituals:

W'en I'm uh gone, gone, gone,
W'en I'm uh gone, to come no mo'
Chu'ch I know yuh gwine tuh miss me w'en I'm gone.

Youse uh gwine tuh miss me by my walk,
Youse uh gwine tuh miss me by my talk,
Chu'ch I know yuh gwine tuh miss me w'en I'm uh gone.

Youse uh gwine tuh miss duh wuk I do,
Youse uh gwine tuh miss me from my pew,
Chu'ch I know yuh gwine tuh miss me wh'en I'm uh gone. . . . [70]

The awareness of death and the sense of loss reflected in this spiritual made
it an appropriate model for Gershwin to follow in *Porgy and Bess* and for Botkin

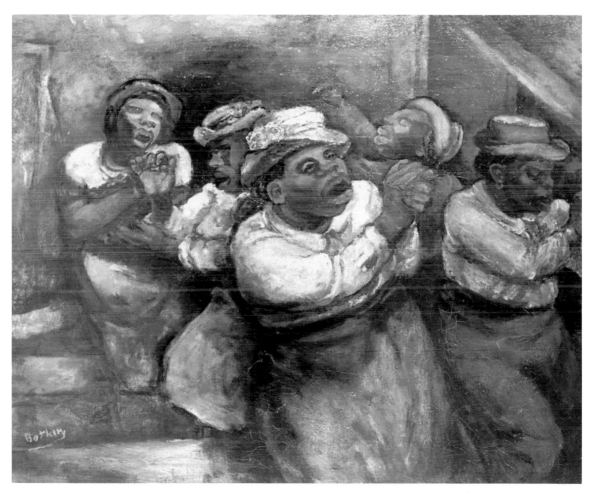

Fig. 5.11. Henry Botkin, *Revival Meeting* (1934–35). Oil on canvas, 20 x 24 inches.
Courtesy Childs Gallery, New York and Boston.

to paint in *Revival Meeting,* a canvas whose title was most probably assigned after the fact rather than at the actual time of painting.[71] Intent upon capturing the drama and pathos of Negro life in his canvas, Botkin transposed into paint effects similar to those Gershwin strove for in music, emphasizing in his bold composition the moving spectacle of the funeral scene from Act I of *Porgy and Bess.* Botkin places two large women mourners in the foreground, garbing them in bright green, pink, blue and yellow skirts and blouses. Their commanding presence and bold costumes hold our attention as they shuffle their feet, clap hands, wail and sway to the rhythm of the plaintive spiritual chorused by the figures in the background. As in Gershwin's drama, which plays on the alliterative force of the word "gone" to create rhythmic effects, so, too, in Botkin's painting the visual impact of contrasting large and small figures establishes a rhythmic beat between foreground and background that aptly conveys a sense of the driving spiritual rhythm of the Negro hymn.

Botkin exhibited his canvas along with several other studies of black life at the Marie Herriman Gallery in New York and later at the Ehrich Newhouse Gallery.[72] However, the artist received mixed reviews for his interpretation of Negro life and religion. Malcolm Vaughn of the *New York American* felt Botkin captured the spirit of life on Folly Island, and the art critic for the *New York World Telegram* called the artist an American Gauguin and Folly Island "the closest thing to Tahiti this side of the Pacific."[73] But a reviewer for the *American Magazine of Art* accused Botkin of deliberately ignoring the true conditions of southern blacks and managed to excoriate the Regionalist movement to boot.[74]

An equally equivocal effect was produced by Franklin Watkins's *Negro Spiritual* of 1932 (Fig. 5.12), which generated conflicting opinions when it was displayed at the Rehn Galleries in New York City. Picturing a Negro youth with his head thrown back in song, Watkins purposefully distorted the figure by elongating the arms, broadening the neck and expanding the proportions of the thighs and hips. Cognoscenti of the art world praised Watkins's ability to employ cubistic distortions and still present a cogent image.[75] However, when *Negro Spiritual* premiered in 1934, public reaction proved anything but favorable. The *New York Post* wondered about the "impression of meaningless distortion and lack of design," while *Trend* magazine questioned the artist's ability to draw in a consistent manner.[76] The *New York American* and the *Chicago Herald Examiner* ran reviews by Malcolm Vaughan that praised the head and shoulders of the youth yet pronounced the overall painting "injured by an experiment in the lower part of the figure . . . that is merely eccentric in effect [and] . . . serves no valuable purpose."[77] Perhaps radio station WOR, broadcasting a program called "Art Today: A Radio Review" with host E.M. Benson, came close to the mark in 1934 when the commentator announced that,

Fig. 5.12. Franklin Watkins, *Negro Spiritual* (1932). Oil on canvas, 54 x 36 inches. Maier Museum of Art, Randolph-Macon Woman's College, Lynchburg, Virginia.

The finest thing that can be said in Watkins' defense is that he is trying to develop a style of painting that is a consistent and honest development of his point of view on life. Tragedy that borders on melodrama has a special appeal for him—as it had, also for the great 16th century German painter Gruenewald, and that is distilled into his work.[78]

This notion of tragedy bordering on melodrama not only aptly describes the evolution of Watkins's style but also indicates why critical reaction to *Negro Spiritual* ran so generally against the artist in 1932–34.

Born in New York in 1894, Watkins moved to Philadelphia with his family and eventually undertook art studies at the Pennsylvania Academy of Fine Arts. Before settling in Philadelphia, however, Watkins lived in North Carolina and Virginia, where he experienced firsthand the mob violence of lynch law. He would later record his impressions of these events in a series of canvases titled *Crucifixion* in which the tormented body of Christ writhes in agony and pain symbolic of the racial hatred and painful martyrdom many blacks endured at the hands of vigilante justice.[79] Service in a Navy camouflage unit during World War I gave the aspiring artist contact with the business of modern warfare and prompted him to turn for inspiration to the work of Goya, Grüenewald, and the European Expressionists when he later journeyed to Europe on a traveling fellowship after the war. Grüenewald's *Crying Angel,* with its head thrown back in a cry of torment and the emphasis placed upon the thick, fleshy mass of the neck, closely parallels the pose and form of the head Watkins depicted in *Negro Spiritual.* Watkins also earned his living by painting "deaders," that is, portraits of the deceased taken from old photographs.[80] The confluence of these various influences explains Watkins's deliberate choice to depict anatomical distortions in *Negro Spiritual* in order to convey the anguish and pathos of a black hymn singer. Watkins described his own attitude leading up to the painting of *Negro Spiritual* as becoming increasingly pessimistic: "I went through a rather morose period of spiking myself up by getting gloomy. Race and religious questions and 'what a mess things are in and getting worse' were fruitful trains of thought."[81] The exact occasion prompting the painting of *Negro Spiritual* was a black choir concert where Watkins heard the sorrow song *Dis Ain't de Preacher but It's Me, O Lord.*[82] This spiritual relating the desperate plea of a downcast Negro begging the Lord to listen to his humble words suited Watkins's gloomy mood of 1932.

One year earlier, the artist's thoughts had turned to suicide, producing his shocking Carnegie International prizewinner *Suicide in Costume.* Critics either reacted with outrage that such a theme could be deemed acceptable to win first prize at the Carnegie exhibition or else praised its expressive qualities, but many

also wondered what the picture ultimately signified.[83] It was this sense of ambiguity, the critics' inability to figure out precisely what the artist intended, that caused so much consternation and which ricocheted against *Negro Spiritual* the following year. Although the painting depicted a youthful black man in clearly representational terms, critics, perhaps obsessed with attempting to interpret Watkins's lugubrious moods, ignored the narrative content and focused instead on what they regarded as "eccentric effects" and "meaningless distortions."

Moderate use of figural distortion to convey emotion could be found acceptable in the work of less morose artists than Watkins. Alabaman Charles Shannon's 1936 painting of the spiritual "Lonesome Road" (Fig. 5.13), for example, completed only four years after Watkins's canvas, raised hardly an eyebrow despite its obvious similarity to and probable derivation from Watkins's *Negro Spiritual*. Like his counterpart in Watkins's painting, the figure in *Lonesome Road* shares the standing posture, thrown-back head, and elongated left arm with outstretched, curved fingers. Whereas Watkins positioned the right arm of his gospel singer in a flexed posture, arm curving downward toward the waist, Shannon slightly altered the position of that arm by raising it upward at the elbow. Shannon also modified Watkins's composition by eliminating the voluminous distortion of the waist and thighs of the figure, replacing it with an overall elongation and attentuation of the legs, arms, and torso. Shannon, who was enrolled at the Cleveland School of Art from 1932 to 1934, would certainly have had the opportunity to view Watkins's *Negro Spiritual* when it premiered in 1934 at the Carnegie Institute in Pittsburgh.[84]

But while Shannon used *Negro Spiritual* as a model for *Lonesome Road*, his personal exposure to black religious life served as the proximate occasion from which to develop his own version of this theme. During the summer of 1935 he returned south and rented an acre of land in the village of Circe, Alabama. With the help of three black tenant farmers, he built a one-room cabin and shared in their labor and religious services.[85] Shannon greatly enjoyed this experience and continued to visit black churches in subsequent years to collect material for painting.[86] Inspired by the piety of the black folk he lived with that summer, Shannon returned to Cleveland to develop his ideas into paintings.

As indicated by its title, *Lonesome Road* depicts a theme closely related to the spiritual "Lonesome Valley." The lyrics express the idea that the Christian soul walks a solitary path in life and ultimately must face death and judgment alone. But while critics found Watkins's distortions of form unacceptable, they reacted favorably to Shannon's painting, comparing his work to that of El Greco and praising the artist's familiarity with his subject, born of a close intimacy with and affection for it.[87] Abstraction or distortion was not the sole issue. The real issue lay in the ability of the critics (and by implication the public) to com-

prehend what the artist meant to suggest in his canvases. Watkins's openly morbid moods and much-publicized success-by-scandal with *Suicide in Costume* in the 1931 Carnegie International helps explain the critics' reaction to *Negro Spiritual* in 1932. They attempted to grapple with the themes of death and suicide posed by Watkins by intimating that *Negro Spiritual* somehow lacked good drawing or suffered from unwarranted experiments in form. Ironically, Shannon, who also explored the anguish of existence in *Lonesome Road*, enjoyed widespread approval for his interpretation, partly because his paintings were perceived as expressions of affection rather than the product of a morose and troubled mind.

The Negro spiritual was not the only musical-religious source of inspiration available to painters. Artists also selected from among white Protestant hymns those songs in which the lyrics called to mind familiar images of pious, small-town America or the religious habits of childhood. For example, in *Sweet Hour of Prayer* of 1940 (Fig. 5.14) and *Choir Practice* of 1935 (Fig. 5.18), Paul Sample and Lauren Ford examined American religious life, utilizing the hymn tradition of white Protestant America.

Born in Louisville, Kentucky, in 1896, Sample spent his first fifteen years following his civil engineer father from job to job. The family finally managed to settle in Glencoe, Illinois, where Sample was graduated from high school before he moved once more — this time to Hanover, New Hampshire, where he was graduated from Dartmouth College in 1921. Soon after graduation he contracted tuberculosis and spent the next four years at a sanitarium at Saranac Lake, New York, an experience that ultimately led to his decision to pursue a career in art.[88] To pass the long, boring hours of his convalescence, he began to draw, taking informal lessons with Jonas Lie, whose wife also had been admitted as a patient to the same sanitarium.[89] When Sample moved to southern California in the mid 1920s, he secured a part-time teaching position at the University of Southern California, eventually rising to chair of the department of fine arts in the mid 1930s. While there he came into contact with Barse Miller and the two became close friends. Throughout the thirties, Sample participated in a number of major art shows, winning several awards, held a successful one-man exhibition at the Ferargil Gallery in New York in 1934, and four years later received the appointment of artist-in-residence at his old alma mater, Dartmouth.[90]

In 1940 Sample painted his large watercolor titled *Sweet Hour of Prayer* (Fig. 5.14), based on a theme adapted from a popular hymn of that title:

Sweet hour of Prayer! Sweet hour of Prayer!
That calls me from a world of care.
And bids me at my Father's throne
Make all my wants and wishes known;

Fig. 5.13. Charles Shannon, *Lonesome Road*
(1936). Oil on canvas, 56 x 25 inches.
Courtesy Charles Shannon.

Fig. 5.14. Paul Sample, *Sweet Hour of Prayer* (1940). Watercolor. Present location unknown. From: "Paul Sample." *American Artist* 6 (April 1942): 17.

In seasons of distress and grief,
My soul has often found relief,
And oft escaped the tempter's snare
By thy return, sweet hour of prayer. . . .[91]

Seated alone before an old-fashioned foot pump organ, an elderly woman concentrates on playing the above-mentioned hymn. Her quaint domesticity and frugal existence appear in the crocheted piano stool cover, hand-tied rugs, and large wood-burning stove — furnishings that reinforce by their hand-crafted, antique look the image of a bygone America. Sample expands this notion of the American past in the elderly woman's outmoded hairdo, which recalls the piled-up hair styles of the Victorian era and visually reinforces the relationship between her and the late nineteenth-century organ she plays. Her childlike faith and the firm confidence with which she vocalizes all her "wants and wishes" link this watercolor with an earlier Sample work, *Church Supper* of 1933 (Fig. 5.15). In

Church Supper the Victorian era is suggested not only by the prominent Carpenter's Gothic chapel forming a background for the scene but also by the conservative, lace collar dresses, cameo brooches, and bun hairdos of the church women waiting upon the men at a social. Some of their husbands are decidedly less interested in the tasty dishes heaped before them than in the tantalizing spectacle of an up-to-date beauty just returned from the big city in her revealing outfit. Her wanton display of femininity and modernity clashes with the homespun, prim and proper attire of these matronly Vermonters. Indeed, the solitary, gray-haired matron, softly pedaling "Sweet Hour of Prayer" upon the organ, could well represent one of these older, more conservative women now living alone with nothing but her memories of a young womanhood spent at church socials and choir.

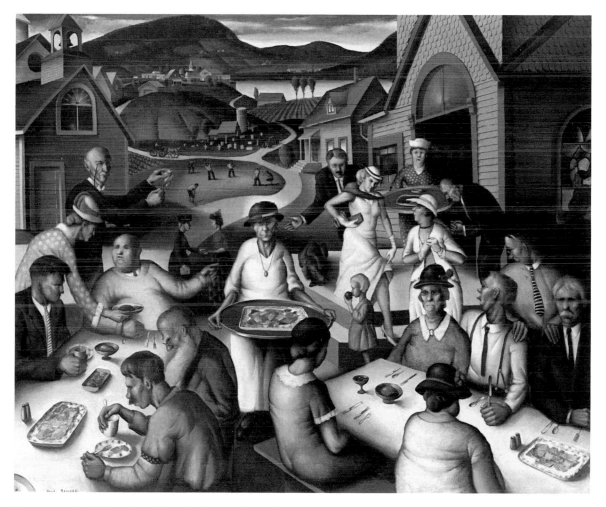

Fig. 5.15. Paul Sample, *Church Supper* (1933). Oil on canvas, 40 x 48 inches. Museum of Fine Arts, Springfield, Massachusetts. The James Philip Gray Collection.

Whether or not Sample intended to suggest such a link between these two paintings, it remains a fact that upon his marriage in 1929, the religious mores and customs of small-town New England—concretized in the stern habits of his mother-in-law—formed an important influence on Sample's work. The artist's wife, Sylvia Ann Howland, descended from a clan of pious Vermonters, and the Samples took annual summer excursions to Vermont to visit Howland's mother until they eventually settled in New Hampshire in 1938.[92] Howland's mother knew the Bible by heart and would often recite entire passages of Scripture from memory, a carryover from the days of her own upbringing, when children often learned to read by memorizing passages from the Bible and when Biblical tales formed the basis of the Sunday School curriculum.[93] While in Vermont the artist occasionally attended church services and freely socialized with his acquaintances from Willoughby Lake, one of whom played the organ in the local church.[94] Sample's reminiscence of his Bible-quoting mother-in-law and of the organist at the Willoughby Lake church furnished the raw material for such paintings as *Church Supper* and *Sweet Hour of Prayer*.

Sample linked his personal experience of these people with two additional paintings done in 1938–39, *Lamentations V:18* (Fig. 5.16) and *Matthew VI:19* (Fig. 5.17). All four works form a unified whole as to theme—the persistence of the American past through the popular piety of people like those the artist knew personally. *Lamentations V:18* presents a genre study of rural New Englanders outfitted for a hunting expedition walking with their hounds through rolling, snow-covered hills in search of prey. The bird's-eye perspective and the diminutive size of the figures in relation to the pristine winter landscape recall *Hunters in the Snow* by Pieter Breughel, an artist Sample greatly admired and one who also excelled at depicting scenes of daily life.[95] Sample's title for this painting refers to a verse in the Old Testament's Book of Lamentations: "Because of the mountain of Zion, which is desolate, the foxes walk upon it." An ambiguous and foreboding line, part of a series of poems written after the destruction of the Jerusalem temple and the Jewish exile to Babylon in 587 B.C., this scriptural passage would seem to indicate a sense of suffering or mourning over the lost glory of Israel.[96] Yet Sample used it to describe a popular winter sports activity. If the viewer knows the verse, the odd disparity between title and image has a jarring effect, forcing one to focus upon the content of the work in an attempt to ascertain the appropriateness of the title for the picture.

The confusion created by the lack of correlation between title and image is not wholly unlike the momentary confusion created in the Sample family when the artist's mother-in-law would recite aloud odd scriptural verses at illogical and unexpected moments. A frequent occurrence in the Sample household his

Fig. 5.16. Paul Sample, *Lamentations V:18* (1938). Oil on canvas, 30 x 36 inches. Addison Gallery of American Art, Phillips Academy, Andover, Massachusetts.

mother-in-law's odd habit may have served as the artist's inspiration when he chose on several occasions to give his paintings inappropriate scriptural titles.

Sample used another scriptural title for *Matthew VI:19* (Fig. 5.17), painted in 1939. This work depicts a country estate auction with people bundled up against the outdoor chill as they pore over antique sofas, dressers, paintings, porcelain, and autos in search of bargains and treasures. The actual Matthew 6:19 includes Christ's famous warning, "lay not up for yourselves treasures upon earth, where moth and rust doth corrupt, and where thieves break through and steal." However, the artist deliberately excluded from the title to his painting the concluding verse of this admonition, which is found in Matthew 6:20: "but lay up for yourselves

Fig. 5.17. Paul Sample, *Matthew VI:19* (1938–39). Oil on canvas, 30 x 36 inches. Lowe Art Museum, University of Miami. Gift of Mrs. Myron Hokin.

treasures in heaven . . . for where your treasure is, there will your heart be also." The omission of verse 20, crucial for a correct interpretation of Matthew's famous saying, again raises questions as to the intended meaning of Sample's painting. The viewer is thus forced to confront the content of the painting as providing the only evidence available as to Sample's meaning.

Sample included in the background to his painting a vision of an old woman (like the one pictured in *Sweet Hour of Prayer*) who presumably has died. Her figure, which appears above the church cemetery visible in the background, is clothed in an old-fashioned nightgown and her head is framed by carefully combed-back tresses of gray hair. Her faithful dog accompanies his mistress to her heavenly reward. An ancient symbol of fidelity, this companion seems to

Fig. 5.18. Lauren Ford, *Choir Practice* (1935). Oil on panel, 13¾ x 18⅛ inches. In the Collection of the Corcoran Gallery of Art. Museum Purchase, Anna E. Clark Fund.

indicate that the deceased not only acquainted herself with the words of Scripture found in Matthew, but also followed its injunctions. Yet the amount of material goods up for auction casts doubt upon whether, in fact, she truly honored this command.

Artist Lauren Ford also looked to a bygone age — the years of childhood — in order to express in *Choir Practice* of 1934 (Fig. 5.18), an image of childlike devotion familiar from her Catholic upbringing. Described as "a neat mixture of Peter Pan and Wendy" by the *Survey Graphic*, Ford spent most of her girlhood in New York City.[97] Her mother sponsored an organization for the encouragement of children's literature and herself authored several books and plays for children.[98] Although Ford studied at the New York Art Students League and held her first exhibition in 1928, most of her adult life prior to that time was

spent as a lay member of a religious community in France, where she familiarized herself with Gregorian Chant and carefully studied illuminated manuscripts.[99] These influences from her convent days are felt continually in Ford's later work and are apparent in an illustrated book she published in 1934 titled *The Little Book about God.* In this volume Ford illustrated such scenes as Adam and Eve, Noah and the Flood, and the Annunciation, interspersing these Biblical tales with children's stories presented in bright colors reminiscent of medieval manuscripts.

Ford also painted canvases such as *Resurrection at Monguyon,* in which the dead from every age are shown rising up from their graves in an old French churchyard, and *Vision of the Innocents,* depicting the legend of the appearance of the Virgin to a group of French children of Point Main in Brittany during the Franco-Prussian War of 1871. Upon her return to America and subsequent marriage, Ford continued to paint a variety of naive religious scenes, childhood reminiscences, and the scenery familiar to her from farm life in Bethlehem, Connecticut.

Choir Practice (Fig. 5.18) presents a scene illustrating this curious blending of the Victorian past with the world of childhood. The title lends the work a religious tone, while the wooden panel surface on which it is painted creates an archaic effect reminiscent of American folk painting or of the medieval panel pictures familiar to Ford. Within a cottage interior, its rustic, old-fashioned quality suggested by the rough plaster walls, wide board floors, and unfinished ceiling, a woman wearing a long white robe is seated behind a portable parlor organ. The domesticity of the scene is suggested through the large stuffed chairs and heavy wooden armoire as well as by the needlepoint embroidery on the wall. A group of children have clustered about the woman to practice a hymn. The short pants worn by the boys and the bare feet and lightweight print dresses of the girls suggest that they have just come in from playing outdoors in fine, warm weather. When, in 1935, Ford showed this picture at the annual exhibition of contemporary oil painting held at the Corcoran Gallery of Art in Washington, D.C., the exhibition committee purchased the panel for the gallery's permanent collection, noting the artist "achieved the indoor atmosphere of an American home."[100]

The appeal of Ford's painting, which portrayed a number of children and managed to convey an ambiance deemed authentic to American domestic life, recalls the notion that America's lost childhood could be found on the frontier.[101] Van Wyck Brooks lamented the fact that as a result of the Puritan influence on America "we have no myths, there is nothing childlike in our past, and when we look to our ancestors to help us we find them almost as grown up and self-conscious as ourselves"; and H.L. Mencken bewailed the lost "naif joie de vivre" and "moral innocence" of the Elizabethan Age when measured against the Puritan

reaction in America.[102] In response, Americans increasingly focused attention on that supposed repository of virtues, the frontier childhood. They pointed with pride and satisfaction to the growth of the Boy Scouts of America and the Campfire Girls. And by the 1930s Constance Rourke found the gumption to challenge Van Wyck Brooks's assertion, declaring that the Puritan attempts to suppress fantasy and childhood merrymaking had been foiled by the earthy frontiersman and his family: "Far from having no childhood, the American nation was having a prolonged childhood."[103]

The notion of America's prolonged childhood surely appealed to Ford, whose own grandparents had settled in Indiana and only later moved back east to Connecticut. Moreover, Ford's early attempts at illustrating children's books and her later successful efforts in this field, her constant use of children as figures in her work, the use she made of Victorian-style furnishings or fixtures in her pictures (as in *Choir Practice*) suggest her familiarity with the frontier world of her grandparents and the world of children.

The growing interest in America's prolonged childhood on the part of historians, scholars, or artists like Ford takes on particular appropriateness in light of the debates waged during the 1920s and the early 1930s as to revised school curricula offered children and the role expected of educators. *Education for the Needs of Life*, a standard text on the subject published by the Macmillan Company in 1927, stated that the learning of children needed more definite, continuous, and intentional guidance and noted that the primary function of the teacher was one of providing guidance to her young charges.[104] Ford underlines the importance of such concepts in *Choir Practice* in the robes she assigned the choir director. Clothed in a flowing white garment, like the guardian angel in a popular Currier and Ives lithograph, she gently gathers the children about her, as does the Currier and Ives angel, and guides them in a hymn. Out of the depths of 1934 Depression America, Ford artfully created in *Choir Practice* a childhood myth, blending elements from the American past, memories of her grandparents' Indiana frontier adventures, her personal interest in the world of children, and her strong Catholic faith.

From the late 1920s well into the 1940s, artists found inspiration in Negro spirituals and occasionally in white Protestant hymns. The varied reception these paintings received from the public, critics, and black Americans themselves reflected the growing ambivalence of blacks toward their own musical heritage in light of changing social consciousness and growing racial pride. Some artists demonstrated their sensitivity to blacks' current status, as well as to past social injustices, and attempted to incorporate these concerns into their canvases. Recep-

tion of these works often depended on the point of view of the audience, and ultimately meant that such themes would become less acceptable as the changing racial climate grew more militant and less tolerant of artists' attempts to use black spiritual themes in their work. Paintings with themes borrowed from popular hymns of white Protestant America also continued to be used throughout the 1930s and 1940s, but often for the sake of the more pleasant, if somewhat inaccurate, images of a bygone America they evoked.

Chapter Six

Shall We Gather at the River?

Gospel hymns and spirituals were but one way for churches to generate an emotional response among believers while cultivating a spirit of church fellowship. Most Protestant denominations also continued another such energizing and unifying device – the practice of baptism. Among Baptists, this ritual came to be viewed as a commemorative act performed by the already converted in obedience to the clear command of Christ contained in the Bible. As such, baptism developed into an adult rite, consisting of total immersion of a person's body in a pool of water in imitation of Jesus' baptism in the Jordan River.

The importance of this development for revivalism in America, and for American artists, rested upon the fact that Baptists constituted one of the premiere missionary churches, evangelizing rural American settlements and frontier hamlets. By the 1920s, the fruit of these labors provided American Baptists with the largest church membership of any Protestant denomination.[1] Their highly visible numbers meant that for many Protestants living in isolated rural districts total immersion constituted the only known method of Baptism. Performed al fresco in a standing body of water, an essentially religious rite became a social and public spectacle as well, particularly after protracted revival meetings, when large crowds witnessed the event. In the hands of Holiness and Pentecostal sects and independent black churches, emotional displays associated with the outpouring of the Holy Spirit during the ritual heightened the drama and increased the appeal for spectators.

So popular did the act become that artists interested in recording and commenting on it would have had ready access to this colorful and interesting subject matter. In an effort to propagandize the distinct theological opinions of Baptists concerning immersion, Rev. E.T. Sanford of the Northern Baptist Convention played upon patriotic and pious sympathies by commissioning *The Baptism of*

George Washington. This painting received considerable attention in 1926, during the nation's Sesquicentennial celebration, and again in 1932, when Americans commemorated the 200th anniversary of Washington's birth. Traveling through the Appalachians, Thomas Hart Benton recorded his impressions of a creek baptism in a sketch book and later in *An Artist in America.* Such impressions formed the basis for the Ozark baptism scene the artist included in his Missouri Capitol murals of 1936. Regionalist John Steuart Curry also found immersion baptisms noteworthy. Curry's painting *Baptism in Kansas* catapulted him to national attention in 1928 and signaled the beginning of a series of works he painted based upon reminiscences of his Kansas boyhood. When Curry turned to lithography, he continued to explore the theme in *Baptism in Big Stranger Creek.* Southerner John Kelly Fitzpatrick and New Englander Howard Cook focused their attention on southern Negro baptisms. During his sojourn through rural Alabama, Cook managed to portray the secret rites associated with a black footwashing ceremony engaged in by members of a "primitive" Baptist church. Conrad Albrizio recorded an Alabama baptism, stressing the emotional aspects of the event by means of his architectural and abstract drawing style.

In 1908, Rev. E.T. Sanford, Baptist pastor of North Church in New York City, commissioned an artist (whose name went unrecorded) to paint a portrait of George Washington receiving baptism at the hands of preacher John Gano in the Potomac River (Fig. 6.1). Sanford undoubtedly intended the work to commemorate a renowned Baptist minister's role in the American Revolution, as well as to impress upon his congregation the heritage they shared with the Father of their Country in professing a belief in immersion baptism. Rev. Sanford soon had the painting transferred to the Baptist church at Asbury Park, New Jersey, where it remained until 1926.[2] In that year, the great-granddaughter of John Gano presented the painting to William Jewell College in Liberty, Missouri, during the dedication ceremony for the John Gano Memorial Chapel, an event that served as both the college's and the Baptists' contribution to the U.S. sesquicentennial celebration observed during 1926.[3] The painting next came to public attention when *Time* reproduced the canvas in its September 5, 1932, issue.

The artist depicted Washington and Gano waist-deep in the Potomac. Washington's pose and facial characteristics, particularly the bulbous nose, thin lips, and arrangement of the hair, closely parallel these same features in Gilbert Stuart's *Athenaeum Portrait,* but as they appear reproduced in reverse on the face of a dollar bill. What appear as shaded lines above Washington's recessed eyes on the dollar bill are here rendered as thick, bushy eyebrows. The anonymous painter placed the figures of Washington and Gano waist-deep in water, as required by the immersion ceremony. Yet this device conveniently eliminated the

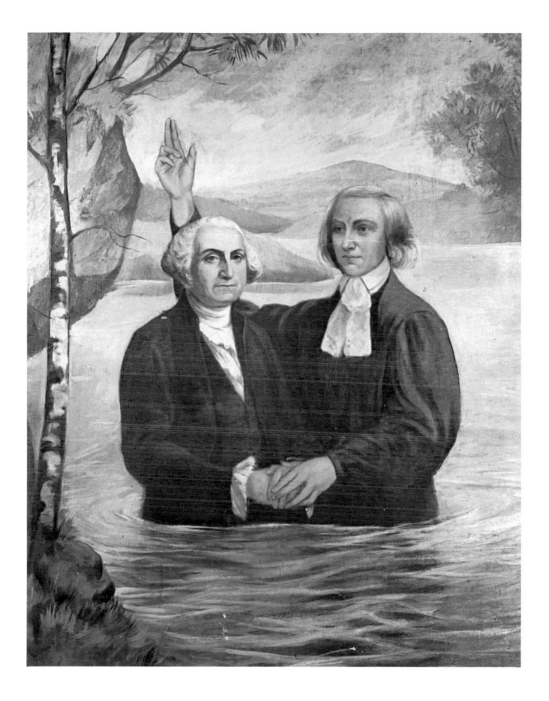

Fig. 6.1. Anonymous, *Baptism of George Washington* (1908). Oil on canvas.
William Jewell College, Gano Chapel.

need to paint Washington's lower body, which does not appear in Gilbert Stuart's portrait or the dollar bill. The Pater Patriae retains the calm, self-possessed look borrowed from Stuart's portrait because the artist carefully chose not to show the actual baptism but the moment when Gano imparts a benediction prior to the act of immersion. For his model of Gano the artist borrowed an engraving of the preacher that appeared in the 1883 edition of the *Baptist Encyclopedia.* That engraving displays all the characteristic facial features found on the Gano face in *The Baptism of George Washington:* pronounced chin, pursed lips, long, slightly aquiline nose, and arched brows with heavy lids. However, the artist elected to change the wig, giving Gano a more curly mane. The eclectic borrowings for the figures in this painting indicate that the anonymous artist may also have resorted to familiar Bible engravings as a source for the motif of Gano's right hand raised in benediction behind Washington's head.

Although the product of an unskilled hand, this canvas's unique subject matter, together with its transference to William Jewell College in 1926 and its reproduction in *Time* in 1932, indicate that many Americans continued to view *The Baptism of George Washington* as historically and religiously significant nearly twenty-five years after it was commissioned. This renewed interest in Washington's immersion not only served the narrower sectarian interests of denominational pride but afforded a powerful visual tool to Baptist conservatives in their efforts to retain immersion, a practice that came under increasing fire from liberals. By emphasizing the Gano Memorial Chapel dedication ceremony as their contribution to the nation's sesquicentennial, conservative Baptists could reassert their links to historic Baptist practice while couching that assertion under the guise of patriotic pride.

In 1926, delegates to the annual Northern Baptist Convention, held that year in Washington, D.C., arrived with sharp differences of opinion as to the necessity of accepting a formal creed and the wisdom of requiring all new members to undergo immersion.[4] Anathema to freethinking Baptists, the notion of adopting a formal creedal statement seemed necessary to the fundamentalist wing of the convention to counter the growing influence of theological liberals, headquartered at the Baptist-founded University of Chicago Divinity School. Conservative Baptists likewise deplored the tendency of liberal churches to admit congregants from other Protestant bodies into full communion without first ascertaining their mode of baptism.[5] Previously, at the 1925 convention held in Seattle, clergy delegate R.V. Meigs of Illinois succeeded in having the convention adopt his proposal, which eliminated a formal creedal statement in favor of a general reference to the New Testament as the basis for Baptist belief. That same convention adopted into its by-laws a definition of a Baptist church as "one ac-

cepting the New Testament as its guide and composed only of baptized believers, baptism being by immersion."[6]

This statement set the stage for the 1926 debate over baptism, a debate that became increasingly strident in light of the growing defiance of Baptist churches to adhere to an immersion-only policy. On March 23, 1925, the Park Avenue Baptist Church of New York City publicly announced that as of October 1926 it would abandon baptism by immersion as a requisite for membership, and sent a circular letter to all other ministers within the Northern Baptist Convention indicating its intended action.[7] This public action had been advocated by the church's retiring pastor, Rev. Cornelius Woelfkin, a longtime supporter of "associate membership" status for non-immersed Christians who chose to affiliate with his congregation. Further, the new pastor, Dr. Harry Emerson Fosdick, a leading modernist theologian and writer, openly disclaimed immersion as the only valid form of baptism.[8] This action of the Park Avenue Church prompted a sharp rebuttal from conservative New York Baptist John Roach Straton. Straton's Sunday sermon of May 18th, "Shall New York Baptists Haul Down the Flag through the Leadership of Unbelief, Worldliness and Subserviency to Great Wealth," attacked Fosdick and the Park Avenue Church and gained public notice when reported in the *New York Times*.[9]

According to the *Times*, Straton accused Fosdick of being corrupted by "the influence of great wealth," which Baptist layman John D. Rockefeller, Jr., threatened to withhold from the church unless the denomination ceased to concern itself with petty, internecine politics and devoted its energies to further social programs beneficial to all mankind.[10] In Straton's view, this led to open rejection of baptism by immersion and nothing short of turning away from "the great truths and principles" for which Baptists historically stood as a people.[11] Straton brought the matter before the New York Baptist Minister's Council on May 18, 1925, in the form of a written resolution that reaffirmed Baptist belief in full immersion. The Council refused, however, to adopt Straton's proposal.

Against this background, the dedication of the John Gano Chapel provided an opportunity, difficult for the conservative immersionist-only faction to ignore, to propagandize for their cause. Using the official bulletin of William Jewell College, L.C. Barnes linked the 150th anniversary of American independence with the memory of John Gano, "the fighting chaplain of the Revolutionary War," and a close friend of Washington.[12] According to Barnes, the importance of Gano's friendship with Washington lay precisely in the fact that the Commander-in-Chief insisted on immersion in accordance with Baptist practice once he "became personally convinced that he had never personally obeyed one of the explicit teachings of Christ taught both by word and example."[13] Assured

of the correctness of the Baptist position, Washington obeyed "with soldierly precision."[14] Not wishing to call public attention to this affair, and "too wise a man to make public in any way a purely private religious matter," Washington declined to call out the troops as witnesses, deciding instead to have only a few fellow Masonic officers (which included Gano) present at the event.[15] Their Masonic oaths of secrecy guaranteed that the immersion would forever remain a private affair. Years later, digging through affidavits from Gano's descendants, and amassing a web of circumstantial evidence linking Gano and the Baptists to important moments in Washington's life, Barnes recreated a scenario that stressed the plausibility of Washington's baptism in the Potomac at Gano's hand.

The moralistic conclusion of Barnes's story and the patriotic sentiments kindled by the nation's 150th birthday celebration combined to create a message with obvious implications for liberal Baptist opponents of an exclusive, immersionist position.[16] The message was clear: "intense, personal religion," as practiced by Washington and Gano, involved a firm resolve and commitment to submit to immersion as the only scripturally endorsed form of Christian initiation. A majority of the delegates at the 1926 Northern Baptist Convention thought so too, for they adopted the following resolution by a substantial margin:

> The Northern Baptist Convention recognizes its constituency as consisting solely of those Baptist churches in which the immersion of believers is recognized and practiced as the only Scriptural baptism; and the convention hereby declares that only immersed members will be recognized as delegates to the convention.[17]

This action did little to quell Baptist squabbling. Throughout the late 1920s, and well into the 1930s, Baptists continued to dispute the necessity of immersion. Writing in the *Christian Century*, for example, Charles T. Holman raised the issue in such a way that the real problem with the immersionist-only position became inescapable. Asking the question "Are Baptist Churches Christian Churches?" Holman challenged immersion on the grounds that it violated Christian fellowship and common witness to Christ.[18]

In reply, Baptist layman James Alexander Thomas responded in a letter to the editor of *Christian Century*. Thomas claimed that the twenty-first and twenty-second verses of the first chapter of *Acts* proved that to become a witness for Christ it was necessary for the Apostles to have known Jesus "beginning with the baptism of John unto the day he was received up."[19] Following Thomas's interpretation of Scripture, it appeared certain "that every one of the apostles were Baptist and immersed every convert into the Christian assembly."[20] Other Baptists weren't as convinced of this revelation as Thomas. By the mid 1930s, even conservative Baptist churches could no longer avoid the thorny issue raised by

Holman. The most dramatic example of this change in attitude came in 1936 when Temple Baptist Church of Philadelphia, "a conservative congregation," dropped the immersion requirement for new members. In its stead, Temple Baptist agreed to honor church letters from non-immersionist denominations as valid criteria for membership, and even called a non-immersed minister, Rev. Poling of the Dutch Reformed Church, as its new pastor.[21]

The continuing dispute over immersion baptism helps explain why, six years after the 1926 Northern Baptist Convention resolution, *Time* found the legend of Washington's dunking in the Potomac sufficiently newsworthy to mention the fact during the 1932 celebrations honoring Washington's birth. In so doing, *Time* pandered to the public's insatiable curiosity for details surrounding the first president's personal life, a curiosity fed by the various bicentennial events and activities. According to *Time*, other newsworthy items discovered about Washington included the facts that he did not smoke, that he ordered his wife's dresses, was a shrewd landowner who left an estate of one million dollars, and that he falsely claimed to have written a poem titled "On Christmas Day."[22] Given this diverse information, *Time's* religious editors felt it only appropriate that the "facts" surrounding Washington's baptism be presented to their readers, and they backed up this account by including a reproduction of *The Baptism of George Washington* (Fig. 6.1).[23]

While Baptists of Liberty, Missouri, and their co-religionists elsewhere in the nation gloried in the fact that the John Gano Memorial Chapel had become the permanent home for *The Baptism of George Washington*, Thomas Hart Benton was attending creek baptisms and revivals as he explored the Ozarks and Appalachians gathering material. The ideas Benton received from these excursions resulted in a sketch titled *Baptism* (Fig. 6.2), drawn on a trip through the Appalachians between 1925 and 1929, and a painted scene of an Ozark creek baptism executed in 1936 for the *Social History of the State of Missouri*. Benton exhibited *Baptism* as part of the series of drawings that were included in the "Holy Roller Camp Meeting" segment of his work shown at the Delphic Studios in New York City.[24]

According to Benton, almost as soon as he could walk, his father, a U.S. congressman from Missouri, took him along on Ozark backwoods electioneering trips, during which the two often attended camp meetings as part of the elder Benton's vote-getting strategy. Although specific locales remained hazy, Benton recalled the frontier atmosphere of these trips in his 1937 autobiography.

The memory of the "pioneer flavor" of those meetings provided an important motivation for the artist when, following his father's death in 1924, he began searching in earnest for authentic American themes. In *Ozark Baptizings*,

Hangings and Other Diversions, Theatrical Folkways of Rural Missouri, 1885–1910, Robert K. Gilmore recorded the religious atmosphere of that southern Missouri world of the 1890s. Gilmore notes that among their ministers preaching developed into a fine art, with public debates on religious issues well attended by vast throngs. A frequent topic debated between ministers of various denominations concerned the necessity of water baptism for salvation. That subject proved "very popular" in the Ozark towns of Gainesville, Northfield, Washburn, and at a marathon ten-day debate in Greene County between a Campbellite minister and his Methodist counterpart.[25] When not debating the issue, Missouri Ozark folk congregated in large festive gatherings to watch baptisms take place. The custom of attending immersions grew so popular that southern Missourians developed a special vocabulary, derisively referring to winter converts who waited until summer to undergo their salvational plunge as "warm-weather Baptists."[26]

Given the prevalence of baptismal debates and rites among rural Missouri folk during the very period when the young Benton stumped through the Ozarks with his politician father, the probability that Benton witnessed such events seems high indeed. Later in his life, when the artist worked as a surveyor and cartoonist in Joplin, that area teemed with the Pentecostal antics of Charles Fox Parham and his Apostolic Faith Movement. In the fall of 1903, Parham had shifted his emphasis from speaking in tongues to faith healing, establishing headquarters in Galena, Kansas, near the Missouri-Kansas-Oklahoma border area.[27] Holding a winter-long revival meeting in a tent accommodating two thousand spectators, Parham attracted thousands of interested people from over a hundred-mile radius. The culmination of their revival resulted in the mass immersion of over 250 converts, who returned to spread the word of Parham's healing powers to Joplin as well as towns in Kansas and Oklahoma.[28] Recollections of these events from the time he spent in Joplin would have provided Benton with sufficient material for later use in *Social History of the State of Missouri.*[29]

Benton also recalled his family's arguments over religion—his Baptist mother and Methodist father were unable to agree on the way their children should be saved.[30] These arguments resulted in Benton's never being baptized, and at the time of his eightieth birthday the artist noted that a Catholic priest friend had recently attempted to persuade him to receive the sacrament.[31] If true, this story indicates that the spectacle of baptism could have generated conflicting emotions within the artist who, aware of the disagreements the subject had sparked between his parents, and nonetheless drawn toward witnessing immersion baptisms himself, never personally participated in such an event.

In *An Artist in America,* Benton described a baptismal incident he specifically remembered in which a young girl, hysterical at the sight of a water snake

swimming near her, tried to escape from being immersed, only to get tangled in the midst of the preachers conducting the ceremony. Seeing this spectacle, an old cynic among the crowd of onlookers brayed at the top of his lungs, "Thar goes the devil a-comin' out'n her," as the crowd roared with laughter.[32]

In his drawing of this scene (Fig. 6.2), Benton altered the scenario somewhat. Through the middle of a mountain valley surrounded by a fenced cornfield and lush foliage, a murky creek twists and turns. Waistdeep at its midpoint, the waters of this stream serve as the site for a country baptism. On the far bank a crowd of believers has congregated. Grouped together as a choir, baldheaded men and sunbonneted women sing an appropriate hymn as a bearded elder raises his arms in jubilation. A dripping-wet girl, clad appropriately enough in a white baptismal dress, hair streaming down her face, limply makes for the river bank. Aided by a solicitous mountain woman, the girl is oblivious to the stares of a crouching farmer, who attempts to get a good look at her face. Be-

Fig. 6.2. Thomas Hart Benton, *Baptism* (1925–29). Pen and wash, 31.0 x 23.5 cm. The Art Museum, Princeton University. Gift of Frank Jewett Mather, Jr.

hind her, in the creek, two overall-clad ministers make ready to dunk another woman as the crowd of curious onlookers stares with obvious interest. At the extreme left, a group of boys dressed like Huck Finn and Tom Sawyer, have discovered a convenient perch from which they dangle their feet into the water.

Benton's drawing is not site specific, as the mountains in the background could just as well represent the Ozarks as the Appalachians. But his decision to locate the scene in a fertile bottomland creek at the edge of a cornfield and to include several women wearing sunbonnets, links *Baptism* with memories of the self-sufficient, rustic Ozark folk Benton recalled from his youth. Moreover, the odd chain of events Benton described in *An Artist in America* resembles similar mishaps frequently reported in local Ozark newspapers of the 1880s, a fact that raises the probability that when Benton witnessed the Cumberland mountain immersion described in his autobiography, he may well have associated it with scenes from the days spent on the campaign trail with his father.[33] Such recollections provided Benton with the impetus to sketch *Baptizing* and later paint a similar event for the Missouri State Capitol (see Fig. 1.9).

In that mural, blue waters flow past an eroded bluff, while upon a hill a whitewashed country church and a pair of Missouri mules establish the rural setting. White-clad and bonneted women — neophytes awaiting their turns at immersion — kneel on the shore, while in midstream a preacher "wrestles the devil" out of a woman just prior to her immersion in the creek. Black-frocked church elders form a backdrop to this dramatic scene.

That Benton chose to pursue this theme in his Missouri Capitol mural indicates that he believed such religious expression constituted a significant element in the social history of his native state, as it had in Appalachia. In 1934, two years before beginning the Missouri mural, Benton contributed several illustrations and an article titled "America's Yesterday" to *Travel* magazine. Describing the special qualities of the Ozark region, the artist viewed its people as possessing a pioneer spirit filled with "a fundamental American psychology" born when their forefathers lived in Appalachia.[34] Noting the hold of the past on the area, Benton stressed the extent to which the pioneer religious spirit had survived, as manifested in "gross superstitions regarding everything from the imminent presence of the Deity to the effect of the moon on the corn crop," the proliferation of "little theological colleges where a most primitive fundamentalism is taught," and the taboo on dancing, an activity regarded by the seriously religious as "a trap of the devil."[35]

If Benton saw these qualities as fundamental legacies of frontier Missouri life, and if he desired to convey the spirit of this religious fervor in his public mural for the state, he needed to express such concepts in a readily recognizable form to the general public. A creek baptism would fulfill this requirement in sev-

Fig. 6.3. James Daugherty, *Baptizing at Wild Pigeon* (1934). Illustration for *Forum and Century* 91 (June 1934), 379. Reproduced with permission of *Current History.*

eral ways. It would link the world of the Missouri Ozarks with the Appalachian region and with the baptism Benton personally witnessed there; it would recall the era of his young manhood in the 1890s when baptisms served a function as public entertainment; and it would picture a ceremonial familiar to many in the 1930s, an era when immersion baptism emerged as a topic for public debate among Baptists.

In 1934, Dora Aydelotte contributed a short story, "Baptizing at Wild Pigeon," with illustrations by James Daugherty, to *Forum and Century* magazine.[36] One of Daugherty's drawings (Fig. 6.3) is similar to Benton's painted mural scene of 1936 in the positioning of the two central figures in midstream. Bent forward at the waist, arms raised at her sides, a woman holds onto a preacher for support as she awkwardly wades out into the middle of the stream. With her back toward the viewer, who occupies a place as a distant observer behind the crowd of witnesses, the woman's ungainly pose resembles that of a wrestler jockeying

for position. Like a tournament between the powers of sin and forces of good, these two figures grapple as a crowd of onlookers awaits the outcome. Benton's *Baptism* (Fig. 6.2) repeats this same basic formula, reversing the figures so that they face toward the left, while accentuating the bends and twists of their bodies. These similarities indicate that Benton's placement of the central figures in his baptism scene is modeled after Daugherty's sketch.

Daugherty's early mural style of the 1920s—flat, decorative, and derivative of the work of Maxfield Parrish—offers little indication that Benton could find any inspiration from such a source.[37] But in the background of the mural he painted for the Lowe's State Theatre in Cleveland, for example, Daugherty resorted to painting a cubist abstract sky. This juxtaposition of cubism with figural representation would greatly have interested Benton, then busily engaged in resolving just such a relationship in his own *American Historical Epic* murals. Prior to the early attempts at mural painting, both Benton and Daugherty worked in the Virginia Naval shipyards during World War I—Daugherty as a camouflage artist in Newport News and Benton as a draughtsman in Norfolk. If the two young artists met on this occasion, they would have had much in common.[38] After the war, Daugherty settled in suburban Connecticut, where in 1926 he worked with John Steuart Curry on a mural project for the sesquicentennial celebration in Philadelphia. As he worked with Curry, Daugherty's style began to change until, by 1937, *Time* magazine could refer to his mural work as "resembling that of a somewhat superficial Curry."[39] The growing friendship between these two artists probably led Curry to introduce Daugherty to Benton (if the two had not met earlier).

Daugherty achieved his greatest fame as an illustrator of children's books, winning the John Newberry Medal in 1939 for writing and illustrating *Daniel Boone*. Like Benton, Daugherty also loved to express a lusty, vigorous America in his drawings, symbolic of the physical fortitude and energy of the pioneer nation. He demonstrated that style in several illustrations for books, including Washington Irving's *Knickerbocker History of New York* and *The Bold Dragoon* and Charles J. Finger's *Courageous Companions*. Nearly fifteen years before Benton illustrated *The Oregon Trail* for Doubleday, Daugherty illustrated this same book for Farrar and Rinehart. The muscular, attenuated figures found in Benton's 1946 illustrations bear a close resemblance to the figures in Daugherty's illustrations for the 1931 Farrar and Rinehart edition, indicating that Benton would not have been adverse to looking at and learning from Daugherty's work.

Assuming that Benton knew and approved of Daugherty's illustrations, he would surely have responded favorably to the baptismal scene Daugherty created to accompany "Baptizing at Wild Pigeon." Daugherty's drawing (Fig. 6.3) pictured a turn-of-the-century creek baptism reminiscent of those Benton at-

tended in his youth. Aydelotte's short story portrayed baptism through the eyes of young Barbry Miller, still a child, yet old enough to decide for herself and undergo immersion. The tale unfolds as Grandma and Ma Miller, like Benton's parents arguing over salvation, debate the necessity of immersion, which Grandma favors, as opposed to the simple sprinkling preferred by Ma Miller. The excitement created in the household as Ma Miller makes a special trip to town to purchase white cheesecloth for Barbry's baptismal robe, the anguish of soul Barbry feels as she attempts to "reflect upon spiritchul things," the "reg'lar comp'ny dinner" prepared for the occasion, and the baptism itself convey the specialness of this event in the lives of this rural American family.

Aydelotte's story recreated the dynamic, frontier-like world Benton remembered from his Ozark boyhood travels and his days in Joplin and experienced again in his later trips to the Cumberland and Ozark mountains. Given the parallels between Benton's and Daugherty's illustrations, it is not unlikely that Benton familiarized himself with Daugherty's drawing, using it as a general model when he decided to include a baptism scene in his Missouri mural (1.9). Benton changed considerably the details of setting and costume, preferring to include a country church and a pair of Missouri mules to establish an Ozark setting for this baptism. The positioning of the baptism scene towards the background of his mural eliminated the need to include groups of spectators. The eye is led into the scene by following the perspectival recession of surrounding incidents. The female figures included on the far shore of the river wear white robes and bonnets, a feature observed in Benton's earlier *Baptizing* drawing.

Other Regionalist painters considered the subject of immersion baptism sufficiently important to develop major works on that theme. John Steuart Curry launched his career in 1928 with the successful début of *Baptism in Kansas* (see Plate 14) at the 11th Corcoran Exhibition of American Paintings in Washington, D.C., and returned to the subject four years later in a lithograph titled *Baptism in Big Stranger Creek* (Fig. 6.4).

Baptism in Kansas portrays an immersion ceremony taking place in a Kansas farmyard watering tank. Standing knee-deep in water, a young woman, garbed in a white robe with a braid of hair across her shoulder, closes her eyes as she clasps her hands to her breast in anticipation of the dunking she is about to receive at the hands of a moustachioed, black-clad minister. Off to the right, quietly standing in two files, six white-robed figures await their turn for a plunge into the waters. Gathered around the tank, congregants stand as witnesses, some holding hymn books, as they accompany the ceremony with an appropriate psalm of praise. Behind the throng, a line of Model Ts forms a mechanical backdrop. Overhead, from out of a cloud-flecked sky, bright rays of light shine forth

and two doves flutter about, like the Spirit of God descending upon the baptized Christ in the form of a dove, as seen in traditional popular depictions of Jesus' baptism. The presence of two birds in Curry's picture serves as a sign of the fervent belief of these Christians and their conviction that God has truly blessed these proceedings.

Curry invited the viewer to participate vicariously in this scene by flattening out the barn and farmhouse along the horizon line, establishing a visual boundary in front of which everything falls into the viewer's space. He further enhanced this effect by positioning a Kansas family in the lower right-hand corner of the picture. Seen from the waist up, they are placed with their backs toward the viewer. Not fully visible, their bodies must, ergo, extend into the space outside of and below the canvas. Pressed up against the picture plane, they reinforce the sensation that the viewer has joined the fringes of this crowd of onlookers. Curry drew further attention to the importance of this immersion ceremony by repeating the circular form of the water tank in the curve of the spectators and row of surrounding Model Ts. The artist emphasized the vertical axis of the two central figures by extending an imaginary line upward, through the carefully positioned windmill, and downward, through the figure of the little boy standing next to his mother in the foreground.

Publicly, Curry stressed the veracity of this scene. In a letter to Margit Varga of *Life* he wrote:

> This baptism was on the farm of our neighbor, Will McBride. It was under the auspices of the Christian Church, of Campbellites, as we called them. We were Presbyterians and were sprinkled only, but were interested spectators at all immersion baptisms. They were usually held in the creeks, but at this particular time the creeks were dry and the only available water suitable was in the tanks. It was not considered a strange procedure.
>
> My presentation of the scene is fairly accurate, even to the doves descending in the ray of light from heaven. I consider this presentation as near as anything that has been done, in recent times, to the original "Baptism in Jordan." At that time, the setting, the ceremony, the flying pigeons, the emotional crowd affected me, and years later I put down what my poor abilities permitted me.[40]

Contemporary opinion either accepted Curry's account at face value or else saw in his painting a mocking of midwestern piety. Thomas Craven deemed *Baptism in Kansas* a work "conceived in reverence and spiritual understanding, and executed with an honesty of purpose that is all too rare in any art."[41] He went on to laud the "profoundly moving" actions of the "real" characters Curry presented in his canvas, praising them as "fresh and true and typical of rustic piety." Critic Nathaniel Pousette-Dart, writing in *Art of Today*, concurred with Craven:

"When one looks at this painting one feels that it has sprung from the living. In it we find none of the cold sneering and aloofness of Sinclair Lewis. Curry not only understands these people, he is one of them. Very likely many of these people are definite individuals that have printed their portraits on his subconscious mind."[42]

At the other extreme, *New York Times* critic Edward Alden Jewell saw *Baptism in Kansas* as "a gorgeous piece of satire," maintaining that "religious fanaticism of the hinterland saturates the scene."[43] Unaware of the Gospel texts that described the Holy Spirit as having descended in the form of a dove at the time of Christ's baptism, Jewell viewed the birds as "symbols straight from the Apocalypse," a reference in keeping with his belief that this barnyard reflected "the shut-in frenzy of the human soul."

Curry's own attitude toward the event he portrayed lay somewhere in between these two extremes of critical opinion. The careful assembling of all the elements in the canvas—figures, backdrop props, and the circular, horizontal, and vertical compositional lines—reveals that while the artist witnessed an actual Campbellite immersion ceremony and was attempting to reproduce its essentials, he took great pains to maximize its visual impact. Given this carefully planned arrangement, it is highly unlikely that one should accept this scene as a literal representation. In *Baptism in Kansas*, Curry offered a personal glimpse into his own religious searching and questioning under the guise of a Campbellite—not a Scotch Covenanter—ceremony.[44] The artist hinted at his ambiguous religious attitude in such telling details as the mail-order dresses, cloche hats, and short skirts worn by the younger women. These features of contemporary life in the twenties belie Campbellite belief in a literally interpreted Bible, in which St. Paul's recommendation that women dress "modestly" would be adhered to with utmost seriousness. That several of these believers freely use the fruits of a mechanized, technological society—evidenced by the fleet of Model Ts in the background—at the same time as they cling to their traditional beliefs further emphasizes the ambivalence of 1920s America, in which the "old-time religion" sought to come to terms with a rapidly changing social order. In contrast to the growing modernism evidenced in the congregation, the minister, with his bushy moustache and traditional knee-length preacher's jacket, and the woman he baptizes, with her long braided hair, seem like nineteenth-century figures on this twentieth-century farm. The appearance of two doves in the sky overhead, rather than the single one of Biblical tradition, contributes to the peculiarity of this scene.

By 1928, when he painted *Baptism in Kansas*, Curry had long since begun to question his own religious Scotch Covenanter faith, a process he began during his student days in Chicago. His doubts continued to increase when his brother

Paul died while still in college. Curry never forgot his mother's remark that Paul died "a glorious death," meaning he died "saved."[45] To Curry, there was no glory in the young man's death at all, just a great waste of life. According to his second wife, Curry remained opposed to organized religion as a sort of personal revolt from his experience of Christianity.[46] Curry's decision to settle in Westport, Connecticut, rather than return to the Midwest of his youth, indicated the growing alienation he was feeling toward the faith of his Kansas past. The artist may have presented a "typical Kansas scene" in *Baptism in Kansas,* but he did so at a considerable distance from the actual event.

Curry's "personal revolt" from his Covenanter background helps explain why he elected not to portray a Covenanter ceremony. If the artist meant to offer a critical reflection on fundamentalist religion, the choice of the Campbellites, with their Biblical literalism and immersion baptism—and the timely focus of a popular religious dispute in the 1920s—would have afforded dramatic possibilities unavailable in the quiet, reserved worship of the Covenanters. A witness to Campbellite baptisms as a boy, Curry was aware of the sect's origins within the Scotch Presbyterian (i.e., Covenanter) Church. This early tie to Covenanter tradition provided a logical link between the two denominations in Curry's mind, allowing him to substitute the more dramatic rites of the Campbellites while still offering a personal reflection on the religious world of his Kansas boyhood.

Ever since their founding by Alexander Campbell, the "Campbellites," or "Disciples," as they preferred to be called, had held to the "Great Commission" as their rule of faith: "to disciple all people and to immerse all Christians in the name of the Trinity."[47] They believed that this summed up the requirements of primitive Christianity, which Disciples felt called to restore among true believers. Committed to eliminating all denominational differences, certain Disciples churches increasingly came to stress Christian unity above all other considerations. By 1896, the large and influential Aetna Street Disciples Church of Cleveland proposed an "open membership" plan whereby all who professed belief in Christ—even the un-immersed—would be accepted into fellowship as Disciples.[48] That same year, progressive members of the denomination, "drawn together by their common experience of having felt the impact of the larger world of culture upon their religious inheritance," organized the Campbell Institute to acclimate Disciples to modern scholarship and to foster interchurch cooperation.[49]

Headquartered at Disciple Divinity House (located at the University of Chicago), members of the Campbell Institute began to adopt and teach form-critical methods in the study of the Bible and published *Christian Century* as an organ for disseminating liberal Disciples' opinion. In opposition to these developments, orthodox Disciples loudly disclaimed belief in a socially conditioned

Bible and attacked the practice of accepting non-immersed members. The conflict between these varying viewpoints seriously upset the harmony within the denomination. At the 1920 Disciples convention in St. Louis, traditionalist members decided to focus their criticism on the issue of accepting non-immersed members into mission congregations supported by the church. They succeeded in having the convention adopt a resolution that expressly forbid "the advocacy or practice of open membership among the missionaries or mission stations."[50] By engaging in this tactic, conservative Disciples succeeded in enforcing this same policy in home churches as well, for what applied to missionaries sent to preach the faith obviously applied to those who sent them. Under pressure from liberals of the Campbell Institute, however, Disciples reversed this policy the following year, thereby prompting conservative member churches to withhold funds from the national church organization until such time as the church firmly committed itself doctrinally to the necessity of immersion baptism. Alarmed at the growing rift in Disciple ranks, the national church body agreed to adopt a traditional creedal statement, incumbent upon all members, which upheld the necessity of immersion—a statememt renewed at the 1922 convention.[51]

The conservative faction, mollified by this second victory, failed to sustain their efforts at the 1923 convention. Vastly outnumbered, conservatives watched as the members once more reversed themselves by adopting a noncommital doctrinal program. The national convention seesawed back and forth in this manner for another two years. The situation among Disciples reached the breaking point at the 1925 gathering when, after five-and-a-half hours of debate, the convention voted in favor of recalling the "open membership" policy, a vote that the Board of Managers of the church interpreted to mean that no person could be employed as a missioner who could not subscribe to belief in immersion baptism.[52] Following this decision, both liberals and conservatives continued to meet separately, to organize their own publications, and to manage generally independent educational, missionary, and administrative organizations. The anomaly of the Campbellite church, committed to Christian unity yet so obviously divided as to the mode of baptism and the role of the Bible, must have seemed ironic to Curry when he came to paint *Baptism in Kansas* in 1928. Having long since abandoned his own Scotch Covenanter background, but never quite able to escape its influence, Curry would have recalled in the Campbellite debates over baptism the immersion ceremonies he witnessed as a Kansas farm boy. Searching for a viable subject matter to make his own, Curry employed the idea of a Campbellite baptism as an authentic and familiar feature of Kansas life, while carefully crafting his composition to reflect personal doubts about fundamentalist religion in general. As a focus of religious dissension in the 1920s, a Campbellite immersion would provide a topical religious theme. At least one

critic, Thomas Craven, recognized the scene as a Campbellite ceremony, and the painting led others to reflect upon the role and place of religion in twentieth-century America.[53]

Curry returned to the immersion theme in a 1932 lithograph, *Baptism in Big Stranger Creek* (Fig. 6.4). Gathered in a circular formation as in *Baptism in Kansas*, a throng of worshipers — and the merely curious — have gathered to witness the baptism of several adults and children in the waters of an elm-shaded creek. A choir, massed at the lower right, uses the sloping river bank as natural tiers that allow them to assemble in concert formation. Diagonally opposite, at the other end of the creek, an echoing tier arrangement appears in the group of neophytes descending into the water. Stately elms resembling Gothic arches dwarf the massive crowd on the far bank and give the scene all the grandeur of a medieval cathedral ceremony. The beams of sunlight shining down upon the minister and his flock provide heavenly confirmation that the light of God

Fig. 6.4. John Steuart Curry, *Baptism in Big Stranger Creek* (1932). Lithograph, 9⅞ x 13⅝ inches. Courtesy of the Billy Graham Center Museum.

Art and Popular Religion in Evangelical America, 1915–1940

hallows these rites. Despite the multitude gathered together, the secluded forest setting exudes an atmosphere of quiet and peace.

The dramatic arrangement Curry created for this scene uses the natural setting to reinforce the religious theme. The artist once revealed his essentially religious attitude toward nature, an attitude that remained with him despite his alienation from his Scotch Covenanter background, in a foreword he wrote for a catalogue of his work published by the American Artists Group.[54] The memory of his youth, when "bad weather, crop or cattle disease . . . were looked upon as vengeful acts of a terrible God," and where "the twin themes of repentance and faith" formed essential features of the doctrine of economic survival, remained deeply ingrained within him.[55] The relationship of nature to man in his work—destructive in such a canvas as *Tornado over Kansas*, beneficent in *Baptism in Big Stanger Creek*—became the artist's equivalent metaphor for the forces of God acting in the world.

Curry conceived the setting for *Baptism in Big Stranger Creek* from another childhood memory, a story of a heroic Scots Covenanter baptism written by John Wilson and reproduced in *McGuffey's 6th Eclectic Reader*, a standard reading book in many American public schools. The story took place near Lanark, a small Scottish town in the valley of the Clyde, during the time of religious persecution under Charles I. On the Sabbath, a group of about a hundred Covenanters has silently gathered at a secluded spot deep in the hills, "a place more magnificent than any temple that human hands had ever built to Deity . . . hewn by God's hand out of the eternal rock [where] . . . a river rolled its way through a mighty chasm of cliffs."[56] At the conclusion of the service, a baptism takes place in which "a row of maidens, all clothed in the purest white, come gliding off from the congregation" to receive the sacrament from the minister's hand.[57]

After the gathered Covenanters sing the final hymn, a watchman suddenly sounds the alarm, indicating the approach of the king's soldiers. Quickly the worshipers climb up the cliffs and disperse into numerous caves concealed by the dense foliage. When the troops arrive, cursing the "canting Covenanters" for "deceiving honest soldiers on the very sabbath day," they quickly realize their muskets and bayonets are useless in these wooded cliffs.[58] Then, amidst the profound stillness of this secluded retreat, they hear a terrible roar of water. Like the soldiers of Pharoah's army pursuing the Israelites into the Red Sea, the troops are suddenly swallowed up in a flash flood that thunders down upon them from the moorlands. In answer to their cries for help, the Covenanter minister screams from his hiding place, "the Lord God terrible reigneth!"[59]

The majestic natural setting, the terrible force of nature unleashed upon the soldiers, and the depiction of Covenanters as noble, heroic Christians under-

going persecution furnish all the elements for a dramatic adventure story. Given Curry's rural upbringing as a Covenanter in Kansas, where the forces of nature were viewed as the just acts of a vengeful God, the appeal of this story would have been magnified considerably. Childhood beliefs and memories of the wrathful God who ruled sternly over his magnificent creation merged with the dramatic baptism in Wilson's story to provide a fruitful source for Curry to draw upon in later life.

Similar memories of Baptist and Methodist revivals, combined with the sobering effects of life in a desert climate, also affected Peter Hurd's choice of subject matter. In 1935 Hurd produced a lithograph, *Baptism at Three Wells* (Fig. 6.6), which he recreated as a tempera on gesso panel two years later (see Plate 15). These works together with a lithograph Hurd executed of a New Mexico revival meeting, titled *Sermon from Revelations* (Fig. 6.5), provide evidence of his interest in the revivalist religion that flourished in the Southwest.

Hurd's family journeyed from New England to the arid land of New Mexico at the turn of the century, eventually settling in Roswell, a sleepy cow town of 1800 and the third largest settlement of the New Mexico Territory in 1904. Hurd would later recall the frontier life fond in this cultural crossroads community.[60] Half the population spoke Spanish and practiced Catholicism, Indian religion, or a blend of the two, while the other half, mostly displaced Texans and southerners, clung to the familiar ways inherited from the antebellum South:

> The Protestant churches mostly attended by the American population were the Baptist, Methodist and Presbyterian. So bitter was the remembrance of the War between the States that each of these denominations was represented by two churches. There was, for instance, a great square, gaunt brick structure with incongruous Greek columns which was the First Baptist Church, South, and one block away was a much smaller building of adobe and wood: The First Baptist Church, North.[61]

Writing of the congregants who frequented these houses of worship, Hurd remembered, "The loneliness of their lives has fostered their religion and of their loneliness is also born their wide and reckless hospitality."[62]

Hurd began his education as a day pupil at the local convent school run by the Sisters of St. Francis of Assisi, where he quickly became bilingual in Spanish. The excitement generated by the outbreak of the Mexican Revolution and Pancho Villa's 1916 raid on Columbus, New Mexico, influenced Hurd's decision to attend the New Mexico Military Institute located in Roswell, and to obtain an appointment to West Point in 1921.[63] The young cadet spent all his spare time drawing and nearly flunked out of the Academy, a situation that came to the attention of his company tactical officer, who discussed the matter with

Brigadier General Douglas McArthur.[64] The hopeful artist left West Point after his second year, transferring to the very unmilitary Quaker college of Haverford. There he met Charles Beck, a noted engraver who produced high quality plates used in the reproduction of illustrations. Their friendship resulted in Beck's introducing Hurd to N.C. Wyeth, who in 1924 accepted the young man as his pupil.[65]

After studying with Wyeth for five years, Hurd married his daughter Henriette in 1929 and began a career as an artist-illustrator. The outbreak of the Great Depression sharply curtailed the market for the illustrations Hurd supplied to the publishers of juvenile books. In 1933, the artist received an invitation to execute a mural triptych for the New Mexico Military Institute, a task he later completed under PWAP auspices. Returning to New Mexico permanently in 1935, Hurd purchased a small ranch and began to rediscover and paint the land he knew so well as a boy.

The Depression forced Hurd to turn to lithography as a way to produce works ranging in price from ten to twenty dollars.[66] In so doing, he looked to the example of George Bellows, whose book of lithographs Hurd had received as a Christmas gift in 1927.[67] Bellows's many lithographs lampooning Billy Sunday and his brand of mass revivalism provided the catalyst for Hurd to turn to this subject as he found it expressed in his native Southwest. The artist frequently attended revivals held on the outskirts of Roswell.[68] In a letter to his wife dated July 24, 1935, Hurd remarked about a particularly lively meeting: "It was all mad—a wild combination of Goya and Daumier in the sharp focus of [its] superreality."[69]

From this revival Hurd drew *Sermon from Revelations* (Fig. 6.5), in which a revivalist preacher is shown holding forth at an evening meeting by the light of a kerosene lamp. The initial sketch, which the artist made on the spot in a quick pen-and-ink wash, shows that Hurd altered his subject matter. In the lithograph he enhanced the dramatic contrast of bright light and long shadows and rearranged the huddled group of figures found in the original sketch into a vast audience of farmers and ranchers lounging under cottonwood trees, creating a striking setting for his ranting evangelist. The preacher makes a dramatic Billy Sunday-style gesture as he emphasizes a point from the Book of Revelation (i.e., the Apocalypse). Aided by the dramatic light glowing behind him, the evangelist's apocalyptic imagery creates a powerful impact on one member of the congregation, who jumps up in terror.

Dissatisfied with the results achieved in his first attempt at this scene Hurd reworked the stone, altering the highlights cast by the glow of the kerosene lamp so that the overhanging trees formed an eerie tentlike canopy and adding *repoussoir* cowboy figures in the foreground that serve as the viewer's entrée into the

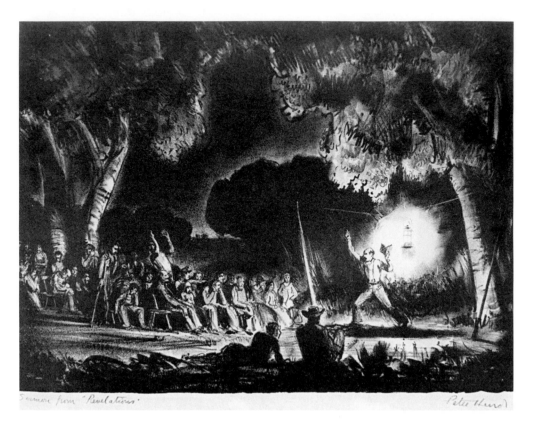

Fig. 6.5. Peter Hurd, *Sermon from Revelations* (1938). Lithograph 10 x 13½ inches. Permanent collection, Roswell Museum and Art Center. Gift of Mr. and Mrs. Donald Winston.

scene. In this final reworking, Hurd changed the appearance of the young evangelist, aging him considerably by rounding out his face and giving him a balding head similar to that found in Bellows's *Billy Sunday*. Hurd further accentuated the forward thrust of the preacher's body, making him look as if he were leaning forward on a Sunday-style tabernacle podium to excoriate a captive audience. Bellows carefully depicted the front row of the Philadelphia tabernacle crowd captured in various attitudes of despair, attention, anguish, or adulation. Likewise, the front-row listeners in Hurd's lithograph display a range of emotions ranging from crestfallen dismay to rapt attention.

Hurd continued to pursue his interest in the folkways of the Southwest in a lithograph of a country baptism he drew in 1937. Acquired by the New York Public Library in June of that year, *Baptism at Three Wells* (Fig. 6.6) received Honorable Mention at the Philadelphia Print Club exhibition and also appeared by special invitation in the spring show at the Art Institute of Chicago.[70] Hurd chanced upon the scene quite by accident. While sketching one afternoon along

Art and Popular Religion in Evangelical America, 1915–1940

a normally deserted country road, he noticed crowds of people streaming by, some walking, others driving old jalopies. Curious about this commotion, he asked two boys where all these folks were headed. "Ain't yu heerd, it's a baptism over at Three Wells," came the reply.[71] Quickly the artist packed up his things and joined in the procession, arriving in time to sketch the scene for later use in a lithograph and a painting.

Upon a grassy plain, a crowd of onlookers has gathered beside a waist-deep spring to witness a baptism. Shielding themselves from the hot New Mexico sun with large umbrellas, some form a guitar-accompanied choir while others, perched upon running boards, hoods, and car roofs, watch the spectacle from a distance or ignore it altogether for the more mundane task of changing a flat tire. A tiny group of seven believers accompanied by their minister descends into the water to undergo immersion. Guided by the pastor's waving arm, they sing a hymn prior to their baptism. In the tempera painting of 1937 (see Plate 15), Hurd emphasized their song by placing a hymn book in the preacher's right hand. Differences also appear in the diagonal rays of light that seem like giant,

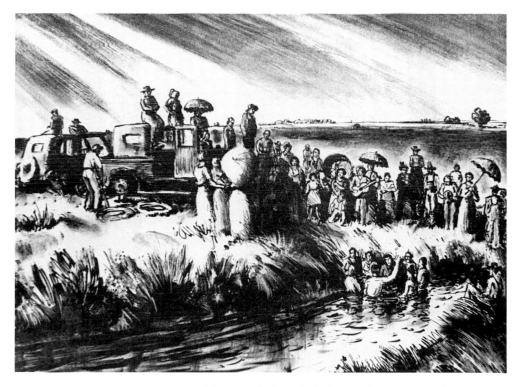

Fig. 6.6. Peter Hurd, *Baptism at Three Wells* (1935). Lithograph, 10 x 14 inches. Permanent collection, Roswell Museum and Art Center. Gift of Mr. and Mrs. Donald Winston.

Shall We Gather at the River? [201]

heavenly beacons shining down upon the scene in the lithograph; in the tempera panel these have been altered into a cloudburst threatening to immerse all those present.

Similar to John Steuart Curry's view of the interrelationship between the forces of nature and humanity, Hurd's reworking of this baptismal scene suggests his interest in the daily struggle of southwesterners as they attempted to create a meaningful existence amid the harsh conditions of the New Mexican climate. Although not overly religious, Hurd surrounded his work with religious metaphors. He once described painting as a "religious experience," and when deeply engaged in interpreting that existence the artist hung a sign on his studio door bluntly warning: "If it is the Second Coming call me out. Otherwise, let me a lone."[72] On sketching trips, Hurd carried lead pencils, pens, and a small watercolor brush in a tiny leather satchel dubbed "the scapular."[73] Whenever the artist felt he ate too much he fasted for a few days, terming the experience his Ramadan, thereby indicating his familiarity with the literature of non-western religions that he enjoyed reading in his spare time.[74]

The religious metaphors Hurd employed to describe his life he also translated into paintings and landscapes of the Southwest. As a child, the artist experienced "the beneficence of rainfall, feeling its mystery and sacredness as . . . only people can who live in arid lands."[75] Later, as an adult, he described the wondrous quality of the rainy season in the Southwest, rejoicing as a painter in "the visual marvel of water in all its varied forms."[76]

Hurd struggled to capture these effects in *Baptizing at Three Wells.* In the painting, although the crowd of figures watching the baptism has nearly doubled in size from the lithograph, it appears sharply diminished in scale when measured against the backdrop of the arid plains and withered pampas grass. In contrast, the sky is vast and expansive, dominating the scene with a brilliant white haze produced by the shimmering New Mexico sunlight. The forces of nature command respect and scrutiny as storm clouds suddenly emerge from the corners of the picture to block out the light and send down a stream of rain (in the upper right corner of the picture) upon the parched land. Like the life-renewing waters of baptism (in the lower right of the painting), which serve as a visual counterpart to the rain, repeating the white and gray pattern observed in the sky above, these welcome summer showers promise new life and moisture to renew the face of the earth.

While artists like Benton, Daugherty, Curry, and Hurd focused their attention on baptisms among midwestern and southwestern types, Alabama native John Kelly Fitzpatrick elected to portray southern immersion rites in *Negro Baptizing* (see Plate 16). Reared in a small Alabama town, Fitzpatrick graduated from the University of Alabama with a degree in journalism.[77] Dissatisfied with

this career, the young man began to explore his interest in art by signing up for a one-year term at the Art Institute of Chicago in 1912. That brief study provided Fitzpatrick's only formal art training, with the exception of a brief sojourn in 1926 at the Academie Julien in Paris.[78]

Returning to Alabama from Paris with canvases titled *Clare de Lune, Petite Trianon,* and *Marche Aux Fleurs,* Fitzpatrick found a ready patron in Mrs. Harry Houghton, who arranged an exhibit of his work at her Montgomery estate and allowed him to teach an art class there.[79] During the summer of 1930 Fitzpatrick painted *Negro Baptizing,* which he regarded as "purely an incident of the Negro's life" on a par with such genre scenes as his *Pickaninny* (1930), *Negro Shack* (1934), and *Washerwoman* (1930).[80]

Along the shore of a river, beneath a rustic bridge made of log supports and plank flooring, a crowd of blacks in their colorful Sunday best have congregated to witness a baptism. Sporting long umbrellas to shade themselves from the intense Alabama sun, their bright costumes contrast with the white-robed, turbaned believers. One candidate for immersion is gently led into the stream by a deacon wearing a white-shirt and a necktie, who uses a pole to feel his way into the water. These two figures face two black-robed officials engaged in the process of immersing another neophyte. Groups of youngsters look down from the railing of the bridge, and a mule-drawn wagon halts so that two brightly clothed women may also view the proceedings. In a letter addressed to Wilbur D. Peat, director of the John Herron Art Institute, and dated September 25, 1932, Fitzpatrick enclosed two sketches depicting a landscape and a baptismal scene similar to those in *Negro Baptizing.* The sketches included penned-in notes detailing the "Alabama pineforest in the background" and the "crowd of Negroes in colored dresses."[81] The arrangement of the composition in the sketches, however, differs considerably from the finished painting.

Fitzpatrick probably based his painting upon popular hand-printed souvenir postcards of these events, such as the one portraying a black baptism scene near New Orleans (Fig. 6.7). The parallel arrangement of river, shore, and crowd on this postcard exists with only slight modifications in Fitzpatrick's painting. The patches of orange-, pink-, and blue-tinted clothing in the postcard and the grouping of black umbrellas in the background also find an echo in the gaily-colored outfits in Fitzpatrick's canvas. The artist attempted to make his painting a bit more site-specific to Alabama by including a rustic, and probably well-known, local bridge. Also, his careful insistence on including an Alabama pine forest in the background, and his parenthetical remark that this baptism incident was "not so typical of that state as the landscape," reinforce the idea that Fitzpatrick viewed his role as a scenic painter and interpreter of Alabama.

In the opinion of the local folk, Fitzpatrick succeeded admirably in depict-

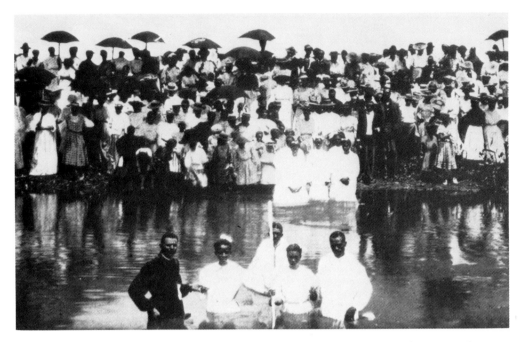

Fig. 6.7. *Negro Baptizing Scene, New Orleans, La* (c. 1910). Color trade postcard, C.B. Mason, New Orleans. Courtesy Billy Graham Center Museum.

ing American Negro life. At the 1930 Alabama State Fair, *Negro Baptizing* won the "most popular" prize for painting. Reflecting on the reason for his success, the artist noted: "There were so many Negroes in the picture that everybody could find their cooks among them and being so pleased to find where she went that Sunday that they voted for the picture."[82]

In contrast to Fitzpatrick's genrelike depiction, Howard Cook's *River Baptism* (Fig. 6.8) and *Footwashing* (Fig. 6.9) of 1935 present black religious rites as an outside observer chancing upon the scene might interpret them. In fact, Cook was just that. A native of Springfield, Massachusetts, Cook received a $500 scholarship to attend the Art Students League in New York upon graduation from high school in 1918.[83] Eager to learn lithography and intaglio techniques, the would-be artist spent the time prior to commencing his studies working in a local lithography shop designing labels for tomato cans at $12.50 a week.[84] Yet, once at the League, Cook avoided all training in the graphic arts and took only traditional figure-drawing courses. After two years of study in New York, he had managed to save enough money to travel abroad for the next few years, visiting Europe and the Orient. Intermittently, the artist spent additional time at the Art Students League learning the basic techniques of etching

Art and Popular Religion in Evangelical America, 1915–1940

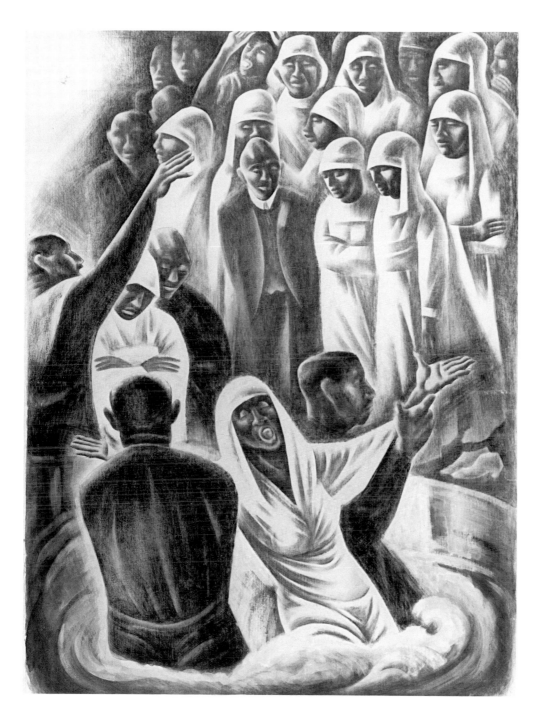

Fig. 6.8. Howard Cook, *River Baptism* (1935). Ink (dry brush), conte crayon and watercolor on paper, 33 ⅝ x 24 ⅜ inches. Georgia Museum of Art, The University of Georgia. Gift of the Artist, Friends of the Art Department and Museum.

with Joseph Pennell and found a market for his work in such journals as *Harper's* and *Century*.[85]

By 1924 Cook found regular employment with *Forum* and contributed a number of woodcuts and etchings to that journal. In 1929 he traveled abroad once more, this time to Paris. Armed with a letter of introduction from Carl Zigrosser, director of the Weyhe Gallery in New York and soon-to-be curator of prints at the Philadelphia Museum of Art, Cook introduced himself to Désjobert at the latter's Paris lithographic studios and undertook to study that medium.[86]

Returning to New York in late 1929, Cook began to record the city's progress in such works as *Times Square Sector*, *Chrysler Building*, and *The New Yorker*. In 1931 the artist was awarded a Guggenheim Travel Fellowship to Mexico. He settled in Taxco with his wife and a three-hundred-pound printing press, and spent the next year executing a number of engravings, etchings, and aquatints of colorful Mexican fiestas, markets, and peasant types, as well as painting his first fresco for the Hotel Taxqueno.[87] Arriving back in the United States during the depths of the Depression, Cook applied for and received a commission

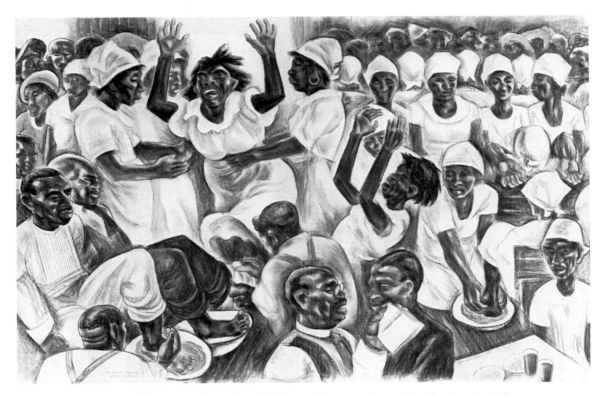

Fig. 6.9. Howard Cook, *Footwashing* (1935). Conte Crayon, charcoal and colored chalk, 24⅜ x 37⅜ inches. Georgia Museum of Art, The University of Georgia. Gift of the Artist, Friends of the Art Department and Museum.

from the Treasury Section of Painting and Sculpture to paint a mural for the courthouse in his native Springfield. Upon completion of that project in 1934, the artist once more received a Guggenheim Travel Fellowship, this time for the purpose of journeying throughout the South to portray the rural folk of that region. It was during this trip that Cook drew *River Baptism* and *Footwashing.*

In *River Baptism* (Fig. 6.8), Cook depicted the immersion rite of an independent black Baptist church. He had surreptitiously witnessed the ceremony on the outskirts of Moundville, Alabama.[88] The artist recorded the baptism scene in his journal:

> . . . about twenty-five Negroes dressed in white robes with Moorishly-draped white head pieces were lined up in several rows at the bank of a deep pool . . . near Moundville, Alabama early one cloudy Sunday morning. . . . The preacher strode in his white robes into the water. . . . Getting in deeper, he tapped all around the muddy bottom with a long slender stick and finding a suitable place up to his waist pushed the stick rigidly into the mud.
>
> The scene was set, whereupon two deacons- . . . gently led in the first victim who received a benediction from the minister. Then the two strong-armed deacons took the communicant around the shoulders and waist, thrusting her with a great splash completely out of sight. She came up quickly on the rebound, blowing spray and waving her arms wildly, thrashing about like a large fish caught in too shallow water. As soon as the choking was over the energy created by the shock was unloosed, causing a hoarse screaming and sobbing.[89]

Footwashing (Fig. 6.9) illustrated another normally secret water ritual that Cook had observed in a tiny church near the village of Eutaw, Alabama. Church members, garbed in the traditional white of purity, have gathered for a repentance meeting, shaking and screaming wildly until they "got the devil out of their souls" by means of these spasmodic contortions.[90] Thoroughly cleansed of sin, these believers proceeded to arrange themselves on either side of the church, men on the right, women on the left. They then removed their shoes and began to wash one another's feet in imitation of the act Jesus performed on his disciples at the Last Supper. The ritual completed, the church members partook of large cups of wine.

In both of these drawings Cook has preserved all the details as if for a sociological field study. The white robes and "Moorish hood" of the baptized woman as well as the black robes of the deacons are carefully drawn. Cook records the ecstatic expression on the baptized woman's face, her flailing arms, and her clinging, wet robe. He also carefully notes the gyrations and screams of the women having the devil shaken out of them in *Footwashing.* He again takes pains to record the white costumes, large basins of water, and cups of wine upon the altar table.

In contrast to Fitzpatrick's generalized impressions of a Negro baptism, Cook takes a photographer's delight in "zooming in" on the scene to capture all the idiosyncratic details of costume, gesture, and action. His fascination with the strangeness of these water rites is further indicated by his linking of *River Baptism* and *Footwashing* in a single series of prints. Cook's dynamic, gyrating compositions incline more toward exposing the "primitive Africanisms" that American sociologists believed lay behind such rites.[91]

Emphasizing analogies between immersion baptism ceremonies and the water rituals of African tribes, Melville J. Herskovits noted that among West Africans, river spirits constituted one of the most powerful deities inhabiting the supernatural world, the priests of their cult likewise exercising considerable power within the tribe.[92] He pointed out that when the Dahomean Kingdom expanded its influence in West Africa, opposition and intransigence on the part of the priests of the river cult was so marked that, more than any other group of holy men, they continued to be sold into slavery.[93] Herskovits concluded that the proselytizing activities of Protestantism made it impossible for such priests and their followers, living as slaves in the New World, to continue the practice of their water rites in their outward form. Seizing upon the next best alternative, slaves gravitated toward the Baptist church, where their ecstatic behavior would not only be tolerated but welcomed as a true sign of conversion, and where the Baptist insistence upon immersion in a pool of running water echoed a familiar African ritual practice.[94]

The careful scrutiny Cook gave to the racial physiognomies, emotional expressions, and details of costume in *River Baptism* and *Footwashing* make it clear that, whether or not the artist specifically knew about these contemporary sociological explorations, he followed a descriptive, almost analytical approach in presenting such rites in his art and stressed the primitive emotionalism he believed characterized these rituals.

Equally fascinated by the emotional antics of such rites, Conrad Albrizio described the frenzied drama of an immersion ceremony in another painting titled *River Baptism* (Fig. 6.10) from 1937. The architecturally constructed space and the sharp, angular distortions help emphasize the fervor of the scene. As white-clad baptismal candidates undergo immersion, as depicted in the upper left corner of the painting, they experience the "power of the Holy Spirit" taking possession of their bodies as their sin is washed away and replaced by a life of grace. The effects produce a profound psychological reaction when the baptized rise from the water. They jerk and writhe in joy. Two figures continue their contortions upon the river bank in the center of the picture, and their display prompts a crowd of witnesses to take up their actions. Kneeling, crying out,

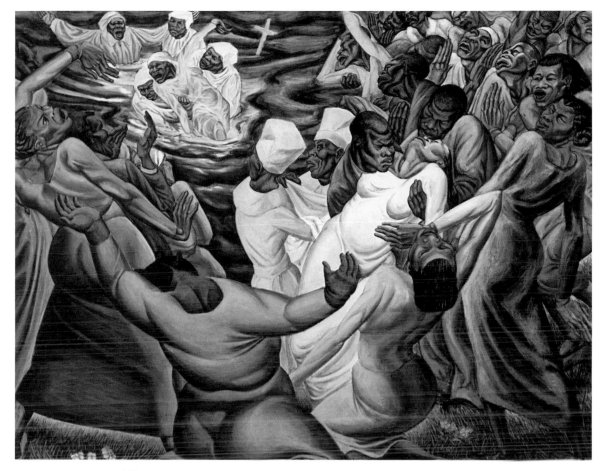

Fig. 6.10. Conrad Albrizio, *River Baptism* (1937). Tempera on board, 40 x 48 inches. Collection of the Louisiana Arts and Science Center, Baton Rouge.

shaking and moaning, these believers vicariously share in the moment of grace experienced by the newly baptized.

In the angular shapes and planar spatial constructions, Albrizio reveals his architectural training and orientation. Born in New York City in 1894, Albrizio studied architectural drawing at Cooper Union in 1911 and the following year found employment as a draughtsman.[95] He continued his studies in architecture at the Beaux Arts Society from 1914 to 1918 and then worked as a draughtsman and designer in New Orleans. His formal art training consisted of a brief period of study at the Art Students League in New York, where he worked under George Luks. Traveling to Europe, Albrizio pursued his interests in architectural drawing and design and acquired knowledge of fresco techniques while taking courses

in Italy at the Sculoe Industriale Nazionale in Rome. Returning to the United States, the artist obtained a commission in 1931 to decorate the Governor's Reception Room and the Court Room of the Louisiana State Capitol in Baton Rouge.[96] His designs of Mississippi stevedores reflect Albrizio's concern with preserving the planar integrity of the wall space and his manifest interest in local southern culture — features that also characterize *River Baptism*.

Following completion of his Louisiana mural project, Albrizio returned once more to Italy, where he studied fresco and encaustic at Pompeii. The financial strain on the artist's resources caused by the Depression forced him to return to New York. He was briefly employed under the PWAP in New York and found part-time work teaching in the New York public schools.[97] Albrizio's one religious commission during this time consisted of a modernistic Stations of the Cross series he painted for the Church of St. Cecelia in Detroit. Executed in tempera and gold on gesso, this series departed from the traditional clichéd arrangement by using a scheme *Commonweal* praised for its "freshness of pattern in color and massing and the continuity of indicated movement, connecting the Stations to one another."[98]

River Baptism may have been occasioned by Albrizio's stay in Russellville, Alabama, where in 1932 he painted a mural for the local post office under the Treasury Section of Fine Arts.[99] As a Yankee, and an outsider, he shared a tourist's curiosity about black religious revivals and baptisms, which whites sometimes attended as amused spectators. Such events provided opportunities for black ministers to display their preaching abilities before a white audience and for the congregation to carry on freely before that same audience, uninhibited by the usual social constraints governing interracial relations in the South. In *Caste and Class in a Southern Town* (published the same year Albrizio painted *River Baptism*), John Dollard described a baptism that closely paralleled the scene Albrizio depicted in his watercolor:

> The watchers were standing on the shore and the preacher came down, followed by the thirty all dressed in long white cotton robes with their heads tied in white kerchiefs. . . . Then the preacher, dressed in a long blue robe, and the deacon led the procession into the water; they walked in about waist-deep, formed a semicircle, and all joined hands. . . . Then they started the baptizing. . . . Several as they came out of the water screamed, "Thank you, Jesus," "Hallelujah," or "Oh, Lord, I'm saved," and several on the shore would shout and carry on. Apparently the parents or family of the one being baptized did most of the shouting; perhaps they were overjoyed by the certainty of being united with their loved one beyond the grave.[100]

Paralleling Dollard's description of this event, Albrizio focuses upon the reaction of the audience of witnesses. The artist tucked into the left-hand corner of his picture (Fig. 6.10) those undergoing immersion. The focus of the composition centers around two baptized figures who have returned to the shore (in the center of the picture), and the reactions of their friends and relatives. Directly in front of those newly baptized, two women fall to their knees. Waving their arms and rolling back their heads, they cry in joy, as if shouting the "Hallelujah" and "Thank You, Jesus" recorded by Dollard. The upraised arms of the woman kneeling directly at the surface of the picture plane establish the angular thrust and rhythm echoed throughout the entire canvas. Spectators on the left side of the painting bend back along the line formed by her right arm, while those on the right side of the watercolor angle back along a line formed by her left arm. The striking pattern created by this arrangement conveys the intense emotion of the moment to the viewer.

During the 1920s and 1930s public disputes and controversies surrounding the baptismal requirements for salvation erupted between modernist and fundamentalist theologians in the Northern Baptist Convention. Although painted nearly two decades prior to this religious crisis, *The Baptism of George Washington* provides an important example of how such art came to be recognized and valued for the propaganda opportunities it afforded in quickly disseminating a particular religious viewpoint. That a popular national weekly like *Time* saw fit to reproduce this painting in its September 5, 1932, edition and to discuss the events of Washington's baptism at length indicates the extent to which a seemingly minor detail of Washington's life could be manipulated by a particular faction to further its own religious views.

Regionalist artists Thomas Hart Benton and John Steuart Curry were fully aware of such developments. They used similar religious scenes remembered from their own rural midwestern pasts and information from the then-current debates surrounding baptism to create widely popular, highly publicized images of country baptisms. In *Baptism in Kansas*, in particular, Curry skillfully made a veiled attack upon the Scotch Covenanter world of his youth by including in his painting references to the open-air immersion ceremonies of the Covenanter-derived Campbellites, a denomination in serious disarray by 1928. Yet, in the romanticized compositional formula he selected to present in his Baptism painting and lithograph, Curry, like Benton, also displayed an ambivalence toward the religious world of fundamentalist Protestant sectarianism. In this respect both Curry and Benton demonstrate, once again, their deep ties to that generation born "near the corner of the century" that, while accepting modern secular

society, could never completely jettison all ties to the essentially nineteenth-century religious world view which surrounded them in their youth.

For a younger generation of artists, like Peter Hurd, John Kelly Fitzpatrick, Howard Cook, and Conrad Albrizio, these ties were not as pronounced. With the exception of Hurd, whose *Baptism at Three Wells* clearly displays the God-in-nature theme that so fascinated Curry, the work of these men appears more reportorial and detached. The harsh conditions of the desert life of his youth explain Hurd's quasi-religious sensitivity to the elements of nature. Yet in *Sermon from Revelations*, he demonstrates his debt to George Bellows and reveals his essential sympathy with the satirical intent of that artist. In contrast, Fitzpatrick's *Negro Baptizing* strives for all the popularity and reportorial quality of a tourist souvenir postcard. Formalist concerns of abstract art dominate Albrizio's *River Baptism*. However, both Albrizio and Cook display an outsider's curiosity and fascination with the frenzy of black worship, an element absent from the work of Fitzpatrick. In this respect, the paintings of Cook and Albrizio offer a visual parallel to contemporary sociological investigations into the supposed African origins of American Negro religion, a point hotly debated throughout the 1930s and 1940s.

Chapter Seven

Revivalism Redirected

Roosevelt's early moves were . . . overwhelmingly Americanist and were concentrated on the solution of specifically American problems. This Americanism found its aesthetic expression in Regionalism. When the world situation began in 1938 and 1939 to inject itself into American politics, and Americans of all classes and of all factions began to realize that our very survival as a nation was being menaced by what was occurring in Europe, American particularisms were pushed into the background and subordinated to the international problem. In this reorientation of our national life and thought, Regionalism was as much out of place as New Dealism itself. It declined in popular interest and lost its grip on the minds of young artists.[1]

In this post-mortem for the Regionalist movement, Thomas Hart Benton offered his rationale for the demise of Regionalism in the 1940s. Confronted with the fundamental issue of national survival brought on by the Japanese attack on Pearl Harbor, Americans turned away from local concerns to concentrate their efforts in a unified assault against the enemies of American democracy. Many artists joined in the war effort by designing posters for the Office of War Information. In such a charged atmosphere, paintings and drawings depicting the rustic religious doings of ordinary American folk seemed out of touch with the contemporary realities that American scene painting strove to present.

Faced with this altered social and political climate, painters of the American religious scene either abandoned religious subjects altogether, as did John McCrady, or else adapted religious imagery to reflect the new international situation. The most notable occurrence of this shift appeared in the canvases of Thomas Hart Benton and John Steuart Curry. Within the Benton-Curry-Wood triumvirate, the advent of World War II caused profound changes. Fatally ill with

liver cancer, Wood died in early February 1942. The two surviving Regionalists radically altered their themes in an attempt to respond to the war. Shortly before the debacle of Pearl Harbor, Curry undertook a commission for *Esquire*, painting *The Light of the World* (Fig. 7.1) for the magazine's December 1941 issue. The artist presented an apocalyptic vision of the approaching Armageddon that threatened to engulf the nation. Benton revealed his own pessimistic mood in such a seemingly traditional Regionalist painting as *The Prodigal Son* (Fig. 7.3). Following the attack on Pearl Harbor, he cancelled a lecture tour, returned to Kansas City and painted the *Year of Peril* series — gruesome, almost surreal, works depicting the horror of modern warfare. Benton made use of traditional religious imagery to underscore the "war is hell" message of these paintings in one of them, a canvas titled *Again* (Fig. 7.5). The change in theme that Regionalist artists like Benton and Curry attempted to incorporate into their pictures of the 1940s could not redeem the essentially optimistic outlook of Regionalist painting from appearing increasingly bankrupt in the face of the grim realities confronting America by 1941.

Furthermore, by the 1940s, battles that pitted defenders of the "old-time religion" against modernist theologians, and that so rattled the foundations of Protestant America during the 1920s and 1930s, had resulted in a stalemate, with modernists gaining control of the mainline Protestant denominations while their fundamentalist adversaries withdrew and regrouped under the banner of small, independent church structures. By 1941, the colorful revivalists who captured popular interest in the decades between the wars had largely passed from the American scene. In 1925, William Jennings Bryan collapsed and died following his ignominious defense of the Tennessee anti-evolution statute. Billy Sunday preached to ever-dwindling crowds until he, too, passed on to meet his maker in 1935. Although Sister Aimee Semple McPherson used wartime patriotism to hawk Bibles to servicemen, while hurling terrible curses at Tojo and Hitler, America's premier female evangelist did not live to see the successful conclusion of the D-Day invasion of Europe. The social causes for which many revivalists crusaded — from the prohibitionism advocated by Carry Nation and the WCTU to the social programs for the poor favored by the Salvation Army and Father Coughlin — had largely become dead issues with the passage of the Twenty-first Amendment and the birth of a plethora of New Deal social welfare programs.

During the 1940s, American evangelicals busied themselves in building up adequate denominational and private resources with which to relaunch their crusade to save America after the war. The mass revivalism that so captured popular interest when manipulated by a skillful Billy Sunday, Fr. Divine, or Aimee Semple McPherson would not re-emerge as a major factor in evangelical

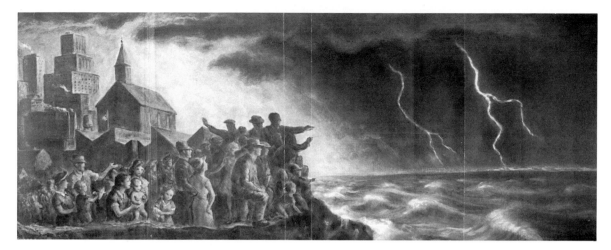

Fig. 7.1. John Steuart Curry, *The Light of the World* (1941). Painted illustration for *Esquire* 16 (Dec. 1941), insert following page 100. Reproduced with permission from *Esquire* Copyright © 1941 by Esquire Associates.

Christianity until the Billy Graham crusades of the 1950s. The evident hiatus in such public religious activities during the decade of the 1940s contributed to the redirecting of popular religious imagery into the more privatized and politicized usages evident in such canvases as *The Light of the World* and *Again*.

Late in the autumn of 1941, after much hesitation and careful thought, John Steuart Curry completed his large painting for *Esquire* magazine. In response to the request of the editors that the work aim at "an interpretation of the state of our time," Curry titled his work *The Light of the World*.[2] Those same officials wanted Curry to paint a resolution to the question nagging at the conscience of most Americans by late 1941: "Is the light of the world today . . . the awful lightning of a storm that is ending the world as we know it? Or is our land itself the light of the world?"[3] After two trips to Madison, Wisconsin, where Curry was serving as artist-in-residence at the University of Wisconsin, agents for *Esquire* successfully prevailed upon the artist to accept their offer, and explained the delay to readers by noting that Curry deemed it important to be in the "right" frame of mind before painting such a picture.[4] The editors hoped Curry would produce another *Line Storm*, or a variation of his canvases wherein the forces of nature unleashed their full power against a heroically struggling humanity. Often in such paintings of Curry's, unfettered nature seems to allegorically represent God's sovereign and free control over creation. The lightning in *Line Storm*, or the funnel cloud in Curry's *Tornado over Kansas*, while potentially violent and destructive in their effects, leave the figures in the paintings — and the viewers of such pictures — with a sense of awe, as well as dread. An es-

sentially religious emotion—theologically expressed in the phrase *"mysterium tremendum et fascinans"*—the awe generated in Curry's storm paintings revealed the strength of the artist's ties to his Scotch Covenanter past.[5] But by 1941 Curry's mood had changed drastically. *The Light of the World* (Fig. 7.1), while presenting Curry's most transparent use of the religion-in-nature theme, lacks the assurance of future security and a safe conclusion to the cosmic battles that implicitly exist in the artist's earlier storm paintings.[6] In front of a carefully arranged cityscape consisting of skyscrapers, smokestacks, and factories, a crowd of people have gathered behind what at first glance appears to be a river levee. Prominent in the lower left foreground of this city scene, the gambrel roof of a country barn occupies the corner of the painting, uniting city to country. This barn is the anchor point of an imaginary diagonal line running from barn to factory smokestacks to the greatly enlarged image of a tiny wayside chapel. Completely in shadow, the façade of this church acts as a flat backdrop that props up and highlights a lone American flag fluttering peacefully in the breeze despite the clouds threatening to engulf the scene. This microcosmic image of the American nation—great in its cities, strong in its economic productivity, blessed from sea to shining sea with agricultural abundance, and united under God—constitutes a formidable bulwark against any potential threat. That bulwark takes on symbolic form in the protective earthen embankment separating the multitudes from the raging, rising tide.

Upon closer examination, the viewer sees the seemingly secure men, women, and children look anxiously out across the brooding waters, pointing and staring with nervous attention at the pitch-black sky and violent lightning, whose charged bolts ignite the distant shore in an eerie glow. That mysterious conflagration, unleashed across the vast, oceanic river, draws ever nearer, blacking out the sky over this microcosmic America. Unlike the fleeing figures in *Line Storm* or *Tornado over Kansas*, the people in *The Light of the World* simply watch and wait, uncertain what course this storm will take, yet fearful that there may be no escape from this violent tempest.

Curry revealed his ambivalent attitude in the title he gave this work. *The Light of the World* refers to the admonition of Jesus to his disciples as recorded in the fifth chapter of Matthew's gospel:

> You are the light of the world. A city built on a hill top cannot be hidden. No one lights a lamp to put it under a tub; they put it on the lampstand where it shines for everyone in the house. In the same way your light must shine in the sight of men, so that, seeing your good works, they may give the praise to your Father in heaven.[7]

Matthew's version of this saying of Jesus clearly stressed the witness and good example offered by disciples to others in order that these others might see and experience God's love and in turn glorify the Lord. The emphasis rests upon an "upbeat," positive demonstration of what it means to be called the Light of the World. In Curry's painting, however, the City of God seems sunk into a low-lying valley needing the protection of higher-than-land-level dams and levees. Far from shining brightly upon a hill, no lights emanate from this city wrapped in long, dark shadows. What natural light does appear in the sky overhead is rapidly enveloped in dark, stormy clouds. The fact that Curry delayed his acceptance of the *Esquire* commission until he felt "right" about undertaking such a painting indicates that the anxious, apprehensive tone of *The Light of the World* accurately reflected the artist's own mood in 1941.

In that year, Curry still felt keenly his disappointment over the failure to complete his Kansas Capitol mural program. As late as 1969 Curry's widow maintained that the shabby treatment the artist received at the hands of a Kansas legislative committee, which refused to remove part of the Italian marble wainscoting to allow room for certain mural panels, contributed to the artist's untimely death in 1946.[8] The Kansas Capitol murals remained important for Curry on several levels, one of which involved the artist's use of apocalyptic imagery in the John Brown panel (titled *The Tragic Prelude*) as a warning to fellow Kansans of the danger of being drawn into war by heated emotions and the influence of extremist elements.[9] However, Curry balanced the fundamentalist, pre-millenialist image of the ranting John Brown with a messianic vision of peace and plenty found in the *Kansas Pastoral* segment of his Capitol mural. Depicting a modern, mechanized farm and a nuclear family, Curry's agrarian utopia put forth a futuristic picture of rural life on the Kansas plains. But, between 1940, when he stopped work on the Topeka murals, and December 1941, when *The Light of the World* appeared in *Esquire*, the international situation inched America along the road to war, and Curry's mood grew progressively darker.

In the summer of 1940 Roosevelt traded World War I vintage destroyers to Great Britain in exchange for the use of Caribbean bases. In September 1940 Congress established the first peacetime draft in American history. After the presidential election of November 1940, Roosevelt laid the groundwork for a "lend-lease" program under the terms of which the chief executive could provide badly needed war material to any nation whose defense he deemed vital to the security of the United States. Throughout the spring and into the fall of 1941 the United States occupied Greenland, provided "lend-lease" aid to the Soviet Union, extended the draft, armed American merchant ships, embargoed vital

exports to Japan, and extended loans and credits to China. On a personal level, Curry noticed the shift in American sentiment in the person of Kansan William Allen White, long-time supporter of the artist and influential editor of the *Emporia Gazette*, who had become head of the Committee to Defend America by Aiding the Allies.[10]

Curry at first abjured any claims to the role of political propagandist. However, when he received the commission to decorate the Kansas Capitol two years later, he resorted to using the eschatological imagery of the Apocalypse to warn against the danger posed by pious cranks and extremist policies. He compared American reaction to the growing international threat as equivalent to the passions aroused in rural believers under the crusading zeal of old-time Kansas missionary preachers, yet on a far grander scale.[11] Agreeing with *Esquire* that the time was now "right," Curry responded in his customary way — by using Biblical imagery in contemporary guise, and letting the forces of nature in his painting serve as the key to reveal the deeper implications of the scene he portrayed. Whereas the Kansas Capitol murals contained a positive resolution to *The Tragic Prelude*, as witnessed to in *Kansas Pastoral*, *The Light of the World* lacks any such resolution. The pessimistic tenor of the *Esquire* canvas resulted from the sources Curry drew upon to create his picture.

Curry reinterpreted the end of the ages as foretold in the eighth and ninth chapters of Revelations, when the seven seals are opened and the seven trumpets sound. At the breaking of the final seal, "peals of thunder and flashes of lightning" shake the earth. At the blast of the first trumpet, fire rains down from heaven, while darkness covers the land when the fourth trumpet sounds. This imagery clearly stands behind the pitch black sky, violent lightning storm and fire red horizon line of *The Light of the World*.

As he had with *Mississippi Noah* and *Sanctuary*, Curry looked to the tradition of American painting in which nature played a moral or didactic role. Works like Erastus Salisbury Field's *He Turned Their Water into Blood* (c. 1880), or Thomas Cole's *The Course of Empire, Destruction* (1836), portrayed nature as violent and destructive, supremely powerful against the helpless citizens of great civilizations. Field's painting depicted one of the plagues visited by God against the ancient Egyptians in order to convince Pharoah to release the Hebrew slaves. The artist presents his drama in terms similar to those used by Curry. The magnificent Egyptian city occupies the left foreground of the painting, while a sea of waves churns and foams on the right side of the canvas. The sky darkens to a deep black as jagged bolts of lightning pierce through the gloom and set the distant horizon ablaze. People cluster together, pointing and staring out at the bloody waters, helpless before the power of God-in-nature. Cole places the city in the right foreground, but otherwise presents essentially the same elements.

The cityscape occupies one corner of the picture while distraught and terrorized people look out upon a turbulent ocean and violent sky.

The editors of *Esquire* probably recognized the despondent message of Curry's picture even if they did not perceive the apocalyptic sources of his imagery. Yet they permitted its publication. A few weeks before the Pearl Harbor attack Americans still felt secure enough to debate publicly the future course of action the nation should pursue. *Esquire* chose to ignore Curry's pessimistic interpretation, preferring to highlight the picture as indicative of the choices still open to Americans on the eve of December 1941.

The December 1941 issue of *Esquire* hit the news stands only days before the United States entered the Second World War. The surprise attack by Japanese planes against the American fleet at Pearl Harbor galvanized public sentiment behind FDR's declaration of war. The initial feeling of solidarity that produced a closing of ranks behind the president caused the American public to view *The Light of the World*, not as a painting expressive of doubt and despair, but, indeed, as representing America as the light of the world. Americans needed to see their country as the "Arsenal of Democracy" in a world where the lights of civilization had been nearly extinguished. They chose to focus on the title of Curry's painting rather than the content, as if the two could be somehow divorced. Readers bombarded the magazine with letters praising Curry's "master piece." Overwhelmed at the response, editor M. Scott Stewart wrote to the artist in January 1942 to tell him of the tremendous public reaction to his picture:

> The entire public has acclaimed your masterful painting, THE LIGHT OF THE WORLD. as one of the most significant works of American art. . . . Hundreds and hundreds of readers have written us their praises of your painting and their congratulations to us for our part in bringing it to them. . . . [12]

Wartime tensions that caused the public to see only the positive side of *The Light of the World* could not convince Curry himself to alter his depressed mood. At first he attempted to rally to the cause, reworking a 1938 lithograph into a propaganda poster for the Treasury Department. Captioned *Our Good Earth*, (Fig. 7.2), this poster depicted a young, muscled farmer standing in a wheat field with two children at his side. The stalwart figure symbolized the power behind American agricultural production now geared up to feeding millions of GIs fighting to defend the "good earth" for future generations, like those represented by the innocent-looking children who play about the farmer's knees.

Curry's farmer resembled a 1942 photograph of a midwestern wheatgrower that appeared as part of the Museum of Modern Art's "Road to Victory" exhibition organized by Edward Steichen, then serving as lieutenant commander in

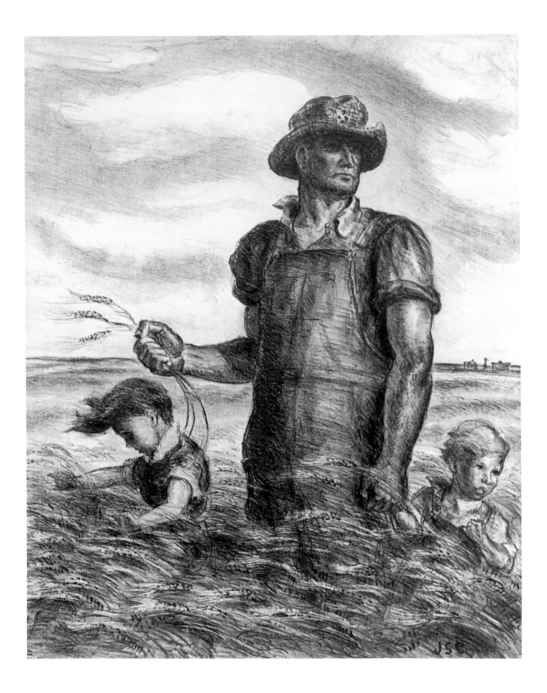

Fig. 7.2. John Steuart Curry, *Our Good Earth* (1940–41). Lithograph, 16 15/16 x 12 5/8 inches. Memphis Brooks Museum of Art, Memphis, Tennessee. Gift of Dr. Louis Levy. 47.328.

Art and Popular Religion in Evangelical America, 1915–1940

the United States Naval Reserve. The Road to Victory show consisted of "a procession of photographs of the nation at war" interspersed with a patriotic text extolling the beauty and magnificence of the American landscape and the American scene, crescendoing up to a photograph of the bombing of Pearl Harbor, and concluding with photographs of GIs marching off to battle. The photographs included such shots as a waving wheat field, a jolly farm couple, a young boy driving cows into a barn, and the stalwart figure of a wheat farmer holding sheaves of grain. The caption read: "Grain to the skyline and beyond. Wheat makes bread and bread breaks hunger — Bread is the renewer of life. The earth is alive. The land laughs. The people laugh. And the fat of the land is here."[13]

The obvious propagandistic uses made of Curry's art only served to increase his despondency and weaken his health. The conflict Curry earnestly hoped to avoid absorbed the nation's energies and interests for nearly four years. During that time Curry's problems with high blood pressure became acute, aggravating his depression and forcing him to undergo an operation in 1945. Resting with Thomas Hart Benton at the latter's Martha's Vineyard retreat in the autumn of 1945, Curry brooded over what he regarded as his failure as an artist. In response to Benton's suggestion that the Kansan had earned a permanent place in American art, Curry weakly replied, "I don't know about that . . . maybe I'd done better to stay on the farm. No one seems interested in my pictures. Nobody thinks I can paint. If I am any good, I lived at the wrong time."[14] Curry died ten months later on August 29, 1946.

Curry did not stand alone in his pessimistic assessment of the world scene and his place in it in 1941. Thomas Hart Benton also felt "impotent" in his efforts to continue to paint American Scene subjects when measured against the "sense of uneasiness" he experienced before the growing international crisis.[15] "By the late autumn of 1941," confessed Benton, "my mind was so much on the international situation that I found it difficult to concentrate on painting. The American scene which had furnished the content and motivation of my work for some twenty years was outweighed by the world one. As I had no pictorial ideas applicable to this new scene, I was almost completely frustrated."[16] Benton's "frustration" expressed itself in odd still-lifes and landscapes. The sharpness of vision and insistent concern for detail evidenced in Benton's paintings of this period carried strong Surrealist overtones.[17] An artistic style then gaining favor with American artists, Surrealism attracted the growing attention of the public, as well as art critics, in part because the bizarre arrangement and uncanny juxtaposition of real and biomorphic elements within vacuum-filled landscapes or illogical architectural settings generated tensions that accurately corresponded to the stressful climate of wartime American life.[18]

This shift in attitude, as it affected Benton's religious painting, first appeared

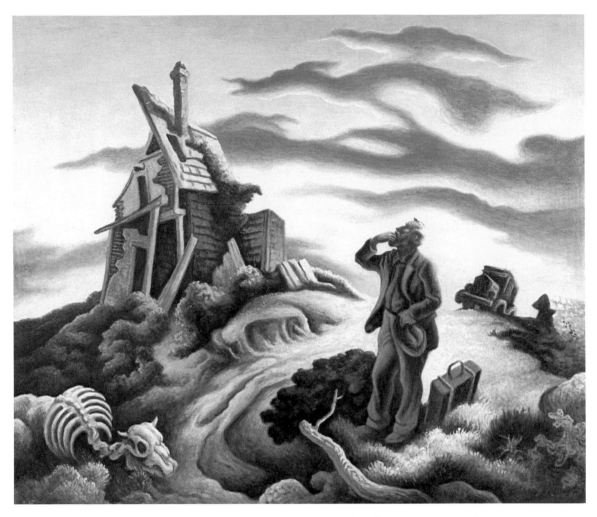

Fig. 7.3. Thomas Hart Benton, *The Prodigal Son* (1941). Oil and tempera on panel, 26⅛ x 30½ inches. Dallas Museum of Art, Dallas Art Association Purchase.

in the biomorphically shaped clouds of *The Prodigal Son*, of 1941 (Fig. 7.3).[19] The title refers to the parable, told in the gospel of Luke 15:11–32, of the rich man's son who, anxious to enjoy life, obtained an early inheritance from his father only to squander the money in "riotous living" in a far-off land. Destitute, and reduced to eating the slop fed to swine, the humbled young man came to his senses, returned home and begged his father for forgiveness. Overjoyed at the boy's return and repentance, the father clothed his son in the finest garments, set a ring upon his finger, and killed the fatted calf so that all might feast and celebrate the joyful return of "the one who was lost."

In 1929, Curry had developed this same story into a watercolor scene wherein the Biblical parable served as a metaphor in which the artist explored — using the familiar idiom of Kansas farm life — his personal feelings about the precarious state of his artistic career. Well acquainted with Curry's work, and himself accustomed to transposing Biblical events into contemporary American guise, as seen, for example, in *Susannah and the Elders*, Benton once again returned to a familiar Bible story to comment upon American life. But, whereas *Susannah and the Elders* presented a salacious nude as Benton's tongue-in-cheek commentary upon the dire seriousness with which fundamentalist exegetes used Scripture to predict twentieth-century events, *The Prodigal Son* has more in common with the dejected mood of Curry's 1929 watercolor.

Like Curry, Benton returned to the days of his "youth" — not the days he spent in Neosho, Missouri, but rather to the time that marked the earliest success of his artistic career when he rediscovered America in the quaint folk of Martha's Vineyard. Benton first sketched the abandoned, ruined shack to which the prodigal in his painting returns during the summer of 1921 in Chilmark, Massachusetts.[20] The setting of *The Prodigal Son*, then, is based upon Martha's Vineyard, where Benton first perfected his Regionalist style. A hint of that 1920s America appears in the out-of-date truck just appearing on the horizon.

That Benton chose Chilmark as the setting for this Biblical fable appears understandable when the form and content of *The Prodigal Son* are measured against the artist's depressed mood, artistic self-doubts, and the international situation in 1941. The story recorded by Luke concluded on a joyous, euphoric note: "Your brother here was dead and has come back to life; he was lost and is found." Yet Benton portrayed the scene as devoid of all joy and hope. The son appears worn with age, his face wrinkled in care. His thin, white hair and gray beard reveal the decades that have passed since the prodigal first left home as a young man. Far from receiving the joyous welcome of his father and the luxurious suit of clothes presented by the household servants, the son-turned-old-man finds a deserted, ruined shack in a twisted, eroded landscape. The aged man strokes his beard in bewilderment at what could have happened to those he loved. This puzzled gesture finds a terrifying hint of an answer in the skeleton in the lower left corner of the painting. Once fattened in anticipation of the happy feast of reunion, this calf's yellowed bones bespeak some terrible carnage. The death and destruction symbolized in the animal carcass, the ruined homestead, and blasted tree trunk at the prodigal's feet find an echo in the setting sun that casts a reddish glow on the biomorphically shaped clouds hovering over the scene. Like a Surrealist detail from Salvador Dali's *Paranoic Critical Solitude*, which also depicts a ruined structure and rusted antique auto, these roseate clouds add a haunting note and heighten the feeling of waste and destruc-

tion. By establishing the setting of *The Prodigal Son* as a ruined Chilmark farm, Benton implied that like the prodigal son, he, too, had squandered his entire career (which really began in earnest in Martha's Vineyard) and lacked confidence to address adequately the changed world situation.

Benton's most obvious attempt to redress this creative impasse by evolving a hybrid Surrealist style appeared in his *Year of Peril* series, painted after the Japanese attack on Pearl Harbor. Within this group of eight canvases, *Again* (Fig. 7.5) demonstrates the new uses Benton made of religious subject matter. The artist deliberately set out to create "propaganda pictures, cartoons in paint, dedicated solely to arousing the public mind."[21] Intended to serve a public function, as had Benton's earlier New School, Whitney Museum, Indiana, and Missouri murals, these large canvases were designed to hang in the cavernous space of Union Station in Kansas City, where thousands of railroad passengers were sure to view them. In this way, Benton hoped to shock hurried, unsuspecting travelers into a deeper, conscious awareness of what the war meant to America and the terrible price the nation would need to pay in order to preserve its freedom.[22] The deliberate "shock value" of the *Year of Peril* series reveals that Benton not only learned from and borrowed Surrealist techniques but also that he assimilated Surrealist theory, which demanded of the viewer a psychological and emotional involvement with the subject matter of art.

In resorting to the use of religious imagery in a Surrealist format of illogical juxtapositions, Benton did not act in isolation. From 1934 to 1937, the American Surrealist painter Peter Blume worked on *The Eternal City* (Fig. 7.4), his personal indictment of the Fascist system of Mussolini's Italy.[23] Blume traveled to Italy in order to study the art of the Italian Renaissance at first hand. Constantly confronted with the harsh realities of Fascism, Blume found he could not concentrate on his research.[24] He resolved, instead, to record on canvas his feelings and impressions of what was transpiring in the Italy of the 1930s.

In *The Eternal City*, amidst the ruins of the Imperial Forum, a green-faced, jack-in-the-box Mussolini glares over the crumbling monuments to past Roman glories. Mounted police quell a riot in the background, as refugees seek asylum within the subterranean passageways of the catacombs or coliseum, and smiling, mobster types look up approvingly at Il Duce's image looming over the scene. To the left, a poor woman begs for alms, while in the upper left a lighted wayside shrine containing an image of the Christ of the Passion forms a counterpoint to Mussolini's glaring head. The Christ of this shrine, seated on a chair and crowned with thorns, is bejeweled with offerings from the pious. Amidst the gold watches, chains, rings, and crosses, three army swords and an encircling halo of military epaulets underline the bizarre intermingling and coexistence of

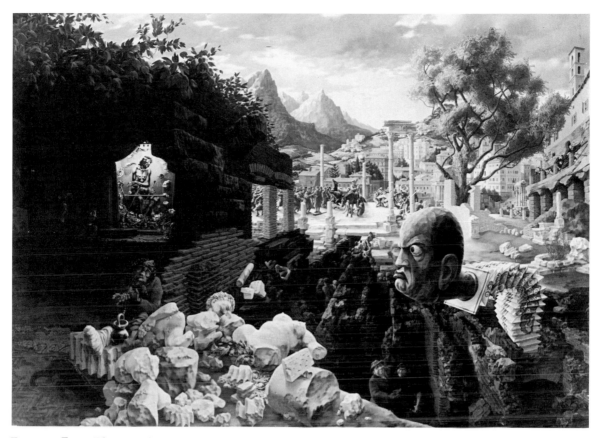

Fig. 7.4. Peter Blume, *The Eternal City* (1937). Oil on composition board, 34 x 47⅞ inches. Collection, The Museum of Modern Art, New York. Mrs. Simon Guggenheim Fund.

religion and Fascism in Mussolini's Italy—a nation which had recently signed a concordat with the Vatican guaranteeing the Holy See the rights and privileges of a sovereign state as well as control over certain church properties within the city of Rome, thereby "safeguarding" Rome's status as "The Eternal City."

The Surrealist juxtapositions used by Blume combined with religious imagery to form a painting with political overtones. Benton used a similar formula when he painted *Again* from his *Year of Peril* series. The eight canvases comprising that series—*Starry Night, Again, Indifference, Casualty, The Sowers, The Harvest, Exterminate!* and *Invasion*—depicted the full horror of modern warfare. Dead and tortured civilians fill the canvases, bombed towns erupt in flames, and maimed GIs fight for their lives against ogrelike Japanese, Nazis, and Fascists who wreak havoc on the land. Perhaps the most shocking canvas from this series, still capable of generating a subliminal emotional response due to the

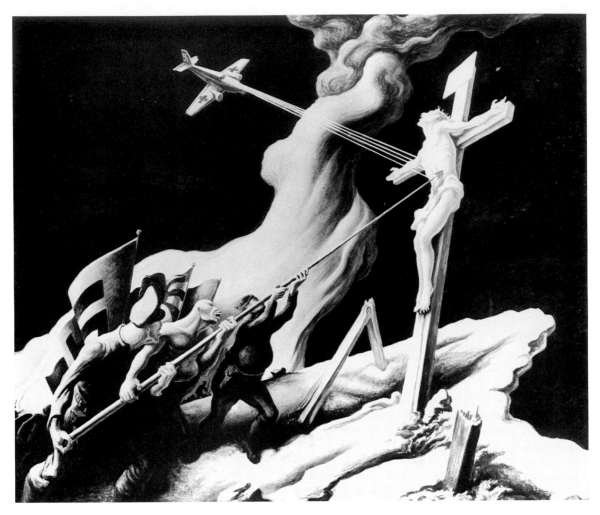

Fig. 7.5. Thomas Hart Benton, *Again* (1941). Oil and tempera on canvas mounted on panel, 47 x 56 inches. The State Historical Society of Missouri, Columbia.

popular religious imagery used, is the scene Benton painted in *Again* (Fig. 7.5). Benton's purpose in painting *Again* can be deduced from reading the caption under the painting as reproduced in the Abbot Laboratories pamphlet:

> Jesus Christ has stood through the centuries as the preeminent symbol of the brotherhood of man. Over and over again evil people, mad with dreams of power, have driven the centurion's spear into His side. Once again today—just as man with his world-wide exchange of goods, and with his devices of communication, has approached a realizable economic brotherhood—the old assault is loosed, mastery not brotherhood, control not share, are the slogans of the new attackers.[25]

Upon a jagged, rocky slope jutting out into a blackened sky, Christ appears nailed to the cross of Calvary. Crowned with thorns, the sign proclaiming his kingship tacked above his agonized head, Christ bleeds profusely from the nail wounds in his feet. The horror of Golgotha acquires a contemporary reference in the three "centurions" who pierce the side of Jesus with a lance. These three stereotyped figures represent the Nazis, the Japanese, and the Italian Fascists, a fact easily determined by their grotesquely caricatured physiognomies as well as by the three flags waving behind them. In the background, modern instruments of war rain down death and destruction, lighting up the sky in a twisting column of smoke and flame. Overhead, a Nazi plane has blasted to oblivion the flanking crosses of the repentant and unrepentant thieves and now trains the full power of its armaments against the helpless Christ who cries out in agony as bullets rip his flesh.

Several of Dali's works painted in reaction to the Spanish Civil War could have served as models for Benton, who probably viewed the 1941 Dali exhibition at the Museum of Modern Art in New York.[26] However, when Benton painted *Again* as a modern-day World War II Crucifixion, although his point of departure may have been Dali, the formal elements of his painting came directly from traditional Italian Trecento models. This blending of traditional European art, modern Surrealist juxtapositions, and Biblical subject matter indicates the state of uncertainty Benton experienced as he searched for a style capable of addressing the problems and concerns of 1940s America. In looking at Trecento Italian art, Benton demonstrated his awareness of the Expressionist trends used by his American contemporary Stephen Greene in such a canvas as *The Deposition* (1947). Greene's slight tonal modulations, sharp, angular patterns, and emphasis on facial expression and gesture recall in a general way compositional techniques familiar from Giotto's frescoes in the Bardi Chapel of Santa Croce in Florence. The fact that the men removing the body of Christ from the cross in Greene's painting wear concentration camp uniforms lends *The Deposition* a contemporary relevance and links the passion of Christ with the horror of modern warfare — a concept also pursued by Benton in *Again*.

Dali, too, resorted to using popular religious imagery in his painting. Works like *Archeological Reminiscences of Millet's Angelus* (1933) or *Gala and the Angelus of Millet Immediately Preceding the Arrival of the Conic Anomorphoses* (1933) made vivid use of Millet's *Angelus*, a painting popularized in America through inexpensive lithographs and color postcards.[27] Aware that in using such religious imagery, Dali established a readily recognizable focal point in his canvases which at the same time accrued all the subconscious religious associations normally connected with Millet's painting, Benton would have been attracted to this same notion, especially since he had been accustomed to using religious

imagery in several Regionalist paintings and was, by 1941, searching for a way to modify his style.

Benton chose the symbol of the Crucifixion shared by all Christian denominations as the central fact of their faith. The distant memory of Protestant divines preaching on the atoning blood of Jesus or the saving power of Christ's death on the cross prompted him to see in the image of the Crucifixion an overarching metaphor for the dogged, self-reliant American Protestant faith familiar from his Missouri boyhood. But as American Protestantism generally eschewed all images of Christ, Benton turned to Catholic tradition, especially Giotto's frescoes, which he had analyzed as early as 1919 in an effort to understand volumetric forms in space. In looking at Giotto, Benton once again returned to an early source for his art, just as he had in *The Prodigal Son.*

Giotto's *Stigmatization of St. Francis* (c. 1320) depicted the legend of Saint Francis of Assisi receiving the stigmata, or five wounds of Christ's passion, at his cliff-top hermitage on Monte Alverna. Hovering over a dark blue sky, Christ on the cross appears to the startled saint, who kneels in awe. From Christ's outstretched hands, feet, and side emanate five golden rays that run in straight lines to corresponding points on Saint Francis's body. This spiritual event mystically relinks the Passion with all humanity (symbolized in the person of the saint).

In *Again,* Benton took up the suggestion, visualized in Giotto's fresco, that humanity could suffer and share metaphorically in the agony of Christ's death. But he reversed the roles. Instead of Christ imparting his wounds in rays of light to a humble saint, power-crazed Nazis and Fascists wound the Lord. Their twentieth-century "stigmatization" of Jews, non-Aryans, and other groups become marks of hate, rather than wounds of love, that pierce the body of Christ in the violent form of an airplane gun's bullets. Benton transformed the Dugento mountain ledge site of Saint Francis's vision into a rocky battleground that erupts in flame. The role reversal evident in *Again,* coupled with the obvious incongruity of twentieth-century instruments of warfare appearing in an event that transpired in 33 A.D., are typical of the illogical and irrational juxtapositions that form a standard part of Surrealist artistic vocabulary.

Benton's artistic insecurities revealed in *The Prodigal Son* and his drift toward a hybrid Surrealist style, as in *Again,* indicate his awareness that Regionalism could no longer address the needs of the 1940s America. Like Curry before him, Benton's growing self-doubts came at a time when the religious fervor that had stirred the nation for over two decades, and provided a rich source of thematic material for artists, settled into a stalemate. The old fiery evangelists had passed from the scene, while a new generation of leaders (like Billy Graham) had not yet risen to take their places. Fundamentalists and revivalist-oriented

Christians had ended up meeting the religious challenges of their generation by withdrawing from the major denominations. They would use the decade of the 1940s to build up their Bible schools, colleges, seminaries, and independent church structures with which to renew the heavenly warfare against what they perceived as the forces of infidelity and unbelief in the post–World-War-II era.

Faced with this scenario at home, and the more urgent crisis posed to the American way of life by the threat of war, artists like Benton and Curry, who once found in American revivalist religion important and vital sources for the subject matter of their paintings, began to turn their attention elsewhere. In the 1940s, Regionalism passed out of favor. Wood and Curry were both dead by 1946, while Benton, although he eventually reverted to his tried-and-true Regionalist style, had fallen from critical favor. The new times gave birth to Surrealism and to the Abstract Expressionism advocated by Benton's most famous pupil, Jackson Pollock. Religious imagery would continue to appear, as in Stephen Greene's *The Deposition* (1947) and in such Abstract Expressionist works as Mark Rothko's *Baptismal Scene* (1945), Jackson Pollock's *Lucifer* (1947), and Robert Motherwell's *The Homely Protestant* (1948). But the lack of recognizable subject matter in such paintings and the privatized, interiorized artistic vocabulary employed by such painters signaled that the days were numbered when American painting could function as a popularly recognizable commentary upon the role that the "old-time religion" exercised within American culture.

Notes

Preface

1. For an excellent study of the response patterns of revivalism within American Protestantism throughout its history, see William G. McLoughlin, *Revivals, Awakenings, and Reform: An Essay on Religion and Social Change in America, 1607–1977* (Chicago: Univ. of Chicago Press, 1978).
2. For Benton's remarks on Parisian modernism, see Thomas Hart Benton, *An Artist in America* (Columbia: Univ. of Missouri Press, 1981), 24; also Thomas Craven, *Thomas Hart Benton: A Descriptive Catalogue of the Work of Thomas Hart Benton* (New York: Associated American Artists, 1939), 11.

Chapter One
Religion, Revivalism, and the American Scene

1. Thomas Hart Benton, "What's Holding Back American Art?" *Saturday Review of Literature* 34 (Dec. 15, 1951), 9.
2. "U.S. Scene," *Time* 24 (Dec. 24, 1934), 24–27. Benton, "What's Holding Back American Art?" 11. The notion that Regionalism constituted a unified school resulted from a misconception popularized through the 1934 *Time* magazine article on the "U.S. Scene."
3. I am indebted to Karal Ann Marling and her provocative article, "Thomas Hart Benton's *Boomtown:* Regionalism Redefined," *Prospects* 6 (1981), 79ff., for this serial, frontier vision of Benton's work.
4. Benton, *An Artist in America*, 76–77.
5. Thomas Hart Benton Papers, Lyman Field, Benton Testamentary Trusts, Microfilm Roll 2325 in the Archives of American Art, Smithsonian Institution, Washington, D.C. (hereafter cited as THB Papers/AAA).
6. Thomas Hart Benton, "The Intimate Story – Boyhood," undated and unpublished typescript, Microfilm Roll 2325, THB Papers/AAA, 22, 45.
7. Ibid., 18.
8. Ibid.
9. Ibid.

10. Spiva Art Center, Missouri Southern State College, *Thomas Hart Benton: A Personal Commemorative, A Retrospective Exhibition of his Work, 1907–1972* (Kansas City: Burd and Fletcher, 1973), 36.

11. Born in Chesterville, Ohio, Frank Wesley Gunsaulus was first ordained in the Methodist Church and spent four years as a circuit preacher. In 1879 he became a Congregational Minister, eventually taking a pulpit at Plymouth Congregational Church in Chicago in 1887. In 1890 Gunsaulus accepted the pastorate at the Independent Central Church, serving there for twenty years. Gunsaulus's six-foot, two-hundred-pound frame cut an imposing figure from the pulpit. The dramatic control he exercised over his preacher's voice, from thunderous roars to tiny whispers, held great crowds spellbound, and he gave lectures across the country. He also collected paintings, drawings, pottery, textiles, manuscripts, and music, and published several sermons and devotional works. See Edgar A. Bancroft, *Doctor Gunsaulus the Citizen* (Chicago: N.p., 1921).

12. Benton to "Dear Mother," dated March 10, 1907, Microfilm Roll 2325, THB Papers/AAA.

13. Ibid.

14. Benton to "Dear Mother," dated 25 March, 1907, THB Papers/AAA.

15. Benton to "Dear Father," dated May 1907, THB Papers/AAA.

16. Paul Cummings, *Artists in Their Own Words* (New York: St. Martin's, 1970), 39; Thomas Hart Benton, *An American in Art: A Professional and Technical Autobiography* (Lawrence: Univ. Press of Kansas, 1969), 5; "Thomas Benton: American Mural Painter," *Design* 36 (Dec. 1934), 32; Malcolm Cowley, "Benton of Missouri," *New Republic* 92 (Nov. 3, 1937), 375; Thomas Hart Benton, "American Regionalism: A Personal History of the Movement," *University of Kansas Review* 18 (1951), 42.

17. Frederick Jackson Turner, *The Frontier in American History* (New York: Holt, Rinehart and Winston, 1920; rpt., 1947, 1962), 345, 164–65.

18. Roberts Gallagher, "Before the Colors Fade," *American Heritage* 24 (June 1973), 48.

19. Polly Burroughs, *Thomas Hart Benton: A Portrait* (Garden City, N.Y.: Doubleday, 1981), 35.

20. After the couple settled in Kansas City, Benton accustomed himself to Rita's Italian Catholic heritage. Crosses hung in their bedroom and entrance foyer, and in Rita's sewing room was a small statue of the Virgin. The Bentons permitted their daughter Jessie to use paints on the leaded glass windows of the entrance way, transforming them into the stained glass windows familiar to her from church. The author personally inspected Benton's library, housed in the artist's private bedroom at 3616 Belleview, Kansas City. Among the volumes found there were such titles as *The Life of Jesus* by Ernst Renan, *My Daily Bread: A Summary of the Spiritual Life* by Anthony J. Paone, S.J., *The Son of Man* by Emil Ludwig, and *Lives of the Saints* by Joseph Vaun, O.F.M.

21. Burroughs, *Thomas Hart Benton: A Portrait*, 67–68.

22. Thomas Hart Benton, "My American Epic in Paint," *Creative Art* 3 (Dec. 1928), xxxv.

23. Burroughs, *Thomas Hart Benton: A Portrait*, 5–6.

24. *Thomas Hart Benton: Drawing and Watercolor Painting, "The South"* (New York: Delphic Studios, 1929). See also "New Benton Drawings," *New York Times*, Oct. 27, 1929, sec. 9, p. 13; "Thomas Hart Benton: Delphic Studios," *Art News* 28 (Oct. 19, 1929), 183, 185–86; "New York Season," *Art Digest* 4 (March 1930), 16–17.

25. See for example Richard Beer, "The Man from Missouri," *Art News* 32 (Jan. 6, 1934), 11; "The Mural by Thomas Hart Benton," *Pencil Points* 11 (Dec. 1930), 987; "Benton in New Set of Murals Interprets the Life of His Age," *Art Digest* 5 (Dec. 1, 1930), 28, 36; Dan Sullivan, "Benton Reviews His New School Mural of the '30s," *New York Times*, June 5, 1968, p. 38; and Thomas Hart Benton, *The Arts of Life in America: A Series of Murals by Thomas Hart Benton* (New York: Whitney Museum of American Art, 1932), 4–5.

26. Peter G. Mode, "Revivalism as a Phase of Frontier Life," *Journal of Religion* 1 (July 1921), 337.

27. Ibid., 337.

28. Arthur B. Strickland, *The Great American Revival: A Case Study in Historical Evangelism with Implications for Today* (Cincinnati: Standard Press, 1934), 12–13.

29. Benton, "What I Think," Microfilm Roll 2325, THB Papers/AAA, n.p.

30. David Lawrence Chambers, *A Hoosier History, Based on the Mural Paintings of Thomas Hart Benton* (Indianapolis: Century of Progress Commission, 1933), 7.

31. Benton, *An Artist in America*, 12.

32. Unpaginated newspaper clipping, "Artist Benton Ends Exile—Finds City Still Boring," *New York Evening Post*, April 17, 1939, Roll D 225, Associated American Artists Scrapbooks, Archives of American Art, Smithsonian Institution, Washington, D.C. Gift of Emily Francis.

33. Vernon E. Mattson, "The Fundamentalist Mind: An Intellectual History of Religious Fundamentalism in the United States" (Ph.D. diss., Univ. of Kansas, 1971), 27–31.

34. Benjamin Severance Winchester, "Without God Is It Education?" *Forum* 77 (June 1927), 802–10; Harvey Maitland Watts, "Which God and Why Schools?" *Forum* 77 (June 1927), 811–17. See also Frederick K. Stramm, "The Bible Today," *Forum* 79 (April 1928), 537–47; *Forum* 80 (Aug. 1928), 194–203; Montgomery Major, "Shall they Go to the Sunday School?" *Forum* 79 (May 1928), 664–69.

35. Frederick K. Stramm, "The Best Seller Nobody Reads," *Forum and Century* 99 (June 1938), 363–66. Stramm's title, of course, parodies Bruce Barton's best seller, *The Man Nobody Knows* (New York: Grosset and Dunlap, 1924). Barton's book portrays Jesus as the quintessential capitalist businessman investing wisely in human resources, making shrewd "business" decisions, and getting people to produce at their maximum potential.

36. Lawrence E. Schmeckebier, *John Steuart Curry's Pageant of America* (New York: American Artists Group, 1943), 8; Thomas Craven, "John Steuart Curry," *Scribner's* 103 (Jan. 1938), 37, 41; Thomas Craven, "Religious Art of the Kansas Prairie," *New York Herald Tribune*, Nov. 21, 1943, Sec. 4, p. 5.

37. "The Shorter Catechism," in *The Constitution of the United Presbyterian Church in the United States of America* (n.p., n.d.).

38. "Excerpts from J.S. Curry Letters by Mildred Curry Fike, Oct. 1972," Typescript, box 1 of 1, acq. 11/75, folder 19, "Letters 1917, John Steuart Curry to Family," Curry Papers, Archives of American Art, Smithsonian Institution. Gift of Mrs. Stanley R. Fike.

39. Delber H. Elliot, ed., *Semi Centennial of the Reformed Presbyterian Church of Winchester, Kansas* (n.p., 1918).

40. Bret Waller, "An Interview with Mrs. John Steuart Curry," in The University of Kansas Museum of Art, *John Steuart Curry: A Retrospective of His Work* (Lawrence: The Univ. Press of Kansas, 1970); reprinted from *Kansas Quarterly* 2, no. 34 (Fall 1970), 6.

41. Ibid., 15.

42. In letters home during 1917, variously dated January 3, February 3, February 12, and April 23, Curry discusses his attendance at Presbyterian church services, often revealing his attendance at more than one service a day. See Microfilm Roll 2714, John Steuart Curry Papers, Archives of American Art, Smithsonian Institution (hereafter cited as JCS Papers/AAA). Gift of Mrs. Stanley R. Fike.

43. Curry to "Dear Mother," Feb. 3, 1917, Microfilm Roll 2714, JSC Papers/AAA.

44. Curry to "Dear Mother," June 21, 1916, Microfilm Roll 2714, JSC Papers/AAA.

45. Curry's prophesy is included in a letter to "Dear Mother and Father," Dec. 10, 1917, Microfilm Roll 2714, JSC Papers/AAA.

46. Steward B. Cole, *The History of Fundamentalism* (New York: Richard R. Smith, 1931), 230.

47. Curry to "Mary Wickerham," July 23, 1945, recalls his mother's discussing Rev. Coulter's Biblical prophecy in regard to the First World War. Microfilm Roll 164, JSC Papers/AAA, cited with permission of Mrs. John Steuart Curry and William A. McCloy.

48. Ernest R. Sandeen, *Origins of Fundamentalism* (Philadelphia: Fortress, 1968), 22.

49. For an excellent review of the state of agriculture in the 1920s and 1930s, see Wayne D. Rasmussen, *Agriculture in the United States of America: A Documentary History*, vol. 3 of *War and Depression and the New Deal, 1914–1940* (New York: Random House, 1975).

50. Curry to "Dear Father," Nov. 12, 1916, Microfilm Roll 2714, JSC Papers/AAA.

51. M. Sue Kendall, *Rethinking Regionalism: John Steuart Curry and the Kansas Murals Controversy* (Washington, D.C.: Smithsonian Institution, 1986), 94–95.

52. Curry, "Speech before the Madison Art Association," Microfilm Roll 165, JSC Papers/AAA. Excerpts from this speech are quoted in Kendall, *Rethinking Regionalism*, 95.

53. This discovery was first noted by Kendall, who discusses Curry's habit of equating Biblical images with contemporary American settings, noting the parallel between this practice and that of the Old Masters, who likewise conflated Biblical scenes with the costume and setting of their day. Curry would have been familiar with this tradition from his study of paintings at the Louvre.

54. Curry later reworked the pyramidal composition of Géricault's *Medusa* into a sketch of refugees to accompany an article in the *Saturday Evening Post* detailing the massive Ohio River floods of 1937. He rotated the figures fifteen degrees so that instead of a profile view we see them floating head-on into our field of vision. He also exaggerated the pyramidal sweep by including a chimney top on the roof of the storm-swept house. Curry's sketch was rejected by the magazine but is illustrated in Laurence E. Schmeckebier, *John Steuart Curry's Pageant of America*, 121.

55. Curry's first major religious canvas, *Baptism in Kansas*, was painted in 1928, one year before *Gospel Train* and *Prayer for Grace*. He returned to the baptismal theme again in 1932, executing a lithograph, *Baptism in Big Stranger Creek*. Both of these works are discussed in ch. 6.

56. Schmeckebier, *John Steuart Curry's Pageant of America*, 100.

57. Mrs. Smith Curry to "Dear Children," undated, Microfilm Roll 164, JSC Papers/AAA.

58. "The Shorter Catechism," *Constitution of the United Presbyterian Church*.

59. Robert Mapes Anderson, *Vision of the Disinherited: The Making of American Pentecostalism* (New York: Oxford Univ. Press, 1979), 29.

60. Material on the "crisis of sanctification" and the "second blessing," as discussed in the text, is based on information found in Anderson, ch. 2, "The Holiness Background," 28–46.

61. Waller, "An Interview with Mrs. Daniel Schuster," 18.

62. Park Rinaud, *Return from Bohemia: A Painter's Story*, Microfilm Roll D 24, Grant Wood Papers, Archives of American Art, Smithsonian Institution (hereafter cited as GW Papers/AAA). Gift of Doubleday Company.

63. Wanda Corn, "In Detail: Grant Wood's *American Gothic*," *Portfolio* 5 (May/June 1983), 107.

64. Darrell Garwood, *An Artist in Iowa: A Life of Grant Wood* (New York: Norton, 1944), 19–20. Garwood acted as a sort of unofficial biographer of Grant Wood, working closely with friends of the artist and publishing his book shortly after Wood's death.

65. *This is Wood Country* (Davenport, Iowa: Davenport Municipal Art Gallery, 1977), 10, quotes Wood as once stating "I was as bashful a child as ever lived. I could not speak a piece at the Sunday school. . . ."

66. *Return from Bohemia*, Microfilm Roll D 24, GW Papers/AAA.

67. John Liffring Zog, "Grant Wood's Little Sister," *The Iowan* 24 (Sept. 15, 1975), 10.
68. Ibid., 10.
69. Garwood, *An Artist in Iowa*, 92.
70. "Iowa Detail," *Time* 20 (Sept. 5, 1932), 33.
71. For this interpretation of the figures in *First Three Degrees of Free Masonry* I rely on *This Is Grant Wood Country* (Davenport: Davenport Municipal Art Gallery, 1977), 20.
72. *Life* 7 (July 10, 1939), 24–25.
73. Ibid., 25.
74. Nan Wood Graham, "Why my brother painted American Gothic," *Magazine Digest* (May 1944), 45–48. Here Graham clearly identifies the occupation of the man in *American Gothic* as that of a feed store operator or postal clerk, not a farmer. In this article Graham also revealed that the clothes worn by the figures in that painting were deliberately made to look old fashioned and out of date.
75. "American Gothic is Explained to High School Pupils," *Cedar Rapids Gazette,* March 6, 1931.
76. Corn, *Grant Wood: The Regionalist Vision*, 28–29; C.J. Bulleit, "American Normalcy Displayed in Annual Show," *Chicago Evening Post*, Oct. 28, 1930, sec. 3, p. 1, 12; Margaret Thoma, "The Art of Grant Wood," *Demcourier* 12 (May 1942), 8.
77. James Dennis, "An Essay into Landscape: The Art of Grant Wood," *Kansas Quarterly* 4 (Fall 1972), 39.
78. "Iowans Get Mad," *Art Digest* 5 (Jan. 1, 1931), 9.
79. "An Iowa Secret," *Art Digest* 8 (Oct. 1, 1933), 6.
80. "The Sunday Register's Open Forum," *Des Moines Sunday Register*, Dec. 14, 1930, 6.
81. Nan Wood Graham, "Why my brother painted American Gothic," 46.
82. "The Sunday Register's Open Forum," *Des Moines Sunday Register,* Dec. 21, 1930, 6.
83. Garwood, *Artist in Iowa: A Life of Grant Wood*, 120.
84. Walter Prichard Eaton, "American Gothic," *Boston Herald*, Nov. 14, 1930, 26.
85. In *Artist in Iowa: A Life of Grant Wood*, Garwood writes: " . . . the criticism of *American Gothic* was enough to disturb him. He was sensitive to it, and it probably helped to dissuade him from anything more along the same line. He had it in mind to paint a circuit-riding minister on horseback, and thought he could do something with a Bible Belt revival meeting. Nothing ever came of these ideas. So *American Gothic* stood alone" (127).

Chapter Two

Baseball, Booze, Bass Drums, and Ballyhoo

1. "How a Baseball Idol 'Hit the Trail,'" *Literary Digest* 58 (July 8, 1916), 92.
2. Ibid., 92, 94.
3. *American Magazine* 78 (Oct. 1914), 63. Sunday tied with Andrew Carnegie and Judge Lindsay for 8th-place honors.
4. Joseph H. Odell, "The Mechanics of Revivalism," *Atlantic Monthly* 115 (May 1915), 591.
5. Rollo Walter Brown, "George Bellows—American," *Scribner's* 83 (May 1928), 585. See also Charles H. Morgan, *George Bellows: Painter of America* (New York: Reynal, 1965), 17.
6. By 1882, Methodists of a Holiness persuasion regularly joined to form independent and separatist congregations. For an excellent study of the conflicts in Methodism, see Charles Jones, *Perfectionist Persuasion: The Holiness Movement and American Metho-*

dism, 1867–1936 (Metuchen, N.J.: Scarecrow, 1974). For a detailed account of the Holiness-separatist movement, see Robert Mapes Anderson, *Vision of the Disinherited: The Making of American Pentecostalism.*

7. Several scholars have commented on the interrelationship of fundamentalism to urban/rural conflicts. See Winthrop Hudson, *American Protestantism* (Chicago: Univ. of Chicago Press, 1961), 148; Henry F. May, *The End of American Innocence: A Study of the First Years of Our Time, 1912–1917)* New York: Knopf, 1959); and Steward Grant Cole, *The History of Fundamentalism,* 52–53, 163–92. For a critique of this interpretation of fundamentalism, see Robert E. Wenger, "Social Thought in American Fundamentalism, 1918–1933" (Ph.D. diss., Univ. of Nebraska, 1973).

8. George Bellows, "The Big Idea: George Bellows Talks about Patriotism for Beauty," *Touchstone* 1 (July 1917), 270.

9. William G. McLoughlin, Jr., *Billy Sunday Was his Real Name* (Chicago: Univ. of Chicago Press, 1955), 83, quotes unidentified newspaper reports on Rodeheaver as follows: "Rody is one of the greatest adjuncts a revivalist ever had. His musical ability to catch the feeling of the crowd, and his sympathetic smile . . . make him as appealing a figure on the platform as Bryan was in the freshness of his career.

10. Reed, "Back of Billy Sunday," 9.

11. At the conclusion of the 1914 trial for alleged breach of promise, the court ruled in favor of the plaintiff, awarding her $20,000 in damages (McLoughlin, *Billy Sunday,* 269).

12. Joseph Collins, "Revivals Past and Present," *Harper's Magazine* 135 (Nov. 1917), 865.

13. Bernard A. Weisberger, *They Gathered at the River: The Story of the Great Revivalists and Their Impact upon Religion in America* (Boston: Little, Brown, 1958), 252.

14. McLoughlin, *Billy Sunday,* 86.

15. John R. Rice, ed., *The Best of Billy Sunday: 17 Burning Sermons from the most spectacular Evangelist the World has ever Known* (Murfreesboro, Tenn.: Sword of the Lord Publishers, n.d.), 67–68.

16. McLoughlin, *Billy Sunday,* 269, notes that in June 1915 Ackley went so far, while under the influence of drink, as to threaten a lengthy exposé to the press, telling all about the business of professional evangelism.

17. *The Jawbone* 1, 32 (Jan. 1915), 13–15. The masthead of this journal states "Published every now and then in the interests of Righteousness by the Jawbone Publishing Co. Temporary office 1405 West Oxford St., Philadelphia, Pa."

18. Reed, "Back of Billy Sunday," 12.

19. Ibid., 10.

20. *Collier's* 51 (June 26, 1913), 7.

21. "Billy Sunday Hits Philadelphia," *Literary Digest* 50 (Jan. 23, 1915), 152.

22. McLoughlin, *Billy Sunday,* 160.

23. Boardman Robinson made his mark as a noted newspaper illustrator and cartoonist before turning to painting in the 1920s. From 1907 to 1910, Robinson found employment with the *New York Morning Telegram* where he developed a unique style of rapid, sketchlike lines and fresh swashing strokes that differed widely from the prevailing, highly finished style then popular with newspapers. By the time he began to work for the *New York Tribune* in 1910, Robinson's cartoons gained a national reputation. Robinson teamed up with John Reed on his assignment for the *Metropolitan Magazine* to cover the war in the Balkans. Many of these drawings appeared in the 1915 issues of that magazine and were reissued in book form with Reed's *The War in Eastern Europe* in 1916, and in *Cartoons of the War.* By 1916 Robinson had joined the staff of the *Masses.* One of his antiwar cartoons, "Making the World Safe for Democracy," appeared as an exhibit in the government's Espionage Act suit against the *Masses.* For an account of Robinson's place within American journalistic history, see William Murrell,

A History of American Graphic Humor, 1865–1958 (New York: Cooper Square Publishers, 1967), 189, 196–99.

24. Quoted from Sunday's sermon "Theatre, Cards and Dance," in Rice, The Best of Billy Sunday, 130.

25. "40,000 Cheer for War and Religion Mixed by Sunday," New York Times, April 9, 1917, pp. 1, 4.

26. "1,030 Hit the Trail when Sunday Calls; Sailors and Guardsmen in Uniform Among Great Throng of Handshakers," New York Times, April 22, 1917, p. 20.

27. Masses 9 (June 1917), 13.

28. McLoughlin, Billy Sunday, 279.

29. Ibid., 280.

30. Charles H. Morgan, George Bellows: Painter of America (New York: Reynal, 1965), 275.

31. H. Addington Bruce, "With God's Help," Good Housekeeping 79 (Oct. 1924), 171, 177.

32. Ibid., 176.

33. Excerpted from The Best Plays of the Early American Theatre Copyright © 1967 by John Gassner, used by permission of Crown Publishers, Inc. For the impact of this drama on the American Temperance Movement, see Joan L. Silverman, "I'll Never Touch Another Drop: Images of Alcoholism and Temperance in American Popular Culture, 1874–1919" (Ph.D. diss., New York Univ., 1979), 156–60.

34. "The Recall of Evangeline Booth," Literary Digest 75 (Oct. 7, 1922), 34; "Salvation First," Survey 53 (Nov. 15, 1924), 196, notes the following statistics: over 40 million people attended Salvation Army meetings in 1924 alone. The Salvationists managed 59 industrial homes, 45 hotels, 74 labor bureaus, 14 women's homes and hospitals, 5 general hospitals, 8 slum posts and nurseries, 2 dispensaries, and several other types of institutions in their Eastern Territory alone.

35. This description of Evangeline Booth is provided in Herbert Andres Wisbey, "Religion in Action: A History of the Salvation Army in the United States" (Ph.D. diss., Columbia Univ., 1968), 294.

36. "How a Baseball Idol," 34.

37. The description of this Salvation Army annual event is based on Silverman, "I'll Never Touch Another Drop," 311–12.

38. Catalogue of an Exhibition of Original Lithographs by George Bellows (New York: Frederick Keppel, 1921).

39. Silverman, "I'll Never Touch Another Drop," 26–28.

40. C. Howard Hopkins, History of the Y.M.C.A. in North America (New York: Association, 1951), 18.

41. Masses 8 (Feb. 1916), 4.

42. Harry Salpeter, "About Philip Reisman," Coronet 6 (July 1939), 101.

43. Unidentified newspaper clipping, Microfilm Roll NPR 1, Philip Reisman Papers, Archives of American Art, Smithsonian Institution. Lent by Mr. Philip Reisman. Quoted with permission.

44. The information which follows in the text is based on Lilian Brandt, An Impressionistic View of the Winter of 1930–31 in New York City Based on Statements from Some 900 Social Workers and Public Health Nurses (New York: Welfare Council of New York City, 1932), –15.

45. "Sousa Leads Band of Salvation Army," New York Times, May 18, 1930, sec. 1, p. 15.

46. Hugh Leamy, "Tambourines," Collier's 82 (Sept. 8, 1928), 12, 41.

47. Isidor Schneider, "Philip Reisman's Paintings," New Masses 19 (April 21, 1936), 28.

48. New Yorker 12 (April 18, 1936), 61.

49. "Salvation Army: Evangeline Booth to Become Number One Lassie," Newsweek 4

(Sept. 8, 1934), 38; "Army Now Obeys 'General' Eva," *Christian Century* 59 (Sept. 26, 1934), 1221; "Evangeline Booth Salvation Chief," *New York Times*, Sept. 4, 1934, pp. 1, 7; "Miss Booth Plans to Keep All Power," *New York Times*, Sept. 5, 1934, p. 23.

50. "Bosch-esque Satire by Mervin Jules," *Art Digest* 13 (Feb. 15, 1939), 17. This article illustrated Jules's *O! Promise Me!*

51. "Underdog Lover," *Time* 30 (Nov. 8, 1937), 41.

52. In a personal letter from the artist to the author dated July 21, 1984, Jules discussed his habit of painting things he saw around New York City. Another letter, dated October 28, 1984, relates the artist's anti-religious feelings. The lyrics to "Oh Promise Me" are taken from Orwell E. Soien, *Everybody's Favorite Wedding and Sacred Music for the Organ* (New York: Amsco Music Publishing Co., 1948), 17–19. Lyrics used with permission of Songsmith, Inc.

Chapter Three
Prohibition, Politics, and Prophets

1. Dixon Wecter, *The Age of the Great Depression, 1929–1941* (New York: Macmillan, 1948), 71.

2. Soon Man Rhim, "The Response of American Protestantism to Selected Social Problems in the 1930s with Particular Reference to the Liberals, the Fundamentalists, and the Sectarians" (Ph.D. diss., Drew University, 1972), 18.

3. J.T. Larson, "Shall We Repeal or Enforce the Eighteenth Amendment?" *Moody Monthly* 31 (July 1931), 548–49.

4. "The Saloon Again," *Moody Monthly* 38 (July 1938), 560.

5. "The Public and Prohibition," *Pentecost Evangel*, July 20, 1940, p. 7. The *Pentecost Evangel* served as an official organ of the Assemblies of God.

6. The description of the 1934 *WCTU* Convention which follows in the text is based on accounts recorded in Helen E. Tyler, *Where Prayer and Purpose Meet, The WCTU Story, 1874–1949* (Evanston, Ill.: Signal, 1949), 202–203.

7. "Women Help to Dump Booze," *Cleveland Press*, Nov. 19, 1923, p. 2.

8. What was to become the Public Works of Art Project (PWAP) was originally suggested to FDR in a letter from George Biddle dated May 9, 1933. Biddle, descendant of a socially prominent Philadelphia family, brother of Solicitor General and New Deal advisor Francis Biddle, enabled the proposal to gain a fair hearing. Biddle portrayed young American artists as eager supporters of FDR's New Deal proposals, willing to express those ideals and proposals on the public walls of America. After receiving Biddle's letter, FDR asked the artist to speak with Assistant Secretary of the Treasury Lawrence W. Robert, the Custodian of Federal Buildings. Enthusiastic over his initially favorable response, Biddle set about organizing a group of prominent American mural artists who would be sympathetic to this cause.

Biddle's proposal to decorate federal buildings, however, soon ran into trouble when Charles Moore, chairman of the National Commission of Fine Arts, which traditionally advised upon questions involving federal buildings and art, took a decidedly negative stand against any non-classical art in federal buildings. In the meantime, however, Robert had sought advice from fellow treasury department official Edward Bruce, who, enthusiastic over the idea, organized a series of working dinners in the fall of 1933 at his home, recruiting several key government officials to the idea of a government-sponsored public art program.

In November 1933, Bruce and Biddle talked with Charles L. Borie, architect of the Department of Justice Building, who, as building architect, traditionally could se-

lect artists for any decorative scheme the building might require. He also became enthusiastic about a mural project. Biddle and Bruce then secured the support of Public Works Administrator Harold L. Ickes, who transferred a percentage of the $400 million in PWA funds alloted the relief administration to the treasury department for use in a project to employ artists.

With funds on the way, Bruce and Biddle rethought their original plan of having an advisory committee composed of artists in charge of the program, and organized, instead, an advisory committee of New Dealers and the chairman of the Commission of Fine Arts. Bruce acted as secretary of the committee and general overlord of the project.

The PWAP was organized on a national level by using the sixteen regional divisions already set up by the Civil Works Administration and by providing each region with a chairman and an advisory committee selected by the central office in Washington. The regional PWAP Committee received responsibility for selecting and supervising artists within their region. The above is excerpted from Richard D. McKinzie, *The New Deal for Artists* (Princeton: Princeton Univ. Press, 1973), 5–10. Used with permission of Princeton University Press.

9. Selden Rodman, *Portrait of the Artist as an American. Ben Shahn: A Biography with Pictures* (New York: Harper, 1951), 33.

10. Concerning his attitude toward the Sacco-Vanzetti trial, Shahn stated to James Thrall Soby in an interview, "Ever since I could remember I'd wished that I'd been lucky enough to be alive at a great time when something big was going on, like the Crucifixion. And suddenly I realized I was. Here I was living through another crucifixion. Here was something to paint" (quoted in James Thrall Soby, *Ben Shahn* [West Drayton, Middlesex, England: Penguin, 1947], 7). For details of the Sacco-Vanzetti trial, see *The Sacco-Vanzetti Case; Transcript of the Record of Nicola Sacco and Bartolomeo Vanzetti in the Courts of Massachusetts and Subsequent Proceedings, 1920–27* (New York: Holt, 1928–29).

11. Belisario Ramón Contreras, "The New Deal Treasury Department Arts Programs and the American Artists: 1933 to 1943" (Ph.D. diss., The American University, 1967), 35.

12. Ben Shahn to Lloyd Goodrich, n.d., Record Group 121, Records of the Public Building Service of the Social and Economic Branch of the National Archives in Washington, D.C., Entry 117, Box 9, National Archives, Washington, DC. This information is also cited in Contreras, 37.

13. John D. Morse, ed., *Ben Shahn* (New York: Praeger, 1972), 13. For Shahn's attitude on the merits and psychological effects of lithography and commercial lettering upon the eye, see, Ben Shahn, *Love and Joy about Letters* (New York: Grossman, 1963).

14. McKinzie, *The New Deal for Artists*, 14.

15. "80 Jobless Artists Already at Work," *New York Times*, Dec. 22, 1933, p. 19.

16. Rodman, *Portrait of the Artist as an American*, 116.

17. McKinzie, *The New Deal for Artists*, 16.

18. The New York City Art Commission was a local board set up to pass approval on all art commissions to be carried out on New York City public property. As such, it has the final say on public murals and sculptures to be placed in parks, libraries, schools, city buildings, etc. The artistic leanings of this Art Commission, under the leadership of Isaac Newton Phelps Stokes, were decidedly conservative. The Commission rejected Ben Shahn's and Lou Block's designs for Riker's Island penitentiary even after the designs had been approved by the Commissioner of Corrections and by Mayor LaGuardia. Shahn and Block had even taken the precaution of having the prisoners themselves vote on whether they liked the design. The Commission dismissed Shahn's plan as being inappropriate for the corridors leading to the prison chapel.

The New York City Art Commission also delayed the final approval of the murals for the New York Public Library. Edward Laning was finally granted approval to execute his plan for the *History of the Recorded Word* only after Stokes had seen and approved Laning's designs for the Ellis Island Immigrant's Dining Room. Even here, however, Laning was forced to make several specific changes in his design before final approval was granted. The above information is adapted by permission of Smithsonian Institution Press from *The New Deal Art Projects: An Anthology of Memoirs*, edited by Francis V. O'Connor (© Smithsonian Institution Press, Washington, D.C., 1972). See

also Rodman, *Portrait of the Artist as an American*, 96–99.

19. Carleton Beals, *Cyclone Carry: The Story of Carry Nation* (Philadelphia: Chilton, 1962), 110.
20. Ibid., 124–25.
21. Herbert Asbury, *Carry Nation* (New York: Knopf, 1929), 83.
22. Ibid., 123.
23. *Reunion at Kansas City*, Edward Laning Papers, Archives of American Art, Smithsonian Institution. This brochure is contained with an unfilmed group of the artist's papers, Edward Laning File (hereafter cited Laning File/AAA).
24. M. Sue Kendall, *Rethinking Regionalism*, 66ff., discusses the uniqueness of Curry's depiction of John Brown.
25. Charles Driscoll, "Why Men Leave Kansas," *American Mercury* 3 (Oct. 1924), 175, 178.
26. Unfilmed material, Laning File/AAA. This includes a copy of the following transcript from the Art Students League:

PERIOD	COURSE	INSTRUCTOR
Oct. 1927–Feb. 1928	Life drawing, ptg., comp.	John Sloan
March 1928–May 1928	Life drawing, ptg., comp.	T.H. Benton
Oct. 1928–May 1929	Life drawing, ptg., comp.	John Sloan
Jan. 1929–March 1929	Lithography	Charles Locke
Sept. 1929–May 1930	Mural Painting	K.H. Miller
Sept. 1930–April 1931	Mural Painting	K.H. Miller

27. Edward Laning, "The New Deal Mural Projects," in O'Connor, *The New Deal Art Projects*, 82.
28. Undated letter, Dorothy Allen to "Metropolitan Museum of Art," Laning File/AAA.
29. Laning, "The New Deal Mural Projects," in O'Connor, *The New Deal Art Projects*, 81.
30. Edward Laning, "Spoon River Revisited," *American Heritage* 22 (June 1971), 17.
31. Ibid., 105.
32. Ibid.
33. *13th Annual Painting and Sculpture Exhibition* (Los Angeles: Los Angeles Museum, 1932), n.p.
34. Lately Thomas, *Storming Heaven, The Lives and Turmoils of Minnie Kennedy and Aimee Semple McPherson* (New York: Morrow, 1970), 20.
35. Julia N. Bundlong, "Aimee Semple McPherson," *The Nation* 128 (July 19, 1929), 737.
36. Thomas, *Storming Heaven*, 75.
37. "Aimee Semple McPherson Here," *New York Times*, May 13, 1931, p. 27.
38. "'Apparition' on Show in Art Center," *Los Angeles Times*, April 19, 1932, sec. 2, p. 20.
39. Miller also did two other murals for the Section. One, painted in 1938 for the Goose Creek, Texas Post Office, shows *Texas* as a colossal nude figure holding an airplane in one hand while reaching for a star with the other. A tiny Conestoga wagon and locomotive pass below the figure. Miller's other mural, painted for the Island Pond, Ver-

mont Post Office in 1939, shows the local saw mill industry. See Karal Ann Marling, *Wall-to-Wall America: A Cultural History of Post Office Murals in the Great Depression* (Minneapolis: Univ. of Minnesota Press, 1983), 139–40, 162.

40. "Sensation Forecast as Curtain Rises Today on Nurse Balm Suit Against Hutton," *Los Angeles Times*, June 20, 1932, sec. 2, p. 2.

41. "Here Are Winners in Museum Annual," *Los Angeles Times*, April 17, 1932, sec. 3, p. 21.

42. "North to See 'Apparition,'" *Los Angeles Times*, April 21, 1932, sec. 2, p. 8.

43. Ibid.; "'Apparition' on Show at Art Center," *Los Angeles Times*, April 19, 1932, sec. 2, p. 20.

44. "'Apparition' on Show at Art Center," sec. 2, p. 20.

45. "Barse Miller's Award Winning Picture Removed from Show," *Art Digest* 6 (May 1, 1932), 9.

46. Miller enlisted the aid of his colleague and friend Paul Sample, retired president of the California Art Club, in this effort to ensure his painting a public reception. Sample himself painted several works dealing with religious themes and was more than sympathetic to the artist's cause. He considered Miller's cause a fight "to show whether artists shall paint subjects of vital interest or shall be confined to painting pretty flowers and eucalyptus trees" (ibid).

47. "Painting Irks Evangelist; Mrs. McPherson-Hutton Gives Orders for Legal Action to Stop Showing as She Leaves Town," *Los Angeles Times*, April 20, 1932, sec. 2, p. 2.

48. Irving Kolodin, "Propaganda on the Air," *American Mercury* 35 (July 1935), 294.

49. Richard Aiken Davis, "Radio Priest; The Public Career of Fr. Charles Edward Coughlin" (Ph.D. diss., University of North Carolina, 1974), 71–73.

50. Charles E. Coughlin, *Radio Sermons* (Baltimore: Knox and O'Leary, 1931), 152.

51. "Silver Found New Champion in Radio Priest," *New York Times*, April 15, 1934, sec. 2, p. 17.

52. Ibid.

53. Hugo Gellert, "Fascism, War and the Artist," in Jerome Klein, ed., *First American Artists Congress, 1936* (New York: American Artists Congress, 1936), 76. *New Masses*, a Communist literary, political, and cultural journal published regularly between 1930 and 1937, featured articles of political and social interest to which several artists, including Gellert, Shahn, Maxfield Parish, and others contributed illustrations. Gellert furnished drawings for the October 7, 1930, cover, which pictured American Communist journalist John Reed; the July 1931 cover featuring striking coal miners, and a page-length drawing of Lenin which the magazine offered as a framable print to its new subscribers in November, 1931. In addition, numerous articles ridiculing Roosevelt's New Deal measures, the state of race relations in America, and wealthy capitalists featured cartoonlike drawings by Gellert.

54. "The Silver-Tongued Orator," *New Masses* 2 (May 8, 1934), 6.

55. Hugo Gellert, *Aesop Said So* (New York: Covici Friede, 1936), n.p.

Chapter Four
Dixie Divines and Harlem Heavens

1. Seth M. Schneider, "The Negro Church and the Northern City, 1890–1930," in William G. Shade, Roy C. Herrenkohl, eds., *Seven on Black: Reflections on the Negro Experience in America* (Philadelphia: Lippincott, 1969), 94.

2. Ibid., 99.

3. C. Luther Fry, *The U.S. Looks at Its Churches* (New York: Institute of Social and Religious Research, 1930), 21.

4. Arthur Huff Fauset, *Black Gods of the Metropolis,* vol. 3 of Publications of the Philadelphia Anthropological Society (Philadelphia: Univ. of Pennsylvania Press, 1944), 80.

5. For an excellent study of Harlem in the 1920s, see David L. Lewis, *When Harlem was in Vogue* (New York: Knopf, 1981).

6. James Weldon Johnson, *God's Trombones: Seven Negro Sermons in Verse* (New York: Viking, 1927; rpt., 1955), 53, 55, 56.

7. James Weldon Johnson and J. Rosamund Johnson, *The Book of American Negro Spirituals* (New York: Viking, 1955), originally issued in 1926.

8. W.E.B. DuBois, "Of the Faith of Our Fathers," in *The Souls of Black Folk* (Chicago: McClurg, 1903), 193–94.

9. Howard W. Odum and Guy B. Johnson, *The Negro and His Songs: A Study of Typical Negro Songs in the South* (Chapel Hill: Univ. of North Carolina Press, 1925).

10. Newbell N. Puckett, *Folk Beliefs of the Southern Negro* (New York: Negro Universities Press, 1968), originally issued in 1928. Newman I. White, *American Negro Folk Songs* (Cambridge: Harvard Univ. Press, 1928).

11. Eugene O'Neill, *The Emperor Jones, Diff'rent Strokes, The Straw* (New York: Boni and Liveright, 1921), 165.

12. Paul Green, *The Field God and In Abraham's Bosom* (New York: Robert M. McBride, 1927).

13. Dorothy Heyward and Dubose Heyward, *Porgy* (Garden City, N.Y.: Doubleday, Doran, 1928).

14. M.M. Wisehart, "'If You Wish to Know Whether or Not You Really Want a Thing Try Giving It Up' Says Wayman Adams," *American Magazine* 106 (Oct. 1928), 180.

15. For comments on and reproductions of some of Adams's most successful portraits, see Helen Comstock, "Portraits of Wayman Adams," *International Studio* 77 (May 1923), 87–91. The McBeth Gallery Papers, Microfilm Roll NMc 22, Archives of American Art, Smithsonian Institution, Gift of Robert McIntyre contains a letter from Adams to the McBeth Galleries in New York in which the artist quotes the following prices for his portraits: Head $1,500; Two-thirds figure $2,000; full-figure $2,500. For two persons on one canvas Adams quoted a figure of $2,500 for the heads alone, $3,500 for two-thirds of both figures, and $4,000 for a full length, double portrait.

16. In an unspecified interview dated May 31, 1927, Adams stated "I go to New Orleans about every year" (DeWitt McClellan Papers, Microfilm Roll 502, Archives of American Art, Smithsonian Institution, Lent by the New York Historical Society. Quoted with permission).

17. Helen Comstock, "Portraits of Wayman Adams," 90. Adams's Negro portraits of this period bear a close resemblance to such early Winslow Homer canvases as *Sunday Morning in Virginia* and *Cotton Pickers.*

18. "Southern Sketches," *Survey Graphic* 64 (July 1, 1930), 318–19, reproduces four of Adams's watercolors from the Newhouse exhibition.

19. In a letter to the author, dated July 10, 1984, from Janet Feemster, Curatorial Secretary at the Indianapolis Museum of Art, the museum confirmed that *The Offering* was based on a sketch Adams did in New Orleans.

20. Howard Snyder, "A Plantation Revival Service," *Yale Review* 10 (Oct. 1920), 169–80. Synder's article appears to be but one of several articles on religion which the *Yale Review* published during this period. See, for example, Agnes Reppliers, "The Masterful Puritan," *Yale Review* 10 (Jan. 1921), 262–74; James J. Coale, "Protestantism and the Masses," *Yale Review* 11 (Oct. 1921), 78–88; and Howard Snyder, "Paradise Negro School," *Yale Review* 11 (Oct. 1921), 158–69.

21. Snyder, "Plantation Revival Service," 169.
22. Ibid.
23. Ibid., 171–72.
24. Ibid., 170.
25. *The Darkness and the Light: Photographs by Doris Ulmann* (Millerton, N.Y.: Aperture, 1974), 8.
26. Ibid., 10.
27. Ibid.
28. Alice Lee Parker, "American Prints to Be Shown in Italy," *American Magazine of Art* 23 (Oct. 1931), 292.
29. Evelyn Quita Craig, *Black Drama of the Federal Theatre Era* (Amherst: Univ. of Massachusetts Press, 1980), 107.
30. The Salmagundi Club had its beginnings in New York City in December 1871 in the weekly gatherings of a group of art students who met in the sketch class of Jonathan Scott Hartley. From the beginning, the club counted laymen among its members and in 1877 adopted the official name, "The Salmagundi Sketch Club," borrowing the term from an Italian word which indicated a salad containing many ingredients. In 1879 the club began a regular series of "Black and White Exhibitions" displaying the work of club members at the club's new headquarters at Number 1 Union Square. Some club members began to gather for weekly dinners at which beer and the official club beverage, a mixture of coffee and chocolate labeled "Salmagundi" was served. The dinners became a regular feature when the club moved into permanent quarters on 8th Street. From 1879 to 1887 the club developed a national reputation though its annual "Black and White Exhibitions," which were open to all but juried by club members. In 1888 the club changed from being primarily a sketching class and exhibition patron into a social and supper club with an expanded membership of over sixty-five. New quarters were also obtained at 123 5th Avenue. See, William Henry Shelton, *The Salmagundi Club* (New York: Houghton Mifflin, 1918).
31. According to the reports of this dinner and reception for Turner:

> The walls of the club parlor were hung with sketches in black and white, mostly of a humorous nature, especially executed in honor of the occasion. Those which excited the most merriment were a travesty on the *Angelus* by W.H. Shelton, and a clever imitation of Turner, done in oil on a round panel by Thomas Moran. The *Angelus* travesty depicted the peasants both smoking, real patches sewn on the man's garments, real potato skins in the basket, and a real safety pin fastening the woman's skirt. The inscription on the Turner read, "Bought by an American millionaire from a needy English Duke for $291,000.75, painted by Jim Jam M.W. Turner."
>
> (Quoted in Shelton, The Salmagundi Club, 56.)

32. "Mural Turns Gallery into Negro Church," *Art Digest* 8 (March 1, 1934), 25.
33. Keith Marshall, *John McCrady, 1911–1968* (New Orleans: New Orleans Museum of Art, 1975), 12.
34. Ibid.
35. Ibid.
36. Ibid., 16.
37. "Loneliness Stirred his Brush to Activity," *Art Digest* 12 (Oct. 15, 1937), 15.
38. "New Season," *Time* 30 (Oct. 18, 1937), 37. "'Swing Low Sweet Chariot' and other Paintings by McCrady," *Life* 3 (Oct. 18, 1937), 38–42.
39. Stark Young, "Coming to Carry Me Home," *New Republic* 92 (Nov. 3, 1937), 372–73.

40. W.W. Hall, *Eyes on America: The United States as Seen by Her Artists* (New York: Studio Publications, 1942), 76.

41. The number of figures is quoted from "New Season," 37.

42. Roll D 255, Associated American Artists Scrapbooks, Archives of American Art, Smithsonian Institution, Gift of Emily Francis. See also "Art Year," *Time* 31 (Jan. 3, 1938), 28.

43. Dorothy Grafly, "Braver Art in Academy Show," *Philadelphia Record*, undated newspaper clipping from Roll 2415, Franklin Watkins Papers, Archives of American Art, Smithsonian Institution, Gift of Mrs. Ida Harkness.

44. Marshall, *John McCrady, 1911–1968*, 12.

45. Hallie Flanagan, *Arena* (New York: Duell, Sloan and Pearce, 1940), 393. McCrady had an exhibition of his work at the High Museum of Art in Atlanta in November 1937, at which time the museum purchased his *Woman Mounting a Horse*. This exhibition and the sale of McCrady's painting coincided with the dates of the Federal Theatre Project's production of *Heaven Bound* and would seem to indicate that McCrady was in Atlanta sometime during the FTP production. See Marshall, *John McCrady*, 12, for a chronology of McCrady's activities.

46. Harold A. Carter, *The Prayer Tradition of Black People* (Valley Forge, Pa.: Judson, 1976), 59. Excerpted from Newbell Niles Puckett, *Folk Beliefs of the Southern Negro* (Chapel Hill: Univ. North Carolina Press, 1926). Used with permission.

47. Johnson, *God's Trombones: Seven Negro Sermons in Verse*, 53, 55, 56. Used with Permission of Viking Penguin, Inc.

48. Richard Cox, *Caroline Durieux Lithographs of the 30s and 40s* (Baton Rouge: Louisiana State Univ. Press, 1977), 38.

49. Ibid., 3.

50. "She is 'politely cruel, charmingly venomous,'" *Art Digest* 10 (Dec. 1, 1935), 14. This phrase appears in a review of Durieux's work exhibited at the Marie Steiner Galleries, New York, Dec. 12–21, 1935.

51. Carl Zigrosser, *The Artist in America* (New York: Knopf, 1942), 127.

52. Zigrosser, 128, states that *First Communion* dates from 1933 while Cox, 39, implies that Durieux produced this lithograph around 1937, after her return to New Orleans.

53. Caroline Durieux, "An Inquiry into the Nature of Satire," (Master's Thesis, Louisiana State Univ., 1949), 21. Also quoted in Cox, *Caroline Durieux Lithographs*, 39.

54. Federal Writers Project of the Works Progress Administration for the City of New Orleans, *American Guide Series, New Orleans City Guide* (Boston: Houghton Mifflin, 1938), 199.

55. Ibid.

56. Ibid.

57. Lyle Saxon, *Gumbo Ya-Ya: A Collection of Louisiana Folktales* (Boston: Houghton Mifflin, 1945), 210.

58. Ibid., 208.

59. *American Guide Series, New Orleans City Guide*, 200.

60. Ibid.

61. Ibid., 201.

62. Ibid., 205.

63. Ibid.

64. Ibid., 205–206.

65. John Hoshor, *God in a Rolls Royce: The Rise of Father Divine Madman, Menace or Messiah* (New York: Hillman-Curl, 1936), 101–24.

66. Jack Alexander, "All Father's Chillun Got Heavens," *Saturday Evening Post* 212 (Nov. 18, 1939), 72.

67. Robert Weisbrot, *Father Divine and the Struggle for Racial Equality* (Chicago: Univ. of Illinois Press, 1983).

68. St. Clair McKelway and J.J. Liebling, "Profiles: Who Is This King of Glory, II?" *New Yorker* 12 (June 20, 1936), 24.

69. Henry Lee Moon, "Thank You, Father, So Sweet," *New Republic* 88 (Sept. 16, 1936), 149.

70. The photograph of this painting appears in Hoshor, *Rolls Royce*, 103, and Alexander, "All Father's Chillun Got Heavens," 9.

71. Weisbrot, *Father Divine and Racial Equality*, 84.

72. Carl Zigrosser, "Prentiss Taylor," *Exhibition of Prints, Prentiss Taylor* (Richmond: Virginia Museum of Fine Arts, 1942), n.p.

73. Ibid.

74. These lithographs, all done in 1932, are titled *Christ in Alabama, Eight Black Boys, Scottsboro Limited,* and *Town of Scottsboro* (recorded in Zigrosser, "Prentiss Taylor").

75. Public Works of Art Project (PWAP) Papers, Microfilm Roll DC 114, Archives of American Art, Smithsonian Institution. Lent by the National Archives, 8th and Pennsylvania Streets, N.W., Washington, D.C.

76. Charles Spencer Smith, *A History of the African Methodist Church*, vol. 2 (Philadelphia: Book Concern of the A.M.E. Church, 1922), 13-15.

77. Ibid., 36.

78. The identification as "African" of forms of worship practiced by independent Negro Methodist and Baptist congregations captured the attention of several sociologists and religionists in the 1920s and 1930s. See Newbell N. Puckett, *Folk Beliefs of the Southern Negro* (Chapel Hill: Univ. of North Carolina Press, 1926). Also Melville J. Herskovits, *Myth of the Negro Past* (Boston: Beacon Press, 1941) and "What Has Africa Given to America," *New Republic* 84 (Sept. 4, 1935), 92-94.

79. Smith, *A History of the African Methodist Church*, vol. 2, 51-56.

80. Robert Mapes Anderson, *Vision of the Disinherited*, 125.

81. Ibid., 132.

82. Fauset, *Black Gods of the Metropolis*, 20.

Chapter Five
Holy Hymns and Sacred Songs

1. Keith Marshall, *John McCrady, 1911–1968* (New Orleans: New Orleans Museum of Art, 1975), 28.

2. Ibid.

3. W.M. Darling, "Resurgent McCrady Stages Art Show; Local Artist Gets Glory Into Paint and Perhaps Vice Versa," *New Orleans Times-Picayune*, Nov. 10, 1940, sec. 2, p. 2.

4. J. Rosamund Johnson, *Rolling Along in Song: A Chronological Survey of American Negro Music* (New York: Viking/Penguin, 1937; copyright © renewed 1965 by Nora E. Johnson), 48–49. Reprinted by permission of Viking/Penguin, Inc.

5. Darling, "Resurgent McCrady Stages Art Show . . ," 2.

6. "Swope Gallery, Dedicated to American Art, Opens in Terre Haute," *Art Digest* 16 (April 1, 1942), 7.

7. Statement of Purpose submitted by McCrady to the Guggenheim Fellowship Foundation as recorded in Marshall, *John McCrady, 1911–1968*, 49.

8. Lester A. Walton, "Negro is Riding into Prominence by the Spiritual," *New York World*, Jan. 10, 1926, sec. S, p. 8.

9. Ibid. Also, Carl Van Vechten, "All God's Chillun Got Songs," *Theatre Magazine* 42 (Aug. 1925), 24, 63; "Art from the Cabin Door," *Outlook* 141 (Oct. 21, 1925), 268–69.

10. A.M. Chirgwin, "The Vogue of the Negro Spiritual," *Edinburgh Review* 247 (Jan. 1928), 57–74.

11. Ibid., 58.

12. See, for example, A.E. Perkins, "Negro Spirituals from the Far South," *Journal of American Folklore* 35 (April–June 1922), 223–49; A.H. Fausett, "Spirituals," *Journal of American Folklore* 40 (July–Sept. 1927), 294–303; "Notes and Queries: Nine Negro Spirituals," *Journal of American Folklore* 41 (July–Sept. 1928), 579–84; Russel Ames, "Art in Negro Folksong," *Journal of American Folklore* 56 (Oct.–Dec. 1943), 241–54; H.W. Gordon, "Folk Songs of America: Negro 'Shouts,'" *New York Times*, April 24, 1927, sec. 4, pp. 4, 22.

13. See, for example, Marjorie Knox, "In the Cotton Fields," *Etude* 57 (Aug. 1939), 550.

14. B.A. Botkin, "Self-Portraiture and Social Criticism in Negro Folk-Song," *Opportunity* 5 (Feb. 1927), 42.

15. Albert Sydney Beckham, "The Psychology of Negro Spirituals," *Southern Workman* 60 (Sept. 1931), 391–94.

16. "'Swing Low Sweet Chariot' Will Be Popular," *Art Digest* 3 (Mid Jan. 1929), 5–6. Established in 1922 by William H. Harmon, a wealthy New York businessman, the Harmon Foundation was organized as a membership corporation under the laws of New York. Carried on distinctly as a family foundation, it was inaugurated "for the purpose of interesting the founder's children in their responsibility to the social structure, and to help them to render tangible forward-looking service. It was started also as a result of his own long-cherished hope of establishing a constructive type of service that would combine the practical experience of the businessman with public welfare idealism." See *Harmon Foundation Monograph Number 4* (New York: Harmon Foundation, 1932), 7. In 1927, the first of an annual series of literature, art, music, science, business, religion, and education awards were distributed. Dedicated to the purpose of bringing about "a better economic development of the Negro through weighing his accomplishments on a scale with the best that has been done," the awards were distributed annually on February 12, Emancipation Day. In 1929, the year Malvin Gray Johnson received his Harmon Foundation award, the art exhibition segment of the award ceremony was arranged by the Foundation in cooperation with the Commission on Race Relations of the Federal Council of Churches. See, Marian P. Saul, "Negro Ability Gaining Recognition Through Efforts of Harmon Foundation," *Opportunity* 6 (Feb. 1928), 46–47.

17. "Malvin Gray Johnson Memorial," *Art Digest* 9 (May 15, 1935), 18.

18. Charles Z. Offin, "Three Negroes and the Secessionists; Other Events in Manhattan Galleries," *Brooklyn Daily Eagle*, April 28, 1935, sec. C, p. 5.

19. "P.W.A.P. Wins Praise at Its 'Preliminary Hearing' in Washington," *Art Digest* 8 (May 1, 1934), 5–6, 32.

20. "Wins Negro Art Prize," *New York Times*, Jan. 7, 1929, p. 9.

21. "'Swing Low Sweet Chariot' Will Be Popular," 5.

22. Ibid., 5–6.

23. Ibid.

24. From *The Green Pastures* by Marc Connelly. Copyright © 1929, 1930, 1957, 1958 by Marc Connelly. Reprinted by permission of Henry Holt and Company.

25. Copyright © 1930 by Shapiro Bernstein & Co., Inc. Copyright renewed. Used by permission.

26. H.W. Gordon, "Folk Songs of America: Negro Shouts," *New York Times*, April 24, 1927, sec. 4, pp. 4, 22.

27. Marshall, *John McCrady, 1911–1968*, 18.

28. "McCrady Tops Southern League Show," *Art Digest* 15 (May 1, 1941), 13.

29. Letter from John McCrady to Clyde Singer, dated March 17, 1946, as quoted in Marshall, 18.

30. From *Rolling Along in Song*, by J. Rosamund Johnson (1937; copyright © renewed 1965 by Nora E. Johnson), 154–57. Reprinted by permission of Viking Penguin, Inc.

31. Kelly Miller, "The Negro 'Stephen Foster,'" *Etude* 57 (July 1939), 431 and passim. "Putting a Ban on Spirituals," *Southern Workman* 57 (Sept. 1928), 384. "Desecration of Spirituals," *Southern Workman* 51 (Nov. 1922), 501–503.

32. Benjamin Brawley, "The Singing of Spirituals," *Southern Workman* 63 (July 1934), 209–13.

33. Maude Barragan, "Putting the Spirit into Spirituals," *Etude* 49 (Feb. 1931), 95, 148.

34. Ibid., 95.

35. Brawley, "The Singing of Spirituals," 212.

36. Marion Summers, "Studies in Contrasts: Chauvinism and Truth," *Daily Worker* 23 (May 29, 1946), 13.

37. The equation of the three men pictured in *Dilemma* with three different aspects of McCrady's persona was first suggested by Marshall, 38.

38. "An Exhibit Against Lynching," *Crisis* 42 (April 1935), 106.

39. "Art Commentary on Lynching Exhibition Opens," *New York World Telegram*, Feb. 16, 1935, p. 16.

40. Matthew Baigell, "The Relevancy of Curry's Paintings of Black Freedom," in Univ. of Kansas Museum of Art, *John Steuart Curry: A Retrospective Exhibition of His Works Held in the Kansas State Capitol, Topeka, October 3-November 3, 1970* (Topeka: Univ. of Kansas Press, 1970), 19–29.

41. "American Brashness," *Art Digest* 13 (Nov. 15, 1938), 22–23.

42. "Another Nautical Waugh," *Art Digest* 6 (May 1, 1932), 32. "Coulton Waugh, Grand Central Galleries," *Art News* 30 (May 7, 1932), 10.

43. "Against Complacency," *Art Digest* 16 (Jan. 15, 1942), 20.

44. "An Astonishing Jekyll and Hyde," *Art Digest* 6 (May 15, 1932), 16.

45. "Penetrating Observation in a Young Painter, Coulton Waugh," *Art News* 37 (Oct. 29, 1938), 14.

46. "Ruth Star Rose," *Art News* 44 (Jan. 15–31, 1946), 24.

47. Johnson, *Rolling Along in Song*, 204.

48. Lyrics to "De Chain Gang" from *Rolling Along in Song*, by J. Rosamund Johnson (1937; copyright © renewed 1965 by Nora E. Johnson). Reprinted by Permission of Viking Penguin, Inc.

49. William H. Johnson frequently referred to himself in the following terms: "I am a Negro, and a primitive." (Quoted in Adelyn D. Breeskin, *William H. Johnson, 1901–1970* [Washington, D.C.: National Collection of the Fine Arts, Smithsonian Institution, 1971], 8.)

50. Donald Bear, "Recent Pictures by Dan Lutz," *Magazine of Art* 36 (Dec. 1943), 307.

51. "Oakland Oils," *Art Digest* 12 (March 15, 1938), 29.

52. Dalzell Hartfield Galleries, *Dan Lutz Exhibition of Oils and Watercolors, April 15-May 15* (Los Angeles: D. Hartfield Galleries, n.d.), n.p., in Forbes Watson Papers, Microfilm Roll D 56, Archives of American Art, Smithsonian Institution. Gift of Mrs. Forbes Watson.

53. "Dan Lutz Excites West Coast Critics," *Art Digest* 15 (Nov. 1, 1940), 17.

54. Chirgwin, "The Vogue of the Negro Spiritual," 66–67.

55. The popularity of "Swing Low Sweet Chariot" and the demand of white audiences to hear this hymn is noted in A.E. Perkins, "Negro Spirituals from the Far South," *Journal of American Folklore* 35 (April–June 1922), 237.

56. Breeskin, *William H. Johnson, 1901–1970*, 11.
57. Ibid.
58. Ibid., 13.
59. "Is William H. Johnson, Negro Prize Winner, Blazing a New Trail?" *Art Digest* 4 (Mid Jan. 1930), 13.
60. A.E. Perkins, "Negro Spirituals from the Far South," 243. Lyrics quoted with permission of the American Folklore Society, 1703 New Hampshire Avenue, N.W., Washington, D.C.
61. William H. Tallmadge, ed., *Jubilee to Gospel, A Selection of Commercially Recorded Black Religious Music* (Los Angeles: The John Edwards Memorial Foundation, at the Folklore and Mythology Center, Univ. of California at Los Angeles), JEMF-108, side 1, band 3. Used with permission of the John Edwards Memorial Foundation and Mr. William H. Tallmadge.
62. Frederick Douglas Institute, *The Art of Henry O. Tanner 1859–1937.* (Washington, D.C.: National Collection of Fine Arts, Smithsonian Institution, 1969), 11.
63. Breeskin, *William H. Johnson, 1901–1970*, 14.
64. "Botkin Pictures Island Paradise," *New York World-Telegram* 5 (Jan. 1936), 25.
65. The Arts Club of Chicago, *Paintings by Botkin, April 4–19, 1938* (Chicago: Arts Club of Chicago, 1938), n.p.
66. Ibid.
67. Jerome Sidney, "Porgy, Botkin and Bess," *Village Chatter* 13 (June–July 1947), 20.
68. David Ewen, *A Journey to Greatness: The Life and Music of George Gershwin* (New York: Holt, 1956), 282.
69. *Porgy and Bess*, in Stanley Richard, *Ten Great Musicals of the American Theatre* (Radnor, Pa: Chilton, 1973), 83–93.
70. Augustine T. Smythe et al., *The Carolina Low Country* (New York: Macmillan, 1931), 282.
71. There is a great deal of confusion as to the number, location, and titles of Botkin's many canvases dealing with Negro life in the South. In a letter to the author, Botkin's son explained that many of the works were locked away in a Manhattan warehouse, but that there was no exact inventory as to title or location. Likewise, Angela Noel of Childs Gallery, New York, aided in the location of several Botkin works, many in need of cleaning and restoration. Of this group some appear to have been assigned titles by the gallery long after the fact of their being painted.
72. "Depicts Negro Life in Carolina Island Retreat," *Art Digest* 10 (Dec. 1, 1935), 17. "Romanticism and Realism," *Art Digest* 10 (Dec. 15, 1935), 10.
73. Vaughan, "Botkin Pictures Island Paradise," 25.
74. "Porgyland Comes to Marie Herriman Gallery," *American Magazine of Art* 29 (Jan. 1936), 60.
75. Letter from Frank K. Rehn to Franklin Watkins dated March 14, 1932. Franklin Watkins Papers, Microfilm Roll 2411, Archives of American Art, Smithsonian Institution (hereafter cited as FW Papers/AAA). Gift of Mrs. Ida Harkness.
76. "Franklin Watkins," *New York Evening Post*, April 21, 1934, unpaginated clipping from Microfilm Roll 2415, FW Papers/AAA.
77. "Franklin C. Watkins, Carnegie Winner, Makes His Debut," *New York American*, April 21, 1934, unpaginated clipping from Microfilm Roll 2415, FW Papers/AAA.
78. E.M. Benson, "Art of Today, a Radio Interview" (broadcast over WOR, Thursday at 11:30 A.M., 1934, no date indicated), Microfilm Roll 2415, FW Papers/AAA.
79. Earnest Brace, "Franklin Watkins," *American Magazine of Art* 29 (Nov. 1936), 723–29.
80. Ibid., 727.
81. Andrew Carnduff Ritchie, *Franklin C. Watkins* (New York: Museum of Modern Art, 1950), 7.

82. Ibid., 8.

83. See, for example, "The Prize Picture Shocks," *Literary Digest* 111 (Nov. 7, 1931), 16–17.

84. *Charles Shannon Paintings and Drawings* (Montgomery, Ala.: Art South, 1981), 30.

85. "Young Alabama Painter Impresses the Critics with Studies of Negroes," *Newsweek* 11 (Jan. 31, 1938), 22–23.

86. In a letter from Charles Shannon to the author dated October 25, 1984, the artist noted: "I used to go to black churches often in those days. It was easier then to have relationships of trust with black people. Their church services were marvelously spontaneous and rhythmic—these outpourings would go on for hours. I went as an observer. The whole black culture in that time was of great interest and inspiration to me." Shannon included in his letter two pages of sketches he did in 1939 while in attendance at these church services. One, titled *Sunday Night Revival,* consists of a pencil sketch measuring 8⅛ x 6½ inches, and pictures two black men and a shawl-covered woman kneeling before the mourners' bench at the front of a small black church. Above them looms the preacher's stand, covered with a white cloth, from behind which a black-frocked, bespectacled preacher peers out over the congregation. The second sketch, titled *Salvation with Bass Drum,* measures 5 x 7¾ inches. Executed in black and brown ink on paper, it pictures a group of five black people within the same church interior. At the left, a fat woman is seated before a bass drum, pounding with all her might, while behind her stands another woman strumming a guitar. In the center kneel two men, one of whom raises his arm in a frenzy of emotion. The woman at the far right stands, singing, and is about to clash together two large cymbals.

87. "Roundabout the Galleries; Four New Exhibitions," *Art News* 36 (May 21, 1938), 18. "'Down Here', Paintings by Charles Shannon," *Survey Graphic* 27 (Nov. 1938), 552–53.

88. John T. Haletsky, *Paul Sample, Ivy League Regionalist* (Miami: Lowe Art Museum, Univ. of Miami, 1984), 9.

89. Ibid.

90. "The Ivy League in Art," *Art Digest* 12 (Feb. 5, 1938), 3. Alfred Frankenstein, "Paul Sample," *Magazine of Art* 31 (July 1938), 387.

91. *The Immanuel Hymnal* (New York: Macmillan, 1929), hymn number 549. According to the Copyright office, Library of Congress, the lyrics to this hymn are in the public domain.

92. "Paul Sample, Who Worships Peter Breughel." *Art Digest* 8 (May 1, 1934), 8.

93. The background of Mrs. Howland was supplied to the author by Paula F. Glick in a telephone conversation on March 15, 1985.

94. Information on Sample's acquaintance with the church folk of Willoughby Lake and especially with the organist was supplied to the author in a telephone conversation on March 15, 1985, with Paula F. Glick, who is presently researching her Ph.D. dissertation on Paul Sample at Columbia University. It is the folk of Willoughby Lake that Sample put into his painting *Church Supper.*

95. "Paul Sample, Who Worships Peter Breughel," 8. See also John D. Condit, "Paul Sample," (Ph.D. diss., Columbia University, 1953), 25.

96. Herbert G. May and Bruce M. Metzger, eds., *The Annotated Oxford Bible* (New York: Oxford Univ. Press, 1962), 991.

97. "So Full of a Number of Things, Paintings by Lauren Ford," *Survey Graphic* 64 (June 1, 1930), 227.

98. "Bethlehem, Lauren Ford," *Bulletin of the Art Association of Indianapolis, Indiana, John Herron Art Institute* 29 (June 1943), 7–8.

99. Ibid.

100. "Purchase by Corcoran Gallery of Fine Arts Pictures in Current Exhibition Win Applause," *Washington Post,* April 7, 1935, Art and Hobbies Section, p. 5.

101. David Glassberg, "Restoring 'Forgotten Childhood': American Play and the Progressive Era's Elizabethan Past," *American Quarterly* 32 (Fall 1980), 366.

102. Glassberg, "Restoring 'Forgotten Childhood': American Play and The Progressive Era's Elizabethan Past," 366. See also, Van Wych Brooks, *The Wine of the Puritans: A Study of Present-Day America* (New York: M. Kennerly, 1909), 28 and passim. H.L. Mencken, "Puritanism as a Literary Force," *A Book of Prefaces* (New York: Knopf, 1918), 199.

103. Glassberg, "Restoring 'Forgotten Childhood';" 367. See also Constance Mayfield Rourke, *American Humor: A Study of the National Character* (Garden City, N.Y.: Doubleday, 1931).

104. Irving Edgar, *Education for the Needs of Life, A Textbook in the Principles of Education* (New York: Macmillan, 1927), 299.

Chapter Six

Shall We Gather at the River?

1. In 1856 Baptists numbered approximately 700,000 members, or one out of every thirty-two people in the population. By 1900, this number increased to a total of 4,181,686, or one in every eighteen people. See Robert G. Torbet, *A History of the Baptists* (Philadelphia: Judson, 1950), 440. By 1926, total number of churches in the Southern Baptist Convention increased by 5.2% above the 1916 level. See Luther C. Fry, *The U.S. Looks at Its Churches* (New York: Institute of Social and Religious Research, 1930), 37–48).

2. "Washington's Baptism," *Time* 20 (Sept. 5, 1932), 30. John Gano had been converted near Morristown, New Jersey, and first served as pastor there. Gano's early links with New Jersey probably motivated Rev. Sanford to transfer the painting to a New Jersey church.

3. L.C. Barnes, "The John Gano Evidence of George Washington's Religion," *Bulletin of William Jewell College* 24 (1926), 2. "None of the numerous sesquicentennial events in our land has deeper significance than the dedication of a college chapel in the heart of the country in memory of John Gano 'the fighting chaplin' of the Revolutionary War and a close friend of George Washington."

4. Torbet, *A History of the Baptists*, 445–49. See also, George M. Marsden, *Fundamentalism in American Culture: The Shaping of Twentieth-Century Evangelicalism, 1870–1925* (New York: Oxford Univ. Press, 1980, 171–95.

5. Walter Edmund Warren Ellis, "Social and Religious Factors in the Fundamentalist-Modernist Schisms among Baptists in North America, 1895–1934" (Ph.D. diss., University of Pittsburgh, 1974), 189–90.

6. Torbet, *History of the Baptists*, 448–49.

7. Ellis, "Social and Religious Factors," 189–90.

8. "Immersion Fight Lost by Straton," *New York Times*, May 19, 1925, p. 8.

9. "Topics Discussed in Metropolitan Pulpits Yesterday, Radicalism in the Church," *New York Times*, May 18, 1925, p. 8.

10. In 1911, John D. Rockefeller, Sr., turned over the management of his affairs to his son John D. Rockefeller, Jr. The younger Rockefeller was religious but strongly pragmatic, influenced by modern business methods of operation. Rockefeller, Jr., published an article in 1918 titled "The Christian Church, What of Its Future?" in which he argued that as a result of the First World War many otherwise good people felt totally alienated from institutional Christianity. The result, Rockefeller predicted, would be either the death of organized religion or else a resurgence of a lay-directed and organized church which would apply a practical religion based on concrete service to humanity

devoid of ordinances, rituals, and creeds. In short, Rockefeller's church resembled a philanthropic organization. See Ellis, "Social and Religious Factors," 63–68.

11. "Topics Discussed in Metropolitan Pulpits Yesterday," 8.

12. Barnes, "The John Gano Evidence of George Washington's Religion," 2.

13. Ibid., 3.

14. Ibid.

15. Ibid., 5.

16. Ibid., 24.

17. Torbet, *History of the Baptists*, 449.

18. Charles T. Holman, "Are Baptist Churches Christian Churches?" *Christian Century* 47 (March 26, 1930), 398–400.

19. James Alexander Thomas, "The Apostles Were Baptists?" *Christian Century* 47 (April 9, 1930), 466–67.

20. Ibid., 467.

21. "Dr. Poling and Temple Baptist Church," *Christian Century* 53 (Sept. 16, 1936), 1214–16.

22. "Washington's Baptism," *Time*, 30.

23. Ibid.

24. "An Author and a Critic Acquire Bentons," *Art Digest* 4 (Mid Nov. 1929), 8.

25. Robert K. Gilmore, *Ozark Baptizings, Hangings and Other Diversions: Theatrical Folkways of Rural Missouri, 1885–1910* (Norman: Univ. of Oklahoma Press, 1984), 87–88.

26. Ibid., 90.

27. Robert Mapes Anderson, *Vision of the Disinherited*, 58.

28. Ibid., 60.

29. Although Benton never recorded that he actually witnessed immersion baptisms while in Joplin, he did recall the "soliciting preachers" greatly in evidence there, indicating his awareness of the religious ferment in the Joplin of that era. See Benton, *An Artist in America*, 18.

30. Ibid., 12.

31. Thomas Hart Benton Papers, Microfilm Roll 2325, Archives of American Art, Smithsonian Institution, Washington, D.C. Lent by the Benton Testamentary Trusts, Lyman Field, Trustee. Used with permission.

32. Benton, *An Artist in America*, 97–100.

33. Gilmore, *Ozark Baptizings, Hangings and Other Diversions*, 92–93, records the following incidents reported from Missouri newspapers of the 1890s:

> One minister was faced with the task of evacuating from the baptismal pond a reluctant Durham cow who refused to give way to the baptismal party. Another group became entangled in trout lines stretched by fishermen across the stream, and a crowd that gathered at Johnson's Mills (Lawrence County) was astonished when the unrepentant husband of one of the candidates for baptism rode his horse into the middle of the stream and tried to stop the proceedings. . . . A hog, disturbed when a baptismal party invaded his pond, seized a three-year-old child and dragged it some distance away before it could be rescued. The child was unharmed, save for scratches and bruises. The hog was shot."

34. Thomas Hart Benton, "America's Yesterday," *Travel* 63 (July 1934), 6–11, 45–46.

35. Ibid., 9.

36. Dora Aydelotte, "Baptizing at Wild Pigeon," *Form and Century* 91 (June 1934), 377–83. Born in North Carolina, Daugherty spent his early life in Indiana and Ohio. As a child he was regaled with stories of the frontier and tales from Dickens and Poe, and often sketched the legends and lore of frontier America. When the family moved to

Washington, Daugherty began his formal art studies at the Corcoran Art School and later at the Philadelphia Academy of Art. After extensive travel abroad Daugherty began a career as an illustrator until joining the Navy during World War I. Assigned to Newport News, Virginia, he spent his time painting camouflage on ships. After his discharge the artist developed a mural program to decorate the walls of the Cleveland State Theatre, and worked with John Steuart Curry in 1926 on a mural project for the Philadelphia Sesquicentennial. Daugherty won several awards for his book illustrations, and his drawings were in demand in such periodicals as *Forum* and the *New Yorker*. See, "James Daugherty Named Newberry Prize Winner," *Time* 50 (July 26, 1937), 46; May Massee, "James Daugherty's Daniel Boone," *Library Journal* 65 (June 1, 1940), 473–74; Bertha E. Mahoney and Elinor Whitney, *Contemporary Illustrators of Children's Books* (Boston: Woman's Educational and Industrial Union, 1930); Karal Ann Marling, *Wall-to-Wall America*, 33–35.

37. This analysis of Daugherty's mural style is taken from Karal Ann Marling, *Wall-to-Wall America*, 33–35.

38. Benton and Daugherty both spent their youth in Washington, D.C., Benton because his father was a U.S. Congressman and Daugherty because his father worked for the government. Their fathers both loved to read aloud at family gatherings. Both artists had midwestern backgrounds — Benton was from Missouri and Daugherty from a southern Indiana town — wanted to be artists, and pursued their careers while serving in the Navy in Virginia.

39. "Gentle Hogarth," *Time* 50 (July 26, 1937), 46.

40. John Steuart Curry to Margit Varga, Feb. 28, 1942, as recorded in John Steuart Curry Papers, Microfilm Roll 166, Archives of American Art, Smithsonian Institution, Gift of Mrs. J.S. Curry. Quoted with permission of Mrs. J.S. Curry and Dr. William A. McCloy.

41. Thomas Craven, *Catalogue of a Loan Exhibition of Drawings and Paintings by John Steuart Curry with an Evaluation of the Artist and His Work by Thomas Craven* (Chicago: Lakeside Press Galleries, 1939). See New York Public Library Arts Division, Microfilm Roll N 31, Archives of American Art, Smithsonian Institution. Used with permission of Art, Prints and Photographs Division, The New York Public Library, Astor, Lenox and Tilden Foundation.

42. Nathaniel Pousette-Dart, "John Steuart Curry, A Kansas Painter Who Is Typically American," *Art of Today* 6 (Feb. 1935), 16.

43. Edward Alden Jewell, "11th Corcoran Exhibit and German Primitives; Fine American Showing," *New York Times*, Nov. 4, 1928, sec. 9, p. 12.

44. The author is grateful to M. Sue Kendall for calling this fact to his attention. See, M. Sue Kendall, *Rethinking Regionalism, John Steuart Curry and the Kansas Murals Controversy* (Washington, D.C.: Smithsonian Institution, 1986), 92.

45. Bret Waller, "An Interview with Mrs. Daniel Schuster," *John Steuart Curry: A Retrospective of His Work Held in the Kansas State Capitol, Topeka, October 3–November 3, 1970* (Topeka: Univ. of Kansas Press, 1970), 15.

46. Ibid.

47. Stewart G. Cole, *The History of Fundamentalism*, 132; Winthrop S. Hudson, *Religion in America* (New York: Scribner's, 1965), 122–24; Torbet, *History of the Baptists*, 287–92.

48. Ibid., 133.

49. Ibid.

50. Ibid., 137.

51. Ibid., 137–38.

52. Ibid., 138.

53. Craven, *Catalog of a Loan Exhibition of Drawings and Paintings by John Steuart Curry*, 5.

54. John Steuart Curry typescript for American Artists Group monograph on Curry dated March 4, 1945, American Artists Group Papers, Microfilm Roll NAG 2, Archives of American Art, Smithsonian Institution. Lent by the American Artists Group, Inc., 200 Varick Street, New York, New York. Used with permission.

55. Schmeckebier, *John Steuart Curry's Pageant of America*, 9.

56. John Wilson, "The Baptism," in *McGuffy's 6th Eclectic Reader* (New York: Van Nostrand Reinhold, 1921; facsimile reprint of 1921 edition), 180.

57. Ibid., 182.

58. Ibid., 183.

59. Ibid., 184.

60. "Peter Hurd," *American Artist* 39 (Feb. 1975), 46.

61. Peter Hurd, "Painter of New Mexico," *Magazine of Art* 32 (July 1939), 390.

62. Peter Hurd, *Peter Hurd Sketch Book* (Chicago: Swallow Press, 1971), 31.

63. Peter Hurd, "A Southwestern Heritage," *Arizona Highways* 29 (Nov. 1953), 24.

64. Paul Horgan, *Peter Hurd, A Portrait Sketch from Life* (Austin: Univ. of Texas Press, 1964), 23–25.

65. Newell Conyers Wyeth was born in Needham, Massachusetts, in 1882. After deciding upon a career in art, Wyeth joined the cooperative art school of illustrator Howard Pile in Wilmington, Delaware. As a student of Pile Wyeth developed an interest in western themes and spent several years in Colorado and New Mexico, sketching the local scene and living on a Navajo Indian Reservation. Wyeth's sketches appeared in many leading journals, and he also illustrated such well-known books as *The Last of the Mohicans, The Deerslayer,* and *The Song of Hiawatha.* Wyeth also received commissions for public murals, including those in the Federal Reserve Bank of Boston, the Missouri State Capitol, and a triptych for the Chapel of the Holy Spirit for the Episcopal Cathedral in Washington, D.C. See Douglas Allen and Douglas Allen, Jr., *N.C. Wyeth, The Collected Paintings, Illustrations and Murals* (New York: Crown Publishers, 1972).

66. John Meigs, ed., *Peter Hurd, The Lithographs* (Lubbock, Tex.: Baker Gallery Press, 1968), 15.

67. Ibid.

68. Robert Metzger, ed., *My Land Is the Southwest: Peter Hurd Letters and Journals* (College Station, Tex.: Texas A & M Univ. Press, 1983), 172n.

69. Metzger records this sentence in an editor's footnote to a letter from Peter Hurd to Paul Horgan, dated January 28, 1937. In this letter Hurd discusses the revision to his lithograph *Sermon from Revelations,* noting that he had left a party given by Colonel and Mrs. Barry Duffield of the New Mexico Military Institute in order to go off sketching the revival meeting (ibid.).

70. Letter from Hurd to Paul Horgan, dated January 28, 1937, in ibid., 171–72, 173n.

71. Albert Reese, *American Prize Prints of the Twentieth Century* (New York: American Artists Group, 1949), 92.

72. "The Last Frontiersman," *Time* 84 (Jan. 29, 1965), 57.

73. "Peter Hurd," *American Artist,* 100.

74. Paul Horgan, "Peter Hurd: A Portrait Sketch from Life," *Woman's Day* (Aug. 1966), 80.

75. Hurd, "Painter of New Mexico," 390.

76. Peter Hurd, "Peter Hurd Writes with Feeling on the Subject of His Art: New Mexico," *New Mexico Magazine* 39 (Jan. 1961), 34.

77. *John Kelly Fitzpatrick Retrospective Exhibition* (Montgomery, Ala.: Montgomery Museum of Fine Arts, 1970), n.p. (hereafter cited as *Fitzpatrick Retrospective).*

78. Ibid.

79. Ibid.

80. Letter from John Kelly Fitzpatrick to Wilber D. Peat, Director of the John Herron Art Institute, dated September 25, 1932, Herron Museum of Art Papers, Microfilm Roll D 131, Archives of American Art, Smithsonian Institution (hereafter cited as HMA Papers/AAA). Gift of Curtis G. Coley.

81. Ibid.

82. *Fitzpatrick Retrospective.*

83. Typescript of an unpublished interview between Howard Cook and Clinton Adams, director of the Tamarind Institute, Albuquerque, New Mexico, conducted in Santa Fe on July 18, 1978, 1 (hereafter cited as Cook/Adams Interview). Clinton Adams graciously provided the author with a xerox copy of this typescript from the archives of the Tamarind Institute.

84. Ibid., 1.

85. Betty Duffy and Douglas Duffy, *The Graphic Work of Howard Cook: A Catalogue Raisonne* (Bethesda, Md.: Bethesda Art Gallery, 1984), 15.

86. Ibid., 20.

87. Ibid., 21–22.

88. Ibid., 129.

89. Duffy and Duffy record this entry from the journal Cook kept on his second Guggenheim Travel Fellowship tour through the South during 1935–36 (ibid., 129).

90. "A Cook Tour," *Art Digest* 11 (Feb. 15, 1937), 6.

91. Melville J. Herskovits, *The Myth of the Negro Past* (Boston: Beacon, 1941), 232.

92. Ibid.

93. Ibid.

94. Ibid., 233.

95. Typescript of Biography of Conrad Albrizio from PWAP Biographies of Competition Winners and Appointees, Forbes Watson Papers, Microfilm Roll D 51, Archives of American Art, Smithsonian Institution (hereafter cited as FWP/AAA). Gift of Mrs. Forbes Watson.

96. Jules Korscheen, "The Federation of A.E.C. and T. and the CWA," *Pencil Points* 15 (Jan. 1934), 43. This article illustrates two of Albrizio's fresco murals for the Louisiana State Capitol.

97. FWP/AAA.

98. "Albrizio's Station," *Commonweal* 21 (Feb. 15, 1935), 449–50.

99. The artist also painted a mural for the Russellville, Alabama, Post Office in 1938. This is illustrated in Marling, *Wall-To-Wall America*, 172.

100. John Dollard, *Caste and Class in a Southern Town* (New Haven: Yale Univ. Press, 1937; rpt., New York: Doubleday, 1957), 237–38.

Chapter Seven
Revivalism Redirected

1. Thomas Hart Benton, "American Regionalism: A Personal History of the Movement," *University of Kansas City Review* 18 (1951), 74–75.

2. "'The Light of the World': An Interpretation of the State of Our Time, Created Especially for this Issue of Esquire by 'The Most Moving of Living Painters' John Steuart Curry," *Esquire* 16 (Dec. 1941), 100 and insert.

3. Ibid.

4. Ibid.

5. See, for example, Thomas Craven, "John Steuart Curry," *Scribner's* 103 (Jan. 1938), 38, 41.

6. In *Line Storm,* the racing horses and hay wagon head for the sheltering barn in the valley below. In *Tornado Over Kansas,* the family makes for the safety of their earth cellar. The movement in both these works contrasts with the lack of activity of the crowd in *The Light of the World.* The people in the latter simply watch the storm without running for the protection of the buildings in the background. In *Tornado Over Kansas,* the endurance and strength of the family unit in meeting the challenges of their Kansas environment are suggested in the twisting funnel cloud on the horizon. The twisted, active torso of the father in *Tornado Over Kansas* contrasts sharply with the still poses of the men who occupy the vanguard of the crowd in *The Light of the World;* all they can manage is to point at the threatening storm without taking action to avert its impact.

7. Matthew 5:14-16, as recorded in *The Jerusalem Bible* (Garden City, N.Y.: Doubleday, 1966), 22.

8. Bret Waller, "An Interview with Mrs. John Steuart Curry," in *John Steuart Curry: A Retrospective of His Work Held in the Kansas State Capitol, Topeka, October 3–November 3, 1970* (Lawrence: Univ. of Kansas Press, 1970), 10–11.

9. The notion of the apocalyptic and pre-millenial underpinnings of Curry's *Tragic Prelude,* discussed below, is based on the Topeka murals originally discussed by M. Sue Kendall, *Rethinking Regionalism: John Steuart Curry and the Kansas Murals Controversy* (Washington: Smithsonian Institution, 1986), 67–90.

10. William Allen White was a college classmate of Curry's father and, in the early days of John Steuart Curry's career, helped the artist gain exposure in his native state of Kansas. As editor of the *Emporia Gazette* he helped organize a tour of Curry's painting throughout the state.

11. Letter from John Steuart Curry to Miss Doris Fleeson, *New York Daily News,* May 31, 1941, Microfilm Roll 164, JSC Papers/AAA. Gift of Mrs. J.S. Curry. Used with permission of Mrs. J.S. Curry and Dr. William A. McCloy.

12. Letter from M. Scott Stewart to John Steuart Curry, dated January 14, 1942, R. Eugene Curry Papers, Microfilm Roll 2743, Archives of American Art, Smithsonian Institution. Gift of R. Eugene Curry.

13. "'Road to Victory,' A Procession of Photographs of the Nation at War Directed by Lt. Commander Edward Steichen, U.S.N.R. Text by Carl Sandburg," *U.S. Camera 1943* (New York: Duell, Sloan and Pearce, 1942), 19–21.

14. Benton, *An Artist In America,* 321.

15. Ibid., 296–97.

16. Ibid., 297.

17. Matthew Baigell, *Thomas Hart Benton* (New York: Abrams, 1973), 154, 156.

18. For a fine analysis of the popularity of Surrealism in America during the late 1930s and early 1940s, see Erika Lee Doss, "Regionalists in Hollywood: Painting, Film, Patronage, 1925–1945" (Ph.D. diss., University of Minnesota, 1983), 225–42.

19. Baigell gives the date of this work as 1943, and a photograph of this painting obtained by the author from the Dallas Museum of Fine Arts gives the date as 1943. However, this latter date is obviously incorrect, since an article by Milton Brown, "From Salon to Saloon," *Parnassus* 13 (May 1941), 193–94 carries a reproduction of the finished canvas on page 193.

20. Polly Burroughs, *Thomas Hart Benton: A Portrait* (Garden City, N.Y.: Doubleday, 1981), 136. Burroughs reproduces Benton's first sketch of this shack (done in 1921) as Plate 17 in her book.

21. Benton, *An Artist in America,* 298.

22. Ibid.

23. Peter Blume was born in Russia and came to America at the age of five. He studied at the New York Art Students League, where he became interested in the Precisionism of Charles Sheeler. But Blume soon began to alter Sheeler's Precisionist style by adding incongruous and ironic elements to his pictures. His first major success was his 1930 canvas titled *Parade*, which pictured a man walking down a DeChirico-like street and holding a pole from which a suit of armor and machine-like parts were suspended. Blume's *South of Scranton* received first prize at the 1934 *Carnegie International*. This work displays a Surrealist arrangement of freely associated images which Blume remembered seeing on a trip to South Carolina. *The Eternal City* brought Blume his greatest notoriety, especially after the Corcoran Gallery in Washington, D.C., refused to hang the work because of political implications. See, Lee Nordless, ed., *Art USA Now*, vol. 1 (New York: Viking Press, 1963), 148.

24. The recipient of a Guggenheim Fellowship, Blume traveled to Italy to paint and study in 1932–34. This visit coincided with the tenth anniversary of the Fascist March on Rome, and Mussolini's government held massive demonstrations and parades to commemorate the event. At the same time, Mussolini's Fascists invaded Ethiopia, sealed the Axis Pact with Hitler, and announced a general mobilization of 20 million soldiers. These political events remained fresh in Blume's memory after he returned to the United States and propelled the artist to paint *The Eternal City* from 1934 to 1937. See Abraham A. Davidson, *The Eccentrics and Other Visionary Painters* (New York: Dutton, 1978), 170–71.

25. Benton, *The Year of Peril: A Series of War Paintings by Thomas Hart Benton* (Chicago: Abbott Laboratories, 1942), n.p.

26. Doss, "Regionalists in Hollywood," 234.

27. For popular perceptions about the religious associations of Millet's *Angelus* as these were understood in America, see Laura Meixnier, "Popular Criticism of Jean-Francois Millet in Nineteenth-Century America," *Art Bulletin* 65 (March 1983), 94–105.

Selected Bibliography

This bibliography lists only those books and journal articles that directly bear upon the artists and issues discussed in the text. This list is not all-inclusive or exhaustive. The reader should also take note of the many newspaper articles, exhibition catalogues, and doctoral dissertations listed in the notes to each chapter. These provide additional sources of valuable information.

Several rich archival sources should also be consulted. Principal among these is the Archives of American Art, Smithsonian Institution, Washington, D.C., a depository of both microfilm and documentary material relating to American artists, collectors, galleries, museums, and dealers. Many of the heretofore obscure facts surrounding the personal lives of artists discussed in the text can be uncovered in materials stored in this archive. Similarly, the National Archives in Washington, D.C., and the Library of Congress film bureau contain equally important collections of useful information.

BOOKS

Adams, Clinton. *American Lithographers 1900–1660: The Artists and Their Painters.* Albuquerque: Univ. of New Mexico Press, 1983.

Allen, William Francis, et al. *Slave Songs of the United States.* New York: Oak Publications, 1965.

Anderson, Robert Mapes. *Vision of the Disinherited: The Making of American Pentecostalism.* New York: Oxford Univ. Press, 1979.

Asbury, Herbert. *Carry Nation.* New York: Knopf, 1929.

Baigell, Matthew. *Thomas Hart Benton.* New York: Abrams, 1973.

———. *A Thomas Hart Benton Miscellany: Selections from His Published Opinions, 1916–1960.* Lawrence: Univ. of Kansas Press, 1971.

Beals, Carleton. *Cyclone Carry: The Story of Carry Nation.* Philadelphia: Chilton, 1962.

Bellows, Emma S., ed. *George Bellows: His Lithographs.* New York: Knopf, 1927.

Benton, Thomas Hart. *An American in Art: A Professional and Technical Autobiography.* Lawrence: Univ. of Kansas Press, 1969.

———. *An Artist in America,* Columbia: Univ. of Missouri Press, 1981.

Brooks, Van Wyck. *The Wine of the Puritans: A Study of the National Character*. Garden City, N.Y.: Doubleday, 1931.

Burroughs, Polly. *Thomas Hart Benton: A Portrait*. Garden City, N.Y.: Doubleday, 1981.

Carter, Harold A. *The Prayer Tradition of Black People*. Valley Forge, N.Y.: Judson, 1976.

Chambers, David Laurence. *A Hoosier History Based on the Mural Paintings of Thomas Hart Benton*. Indianapolis: Century of Progress Commission, 1933.

Cole, Stewart G. *The History of Fundamentalism*. New York: Smith, 1931.

Connelly, Marc. *The Green Pastures: A Fable Suggested by Roark Bradford's Southern Sketches, "Ol Man Adam and His Chillun'"*. New York: Farrar and Rinehart, 1930.

Corn, Wanda M. *Grant Wood: The Regionalist Vision*. New Haven: Yale Univ. Press, 1983.

Coughlin, Charles E. *Radio Sermons*. Baltimore: Knox and O'Leary, 1931.

Cox, Richard. *Caroline Durieux Lithographs of the 30s and 40s*. Baton Rouge: Louisiana State Univ. Press, 1977.

Craig, Evelyn Quita. *Black Drama of the Federal Theatre Era*. Amherst: Univ. of Massachusetts Press, 1980.

Craven, Thomas, ed. *A Treasury of American Prints*. New York: Simon and Schuster, 1939.

Cummings, Paul. *Artists in Their Own Words*. New York: St. Martin's, 1970.

The Darkness and the Light: Photographs by Doris Ulmann. Millerton, N.Y.: Aperture, 1974.

Dennis, James M. *Grant Wood: A Study in American Art and Culture*. New York: Viking, 1975.

Dollard, John. *Caste and Class in a Southern Town*. New Haven: Yale Univ. Press, 1937. Rpt. Garden City, N.Y.: Doubleday, 1957.

Dooley, Roger. *From Scarface to Scarlett: American Films in the 1930s*. New York: Harcourt Brace Jovanovitch, 1981.

The Doré Bible Illustrations: 241 Illustrations by Gustave Doré. New York: Dover, 1974.

Du Bois, W.E.B. *The Souls of Black Folk*. Chicago: McClurg, 1903.

Ellis, William T. *"Billy" Sunday the Man and His Message*. N.p., 1917.

Fauset, Arthur Huff. *Black Gods of the Metropolis*. Publications of the Philadelphia Anthropological Society, vol. 3. Philadelphia: Univ. of Pennsylvania Press, 1944.

Federal Writers Project of the Works Progress Administration for the City of New Orleans. *American Guide Series, New Orleans City Guide*. Boston: Houghton Mifflin, 1938.

Flanagan, Hallie. *Arena*. New York: Duell, Sloan and Pearce, 1940.

Fry, C. Luther. *The U.S. Looks at Its Churches*. New York: Institute of Social and Religious Research, 1930.

The Fundamentals: A Testimony of Truth. Chicago: Testimony Publishing Co., 1910–15.

Garwood, Darrell. *Artist in Iowa: A Life of Grant Wood*. New York: Norton, 1944.

Gellert, Hugo. *Aesop Said So*. New York: Covici Friede, 1936.

———. *Comrade Gulliver: An Illustrated Account of Travel into that Strange Country the United States of America*. New York: Putnam's, 1935.

———. *Karl Marx 'Capital' in Lithographs*. New York: Ray Long and Richard K. Smith, 1934.

Gilmore, Robert K. *Ozark Baptizings, Hangings and other Diversions: Theatrical Folkways of Rural Missouri 1885–1920*. Norman: Univ. of Oklahoma Press, 1984.

Green, Paul. *The Field God and In Abraham's Bosom*. New York: Robert M. McBride, 1927.

Herskovits, Melville J. *The Myth of the Negro Past*. Boston: Beacon, 1941.

Heyward, Dorothy, and Dubose Heyward. *Porgy*. Garden City, N.Y.: Doubleday, Doran, 1928.

Hofstadter, Richard. *Anti-Intellectualism in American Life*. New York: Knopf, 1966.

Horgan, Paul. *Peter Hurd: A Portrait Sketch from Life*. Austin: Univ. of Texas Press, 1964.

Hoshor, John. *God in a Rolls Royce: The Rise of Father Divine, Madman, Menace or Messiah*. New York: Hillman-Curl, 1936.

Hughes, Langston, and Arna Bontemps. *The Book of Negro Folklore*. New York: Dodd, Mead, 1958.

Hurd, Peter, *Peter Hurd Sketch Book*. Chicago: Swallow Press, 1971.

Johnson, J. Rosamund. *Rolling Along in Song: A Chronological Survey of American Negro Music.* New York: Viking, 1937.

Johnson, James Weldon. *God's Trombones: Seven Negro Sermons in Verse.* New York: Viking, 1927.

————, and J. Rosamund Johnson. *The Book of American Negro Spirituals.* New York: Viking, 1935.

Jones, Charles. *Perfectionist Persuasion: The Holiness Movement and American Methodism, 1867–1936.* Metuchen, N.J.: Scarecrow, 1974.

Klein, Jerome, ed. *First American Artists Congress, 1936.* New York: American Artists Congress, 1936.

Lewis, Davis L. *When Harlem Was in Vogue.* New York: Knopf, 1981.

McKinzie, Richard D. *The New Deal for Artists.* Princeton, N.J.: Princeton Univ. Press, 1973.

McLoughlin, William G. *Billy Sunday Was His Real Name.* Chicago: Univ. of Chicago Press, 1955.

————. *Modern Revivalism: Charles Gradison Finney to Billy Graham.* New York: Ronald Press, 1959.

————. *Revivals, Awakenings and Reform: An Essay on Religion and Social Change in America, 1607–1977.* Chicago: Univ. of Chicago Press, 1978.

Marling, Karal Ann. *Wall-to-Wall America: A Cultural History of Post-Office Murals in the Great Depression.* Minneapolis: Univ. of Minnesota Press, 1982.

————. *Tom Benton and His Drawings.* Columbia: Univ. of Missouri Press, 1985.

Marsden, George M. *Fundamentalism in American Culture: The Shaping of Twentieth-Century Evangelicalism, 1870–1925.* New York: Oxford Univ. Press, 1980.

May, Henry F. *The End of American Innocence: A Study of the First Years of our Time, 1912–1917.* New York: Knopf, 1959.

Mayes, Benjamin E., and Joseph W. Nicholson. *The Negro's Church.* New York: Institute of Social and Religious Research, 1933.

Meigs, John, ed. *Peter Hurd: The Lithographs.* Lubbock, Tex.: Baker Gallery Press, 1968.

Mode, Peter G. *The Frontier Spirit in American Christianity.* New York: Macmillan, 1923.

Morgan, Charles H. *George Bellows: Painter of America.* New York: Reynal, 1965.

Morse, John D., ed. *Ben Shahn.* New York: Praeger, 1972.

Nation, Carry A. *The Use and Need of the Life of Carry A. Nation.* Topeka, Kans.: F.M. Stevens, 1905.

Nottingham, Elizabeth K. *Methodism and the Frontier: Indiana Proving Ground.* New York: Columbia Univ. Press, 1941.

O'Connor, Francis V. *Federal Support for the Visual Arts: The New Deal Then and Now.* Greenwich, Conn.: New York Graphic Society, 1969.

————. *The New Deal Art Projects: An Anthology of Memoirs.* Washington, D.C.: Smithsonian Institution Press, 1972.

O'Connor, John, and Lorraine Brown. *Free, Adult, Uncensored: The Living History of the Federal Theatre Project.* Washington, D.C.: New Republic Books, 1978.

Odum, Howard P., and Guy B. Johnson. *The Negro and His Songs: A Study of Typical Negro Sons in the South.* Chapel Hill: Univ. of North Carolina Press, 1925.

Puckett, Newbell N. *Folk Beliefs of the Southern Negro.* New York: Negro Universities Press, 1968.

Reese, Albert. *American Prize Prints of the 20th Century.* New York: American Artists Group, 1949.

Rice, John R., ed. *The Best of Billy Sunday: 17 Burning Sermons from the Most Spectacular Evangelist the World Has Ever Known.* Murfreesboro, Tenn.: Sword of the Lord Publishers, n.d.

Rodman, Selden. *Portrait of the Artist as an American. Ben Shahn: A Biography with Pictures.* New York: Harper, 1951.

Sandeen, Ernest R. *Origins of Fundamentalism.* Philadelphia: Fortress, 1968.

Saxon, Lyle. *Gumbo Ya-Ya: A Collection of Louisiana Folktales.* Boston: Houghton Mifflin, 1945.

Scarborough, Dorothy. *On the Trail of Negro Folk Songs.* Cambridge: Harvard Univ. Press, 1925.

Schmeckebier, Laurence E. *John Steuart Curry's Pageant of America.* New York: American Artists Group, 1943.

Shade, William G., and Roy C. Herrenkohl, eds. *Seven on Black: Reflections on the Negro Experience in America.* Philadelphia: Lippincott, 1969.

Smythe, Augustine, et al. *The Carolina Low Country.* New York: Macmillan, 1931.

Soby, James Thrall. *Ben Shahn.* West Drayton, Middlesex, England: Penguin Books, 1947.

⸻. *Painting, Drawing, Prints: Salvador Dali.* New York: Museum of Modern Art, 1941.

Stickland, Arthur B. *The Great American Revival: A Case Study in Historical Evangelism with Implications for Today.* Cincinnati: Standard Press, 1934.

Thomas, Lately. *Storming Heaven: The Lives and Turmoils of Minnie Kennedy and Aimee Semple McPherson.* New York: Morrow, 1970.

Turner, Frederick Jackson. *The Frontier in American History.* New York: Holt, Rinehart and Winston, 1920.

Tyler, Helen E. *Where Prayer and Purpose Meet: The WCTU Story, 1874–1949.* Evanston, Ill.: Signal Press, 1949.

Wecter, Dixon. *The Age of the Great Depression, 1929–1941.* New York: Macmillan, 1948.

Weisberger, Bernard A. *They Gathered at the River: The Story of the Great Revivalists and Their Impact upon Religion in America.* Boston: Little, Brown, 1958.

Weisbrot, Robert. *Father Divine and the Struggle for Racial Equality.* Chicago: Univ. of Illinois Press, 1983.

White, Newman I. *American Negro Folk Songs.* Cambridge: Harvard Univ. Press, 1928.

Wilson, John. "The Baptism," in *McGuffey's 6th Eclectic Reader.* New York: Van Nostrand Reinhold, 1921 (facsimile reprint of 1921 edition), 180–85.

Wood, Grant. *Revolt from the City.* Iowa City, Iowa: Clio Press, 1935.

Zigrosser, Carl. *The Artist in America: 24 Close-ups of Contemporary Printmakers.* New York: Knopf, 1942.

MAGAZINE AND JOURNAL ARTICLES

"Against Complacency." *Art Digest* 16 (1942):20.

Alexander, Jack. "All Father's Chillun Got Heavens." *Saturday Evening Post* 212 (1939): 8–9 and passim.

"American Brashness." *Art Digest* 13 (1938):22–23.

Ames, Russell. "Art in Negro Folksong." *Journal of American Folklore* 56 (1943):241–54.

"Another Nautical Waugh." *Outlook* 141 (1925):268–69.

"An Art Exhibit Against Lynching." *Crisis* 42 (1935):106.

"Art from the Cabin Door." *Outlook* 141 (1925):268–69.

"Art Year." *Time* 31 (1938):28.

Aydelotte, Dora. "Baptizing at Wild Pigeon." *Forum and Century* 91 (1934):377–83.

"An Author and a Critic Acquire Bentons." *Art Digest* 4 (1929):8.

"An Iowa Secret." *Art Digest* 8 (1935):6.

Baigell, Matthew. "Thomas Hart Benton in the 1920s." *Art Journal* 29 (1970):422–29.

Barnes, L.C. "The John Gano Evidence of George Washington's Religion." *Bulletin of William Jewell College* 24 (1926):1–24.

Barragan, Maude. "Putting Spirit into Spirituals." *Etude* 49 (1931):95, 148.

"Barse Miller's Award Winning Picture Removed from Show." *Art Digest* 6 (1932):9.

Barton, Bruce. "Billy Sunday—Baseball Evangelist." *Collier's* 51 (1913):7–8, 30.

Bear, Donald. "Recent Pictures by Dan Lutz." *Magazine of Art* 36 (1943):307.

Beckham, Albert Sidney. "The Psychology of Negro Spirituals." *Southern Workman* 60 (1931): 391–94.

Beer, Richard. "The Man From Missouri." *Art News* 32 (1934):11.

Bellows, George. "The Big Idea: George Bellows Talks about Patriotism for Beauty." *Touchstone* 1 (1917):269–75.

"Benton in New Set of Murals Interprets the Life of His Age." *Art Digest* 5 (1930): 28, 36.

Benton, Thomas Hart. "American Regionalism: A Personal History of the Movement." *University of Kansas City Review* 18 (1951):41–75.

———. "America's Yesterday." *Travel* 63 (1934):6–11, 45–46.

———. "My American Epic in Paint." *Creative Art* 3 (1928):xxxi–xxxvi.

———. "What's Holding Back American Art?" *Saturday Review of Literature* 34 (1951):9–11, 38.

"Billy Sunday Hits Philadelphia." *Literary Digest* 50 (1915):152–53.

"Bosch-esque Satire by Mervin Jules." *Art Digest* 13 (1939):17.

Brace, Ernest. "Franklin Watkins." *American Magazine of Art* 29 (1936):723–29.

Brawley, Benjamin. "The Singing of Spirituals." *Southern Workman* 63 (1934):109–213.

Brown, Milton. "From Salon to Saloon." *Parnassus* 13 (1941):193–94.

Bruening, Margaret. "John McCrady Interprets the South." *Art Digest* 20 (1946):10.

Brown, Rollo Walter. "George Bellows—American." *Scribner's* 83 (1915):9–12 and passim.

Bruce H. Addington. "With God's Help." *Good Housekeeping* 79 (1924):171, 177–78.

Bundlong, Julia N. "Aimee Semple McPherson." *Nation* 128 (1929):49–51.

Cahill, Holger. "American Art Today and in the World of Tomorrow: National Panorama of the WPA Projects." *Art News* 38 (1940):49–51.

Chirgwin, A.M. "The Vogue of the Negro Spiritual." *Edinburgh Review* 247 (1928):57–74.

Comstock, Helen. "Portraits of Wayman Adams." *International Studio* 77 (1923):87–91.

"A Cook Tour." *Art Digest* 11 (1937):6.

Corn, Wanda. "In Detail: Grant Wood's *American Gothic*." *Portfolio* 5 (1983):106–11.

"Coulton Waugh, Grand Central Galleries." *Art News* 30 (1932):10.

Cowley, Malcolm. "Benton of Missouri." *New Republic* 92 (1937):375.

Craven, Thomas. "Grant Wood." *Scribner's* 101 (1937):16–22.

———. "John Steuart Curry." *Scribner's* 103 (1938):36–41, 96, 98.

"Dan Lutz Excites West Coast Critics." *Art Digest* 15 (1940):17.

Dennis, James. "An Essay into Landscape: The Art of Grant Wood." *Kansas Quarterly* 4 (1972): 12–122.

"Depicts Negro Life in Carolina Retreat." *Art Digest* 10 (1935):17.

"Desecration of Spirituals." *Southern Workman* 51 (1922):501–503.

Desskinger, Sutherland. "Heaven is in Harlem and a Rolls Royce the 'Sweet Chariot' of a Little Black God." *Forum and Century* 95 (1936):211–18.

"'Down Here,' Paintings by Charles Shannon." *Survey Graphic* 27 (1938):552–53.

Driscoll, Charles. "Why Men Leave Kansas." *American Mercury* 3 (1924):175–78.

"Dyson's Etchings Bits into American Life." *Art Digest* 5 (1931):19.

Edwards, Martha L. "Religious Forces in the United States, 1815–1830." *Mississippi Valley Historical Review* 5 (1919):434–49.

Fausett, A.E. "Negro Spirituals from the Far South." *Journal of American Folklore* 40 (July–Sept. 1927):294–303.

Fisher, William Arms. "'Swing Low Sweet Chariot': The Romance of a Famous Spiritual." *Etude* 50(1932):536.

Frankenstein, Alfred. "Paul Sample." *Magazine of Art* 31 (1938):387.

"George Bellows" *Life* 20 (1925):75.

Geweher, W.M. "Some Factors in the Expansion of Frontier Methodism." *Journal of Religions* 8 (1928):99–120.

Goodrich, Lloyd. "In Missoura." *The Arts* 6 (1924):338.

Herskovits, Melville J. "What Has Africa Given to America?" *New Republic* 84 (1935):149.

"How a Baseball Idol 'Hit the Trail.'" *Literary Digest* 58 (1916):92, 94–95.

Hurd, Peter. "Painter of New Mexico." *Magazine of Art* 32 (1939):390–95, 432–33.

———. "Peter Hurd Writes with Feeling on the Subject of His Art: New Mexico." *New Mexican Magazine* 39 (1961):13, 34, 36.

"Iowa Detail." *Time* 20 (1932):33.

"Iowans Get Mad." *Art Digest* 5 (1931):9.

"John Steuart Curry: The American Farmlands." *American Artist* 30 (1976):46–51, 96.

Knox, Marjorie. "In the Cotton Fields." *Etude* 57 (1939):550.

Kolodin, Irving. "Propaganda on the Air." *American Mercury* 35 (1935):293–300.

Laning, Edward. "Spoon River Revisited. *American Heritage* 22 (1971):14–17, 104–107.

"The Last Frontiersman." *Time* 84 (1965):82.

Leamy, Hugh. "Tambourines." *Collier's* 82 (1928):12, 14.

Levick, Lionel. "Father Divine Is God." *Forum and Century* 92 (1934):217–21.

"'The Light of the World,' an Interpretation of the State of Our Time, Created Especially for This Issue of Esquire by 'The Most Moving of Living Painters' John Steuart Curry." *Esquire* 16 (1941):100 and foldout.

"Loneliness Stirred His Brush to Activity." *Art Digest* 12 (1937):15.

"McCrady Tops Southern League Show." *Art Digest* 15 (1941):13.

McKelway, St. Clair, and A.J. Liebling. "Profiles: Who Is this King of Glory, II?" *New Yorker* 12 (1936):21–26, 28.

Marling, Karal Ann. "Thomas Hart Benton's *Boomtown:* Regionalism Redefined." *Prospects* 6 (1981):73–137.

Moats, Francis L. "The Rise of Methodism in the Middle West." *Mississippi Valley Historical Review* 22 (1935):161–76.

Mode, Peter G. "Revivalism as a Phase of Frontier Life." *Journal of Religion* 1 (1921):337–54.

Moody, V. Alton. "Early Religious Efforts in the Lower Mississippi Valley." *Mississippi Valley Historical Register* 22 (1935):161–76.

Moon, Henry Lee. "Thank You, Father, So Sweet." *New Republic* 88 (1936):149.

Morse, John D. "Ben Shahn: An Interview." *Magazine of Art* 37 (1944):136–41.

"The Mural by Thomas Hart Benton." *Pencil Points* 11 (1930):987.

"Mural Turns Gallery into Negro Church." *Art Digest* 8 (1934):25.

"Mysterious Protests Bar Lynching Show." *Art Digest* 9 (1935):14.

Odell, Joseph H. "The Mechanics of Revivalism." *Atlantic Monthly* 115 (1915):589.

"Orchids for Lutz." *Art Digest* 13 (1938):14.

"Painter: Mississippian Turns to Delta Negroes for Subject." *Newsweek* 10 (1937):32.

"Paul Sample." *American Artist* 6 (1942):16–21.

"Paul Sample, Who Worships Peter Breughel." *Art Digest* 8 (1934):16.

"Penetrating Observation in a Young Painter: Coulton Waugh." *Art News* 37 (1938):14.

Perkins, A.E. "Negro Spirituals from the Far South." *Journal of American Folklore* 35 (1922): 223–49.

"Peter Hurd." *American Artist* 39 (1975):46–51, 100, 104.

"Porgyland Comes to Marie Herriman Gallery." *American Magazine of Art* 29 (1936):60.

"The Prize Picture Shocks." *Literary Digest* 111 (1931):16–17.

"Putting a Ban on Spirituals." *Southern Workman* 57 (1928):384.

"P.W.A.P. Wins Praise at its 'Preliminary Hearing' in Washington." *Art Digest* 8 (1934):5–6.

"The Recall of Evangeline Booth." *Literary Digest* 75 (1922):34–35.

Reed, John. "Back of Billy Sunday." *Metropolitan Magazine* 42 (1915):9–12, 66, 68–92.

"Ruth Star Rose." *Art News* 44 (1946):24.

Ryder, David Warren. "Aimee Semple McPherson." *The Nation* 123 (1926):81–82.

Salpeter, Harry. "About Philip Reisman." *Coronet* 6 (1939):100–101.

"Salvation Army: Evangeline Booth to Become Number One Lassie." *Newsweek* 4 (1934):38.

"Sample Paints with True New England Twang." *Art Digest* 15 (1934):8.

Schneider, Isidor. "Philip Reisman's Paintings." *New Masses* 19 (1936):28.

"She is 'Politely Cruel, Charmingly Venomous.'" *Art Digest* 10 (1935):14.

"The Silver-Tongued Orator." *New Masses* 11 (1934):6.

Snyder, Howard. "A Plantation Revival Service." *Yale Review* 10 (1920):169–80.

"So Full of a Number of Things: Paintings by Lauren Ford." *Survey Graphic* 64 (1930):227.

Summers, Marion. "Studies in Contrast: Chauvinism and Truth." *Daily Worker* 23 (1946):13.

"'Swing Low Sweet Chariot' and Other Paintings by McCrady." *Life* 3 (1937):38–42.

"'Swing Low Sweet Chariot' Will Be Popular." *Art Digest* 3 (1929):5–6.

"Swope Gallery Dedicated to American Art, Opens in Terre Haute." *Art Digest* 16 (1942):7.

"Thomas Hart Benton, Delphic Studios." *Art News* 28 (1929):17.

Thomas, Margaret. "The Art of Grant Wood." *Demcourier* 12 (1942):7–12.

"Two Serigraphers." *Art Digest* 20 (1946):21.

"Underdog Lover." *Time* 30 (1937):41.

"U.S. Scene." *Time* 24 (1934):24–27.

Van Vechten, Carl. "All God's Chillun Got Songs." *Theatre Magazine* 42 (1925):24, 63.

"Virginia Annual at Richmond." *American Magazine of Art* 24 (1932):458, 461.

"Washington's Baptism." *Time* 20 (Sept. 5, 1932), 30.

Wisehart, M.K. "'If you Wish to Know Whether or Not You Really Want a Thing Try Giving It Up' Says Wayman Adams." *American Magazine* 106 (1928):178–81.

"Young Alabama Painter Impresses the Critics with Studies of Negroes." *Newsweek* 11 (1938):22–23.

Young, Stark. "Coming for to Carry Me Home." *New Republic* 92 (1937):372–73.

Zog, Joan Leffring. "Grant Wood's Little Sister." *The Iowan* 24 (1975):8–11.

Index

*Art and Popular Religion in Evangelical America,
1915–1940* was designed by Dariel Mayer, composed
by Lithocraft, Inc., printed by Thomson-Shore, Inc.,
and bound by John H. Dekker & Sons, Inc. The book
is set in Palatino. Text stock is Warren's 80-lb. Lustro
Offset Enamel, dull cream.